The publisher and the Dorra family gratefully acknowledge the generous contribution to this book provided by Jon and Lillian Lovelace.

THE SYMBOLISM

OF PAUL GAUGUIN

The Symbolism of Paul Gauguin

EROTICA, EXOTICA, AND THE GREAT DILEMMAS OF HUMANITY

Henri Dorra

FOREWORD BY RICHARD R. BRETTELL

AFTERWORD BY GABRIEL P. WEISBERG

UNIVERSITY OF CALIFORNIA PRESS *Berkeley Los Angeles London*

University of California Press, one of the most distinguished university presses in the United States, enriches lives around the world by advancing scholarship in the humanities, social sciences, and natural sciences. Its activities are supported by the UC Press Foundation and by philanthropic contributions from individuals and institutions. For more information, visit www.ucpress.edu.

University of California Press
Berkeley and Los Angeles, California

University of California Press, Ltd.
London, England

All artworks are by Paul Gauguin unless otherwise specified. Every effort has been made to identify and locate the rightful copyright holders of all material not specifically commissioned for use in this publication and to secure permission, where applicable, for reuse of all such material. Credit, if and as available, has been provided for all borrowed material either on-page or in the list of illustrations. Any error, omission, or failure to obtain authorization with respect to material copyrighted by other sources has been either unavoidable or unintentional. The author and publisher welcome any information that would allow them to correct future reprints.

Library of Congress Cataloging-in-Publication Data

Dorra, Henri, 1924–2002.
　The symbolism of Paul Gauguin : erotica, exotica, and the great dilemmas of humanity / Henri Dorra ; foreword by Richard R. Brettell ; afterword by Gabriel P. Weisberg.
　　p. cm.
　Includes bibliographical references and index.
　ISBN-13: 978-0-520-24130-5 (cloth : alk. paper)
　ISBN-10: 0-520-24130-4 (cloth : alk. paper)
　1. Gauguin, Paul, 1848–1903—Criticism and interpretation.　I. Title.
　N6853.G34D67　2007
　759.4—dc22
　　　　　　　　　　　　　　　　　　　　　　　　　　　2006030513

Manufactured in Canada

16　15　14　13　12　11　10　09　08　07
10　9　8　7　6　5　4　3　2　1

The paper used in this publication meets the minimum requirements of ANSI/NISO Z39.48–1992 (R 1997) (*Permanence of Paper*).

For Mary Lynn Zink Vance, my former student, whose 1983 dissertation, *Gauguin's Polynesian Pantheon as Visual Language*, inspired the Polynesian section of this study. May her health allow her to return to scholarship.

CONTENTS

FOREWORD

Henri Dorra and Paul Gauguin

RICHARD R. BRETTELL

Henri Dorra published his first words on Gauguin in the *Gazette des Beaux-Arts* in 1952. His article—written in English by a scholar whose French was perfect—was entitled "The First Eves in Gauguin's Eden." It must have been startling at the time, because Gauguin then was thought to be a painter of Tahitian life, whose apprenticeship in France was largely irrelevant to his exotic post-European career. And, by introducing utterly Western—and religious—words into the discourse, Dorra with one essay transformed Gauguin from a latter-day secular "Orientalist" of the Pacific into an artist who injected Christian—and colonial—guilt into the populated tropical landscapes of a faraway French colony. Dorra's Gauguin, like the real Gauguin, was a complex, emotionally guarded, and troubled man, whose odyssey to Polynesia was as laden—and as "Western"—as the journey in Joseph Conrad's *Heart of Darkness*. "What language did they speak in Paradise?" Gauguin had asked that question already, as we learn from Henri Dorra's new—and, sadly, posthumous—book.

When he wrote that article in 1952, Henri Dorra was a graduate student in the fine arts (commonly known as art history) at Harvard University and was already hard at work on his dissertation on Gauguin, completed in the spring of 1954, just fifty-one years after his subject's death. He had already befriended the great German-born scholar of impressionism and post-impressionism John Rewald, with whom he was to collaborate on the first catalogue raisonné of the paintings of Georges Seurat. And Dorra's work on Gauguin (his was only the second dissertation on the artist!) was made available to the professional public of art historians and artists in a veritable stream of brilliant articles that appeared in French, British, and American journals

throughout the subsequent decades. No other art historian of his generation devoted more of his emotional, professional, and personal energy to the understanding of Gauguin; yet only now, four years after his death in 2002 (fifty years after his first article), are we able to read his Gauguin "synthesis."

In many ways, Dorra was singularly well equipped to study Gauguin. Born in Alexandria, Egypt, in 1924 and educated in France, Britain, and the United States, he was truly a citizen of the world. Like Gauguin, Dorra initially pursued an education and early career that revealed little, if anything, about his artistic nature. Dorra's first two university degrees were in engineering, and one suspects that Gauguin the sailor-explorer (his profession before he became a businessman and finally an artist) would have approved! Who would have thought that a young man who had earned a master of science degree in engineering at Harvard in 1950 would complete a doctoral dissertation in art history at the same university just four years later? Yet, in many senses, it was precisely the oddity of his preparation that made him such an important figure in Gauguin studies. No well-heeled young connoisseur from the Boston blueblood or the New York financial aristocracy could have understood this enigmatic post-impressionist as well as the Frenchman born in Africa with a Franco-British-American education. When we read Henri Dorra's lengthy bibliography, we confront major works on European symbolism, on German painting and philosophy of the first half of the nineteenth century, on the American eccentric artist Albert Pinkham Ryder, on Georges Seurat, and article after article on his one aesthetic hero, Paul Gauguin. Dorra was also a fervent reader of European and American literature, as conversant with European poetry, the novel, and the theater as any university professor of French, German, or English and better read in philosophy and the history of religion than most anyone of his generation. Yet this intellectual portrait of Dorra might make one worry that his preparation might be too "verbal" for a visual artist. Fortunately for the history of art, this was not the case. Not only did Dorra study at the Fogg Museum in the glory days of its integration of the art historian and the museum professional, but he also worked at the Metropolitan Museum, the Society of the Four Arts in Palm Beach, the glorious Ringling Museum in Sarasota, the Corcoran Gallery, and the Philadelphia Museum—all before settling into a professorship at UC Santa Barbara a little more than a decade after he finished his dissertation at Harvard.

Henri Dorra's odyssey as a scholar and a museum professional was ideal for a full reinterpretation of Paul Gauguin. Never easy to admire or understand, Gauguin resists lucid commentary—as either a man or an artist. His cavalier treatment of his family, his turning against friends, his escapism, his arrogance, his sardonic wit, and his fear of the very failure he courted—all make him easier to dismiss than admire. And his works, however beautiful their color and composition, are filled with enigmas and even, as he himself said, with a studied ug-

liness. Few historians of modern art are up to the task of explicating Gauguin and his oeuvre, and, among those who attempt the task, there is usually a strong bias for a particular method of analysis. Gauguin was, in short, deliberately evasive—too smart for his commentators and interpreters. Dorra, however, persisted; as we read his text, we have the benefit of more than fifty years of study, of looking, of reading, and of interpretation—in the fullest sense of the word.

As the bibliography in this book makes clear, Dorra zealously kept up with the "Gauguin industry." He was not impartial in his reading, preferring the work of Gauguin's contemporaries and showing little patience for what he might have considered methodological exaggeration. There is no mention, for example, of the work of the ardent feminist Nancy Mowell Mathews or of the sociopolitical historian of art Stephen Eisenman in an otherwise full bibliography. Surely he knew their work, but decided either not to engage with it or, perhaps more likely, not to acknowledge that he had. Yet, if his exclusions are notable, his inclusions are infinitely more interesting and revealing. That major modern works devoted to theology and philosophy, absent in most bibliographies devoted to Gauguin, have pride of place in Dorra's notes and bibliography may be among the most important contributions of his work to the contemporary understanding of this most enigmatic of artists.

The title of Dorra's only book on Gauguin, *The Symbolism of Paul Gauguin: Erotica, Exotica, and the Great Dilemmas of Humanity,* does not indicate the real subject of his work—which is Gauguin's religious and spiritual quest. Indeed, the entire text springs from Dorra's earliest work on Gauguin's "Eves" (note the plural, as if "Eve" were more a condition of womanhood than the identity of a particular woman). For him, as for Gauguin himself, the artist is at once Adam, Christ, Buddha, Jean Valjean, a hospital patient, a journalist, a businessman, and a witness at the crucifixion. And Gauguin's entire life, which Dorra treats fully, is itself a quest or a spiritual odyssey. Dorra's Gauguin is, in a sense, more like Odysseus—or, perhaps more accurately, the mock-heroic Don Quixote—than he is like Delacroix, Manet, or Pissarro.

Dorra's book is in virtually every sense a chronological account of Gauguin's odyssey. Yet, unlike the recent books of David Sweetman or Mathews, it is not a biography. Nor is it a "monograph" in any strict sense—a book that treats Gauguin's works of art in chronological order. Rather, it is a kind of "quest romance" study of a man and an artist whose identities were perpetually in flux as he gained experience, met others, read, and traveled. One of the most important contributions of the book is its frank acceptance of the effect on Gauguin of Theosophy, an intellectual trend, now largely discredited, that had profound consequences for the visual arts in the late nineteenth and early twentieth centuries. Dorra makes clear that Gauguin's most faithful friend, Emile Schuffenecker, was a seminal member of the Theosophist movement and that, from very early in Gauguin's business career, the future artist had a thorough knowledge

of modern investigations of comparative religion. We learn that Gauguin was obsessed with the role of religion in modern global life well before he repudiated the secular naturalism of the impressionists and inaugurated the avant-garde branch of the symbolist movement in France.

Indeed, when one reads Dorra's book on Gauguin in the company of the most recent academic history of symbolism by the French scholar Rodolphe Rapetti, it becomes clear that Gauguin's "symbolism" was of a very different order from that of his contemporary, Odilon Redon. Indeed, the very word "symbol" is difficult to apply to Gauguin, because he was so much more interested in hermeneutic slippage than in clarity that Dorra himself hesitates to identify any form or color in Gauguin's artistic world as a "symbol" for a definable idea. More often, Dorra deals with an overlay of meanings and associations that migrate through Gauguin's oeuvre, never alighting in a single work but assuming greater and greater richness as his career developed. And even when Gauguin attempted the impossible—the visual re-creation of the moral theology of the Polynesian people—he did so with a firm sense of his own roots as a European with a Catholic education. It was Gauguin who transformed Tefatou and Hina into variants of Adam and Eve.

Dorra's book on Gauguin participates in many genres of scholarship. Part biography, part monograph, part quest-romance, part criticism—it attempts to deal completely with the maddening complexities of the man and the artist in the space of a single book. In this, it asks to be compared to Erwin Panofsky's *Dürer*, Kenneth Clark's *Leonardo*, or John Richardson's *Picasso*. Books of this type are unfortunately rare—because the risks in writing them are so great. Indeed, Dorra's book will be read ravenously by a generation of scholars who know only his articles. Like all syntheses, his will please some more than others and will be picked apart by some in the scholarly press. Dorra's identification of the mysterious wooden box made in Copenhagen in the mid-1880s as a "jewelry casket" will not go unchallenged, and certain important connoisseurs do not accept as authentic the mysterious Gauguin self-portrait in San Antonio, Texas, so crucial to Dorra's arguments about Gauguin's interest in religion before his trip to Tahiti. There are also places in which his assured interpretation of certain figures and gestures might be questioned or complicated. But similar criticisms have been leveled at Panofsky's *Dürer* and Clark's *Leonardo*, two books that remain in print, on bookshelves, and in bibliographies more than a generation after they were published.

The sheer sweep of Dorra's book, and the wonderful ease with which his imagination wanders from poetry to arcane religious text to painting to personal letter to ceramic sculpture, makes it the best place for any early twenty-first-century person to start with Gauguin. One hopes that it will be translated into Henri Dorra's native tongue, French, and thus made available to the members of the society that produced Gauguin. I have often pointed out that when Gauguin

signed the guest book in the Auckland City Art Gallery on the trip that was to prove his final return to Polynesia, he did so as "Paul Gauguin de Paris." Unlike Henri Dorra, Gauguin was a prisoner of language, never really perfecting another and, thus, forced to identify French colonies as his temporary "Edens." Fortunately, he operated more fully in the realm of the visual than the verbal, thus becoming an artist who might better be identified as "Paul Gauguin du monde." This is Henri Dorra's Gauguin in his exemplary book.

PREFACE

Astronomers deem a new theory to be successful when, to use a weasel phrase, "almost all the observations seem to fit."[1] And, one might add, when an already established theory is upstaged or demolished by the new, more comprehensive one. The equivalent for students of pictorial symbolism would be to test an analysis of a work of art based on newly interpreted symbols in terms of how well such interpretations "fit" other works where they recur. As a general rule, when a symbol appears to have a specific meaning in the context of one work, perhaps determined with the help of a comment written by the artist or an appropriate analogy, and the same symbol introduces the same meaning in another work, whether it leads to the same or a different overall symbolic message, the symbol can be considered "a good fit," with universal relevance for the artist's work. For example, in Paul Gauguin's work, the symbolic figures for the falling Eve, the fallen Eve, and the self-righting Eves discussed in chapter 4 all appear in the 1899 watercolor painting *Nirvana: Portrait of Jacob Meyer de Haan* (fig. 44), where they make perfect sense in relation to the amorous and moral dilemmas tormenting de Haan at the time.

Gauguin himself expected that a modicum of effort would enable viewers to unravel his symbolism. "Why do you speak to me of my terrible mysticism," he wrote his friend Emile Schuffenecker. "Be impressionist to the end, and fear nothing. It is evident that this symbolist path is full of potholes, and I have only treaded it with the tip of my foot, but it is, after all, part of my nature, and one must always follow one's temperament. I know well that I shall *become less and less* understood. What does it matter if I separate myself from the others? For the masses, I shall be a riddle; for a few, I shall be a poet, and sooner or later quality finds its rightful place."[2]

At times Gauguin discreetly instructed critics about the symbolism of his work, particularly before an exhibition. When *Manao tupapau* (1892; fig. 110) was to be shown at the Copenhagen *Frie Udstilling* exhibition of 1893, he informed his wife about its symbolism: "Here is a little text that will make you knowledgeable in the eyes of the critics when they bombard you with their malicious questions. [But] in conclusion this has to be painting done very simply, the motif being savage, childlike."[3]

In sum, Gauguin's rare hints and even rarer explanations help, but most of the symbols in his work have to be intuited—taking into consideration what is known about the artist's literary tastes and mental habits and about symbols in other works by him. Gauguin's varying moods may have led to differences and even discrepancies, but these are usually understandable and justified. On the whole Gauguin was extraordinarily consistent in his iconography.

Repeatedly, when he referred to iconography, Gauguin stressed the pictorial or sculptural quality of the work: as I have already noted, he characterized *Manao tupapau* as a "painting done very simply." He communicated largely through the expressiveness of line, color, and mass and the harmonies of composition—musicality, in other words. The symbolism of the object was corroborative, a literary or religious allusion to be integrated into the whole, sometimes cynically, sometimes flippantly, and sometimes earnestly. Gauguin has to be interpreted with a very open mind. Ultimately his message gains greatly from his philosophical insights, his subtle studies of character that sometimes encompass whole populaces, and the formidable humor ever at the expense of false vanity, poverty of spirit, and pomposity.

A study of Gauguin's symbolism such as this one could not be exhaustive. Instead, I have attempted to analyze enough examples so that a thoughtful reader can interpret works that could not be included.

*M*y thanks to Colta Ives, curator, Department of Graphic Arts and Photography, the Metropolitan Museum of Art, New York; Virginia Hayes, Lotusland, Santa Barbara; Pierre Rosenberg, former president, Françoise Viatte, chief curator, and Christine André, curator, Department of Graphic Arts and Photography, Musée du Louvre; the registrar of the Decorative Arts Museum, Copenhagen; and Helge Schütze, National Museum of Denmark, Danish Prehistory. I am also grateful to Professor Elizabeth C. Childs, of Washington University, St. Louis; Douglas W. Druick, curator of paintings, and Peter Kort Zegers, curator of prints, at the Art Institute of Chicago, who gave much valuable assistance; the distinguished collector Edward McCormick Blair; Brigitte Béranger-Menand and Professor Denise Delouche of the University of Rennes, who both helped launch this project by asking me to participate in the Graz 2000 *Gau-*

guin exhibition; Professor Bogomila Welsh-Ovcharov, of Erindale College, University of Toronto, always of good counsel; Professor Dario Gamboni of the University of Amsterdam, ever a sharp and constructive critic; Gilles Artur, dedicated Gauguin scholar and publisher; Paule Laudon, former curator of the Gauguin Museum in Papeete, who clarified specific translations; Professor Hope B. Werness, of California State University, Stanislaus, my former student, always a font of advice on Polynesian art; Francesca Consagra, curator of drawings and prints at the Saint Louis Art Museum, who provided a most valuable photocopy of *L'esprit moderne;* Victor Merlhès, the father of Gauguin archival scholarship and a most generous provider of little-known documents; Marina Ducrey, Fondation Félix Vallotton, Lausanne, for Vallotton material; Professor Gabriel P. Weisberg of the University of Minnesota and Yvonne Weisberg, who were always available for discussion; Professor Vojtěk Jirat-Wasiutyński of Queens College, Ontario, who provided useful clarifications; the late Georges and Daniel Wildenstein, Guy Wildenstein, and Sylvie Crussard of the Wildenstein Institute, who responded indefatigably to my queries; and the late Jean Adhémar, print and photography curator of the Bibliothèque nationale, teacher and friend. Finally, I wish to thank Mary Lynn Zink Vance, my student from the time of her undergraduate studies, who presented her doctoral dissertation, "Gauguin's Polynesian Pantheon as a Visual Language," to the University of California, Santa Barbara, in 1983, but could not ready it for publication, first because of the demands of an executive post and then because of a debilitating illness. Her findings paved the way for my own study of Gauguin's Polynesian iconography.

Background and Early Symbolism

Gauguin's Heritage

His Family and Their Nineteenth-Century World

What I wish [to explore] is a still undiscovered
corner of myself.

<div style="text-align:center">To Emile Bernard, end of August 1889</div>

*P*aul Gauguin's paternal grandfather, Guillaume, and his uncle Isidore Gau-
guin appear to have been small property owners in the region of Orléans.
His father, Clovis, had been a political writer on the staff of the left-leaning,
anti-Bonapartiste *Le National* before sailing for Peru in 1849, with his wife,
Aline, their year-old son, Paul, and their daughter, Marie. He intended to
found a newspaper in Peru, but he probably also left France in fear of reprisals
from the leaders of the coup that brought Napoleon III to power. Clovis, who
suffered from a heart ailment, never made it to Peru; he died on the way.[1]

The cultural background of Gauguin's maternal side is much better doc-
umented. His maternal grandfather, André Chazal, descended from a fam-
ily of printers and was one of two artist brothers specializing in decorative
designs; what little of his work has been identified reveals considerable dec-
orative talent and technical skill.[2] In 1821 he married one of the employees
in his printing and lithography workshop, Flora Tristan y Moscoso (fig. 1),
the illegitimate daughter of a Peruvian nobleman who resided in France with
her French mother. The couple had considerable marital difficulties.

Flora left her husband and two children in 1825 and worked to support her-
self. In 1830 she wrote her Peruvian uncle Don Pio Tristan y Moscoso to re-
quest part of a family inheritance. Don Pio had commanded the royalist forces

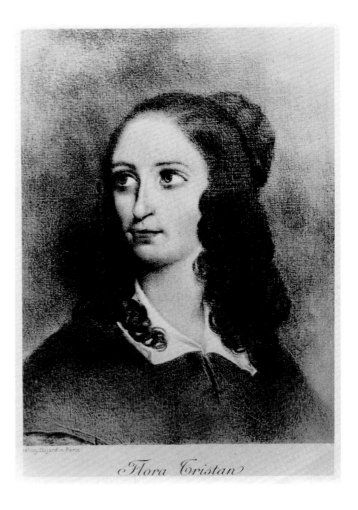

1 Flora Tristan y Moscoso, grandmother of the artist. Lithograph. Bibliothèque Marguerite Durand, Paris/Archives Charmet/Bridgeman Art Library.

Flora Tristan

against Simón Bolívar and his revolutionaries, and been nominated interim viceroy by his generals before the final defeat at Ayacucho. He claimed an aristocratic lineage going back to "the Borgias of Aragon" on the Moscoso side—actually the Spanish Borjas, dukes of Gandia, and the kings of Aragon. He was also related to the Braganza dynasty of Portugal. To these should be added the French Bourbons, through Henry IV of France and Navarre, an Aragon descendant.[3]

In her letter to Don Pio, Flora mentioned that her parents were married only by a priest and not by a civil authority, so they were not legally wed. Consequently, Don Pio responded, she was owed nothing; he nonetheless sent her a small sum and awarded her a minimal living allowance. Hoping to receive a more substantial share of the family's fortune, Flora set out for Peru in 1833, reaching Don Pio's country estate in Arequipa, where she was graciously received. After a few

months there, Flora reiterated her request, to little avail. All Don Pio offered was to let her stay in his household as a family member and to continue providing her small pension. Resigned at first, she soon became outraged. She had been keeping a meticulous and charming diary of her voyage, but after Don Pio's refusal, it acquired a dramatic confessional tone in the Romantic manner. She also began to assume a strong feminist stance: "I revolted against the cruel social order that had so victimized me, that had sanctioned the exploitation of the weaker sex, the plundering of the orphan, and I promised to myself that I would engage in the intrigues of ambition, rival in audacity and cunning with the monk [she had described], to be like him persevering, like him without pity. From now on Hell is in my soul!"[4]

A civil war that had started in Lima and soon reached Arequipa further stimulated Flora. She evoked the tragedies of battle in a colorful and dynamic style. Her writing became particularly powerful when she described the fierce Peruvian camp-followers, the Ravanas, seeing in them paragons of feminine self-assertion:

> They are armed; they load onto mules pots, tents—in sum, all their baggage. They drag behind them a multitude of children of all ages. . . . When nearing an inhabited place, they precipitate themselves toward it like famished beasts, asking the inhabitants for supplies for the army. When these are given with good grace, they do no harm. But when finding resistance they fight like lionesses, and because of their ferocious courage, they always overcome the opposition and pillage and ransack the town, bringing back the booty to the camp to be shared among themselves. These women take care of all the soldiers' needs; they receive no pay, and have for their salary the entitlement to steal without fear of punishment. They belong to the Indian race . . . they are not married, they give themselves to whoever wants them. . . . [They are] horribly ugly, as might be expected in view of the hardships they endure. . . . They are creatures outside of all that is ordinary. . . . There can be no more striking mark of the superiority of woman in primitive populations. Would it not be likewise in a more advanced civilization if both sexes were given a similar education? May the day come when such an experiment will be attempted.[5]

Beyond her ardent feminism, Flora associated the emancipation of woman with her Romantic idealization of the noble savage—heralding, so to speak, Gauguin's passion for the primitive.

Back in Paris from Peru in 1834, Flora turned her diary into the two-volume *Pérégrinations d'une paria*, published in 1838. Flora also traveled to England, making three trips between 1826 and 1839.[6] These trips gave her the opportunity to study women in all walks of life, from those in schools and hostels, to factory workers, to streetwalkers and denizens of brothels, to inmates of asylums and prisons. She also looked at the upper classes of society. She was influenced in her work by the medical-anthropological studies on the condition of underprivileged women by Dr.

Michael Ryan in London and A.-J.-B. Parent-Duchâtelet in Paris.[7] She turned her data into yet another passionate, sometimes blood-curdling text: *Promenades dans Londres, ou L'aristocratie et les prolétaires en Angleterre* (1840).[8]

In 1837, having determined that her husband had attempted to molest their daughter Aline, she gained custody of the girl by court order. In 1838 she obtained a legal separation from André. A year later, under the pretext of her supposedly adulterous relationship with a ship's captain, revealed in the autobiographical *Pérégrinations*, André shot her, permanently lodging a bullet near her heart. She was to survive for five years; he was condemned to twenty years in prison, of which he served seventeen, dying a year after his release.

Flora, in sum, had been a passionate crusader defending abandoned women and their offspring, women held in near-slavery by their mates, and she spoke generally on behalf of the underprivileged of all classes and races, writing about their plight with stirring empathy. Beyond her literary work, she was a political activist, devoting the last decade of her short life to a relentless campaign for workers' rights (she founded a workers' trade union) and the emancipation of women. She died in 1844, at forty-one.

*G*auguin had Flora's *Promenades* in his possession after his mother's death, for he asked his wife to send him the volume, which he lent to his young artist-friend Emile Bernard.[9] He very likely also had access to his grandmother's other books, for his mother's house had contained a "rather important" library, which must have included Flora's works as well as those she is known to have collected of writers sharing some of her views. Incidentally, the house also contained a collection of Peruvian silver and ceramics. Although the house was destroyed in a fire set by the occupying Prussians in 1871, four years after his mother's death, when Gauguin was twenty-two,[10] he had probably spent his home leaves there during his seafaring years, and he was a voracious reader. Most important, he was to articulate themes similar to Flora's in his works, particularly in connection with the various Eve themes, in which seduced and abandoned women are condemned to a life of misery and suffering, followed by time in Hell. At times he decried the bondage of inequitable wedlock. At others, he depicted women who, impervious to sin and the resulting state of disgrace, were able to right themselves in the eyes of society through their will and their abilities, thus asserting their independence, and to make a new start in life. On occasion, he even hinted at happiness in a good relationship.

Flora had died four years before Gauguin's birth, but he was certainly aware of her personality and her achievements. He summed up his impressions at the end of his life, describing her as both "a very pretty and noble lady" and "a strange old dame." According to Gauguin, "Proud-

hon said she had genius.[11] Not knowing anything about it, I trust Proudhon. She invented all kinds of socialist stories, among them the Workers' Union. The grateful workers built a monument [in her memory] in the cemetery of Bordeaux. . . . " When she died, Gauguin added, "Her coffin was followed by many delegations. I know that she devoted her entire fortune to the cause of the workers, traveling incessantly. . . . It is likely she did not know how to cook. [She was] an anarchist bluestocking. Some say that together with old Enfantin she founded a certain religion, the religion of Mapa, of which he would have been the god Ma, and she the goddess Pa."[12]

Flora also counted among her friends another significant socialist utopian, one who strenuously advocated greater freedom and well-being for women: Alphonse Esquiros,[13] whose work appears to have offered Gauguin some important themes. In addition, according to Gauguin, "she was the intimate friend of [the distinguished poet] Madame [Marceline] Desbordes-Valmore," who, just before she died, in 1859, had received official academic honors and was eventually acclaimed by significant members of the new generation of poets, including Charles Baudelaire, Paul Verlaine, and Stéphane Mallarmé.[14] Madame Desbordes-Valmore's brilliant daughter, nicknamed Ondine, became a close friend of Aline's and a witness at her wedding.

Gauguin fully realized that Flora's sustained bid for the emancipation of women implied the same sexual freedom for women as was customary for men. But he may not have quite realized the breadth of her personal conception of sexual freedom. She wrote in a letter to her friend Olympe Chodzko, a married woman, in 1839: "Your letter makes me shudder with pleasure. You say that you love me, that I have a magnetic effect on you, that I cause you to fall into ecstasy. . . . I have possessed you for a long time. Yes, Olympe, I breathe through your bosom. . . . Two women can be in love; likewise two men." In the same breath Flora also revealed how self-centered and indifferent a lover she could be—ultimately as callous as any man or woman: "But I am all at once so ambitious, so demanding, so greedy, so epicurean in my tastes that all that I am offered does not satisfy me."[15] Gauguin appears to have inherited both his grandmother's sexual greed and her ability to hurt—if not her homosexual ardor.

*A*line (fig. 2), for her part, was still a pupil at the Bascan's boarding school for girls in Paris at the time of Flora's death. It was "an essentially '*républicaine*' house," as Gauguin put it—imbued with the ideals of the Age of Reason, including religious skepticism and anticlericalism, an attitude he was himself to espouse.[16] While still at school Aline had friendly relations with novelist George Sand, who wrote to a bachelor friend of hers in his forties: "[Aline] seems as tender and kind as her mother [Flora] was imperious and choleric. . . . Her mourning [for her mother], her beautiful eyes, her [air of] isolation, her modesty have touched my heart. . . . I advise you to fall

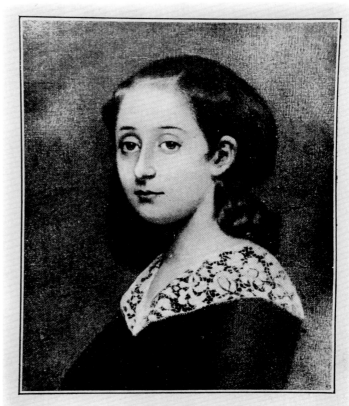

2 Aline Gauguin (Aline Chazal-Tristan), mother of the artist. Lithograph. Bibliothèque Marguerite Durand, Paris/Archives Charmet/Bridgeman Art Library.

Portrait d'ALINE CHAZAL-TRISTAN
(Aimablement communiqué par ses descendants)

in love with her; this should not be difficult. Invite me soon to your wedding."[17] Aline married Clovis Gauguin, a frequent visitor at the establishment, the following year.

Aline was well educated and very sensitive to Romantic literature: "Even a book-binding bearing Lamartine's name reminds me of my adorable mother," Gauguin wrote. "[She] did not miss an opportunity to re-read her *Jocelyn* [Alphonse de Lamartine's two-volume poem about a priest's love and its sublimation]." She was also temperamental, subjecting her child to the brusque mood swings that modern psychologists see as the cause of childhood neuroses: "In her quality of a very great Spanish lady, my mother was violent, and I received a number of slaps from a small hand, supple as rubber. It is true that a few minutes later she would kiss and caress me as she cried." And in a gesture of filial gallantry: "How graceful and pretty [she] was

when she wore her Lima costume, the silk mantilla covering her face and leaving only one eye visible: that eye so sweet, so imperious, so pure and caressing."[18]

Paul was born in Paris in 1848, within earshot of the guns of that year's revolution, but the next year his family left for Peru.[19] He was to retain vivid memories of the family's four-year stay in his grand-uncle's mansion in Lima. The patriarch "fell very much in love with my mother, so pretty and so like his beloved brother, Don Mariano."[20] There is a good chance that Gauguin's memories of life among people of a markedly different culture, as well as the sight of form and colors richer and more vibrant than anything he would see in Europe, affected his aesthetic responses.[21] Likewise, life in considerable luxury among these elegant and refined people must have contributed to both his expensive tastes and his later belief in at least some of the advantages conferred by an aristocracy of mind and soul, as well as of money—including the cultivation of beauty and the arts. Finally, this upbringing may well have stimulated his aspiration to the social status of an officer and gentleman.

In 1855 Aline and her children returned to France, and the children soon received a small inheritance from their paternal grandfather. The family lived in Orléans at first, where Paul became a boarder at the strict Catholic Petit Séminaire de La Chapelle Saint-Mesmin nearby. There the bishop of Orléans himself, Félix Dupanloup, a member of France's leading literary body, the French Academy, formerly a professor of sacred literature at the Sorbonne, and an effective speaker as well as a consequential polemist, taught a course in biblical literature. Gauguin later referred to "certain theological studies of my youth," before excoriating the Catholic Church for its dogmas and rituals. He nevertheless also wrote: "I will not say . . . that this education counts for nothing in my intellectual development; I think, to the contrary, that it did me a lot of good."[22] But, in keeping with his anticlerical background, he noted some of the moral failings of the establishment: "As for the rest, I believe that it is there that I learned from an early age to hate hypocrisy, false virtues, tattling . . . and to distrust anything that was antagonistic to my instincts and my reason." He clearly had strong ties to the Age of Reason.

In describing his psychological and mental development, Gauguin pointed out his gift for preserving the privacy of his thoughts and his tendency toward introspection: "I also acquired a touch of the *esprit d'Escobar,*[23] the art of rationalizing, which is a not insignificant strength in one's struggles. I have also learned to concentrate within my own self, ceaselessly observing the game of my teachers, creating my own entertainments, my hurts too, with all the responsibility they entail. But this is a special case, and, on the whole, I believe that this kind of experimentation is dangerous."[24] He was thus aware of both the advantages and the pitfalls of self-analysis. After the Petit Séminaire, he appears to have attended a lycée in Orléans for a while.

In 1860 Aline moved to Paris, setting herself up as a seamstress in the center of the business

district. She fell ill, however, and retired to the countryside in 1865, shortly thereafter settling in Saint-Cloud, immediately across the River Seine west of Paris, where she died in 1867.[25]

While in Paris, Aline had sent Paul to Loriol, a private school, to prepare him for the very demanding Ecole Navale's entrance competition. The young man's first disciplined training in drawing likely dates from that time, for the examination required drawing from plaster casts and living models as well as mechanical drawing and map-making.[26]

Gauguin was not ready in time for the competition, and the age limit barred him from applying for the next. He nevertheless qualified for acceptance as an officer-cadet *(pilotin)* in the merchant marine in 1865, took three trips to South America, stopping at ports in Brazil, Peru, Chile, as well as in Martinique, and reached the rank of second lieutenant at eighteen, deriving a tangible benefit from his studies.[27] He selected the navy for his military duty, embarking as sailor third class on the speedy yacht allocated to Napoleon III's cousin Prince Napoleon, a little before the 1870–71 Franco-Prussian War. It was initially sent on "scientific" cruises for the benefit of the princes and their learned guests, in the Mediterranean first, then the Arctic. The ship was eventually assigned to combat in the North Sea. A stop in Copenhagen afforded Gauguin a first acquaintance with Denmark.[28]

Released from duty after the conclusion of hostilities, he settled in Paris. Aline had appointed as the legal guardian of her underage children Gustave Arosa, a Parisian financier of half-Spanish descent whose summer residence was near her home in Saint-Cloud. Gustave and his brother had assembled important art collections ranging from Delacroix to the Romantic-naturalist Barbizon School. Gustave's family also counted the impressionist Camille Pissarro among its acquaintances and owned a number of his paintings.[29] Gustave himself had a considerable knowledge of the old masters as well as the more recent luminaries and had launched an enterprise dedicated to publishing photo-lithographic reproductions of works of art—which Gauguin had the opportunity to study.

The Arosas enjoyed entertaining when Gauguin fell into their orbit. Through the brothers and their acquaintances, the artist was introduced to an intellectual milieu of international tastes. There he met a young lady from Copenhagen, Mette Gad, a judge's daughter and formerly a governess to the children of a Danish minister of state. She had accompanied a friend to Paris so that they might both polish their cultural education. Paul and Mette were married November 22, 1873. They were to have five children.[30]

Gauguin's first documented job in Paris was with the financial brokerage Bertin, associated with the Arosas.[31] He was able to support his young wife adequately: indeed, they lived quite well, if not in the most luxurious quarters. Among Gauguin's business colleagues was Emile Schuffenecker, who together with his wife, Louise, became friends of the Gauguins. Schuffe-

necker had trained at the Union Centrale des Beaux-Arts, which specialized in the applied arts, and would eventually turn to art as a career, obtaining a post as a teacher of drawing in a suburban Parisian lycée and participating in exhibitions. Although mediocre, both as a man and as an artist, Schuffenecker came to greatly admire Gauguin and frequently assisted him financially when Gauguin was in dire straits—only to be held in sovereign contempt by the latter.[32] Schuffenecker may well have reinforced Gauguin's interest in art at an early stage. He was very influential in another respect: according to his daughter Jeanne, Schuffenecker had been one of the initial members of the Theosophical movement, founded in New York by Russian-born Helena Petrovna Blavatsky in 1875.[33] This movement had spiritist and esoteric overtones but was also dedicated to establishing the "universal brotherhood of humanity" on the basis of the "ultimate wisdom of all religions."[34] Schuffenecker designed the cover illustration for the 1892 issue of *Le Lotus Bleu*, the movement's French publication, which reveals that he was by then quite familiar with Theosophical symbolism. Gauguin appears to have referred to Theosophical beliefs in numerous works and discussed them at length in his later writings.

Gauguin's own passion for art was beginning to be evident. Already in July 1873, when Mette had returned to Copenhagen to assemble her trousseau, her Danish friend noted: "Paul is terribly distraught without his beloved and devotes his spare time to painting; he is making great strides. Last Sunday he painted for ten hours."[35] Gauguin's early oils were Romantic-naturalist in style, inspired first by Camille Corot, and then more directly by the Barbizon tradition.[36] He exhibited a commendable painting in that style at the Salon of 1876.[37]

By the end of 1876, Mette's friend confided: "Paul's business affairs are not going well, I do not believe his job is secure. This worries Mette."[38] But the artist went on painting in his spare time with increasing diligence. Between 1876 and 1879 he appropriated the light palette, broadly contrasting color areas, and dashing brushwork characteristic of Edouard Manet, intended to capture instantaneous effects of changes in light. He then joined the ranks of the younger impressionists, emulating them in applying comma-like strokes consisting mostly of pure colors. The colors were selected on the basis of what these artists called divisionism: pure hues intended to recombine in the viewer's eye, consisting of the hue of the ambient light or relative shade, the local hue of the object, and reflections from other objects. The impressionists also made use of Michel Eugène Chevreul's Law of Simultaneous Contrast. Chevreul maintained that the eye perceives around each area of color a halo of its complement—when the two complements are adjacent to one another, they cancel each other out at a distance, producing essentially tinted grays, but they vibrate and intensify one another when seen at close range. With this technique, impressionist artists could render the luminous and atmospheric effects of the here-and-now, thus achieving one of the technical aims of naturalism.[39]

Early in 1879 Gauguin befriended Camille Pissarro, who had taken an apartment in Paris but went on prolonged sojourns in the then-distant, and still quite green, Parisian suburb of Pontoise, where Gauguin sometimes painted at his side. At this time Gauguin received a last-minute invitation from Pissarro and Edgar Degas to participate in the fourth impressionist exhibition, which he accepted. He would continue through the eighth and last such exhibition, in 1886. He also came to frequent the impressionists' favorite café: the Café de la Nouvelle Athènes.[40] By the spring of 1879, furthermore, Gauguin had acquired his own collection of impressionist works of outstanding quality.[41]

There is an indication that around 1879 the artist obtained another job: with the banker and stockbroker Bourdon.[42] In 1880 he found yet another lucrative position—the last in his financial career, one that he lost by October of 1883, following the 1882 stock market crash.[43]

When Gauguin started to sell a few of his works at the 1881 impressionist exhibition, he began to consider devoting himself to painting full-time. He wrote Pissarro: "I cannot make up my mind to remain in finance all my life and [as only] a part-time painter; I have taken it into my head that I shall become a painter. As soon as I find the horizon less gloomy [and] that I can earn a living that way, I'll go full steam ahead, and so it is that I am infuriated when I realize that [the possibility of] a *désunion* [falling out with Mette] is the cause of all this ———[presumably 'frustration']."[44] And a few months later he told Pissarro: "As for abandoning painting, never!"[45]

Still unemployed almost a year later, he made up his mind: "I have no job in sight. . . . So, from now on, I shall concentrate on cultivating the [art] dealers. . . . I want to work night and day, and seize the bull by the horns, with energy, and you know how much active strength I have. . . . I have reached an impasse . . . the love of my art fills my head too much for me to be a good worker in a business, where one must not be a dreamer, and yet I have too large a family, and a wife who is incapable of handling misery. . . . I absolutely must seek my existence in painting."[46]

Gauguin must have been strengthened in his resolve by the favorable press received by the 1882 impressionist group exhibition, in which he had twelve works, and by the commercial success of some of the impressionists. Claude Monet participated in several exhibitions, and his work fetched decent prices.[47] When Manet died on April 30, 1883, the press widely covered this event, and Manet's coffin was followed by an impressive group of notables in artistic and official circles. He would soon be canonized as a great artist.

In the meantime, the Gauguin family had to cut down on expenses despite Mette's being "incapable of handling misery." The Pissarros happened to offer a good example of how a still unrecognized impressionist painter and his large and growing family could make ends meet: they lived in small villages, where they rented peasants' buildings. Life in the country also offered a multitude of subjects.

Gauguin decided to leave Paris for Rouen, on January 4, 1884, in search of a lower cost of living, possibly intending to live eventually like Pissarro. Mette, the maid, and their children soon followed. The family rented a small house, but the situation soon became grim. According to Gauguin, they had saved enough to live on for "at most six months, [but] . . . Mette [was] unbearable, [finding] everything disappointing . . . seeing a bleak future. And one must admit that it does look bleak." By the end of July, Mette and two of the children had left for Copenhagen, where they stayed at her mother's; she would eventually give French lessons. Six months later, at the end of November, Gauguin, the maid, and the remaining children joined Mette. He intended to paint and exhibit in Copenhagen, and he had been appointed an agent for Denmark and Norway of a French tarpaulin manufacturer, although he was working on commission only.[48]

In late May 1885 he complained to Pissarro: "At the present time I have reached the limits of my courage and my resources—misery in a foreign city! Without credit or money; every day I ask myself whether I shouldn't climb to the attic and slip a rope around my neck. What keeps me here is painting, and [painting] is at the root of the problem. My wife, the family, everyone blames me for that damned painting, pretending that not earning one's living is shameful." And yet "I can only *do one thing*, paint." By June 22 he and one of his sons were back in Paris, staying with the Schuffeneckers at first. He wrote the impressionist dealer Paul Durand-Ruel that he was "obliged" to return to Paris penniless "by the lack of business abroad." And he told Pissarro it was "impossible to withstand the tempest in Denmark." Later, in response to Mette's recriminations, he wrote: "What would it be like if I had abandoned you forever? Many others would have done it . . . without remorse, since your family encouraged a rupture [between us]."[49]

Gauguin visited Dieppe, on the Normandy coast, where he had a reunion with Degas; then he went to London for a short while before settling in Paris with his son. Their home was tiny. After trying again to work in a brokerage firm, he was reduced, for a while, to making his living by pasting posters in railway stations. And he continued to paint. After placing his son in a boarding school outside Paris, Gauguin moved to Brittany, settling by July 25, 1886, at the Pension Gloanec in Pont-Aven, a fishing village known for its abundance of inexpensive produce and fish as well as cheap and pleasant inns. The place had been discovered by a number of artists, and it soon attracted the attention of a younger generation.[50]

Gauguin's politics during those years may be gathered from his correspondence with Pissarro. From 1883 to 1885 he was associated with a group fomenting a revolution in Spain, which was spearheaded by a group in exile in France led by Manuel-Ruiz Zorilla, who had the support of the Arosas; he even stayed near the border in the summer of 1883 in anticipation of a coup in

Madrid—abortive, it turned out. Zorilla was in effect advocating a parliamentarian monarchy, and his views seem compatible with Gauguin's *républicain* inclinations—a taste for adventure and the possibility of a mercenary's bounty might also have been incentives. He was still involved in these affairs at the time of his visit to London in 1885.[51] That he should have informed Pissarro of his undertaking is not surprising; Pissarro was a dedicated anarchist who contributed cartoons to the movement's periodicals,[52] and as such must have endorsed most kinds of revolutionary activities. Pissarro, nevertheless, did not have unmitigated faith in the purity of Gauguin's intentions or in his political perspicacity: "I am beginning to think that my poor Gauguin does not always see straight. . . . He is always on the side of the cunning ones. . . . He is more naïve than I thought."[53]

Because of his *républicain* outlook, Gauguin shared with Pissarro at least a desire to support a more egalitarian political system. But telling differences nonetheless became apparent: "You are preaching to a convert when you say that we are headed for a moral cataclysm," he wrote Pissarro. "Be confident. The movement [i.e., egalitarian liberalism] is mapped out for centuries, and it is the natural outcome of the unification of man by means of universal rights and the resulting [progress] in education. Money, property for all; the same share of the sun, etc. Yes, there is improvement, and in keeping with my whole *républicaine* philosophy, I cannot find fault in what I have always wanted since I became a man."

And yet, believing that, as their lot improved, the masses would fail to support the arts, he argued:

> I see in this slow revolution a good future at close range, but from the moral standpoint we would be losing much. You think that it will be the same for art, but I believe that you are mistaken, because it will go in the opposite direction. Everyone will have talent, much as everyone will be educated. When everyone is king, no one is expected to support one's neighbor, [but] when there is nobility, when there is government by the few, there is protector and protected. In sum I maintain that the more the mass is uniform, the less it needs art. [In order to instill such] needs, there has to be contemplation, a love of the luxury born from greatness, [an acceptance] of irregularity in the social scale, [and] a little [in the way of selfish] calculation. It so happens that the new society will increasingly distance itself from all this. Does one have time for contemplation? No, the theaters, etc., are here to draw you away from it. . . . Can one do away with [selfish] calculation? No, the [demands] of life are too rough for a man to put his enthusiasm ahead of all else.[54]

And some eight years later, for the benefit of his daughter Aline in 1893 in a notebook she never received: "Long live democracy; it's all there is! . . . [And yet] I love nobility, the beauty of del-

icate tastes and that old-fashioned motto: *Noblesse oblige*. I love good manners. Politeness, even that of Louis X[IV]. I am therefore by instinct, and without knowing why, ARISTO.[55]

In sum, Gauguin in these last passages subordinated political considerations to the needs of art: much as he supported democratic principles, from his standpoint as an artist he felt closer to the ideals of a thoughtful, generous, artistically inclined aristocracy, since it was more likely to support the arts than would a democratic state.

*U*ltimately, Gauguin also subordinated ethical considerations to aesthetic ones, but he was unquestionably concerned with ethics. Later in life he asserted, albeit with some irony, that as a practical matter morality had to be relative: different situations called for different rules, and, most important, individual classes or professions had different ethical codes. Each class or profession, moreover, was hypocritical in the way it judged the others. But Gauguin also implied, as we shall see, that there were absolute principles to be respected and followed. In his words, there is the "morality of one's private parts *[du cul]*, religious morality, patriotic morality, the morality of the soldier, of the policeman, . . . one's duty in the fulfillment of one's responsibilities, the military code (for or against Dreyfus),[56] the morality of [the virulent anti-Semite] Drumont, and of [a milquetoast poet as well as an ardent supporter of would-be strongman General Boulanger] Déroulède." But then, just before this statement, he had acknowledged deeply felt ethical principles, here summarized in the notion of human brotherhood, and made short shrift of the above-mentioned relative moralities. He was, in fact, threatened by them: "Like floods, morality crushes us, suffocates freedom, hates fraternity."[57]

Gauguin's own practical, relative morality was conditioned by the fact that he was originally destined for a naval officer's career, had descended from a long line of Spanish military men on his mother's side, and considered himself to be very much a member of the social caste of officers and gentlemen. At a superficial level, he took great pride in his fencing training and skills—the gentleman's sport par excellence.[58] And wherever he went he took his fencing foils, mask, and gloves. For him, the code of honor of the officer and gentleman—permissive in some ways, draconian in others—prevailed. In business affairs he was honorable or at least did his best to be so. He took advantage of the credit innkeepers often extended to their guests, for instance, but made considerable efforts to settle his debts before leaving their inns.[59] And to the friends who helped him financially, as did Schuffenecker on numerous occasions, he gave works of art.

As far as sex was concerned, Gauguin appears to have been a faithful and loving husband throughout his early married years. After that he took up the life of the carefree bohemian milieu of the artists of his day, nonetheless abiding for the most part by one of the principal rules

of the code of honor: no illicit sex with a member of one's own class unless—and this is a major caveat—all concerned manage to maintain absolute discretion.[60] To the dangers of social scandal and of being named a correspondent in a divorce trial that such an affair entailed,[61] the code of honor added the risk of a duel. An illicit relationship with a member of a lower class, on the other hand, entailed very few social risks and almost certainly no duel. In this last respect Gauguin upheld his grandmother's advocacy of free love, but he was not hypocritical about his failings:

> I have been good sometimes; I don't congratulate myself for it.
>
> I have been bad often; I do not repent.
>
> A skeptic, I look at all these saints, and do not see them [as being] alive. In their cathedral niches they have a meaning—only there. The gargoyles too, unforgettable monsters: my eye follows the accident [of their form] without dread, bizarre creations.[62]

Indeed, the artist revealed a full and frank acceptance of his sinfulness in his works as well. In this he shared Baudelaire's notion that many vital impulses are rooted in evil, so that evil must necessarily figure in aesthetic experience—a notion that may well distantly reflect the emphasis on original sin in the Catholic tradition. In this respect at least, nonbelievers though they were, both Baudelaire and Gauguin appear to have been deeply affected by their strict Catholic early education.

Gauguin's works and his writings occasionally reveal deeply felt ethical principles. Failure to uphold human brotherhood was a major failing. The advent of such a humanitarian attitude has been linked with his reading of Victor Hugo's *Les misérables* during the summer of 1888, his subsequent stay with Vincent van Gogh in Arles, and his becoming aware of Swedenborgian spirituality through his reading of Honoré de Balzac's *Séraphita*.[63] This humanitarian impulse vigorously asserted itself at that time, but its roots went back to an earlier period, to a concern that reflected Flora Tristan's own humanitarian endeavors, expressed in a series of works devoted to allusions to lovemaking in rustic settings and the subsequent distress of little peasant Eves.

In a broader sense, the symbols in Gauguin's work unfold in the same manner as fables; cryptic on first impression, they evoke for those who make the effort to decipher them the greed, deceit, and brutality of some, the foolishness and innocence of others, and ultimately intense anguish and despair. And they do so with simple, almost childlike simplicity, sometimes with sardonic cynicism, sometimes with compassion, and often with both. Reflecting on his art of the previous year—the works that first manifested the full import of these humanitarian concerns—Gauguin asked Emile Bernard in 1889: "Is it nothing, a human cry?"[64] In his Polynesian works Gauguin stressed the brutality, harshness, and intransigence of the old faith and customs as well

as the gentleness and poetry he sensed in the population, and in nature's abundance and luxuri-ousness. In all cases he demonstrated a compassion that reflected his profound humanitarianism and ultimately the echoes of the great religions that had touched him.

Gauguin's anticlericalism and suspicion of blind faith and the rigid adherence to the letter of the scriptures remained with him all his life: "What must be killed never to be born again is God," he exclaimed in Nietzschean fashion in 1897.[65] What he meant, as we shall see, is that he could not accept the notion that an almighty power controlled the fate of the universe with a fierce will and an unerring hand. He was against such a god-creator, he was to assert in later years, and thus drastically altered his religious iconography. Instead, he sought out exemplars of personal generosity and abnegation. He asserted that after he studied "Buddha, simple mortal who never conceived nor apprehended God, and conceived and apprehended all the intelligence of the hu-man heart and arrived at eternal beatitude, Nirvana, the ultimate destination of the soul," he ac-quired "a certain comprehension of [his] own heart . . . [and] set out to study the Gospels, try-ing to decipher [their] meaning." And, he added, "I concede that when I *believed* I understood them, I always found [in them] the wisdom, the elevation of thought in its noblest state." In con-clusion: "I have loved God without knowing it."[66] Victor Hugo, Vincent van Gogh, and Swe-denborg must all have played their part. Perhaps even, against Gauguin's will, so had the bishop of Orléans!

Such feelings played a significant role in Gauguin's creative output. And while it plays a less significant part in his work, Theosophy must also be taken into account. Gauguin was far too much a man of the Enlightenment to dabble in the occult or to be a mystic. And yet however pedantic and trivial the Theosophical approach to the world's religions may have been, it helped him articulate some important ideas. By the time Gauguin executed his first work showing evi-dence of Theosophical influence, the carved-wood *Jewelry Casket* of 1884 (fig. 6; see chapter 2), the movement had spread around the world, through lectures and articles in what came to be a specialized press.[67] According to one of the definitions given by its founder, the Theosophical movement was a "universal brotherhood encompassing the faithful of most world religions," drawing from each "that divine wisdom that manifests itself in everything."[68] While she en-deavored to appeal to members of all faiths, Blavatsky and her immediate followers were par-ticularly attracted by spiritism and the occult. It is significant that her early publication, *The Theosophist*, bore on its cover the motto "Devoted to Oriental Philosophy, Art, Literature and Occultism: Embracing Mesmerism, Spiritualism and Other Secret Sciences."[69]

One side of Theosophical teachings proved particularly germane to Gauguin's thinking and his art: the affirmation that rather than taking literally the accepted texts, rituals, and liturgy of ancient religions, Theosophists sought what they considered to be their common spirituality. In

Blavatsky's words: "Theosophy is . . . the archaic *Wisdom-Religion*, the esoteric doctrine once known in every ancient country having claims to civilization. This 'Wisdom' all the writings show us as an emanation of the divine Principle; and the clear comprehension of it is typified in such names as the Indian Buddha, the Babylonian Nebo."

Blavatsky gave Christianity short shrift at that point, for Theosophy had been "tracked like wild beasts by the Christian clergy—to be known as a Theosopher amounted hardly a century ago to a death warrant."[70] A year later she had become more inclusive: "a 'Universal Brotherhood,' . . . The Theosophical Society is a harp with more than one string. . . . Are you Christian, Buddhist, Brahman, Jew, or Zoroastrian . . . Spiritualist . . . Freethinker? . . . You have only to affiliate with the [appropriate] branch." And, incidentally, again placing the spirit above the letter, she admitted Christ into her pantheon: "It is not necessary to know Christ . . . nor Buddha, nor Zoroaster, nor Parabrahman . . . according to the flesh, but the *ideal* Christ, that is to say the eternal son of God, that divine wisdom which manifests itself in everything."[71] Other leaders of the movement, particularly the head of the French branch, put a greater emphasis on Christianity: "There is a great religion of all humanity . . . and its true name is Christianity."[72]

And yet there can be little question that the prime interest of most Theosophical writers of the time was Buddhism, for the movement sponsored at least three studies of that religion.[73] Moreover, for some Theosophical theorists (particularly Blavatsky) Hinduism, while not ranking quite as high, also held a privileged position among the world's religions.

By 1888–89 Gauguin referred specifically to Buddhist philosophy in his compositions, just as he alluded to Christian themes. As for his own interest in Buddhism, just before he stayed with Vincent van Gogh, Vincent wrote him a letter reminiscing about an article by the Far East scholar and advocate of Theosophy Emile Burnouf, titled[74] "Le bouddhisme en Occident," in the prestigious *Revue des Deux-Mondes*.[75] It is more than likely that he and Vincent discussed it when they joined forces: Burnouf particularly valued the absence of religious hierarchy in Buddhism and that it professed to uphold the "natural equality" of men. It followed "certain rules, certain formulas which happened to be very broad." The principal commandments of Buddhism were "voluntary poverty, . . . the overcoming of desires, . . . celibacy, . . . inalterable patience and universal charity." Killing, stealing, adultery, lying, and drinking alcoholic beverages were forbidden. To war had to be opposed "humility"; and good deeds had to be practiced secretly and effectively.[76] There is no doubt that Burnouf was sympathetic to the Theosophical movement; he praised the "Société théosophique aryenne de New York"[77] and referred to *Cathéchisme bouddhique* by Blavatsky's U.S. lieutenant, Colonel Olcott.[78]

In keeping with the encompassing vision of Theosophy, Burnouf drew parallels between the spiritual messages of Jesus and Buddha. In both traditions good was opposed to evil, the latter

symbolized by Satan and Mara, respectively. And both posited spiritual perfectibility: Christianity, through the stages of earth, purgatory, and heaven; Buddhism, through metempsychosis—the transfer of still-imperfect souls to other bodies at the time of death. What the Ascension was for Christians, Nirvana, the ultimate state of bliss, was for Buddhists.[79]

Gauguin may already have been fully aware of the Theosophers' strong leaning toward Buddhism, but in Burnouf's article he would have found messages relevant to his thinking and his art. He was certainly aware of Vincent van Gogh's *Self-Portrait* (1888) as "a bonze [Buddhist monk of the Far East], a simple worshipper of the eternal Buddha,"[80] as this painting was dedicated to "*Mon ami Paul G.* [my friend Paul G.]."[81] Later, in his own *Self-Portrait with Halo* of mid-November to early December 1889 (fig. 55), Gauguin, would wrap himself in the characteristic saffron-colored robe of a Buddhist monk. Allusions to Buddhism would become frequent in the artist's work from that time on.[82]

Gauguin also reflected Theosophical thinking in his works by juxtaposing allusions to different faiths as if to bring out the poetry of their common humanity. Just as important, in keeping with the notion that a Theosopher is one "who gives you a theory of God, of the works of God, which has, not revelation, but his own inspiration for its basis"[83]—and more specifically, with the distinction between the literal acceptance of scriptural writings, rituals, and liturgy, on the one hand and the "Wisdom-Religion" of various faiths, on the other—Gauguin made a point in several of his later writings of distinguishing between the appearance of a religious scene or the literal sense of a scriptural text (either of which could be trivial or even absurd) and its symbolic message, which could have profound philosophical meaning. He thus asserted in a letter to an art critic:

> The [doctrine] of the Bible presents itself under a double aspect (especially in relation to Christ). . . . The first gives material form to the idea so as to render it more readily perceptible to the senses, [thus] taking on the demeanor of surnaturalism; it is the literal, superficial, figurative, mysterious [aspect] of a parable; and then the second conveys the latter's Spirit. It is no longer the figurative; but the figured, explicit, sense of that parable.[84]

For Gauguin, in religious parables the accepted definition of metaphor is reversed: the signifier, usually considered to be factual, becomes mysterious because it flouts common logic, whereas the signified is "explicit," inasmuch as its philosophical meaning makes good sense. Incidentally, Gauguin was particularly articulate and virulent in his attacks on the Catholic Church's literal interpretation of the scriptures, rituals, and liturgy in his late manuscript *L'esprit moderne et le catholicisme*.[85]

Gauguin's comment here also gives a significant clue to his own handling of symbolic asso-

ciations and metaphors. He had introduced the above passage by explaining to the critic: "I act a little like the Bible [in my use of symbols]." In other words, however crude, incongruous, ironic, or disarming the visual associations and metaphors in his work might be, their symbolic meaning was sensible and philosophically profound—at least for those willing to make the necessary effort of comprehension and feeling.[86]

In broad terms, Gauguin's acceptance of some Theosophical principles contributed to the universality of the humanitarian vision he infused into many of his important works. It enabled him, in particular, to establish sympathetic parallels and oppositions between the religions of differing cultures—what will be called his syncretic approach. Gauguin also drew on Theosophy's speculations on nature, the universe, and evolution in general, evoking these more richly and provocatively, and certainly more imaginatively, than did the scientists of his day.

While Gauguin may have tackled religious subjects or simply raised ethical matters in his work, he was neither a religious painter nor a moralist. He was primarily a fabulist, evoking human predicaments, sometimes with bitterness, even sarcasm, often with compassion, but always at a very high aesthetic level. The failings and sins of common humanity prevailed in the blissful pastoral settings of Brittany and in his paradise of the tropics—without detracting from the richness and beauty of either.

Ultimately, aesthetics usually superseded ethics in Gauguin's scale of values, as articulated in a metaphor he had borrowed from Vincent van Gogh, in which Christ becomes the supreme artist: "What an artist this Jesus, who has chiseled right into humanity."[87] As has been pointed out, Gauguin was paraphrasing a passage of van Gogh's letter to Bernard: "Christ alone—among all the philosophers, magi, etc.—has affirmed as a principal certainty of eternal life the infinitude of time, the nonexistence of death, the necessity and raison d'être of serenity and devotion. He lived serenely, *as an artist greater than all the artists,* ignoring marble and clay and color to work with living flesh."[88] Although Gauguin never seems to have mentioned John Ruskin in his writings, he would probably have agreed with Ruskin's notion that teaching the arts renders humans more ethical for the simple reason that "the faculty for art is a visible sign of national virtue," and the arts "spring from the whole of humanity" and "their object is the whole of humanity."[89]

Finally, Gauguin's increasingly complex symbolism had an effect on his relationship with Camille Pissarro—as if the newly declared divergence in their political views in 1885 were not enough—for Pissarro had become close to Georges Seurat, Paul Signac, and the neo-impressionists and to a considerable extent took up their techniques, continuing to do so until 1890, when he returned to a more spontaneous impressionist treatment. Gauguin's quarrel with Seurat and Signac around mid-June 1886[90] put an end to his contacts with both artists and, apparently, with Pissarro as well.

Gauguin's eventual repudiation of impressionism—his century's final manifestation of naturalism—in favor of symbolism came as a shock to Pissarro. After seeing a work in the new mode—*The Vision after the Sermon: Jacob Wrestling with the Angel* of late September 1888 (fig. 49), which was also Gauguin's first religious subject—Pissarro wrote his son: "I reproach him for not having applied his synthesis in the service of our modern philosophy, which is absolutely social, anti-authoritarian, anti-mystical."[91] Yet, aside from an occasional slight, Gauguin mostly praised the older artist, confiding one year before his own death: "He was one of my masters and I do not deny it."[92]

What Pissarro failed to recognize in Gauguin's development was the ability to introduce complex ideas in his work—and, of course, to convey them by purely plastic means. Indeed, Gauguin was proud of his own meditative argumentation, writing late in life:

Philosophy is heavy-going if it is not [already] in me, by instinct. [It is] sweet in one's sleep, together with the dream which adorns it. Science, it is not . . . or at most [it is] a germ [thereof]—multiple, as is everything in nature, evolving ceaselessly. It is not a consequence [of a deductive process], as solemn personages would have us learn, but rather a weapon we, as savages, build on our own. It does not manifest itself as a reality, but as an image—just like a painting: admirable if the painting is a masterpiece.

Art brings with it philosophy, as philosophy brings with it art. Otherwise what would happen to beauty?[93]

Such "philosophical" thoughts appear both in Gauguin's correspondence and in his copious handwritten notebooks. The latter, compiled mostly at the end of his life, transcribe passages he had collected from his readings over the years. In some cases he names their authors, in others not. The passages are often followed by his own pithy commentaries. And much of the time the ideas are very much his own. The texts are also replete with jokes, political wisecracks, personal anecdotes, and important reminiscences. Spontaneous and untidy, they are further marred by countless repetitions, or rather endless futile attempts to add philosophical rigor to his commentaries. But they are at times witty and frequently quite amusing. Most important, they often lucidly convey the principal thoughts that inform Gauguin's artistic production.[94]

Budding Symbolism

I shall not tell you the truth; everyone prides himself for telling
it; fable alone will reveal my thinking, if, indeed, to Dream is
to Think.

<div align="right">

Le Sourire, August 1899

</div>

*S*ymbolist elements become apparent in Paul Gauguin's work as early as
1881, in *The Little One Is Dreaming* (fig. 3). This composition, with its free
and dashing impressionist style, successfully captures shimmering light
from an unseen window falling tenderly on the artist's four-year-old daugh-
ter Aline, asleep in a gray nightgown on white sheets that stand out against
the dark wainscot. Yet there is more to this than just the here-and-now of nat-
uralism. For Gauguin evokes a father's frame of mind in the moment. Grace-
fully and swiftly flying in various directions, the blackbirds of the wallpaper
suggest a parallel with freely evolving human life. One of them raises its head
as if to warble as it alights on the edge of a nest, thus heralding little Aline's
maternal instincts. To the right, a bearded puppet hangs from the bedstead;
he wears a yellow conical hat and an orange garment ending in points, with
bells attached. This puppet represents a traditional court jester, who, under
the pretense of being humorous and inconsequential, was privileged to tell
unpleasant truths, usually—but not always—without fear of retribution. It
is no doubt meant to allude to the hazards of fate. The birds and the jester
puppet, then, serve as metaphors for a father's hopes and fears about his child's
future, here presented in terms of her dream-consciousness.

Household objects and a wallpaper design again play a significant sym-
bolic role in a portrait executed in a bold and mature impressionist manner:

3 *The Little One Is Dreaming*, ca. 1881. Oil on canvas. Ordrupgaard, Copenhagen.
 Photo: Pernille Klemp.

Sleeping Child, or *Clovis Asleep*, of 1884 (fig. 4).[1] The child's head and upper torso lean against a tabletop. To the left, the shimmering surface of the table serves as a foil for the child's equally shimmering reddish blond hair. Next to the child's right hand is a fur hand puppet, perhaps in the shape of a rabbit, lying in doll sheets, its head resting on a child's orange wooden clog. Below the waist is a light-colored sleeve for the puppeteer's hand. Five high-value spots on the surface may represent small tears in the fur. A relatively large earthenware mug, the same as in *Still Life in an Interior, Copenhagen* of 1885 (fig. 5), sits on the table, apparently as an afterthought: one can see, in a pentimento, part of the child's left hand underneath a layer of paint in the mug that age has made transparent.

The stolid mug could stand, in opposition to the poetic fantasy of the world of toys, for the heavy-handedness and the self-indulgence of the adult world. The contrast seems to be further

4 *Sleeping Child*, or *Clovis Asleep*, 1884. Oil on canvas. Samuel Josefowitz Collection, Lausanne, Switzerland. Photo: Erich Lessing/Art Resource, New York.

5 *Still Life in an Interior, Copenhagen*, 1885. Oil on canvas. Private collection, Switzerland.

developed in the wallpaper design, in which on the right a lightly painted soaring bird appears, somewhat similar to the one in *The Little One Is Dreaming*, but white this time and more stylized and translucent. Higher up, across the picture, more diaphanous white shapes continue and complement the decorative line of the bird. Together with the bird, they suggest a child's whimsical and lighthearted dream. But a giant dragonfly is also visible on the wallpaper. It appears to be a fishing lure, for it bears a tail of a bundle of graceful, thin, shiny feathers in yellow, orange, and silver—an entomological impossibility. The firmly drawn, solid, curved black line under its forward left wing suggests a metal fishhook.[2] Placed as it is right above the child's head, this dragonfly "lure" suggests here, too, that something unpleasant is in store.

Another impressionist work, *Still Life in an Interior, Copenhagen*, conveys Gauguin's sense of isolation among his wife's relatives and friends in Denmark. Essentially seen in caricatural silhouettes against the light, the figures assembled in the far room epitomize the reputed stiffness and lifelessness of the Scandinavian high bourgeoisie of the day.[3] The two rooms are separated by a wall panel. Immediately beyond, two bulky and obtrusive pieces of furniture, a chest of drawers and a brass bed, reveal that the Gauguins' domestic arrangements in Copenhagen were at best makeshift. The furniture also forms a psychological barrier between the assembly in the far room and the artist presumably at work in the near space. In the near room, the still life with its rumpled fabric, feathered game, onions lying at various angles on the table, corpulent earthenware mug,[4] and basket—all subdued in color but rendered in vibrant brushstrokes—has a rich tactile and gustatory appeal that makes it one of the liveliest sober still lifes by anyone, from Gustave Courbet to Paul Cézanne.

The composition of the dividing wall panel contributes its own telling whimsy. From a diaphanous floral pattern centered around a calla lily at the bottom rise two grisaille vines around a fairly abstract picture, dark in value but faintly luminous, in the manner of a mature russet-toned Cézanne, and, centered above, "P. Gauguin" appears in bold and firm letters. All this suggests some imaginary screen on which the painter projects his artistic musings—solace for the stilted conversation of people knowing little French. Like the wallpaper in the two paintings of dreaming children, the wall here offers an opportunity for an escapist dream.

The symbolism of *Jewelry Casket with Carved Reliefs of Dancers* of 1884 (fig. 6), executed in Copenhagen, is particularly bold and powerful. Indeed, the surprise and shock one encounters in untangling its meaning bring to mind Gauguin's remarks at the end of his residence in Denmark: "Do not worry; I have no reason to fear Danish painting in relation to mine; to the contrary, [its] lack of vigor has aroused in me such disgust that I am more than ever convinced that there is no such thing as exaggeration in art. I even believe that the only salvation lies in the extreme; everything in the middle is mediocre."[5]

*T*hree slightly earlier texts reveal that Gauguin had been considering important aesthetic breakthroughs around this time. In the manuscript *Notes synthétiques*, probably from about October 1884,[6] Gauguin claimed that the plastic arts had a major advantage over other art forms, which could only present successive events over time; in contrast, in the plastic arts "[the viewer][7] apprehends at once the prelude, the stage action, and the final outcome." Gauguin gave an example from the theater, on the assumption that a single instant of a well-performed scene can, like a painting, convey past, present, and future, and can be superior: "Whatever talent you may have to recount how Othello arrives, his heart full of jealousy, to kill Desdemona, my soul will never be as impressed as when I shall have seen with my own eyes Othello step forward in the room, his forehead in the grip of a storm." This concept of incorporating a time span in the representation of a single scene flew in the face of the naturalist concern with rendering a specific place and time, and, more particularly, with the impressionist pursuit of immediacy and instantaneity. Beyond that, it contravened the Aristotelian principle of unity that various academies (including the French) had imposed on their members since the seventeenth century. According to this principle (which Shakespeare himself defied), a play or a work of art should be based on a single action, occurring in one location, theoretically in the course of one day. Gauguin had already juxtaposed scenes pertaining to different locations—different psychological worlds, in effect—in the two pictures of his dreaming children, where the child is shown sleeping in a bedroom while the dream taking place in the child's mind is suggested by the symbols in the wallpaper and other objects. *Jewelry Casket* also juxtaposes different actions, in different locations, at different times. Individual figures and objects are invested with symbolic meaning that, when analyzed and considered as a whole, evokes the overall expressive intent—or rather, intents, since Gauguin sought to convey a multiplicity of related meanings.

In late October or early November of 1884, in a statement presumably intended for a Norwegian critic who had recently praised an impressionist exhibition in Oslo that had included works by Gauguin, Gauguin wrote what amounts to a repudiation of the naturalist vision of impressionism, stressing the new importance he was attaching to the dramas of the human soul. In doing so he was articulating the raison d'être of symbolism: "I want a picture that represents the special character of a man. I have no need for the imitation of an apple (nature is worth more), whereas I do have need of bit of temperament." And "very rich is the art made up of bold convictions, even erroneous ones, of the mystery of passion, of nature seen through the veil of the soul [and] free of the habits of yesterday."[8]

Incidentally, the notions that art primarily should express thoughts and emotions rather than depict aspects of nature, and that it should be essentially subjective, had been advanced by that Romantic initiator of symbolist poetry Charles Baudelaire, writing about Eugène Delacroix:

"[The personality of] Delacroix was an admirable admixture of philosophic solidity, light wit, and burning enthusiasm"[9]—all of which allows plenty of room for personal feeling! And as far as the most intimate subjectivity is concerned: "What is this mysterious I-know-not-what that Delacroix . . . has translated better than anyone else? It is the invisible, it is the impalpable, it is the dream, it is the nerves, it is the *soul*."[10]

To achieve this goal, the artist or writer must detach the viewer or reader from some of the contingencies of material reality. Shielding some of those contingencies in a veil of mystery was one way of doing this. Baudelaire explained that Victor Hugo's writings convey "what I would call the *mystery of life* . . . [Hugo] expresses with indispensable obscurity what is obscure and confusedly revealed."[11] Delacroix was even more specific: "The imagination takes delight in vagueness and spreads easily and encompasses vast objects on the basis of summary indications."[12] Gauguin also praised mystery: "When in the moonlight you have before you a sight that is very difficult to explain, its shapes ill-defined, your sensations, either of fear [or] melancholy, or any wholly different impression, do not arise in response to [the question] 'why,' and . . . you [happen not to] flee, [even though the situation] is not [susceptible to a reasoned] explanation. [This would point to the fact that,] in general, mystery begins where poetry is born."[13]

Additional elements of symbolist theory were outlined by Gauguin later, in a letter of January 14, 1885, to Schuffenecker. The artist prefaced his arguments: "As for me, I sometimes think that I am crazy, and yet, the more I think at night in my bed, the more I believe I am right. For a long time, philosophers have discussed phenomena that appear supernatural to us, and of which we nevertheless have the *sensation*." Here too Gauguin's thinking was very close to that of Baudelaire, who concluded that the formation of symbols is related to our perceptions of objects when we are in a state of exceptional poetic awareness: "In certain almost supernatural states of the soul, the profundity of life reveals itself fully in the display before one's eyes, however ordinary it might be. It becomes its symbol."[14] The poet further elaborated on how the creative imagination exploits such symbolist associations, referring to Delacroix among others: "[Imagination] is the analysis, and it is the synthesis. . . . It has created since the beginning of the world analogy and metaphor. It decomposes the whole of creation, and with the materials it has amassed, and disposed of according to rules [emanating only] from the most profound [regions] of the soul, it has created a new world, it has produced the sensation of the new."[15]

Gauguin must have had in mind something on the order of Baudelaire's association between "the display before our eyes" and "certain almost supernatural states of the soul" when he urged Schuffenecker in his January 14 letter: "Observe in the immense creation of nature, and you will see if there are not laws making it possible to create by means of quite different aspects of matter—which nevertheless are similar in their effect on the unconscious—all human feelings.

By way of example: look at a large spider, [or] the trunk of a tree in a forest; both produce a terrible sensation without your becoming aware of it. . . . no reasoning can withstand such feelings." He clearly saw in these objects potential metaphors for disgust and fear, respectively.[16]

In the same letter, Gauguin returned to a subject already adumbrated in *Notes synthétiques*—the notion that the handling of an object's form can strengthen its expressive significance in a composition and, in turn, its symbolic role. This notion is based on the assumption that, as with rhythm and melody in music, harmonies of lines and colors can be pleasing or displeasing and can have in their combinations specific expressive value—hence the term "musicality." Here again, Baudelaire and Delacroix appear to have made an impression. For Baudelaire: "The good way to figure out whether a picture is melodious is to look at it from a sufficient distance so that neither subject nor lines can be distinguished."[17] Delacroix, for his part, refers to "the music of the painting," saying that "when you are too far away from it . . . you are conquered by its magical accord."[18] And Baudelaire again: "There are hues that are gay and frolicsome, others frolicsome and sad, rich and gay, rich and sad, some that are common, and some original."[19] Gauguin accordingly asserted in his letter to Schuffenecker:

> All our five senses reach the brain directly, which no education can destroy. I conclude from this that there are lines that are noble, [others] deceitful, etc. . . . The straight [line] gives [a notion] of the infinite; the curve limits creation. . . . Colors are even more explicative, although less multiple, than lines because of their power over the eye. There are noble tones, others [that are] common, [and] tranquil, consoling harmonies. Others excite you through their boldness. In sum, seek in graphology[20] the traits of a man who is frank and those of a liar. . . . The further I proceed, the more I am rewarded in . . . [such] translations of thought by means other than literary ones. . . . Above all, do not sweat over a painting. A great feeling can be translated immediately. Dream over it and try [to express it] in its simplest form. An equilateral triangle is the most solid and most perfect form of a triangle. A long triangle is more elegant. In pure truth there is no side; to our feeling there is one.[21]

These thoughts were to be systematized, arguably to be sure, by Charles Henry, a mathematician and physiologist whose "scientific" aesthetics had a significant impact on such neoimpressionists as Georges Seurat and Paul Signac, as well as Gauguin. Indeed, Gauguin must already have been aware of the views underlying Henry's theories when he wrote "Lines [directed toward the] right advance, those [toward] the left recede. . . . Why are the willows with drooping branches called 'weeping'? Is it because drooping lines are sad? And are sycamores sad because one plants them in cemeteries? No, it is its color that is sad."[22]

Charles Henry, it so happens, referred to directions from left to right, bottom to top, cen-

trifugal, back to front, as well as warm hues and high values, as uplifting ("dynamogenic"), and the reverse, as depressing ("inhibitory"). His first volume appeared in 1885, but he had given lectures on the subject before that.[23] Further theories attributable to Henry and the neo-impressionists would emerge from Gauguin's "Zunbul-Zadé" text. Gauguin consistently drew from these theories what was useful to him.

*T*o come back to *Jewelry Casket:* it evokes the hopes and pitfalls of life, as well as a vision of a superior spirituality. It does so on three levels. As an evocation of a glorious, but seamy, aspect of Parisian night life, it is heavy with social and moral implications, which are also given a global dimension; as an allusion to the metaphysics of the evolution of matter and spirit in the universe, it can be called cosmic; as a reference to Gauguin's relationship with his wife, it expresses considerable bitterness and cynicism.

The casket is roughly carved in pear wood, with leather, string, and iron attachments. One Japanese *netsuke* mask is inlaid into the front side, and two into the back. On the top and front panels are roughly carved ballerinas derived from Degas's *Ballet Rehearsal on the Stage* of 1874 (fig. 7).[24] Degas's work departs a bit from the purely sensory perceptions of impressionism, achieving a somewhat visionary effect, stressing colored light and movement. In some of his ballet scenes, for instance, he creates poetic renderings of swift feminine bodies melting ethereally into the splendors of stage lighting and theatrical settings.

In the casket Gauguin simulates Degas's sense of movement and ethereal vision through a clever and skillful woodcarver's technique that roughly emulates the vibrant parallel brushstrokes of impressionism. The chisel marks themselves are shorthand equivalents of the impressionist technique. The dancers' angular forms crudely but effectively echo the rhythms of Degas's dancers at rest and in motion. The coarseness of the overall execution also evokes that artist's atmospheric effects.

There are deliberate distortions in Gauguin's composition: one arm is far too long, the other too short. A delicately turned-up nose is finely rendered; another, tubular and stemming straight from the forehead, is grossly caricatural. And, in the top panel, while her skirt is meticulously pleated, the lower part of the leftmost ballerina's face is almost blank. Clearly, Gauguin is interested not so much in the naturalistic here-and-now as in heightening the near-magical animation and theatrical lighting by means of abbreviations and alterations, ultimately preparing the viewer for a set of complex messages that transcend the here-and-now.

Most of the carved ballerinas are derived from Degas's *Ballet Rehearsal*, but the changes are telling. In the front panel, the third figure from the left was clearly inspired by Degas's dancer

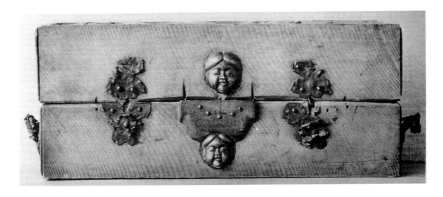

6 *Jewelry Casket with Carved Reliefs of Dancers,* 1884. Pear wood, leather, string, iron, and inlaid *netsuke*. Side, top, side, and interior. Present location unknown.

7 Edgar Degas, *Ballet Rehearsal on the Stage*, 1874. Oil on canvas. Musée d'Orsay, Paris/Giraudon/ Bridgeman Art Library.

lacing her shoe, her head barely above her bent knee. Gauguin's figure, on the other hand, is seated on the floor, her head bent over her knees and held between her hands. She is the prototype of many women in Gauguin's later works in fairly similar positions, intended to convey intense weariness and ultimately despair, as in *Grape Harvest in Arles*, or *Human Misery*, of 1888 (see fig. 29) and *Don't Listen to the Liar*, or *Eve*, of 1889 (see fig. 35).

The source of this weariness and despair becomes evident in the carving's top panel. Three dancers are shown on a stage between what appears to be a furled curtain on the right and a stage flat on the left, both executed in rough striations. The dancer in the center, who has no equivalent in Degas's work, appears to have been improvised. She is facing left, both arms extended and her palms raised to a near-vertical position, the universal language-sign for "stop," apparently objecting to the message conveyed by the group she faces. This group includes, at floor level, the head of a late-middle-aged man with a bulbous nose, an ample mustache, and smiling, foxy eyes. Beyond him sits a bedraggled Meso- or South American woman with a dolorous expression, who is carrying two children in a sling and, with both hands, offering passersby what appear to be comestible goods from a supply in another sling—begging, really.

For the male head, Gauguin drew elements from Degas's thoughtful and sensitive rendering of a good friend, the dedicated bassoonist and composer at the center of *The Orchestra at the*

8 Edgar Degas, *The Orchestra at the Opera—Portrait of Désiré Dihau*, 1868–69. Oil on canvas. Musée d'Orsay, Paris. Photo: Réunion des Musées Nationaux/Art Resource, New York. Photographed by Hervé Lewandowski.

Opera—Portrait of Désiré Dihau of 1868–69 (fig. 8). Gauguin turned Dihau's head into that of a coarse, shifty, inebriated old Gallic bon vivant. This character's role can be understood in terms of the presence of the bearded old man in top hat and morning coat in Degas's *Ballet Rehearsal*, ogling the barely pubescent ballerinas from the right edge of the painting. As is well documented in the literature of the time, such characters were welcome at rehearsals and in girls' dressing rooms, as long as they could afford it; they were encouraged by the girls' parents or guardians to seek romance.

The fate of two ballerina sisters subjected to such attentions is the subject of a novel by a friend of Degas's, Ludovic Halévy, for which Degas composed a superb set of prints: *Les pe-*

BACKGROUND AND EARLY SYMBOLISM

tites Cardinal of 1880.[25] As a rule, after a grueling training started when they were barely more than toddlers, child-ballerinas graduated to even more arduous—and grossly underpaid—work in the Opéra's *corps de ballet*. "Rats" they were called. Their dancing careers usually ended in their teens, as very few rose to stardom. Their most valuable assets were their bodies, but only as long as they remained pubescent. Besides, ill health was a serious hazard, and many died young.

In the novel, the senior Cardinals happened to be kind, affectionate, and caring toward their daughters, eager to ensure a comfortable adulthood for them as well as a decent old age for themselves. They did their best to shelter their girls from "bad" influences and expose them to "good," moneyed ones. They succeeded with only one, "placing" her with a distinguished and wealthy, doting, old pedophile, but they failed with the other, who fell for a hearty, pink-cheeked butcherboy, for whom she abandoned the stage—much to their chagrin. The less scrupulous parents or guardians were no more than crass pimps, and the man with the bulbous nose in the carving may well have been one of those. The ballerina's raised hands in the carving appear to be a symbolic effort to put a stop to such activities.

The fate of the most unlucky "rats," those who died young, was evoked by Gauguin in the interior of the casket (fig. 6, bottom). It was inspired by the oak coffin containing the partially mummified remains of a Bronze Age Nordic warrior at the National Museum in Copenhagen.[26] The features of the adolescent girl in Gauguin's casket are clearly delineated: finely chiseled and still expressing sensitivity, pride, and reserve. The limbs terminate in patterns of mildly radiating, disappearing ridges suggesting some Ophelia lying in a shallow stream, all but her face underwater, the ridges evoking the slipstream. Overall, the carvings of dancers on the casket evoke the exploitation of the young "rats" by society and its tragic consequences, and they do so with an empathy worthy of Flora Tristan, Gauguin's ardently feminist grandmother.[27]

The Meso- or South American woman and her children on the top panel, possibly remembered from Gauguin's travels, symbolize poverty and maternity. In the context of the "rats" and their fate, she provides an example of poverty reducing a woman to a form of slavery: mendicity. The likely threat to her offspring, furthermore, alludes to a frightful form of population control.

In the roughly striated section serving as a stage flat at the far left, moreover, there are two hanging apples, one partly concealing the other, with a leaf in between. They must be biblical apples, alluding to human fallibility as well as to the distress resulting from failures in love and to the misery and disease brought about by overpopulation, yet they also suggest the forces of regeneration. Such symbolic allusions recur frequently in the works of the Brittany period and those of Polynesia.

In keeping with the stagelike space at the top of *Jewelry Casket*, the apples and other objects

function like stage props. At the bottom, below the apples, a group of loosely rounded shapes emerges. These four irregular forms seem roughly similar in size and execution to the apples. They are difficult to interpret, but they can be linked with a passage Gauguin wrote much later in life in one of the several compendia of reading notes and thoughts he had collected. Relying on Theosophy to muse on the evolution of matter and spirit through the millennia, he asked in his 1896–97 notebook *Diverses choses:* "Before it manifested itself in primitive and rudimentary form [microbes, the spores of algae], where did [the soul] reside? What was its existence? . . . It was tossed around, no doubt, amid atoms . . . [which] enveloped it . . . like another atom, one might say." Because of the presence of such a primary soul, a "transformation" occurred, changing "the atom, without feeling, inert, devoid at first of animistic life, into an atom now endowed with feeling, turned into a soul endowed with animistic life." Accordingly, "the history of the atom and that of the soul would be that of a single being at two different ages, nature so expressing itself in the general and the individual development of the same universal life evolving from atom to pure spirit within the immense, eternal and infinite span of time and space."[28]

One finds a rather similar view in Helena Blavatsky's Theosophical writings. "Life is ever present in the atom or matter, whether organic or inorganic," she states. Then, objecting to the idea that "anything in nature can be inorganic," and with a nod to Hinduism, she refers to atoms as being animated by the "dormant Jiva or life-energy," Jiva being the *anima mundi*, the universal living soul." In Blavatsky's opinion, the phenomenon of "the life atom going through endless transmigrations" is fundamental to "the Hindu doctrine of metempsychosis," the notion that when a living organism dies its soul migrates to another organism, lower or higher along the scale of natural development.[29]

This view contrasted with the materialistic formulation by the distinguished astronomer and widely read popular science writer Camille Flammarion, who did not mention the soul. He maintained instead that "in the beginnings of the solar system, the primitive substance of which it is constituted was made up of homogeneous atoms, simple and elementary; the present state of the universe is the outcome of ulterior arrangements between the atoms." Regarding the appearance of sentient life, he wrote: "The organic is derived from the inorganic, life-force being born from the physico-chemical force."[30]

Seen in this light, the rounded forms in the *Jewelry Casket* panel appear to be soul "atoms," or "primordial germs," as Gauguin was to call them, at some stage of their evolution toward a fuller spirituality. Without too much of a stretch, we can imagine these primordial forms evolving into an expression of artistic achievement in the nineteenth century. The vision created by ballet dancers performing their magic on the stage as perceived by Degas and echoed in a different mode by Gauguin is in stark contrast to the ugliness and misery of some of material life's

contingencies. It is a vision suggesting humanity's strides toward "pure spirit in the immense, infinite and eternal span of time and space."

Given all this, *Jewelry Casket* appears as a touching symbolic fable, indeed, a cosmic fable, presenting the aesthetic achievements of the little Opéra "rats," in contrast to the horrors of their exploitation, while offering a glimpse of a Meso-American beggar woman victimized by similar socioeconomic problems. The prime mover behind it all is the relentless force of the Theosophical atoms, which introduce spirit into all matter and bring about its eventual triumph.

Another, more personal layer of meaning has also been proposed for this work. In this interpretation, both the *netsuke* masks and the carved dancers represent "the feminine vanities of life," while the corpse at the bottom of the casket is "a perfect symbol of the *vanitas* or *memento mori* themes" of earlier traditions. Since this box "remained in Mette's possession . . . it is hard to imagine a more complete comment on the futility of the wealth she felt Gauguin should strive for than this corpse beneath her jewels."[31] The identification of the box as a jewel casket is given additional plausibility by its small size: 8⅛ by 5⅞ by 20¼ inches. The very roughness of the execution adds another overtone to this gift, since, as Gauguin wrote to Camille Pissarro with regard to artistic matters in Denmark, "what one sees is so bad that any tiny [manifestation of] art is bound to create an outburst in the midst of it all. . . . For instance, it is a rule to display a few landscapes painted like chromolithographs."[32] The carving was thus an ironic lesson in artistic appreciation for lovers of meticulous representation, such as Mette and her family and friends at that time.

Gauguin's suggestion of multiple meanings is in keeping with literary symbolists' predilection for polysemy—the ancient Greek-derived term for this practice—as a source of ambiguity and ultimately the expression of a complex intellectual and emotional message. Toward the end of his life, Gauguin wrote: "Art encompasses philosophy; as philosophy does art. Otherwise what becomes of beauty?" This was a powerful response to the arguments of art for art's sake, as well as an acknowledgment of the purpose of his symbolism, which was to evoke his own "philosophy." In the subsequent passage, he stressed the subjectivity of his approach, his relativistic view of moral values—giving pride of place to "savage" primordial instincts—as well as his acceptance of a multiplicity of points of view when dealing with human behavior, in the domain of poetry and the arts if not science: "Philosophy is heavy if it does not derive from my own instincts. It is sweet in one's sleep, and dreams are its ornament. Science it is not . . . or at most it is science's germ—it is multiple, as is everything in nature, [and] constantly evolving. It is not a consequence [of observation and analysis (?)], as serious personages would like to teach us, but a weapon that, as savages, we alone build by ourselves. It does not manifest itself as a reality, but as an image, much as does a painting—admirable if the painting is a masterpiece."[33]

*G*auguin's sally into neo-impressionism, in mood and symbolist approach as well as technical devices, is reflected in a text of 1886, presumably written before his quarrel of mid-June 1886 with Seurat and Signac and his departure for Brittany shortly thereafter. In this text he outlined a few theories that brought him much closer to the neo-impressionists than he had been in the January 14, 1885, letter to Schuffenecker. Some of these theories affected his art to the end of his life, as we shall see. The text is facetiously attributed to the "great professor Mani Vehbi-Zunbul-Zadé," who lived "at the time of [the fourteenth-century ruler] Tamerlane, I believe, in the year X before or after Jesus Christ. What does it matter? Precision often spoils the dream, emasculates the fable"—which is to say the text is pure invention on the part of Gauguin![34] There is, however, a real person to whom Gauguin is alluding here: the eighteenth-century Turkish poet—not an artist—Mehmed Sunbulzāde Wehbi Efendi. Gauguin avoided technical terms derived from the nineteenth-century chemist Michel Eugène Chevreul, whose ideas contributed much to impressionism, and Chevreul's contemporaries Wilhelm von Helmholtz and Charles Henry, which would have sounded anachronistic and impaired the tongue-in-cheek humor of his joke. But his indirect references to their theories were in keeping with their use by many—though by no means all—of the neo-impressionists. He referred to Chevreul's division of color and to his law of simultaneous, or complementary, contrasts: "It is the eye of ignorance that assigns a definite, unchangeable [*fixe et immuable*] color to each object. . . . Train yourself to paint the color of each object as it is affected by others [*accouplé*] or by adjoining shadows . . . and so you will please through your truthfulness and your variety."[35]

The appearance of complementary colors proposed by Chevreul's law of contrasts is a purely optical effect, but both the impressionists and the neo-impressionists actually painted these complementaries, undoubtedly to heighten atmospheric and lighting effects. Gauguin-Zunbul, however, had apparently learned from the neo-impressionists how to moderate complementary effects, taking advantage of the other hues resulting from the division of color on the surface of the object and neighboring ones to obtain a range of subtle harmonies. It was probably this quest for harmonies that the distinguished "Turkish professor" referred to when he wrote: "Who says that you must seek the opposition of colors? What could be sweeter for the artist than to bring out in a bouquet of roses the hue of every one of them. . . . Seek harmony rather than opposition, accord rather than shock." He elaborated: "The eye seeks to refresh itself through your work; offer it pleasure rather than gloom." This was tantamount to equating the overall disposition of color with the musical score for a large-scale, harmonious orchestration. Ultimately, however, in his artwork Gauguin would play down the brushwork, preferring to create harmonies and contrasts with large areas of color.

In keeping with neo-impressionist practice and in opposition to the impressionists' blurry de-

lineation of figures and objects, Gauguin-Zunbul maintained: "Give your full attention to the silhouette of every object. The sharpness of the outline is the mark of a hand not weakened by any hesitation of the will." Félix Fénéon, friend and critic of the neo-impressionists, had characterized Seurat's figures as "invested with a hieratic and summary drawing."[36] Seurat's continuous outlines, it must be added, reflect the linearism of Puvis de Chavannes and were undoubtedly also influenced by the woodcuts of Ukiyo-e artists such as Hiroshige and Hokusai.[37]

Aware, no doubt, that such firm outlines tend to give the figures a static, even hieratic quality, and thus were at odds with the impressionists' pursuit of instantaneity, Gauguin-Zunbul continued: "May everything in your work breathe the calm and the peace of the soul. And so avoid the pose suggesting movement. Each of your figures must be static. When Oumra represented the ordeal of Ocrai, he did not show the executioner with a raised saber. . . . And so a whole hour can go by without [the viewer experiencing] any fatigue in front of this scene, which is more tragic in its calm than it would be with an attitude impossible to maintain, inducing a disdainful smile after the first minute." Fénéon, it so happens, was to acknowledge that rather than striving to set the scene during "the minute [that] was unique" as had the impressionists, the neo-impressionists endeavored "to synthetize the landscape into a definitive aspect that perpetuates one's sensation of it."[38]

Outlines would play a major role in Gauguin's synthetist manner, developed in connection with his symbolist aesthetics. In particular, they limited the animation created by the multicolored brushstrokes of impressionism and, except in a few instances, avoided the small dots of neo-impressionism—instead allowing fairly uniform color areas within the delineated areas, which simplifed the overall effect. In fact, Gauguin may have had the neo-impressionist small dot as much in mind as the high finish of tradition-bound artists when he had the professor say, "Do not finish too highly; an impression is not sufficiently lasting for the search of the [infinitely small to] stifle the initial [creative] impulse."

Gauguin's insistence on outlines eventually enabled him to "express himself a little mysteriously, by means of parables." He also drew on the essentially linear manner of "the Persians, the Cambodians, and a little of the Egyptian." And, perhaps because of its stress on naturalism, he indicated that "the great error is the Greek, however beautiful it might be."[39] Here again, incidentally, the artist echoed Baudelaire: "I want to speak of an inevitable barbarity, synthetic, childlike, that frequently remains visible in a perfect art (Mexican, Egyptian, or Ninevite), and that derives from the need to see things on a large scale, to consider them specifically from the standpoint of their totality."[40]

Gauguin countered another important impressionist and neo-impressionist principle in the Zunbul text: "It is best for young people to have a model, but they must pull a curtain over it. It

is best to paint from memory; in this way your work will be yours, [and] your sensation, your intelligence, your soul will survive [the confrontation] with the eye of the art-lover." Gauguin was again echoing Baudelaire, who, with the likes of Honoré Daumier and Constantin Guys in mind, wrote, "All the good and true draftsmen draw according to the image inscribed in their mind, and not after nature," adding that when such artists work in the presence of the model, too much detail causes their "their principal faculty" (presumably imagination) to become "troubled, almost paralyzed."[41]

Gauguin's advice directly contradicted Seurat's approach. Eager to catch precise lighting and atmospheric effects, Seurat had to complete his landscapes on the spot, however long this took. When he wrote to Signac about *Corner of the Harbor, Honfleur* of 1886, after a ship had departed from there, he said that he considered the painting "completed, the motif having long since been broken up."[42] Upon receiving a copy of the "Zunbul" manuscript, which Gauguin sent to him, Seurat praised its emphasis on the "gradation of harmonies" but declared it was "incomplete."[43] He had fully understood Gauguin's plaudits as well as his reservations!

By the mid-1880s Gauguin was already much affected by his symbolist leanings, which gradually led him to abandon the insistence on the here-and-now of naturalism, and more specifically the instantaneity of impressionism, to seek instead a complex play of associations. As he reached this goal in such works as *Grape Harvest in Arles* (see fig. 29) and *The Vision after the Sermon: Jacob Wrestling with the Angel* of 1888 (see fig. 49), Gauguin abandoned any impressionistic brushwork, arriving instead at essentially uniform areas—at least from a distance—of intense color within continuous outlines, in the synthetist manner. This technique was suited to evoking complex ideas and feelings, and it allowed a degree of abstraction of line and color that enabled him to stress the expressiveness of both, as well as to create harmony or even disharmony.

The Brittany Period

Caricatures
and Friendships

As for my son . . . he has been so incapable of making himself
liked by all his friends that he will be very lonely.

> Aline Gauguin, the mother of the artist, in her will

*P*aul Gauguin had been separated from his family for a year or so, living in
Paris, when his so-called Brittany years began, extending from mid-July 1886
until his departure for Tahiti, on March 31, 1891. During this period he un-
dertook a voyage to Panama and Martinique in the company of his younger
friend, the artist Charles Laval, from April 10 to mid-November 1887, and
also stayed several times in Paris, usually at the Schuffeneckers', until he quar-
reled with them in early 1891. In Brittany, he resided most often at the Pen-
sion Gloanec in Pont-Aven, but he also spent time at the nearby, more iso-
lated and more rustic fishing hamlet of Le Pouldu. Gauguin had been making
short visits there since 1886, then stayed for much longer stretches from early
October 1889 through February 5, 1890, and from mid-June until November
7, 1890.[1] Gauguin met Vincent van Gogh and his brother Theo, the art dealer
specializing in modern art, in Paris in late November or early December of
1887.[2] Theo, who managed the modern art section of the Paris-based inter-
national art dealer Goupil, purchased three works from him in early January
1888 and promised to buy more.[3] It was to be the beginning of a slow-paced
but ongoing commercial relationship upon which Gauguin placed high hopes
for his ultimate financial salvation—until Theo became insane in October
1890 and died on January 25, 1891. Gauguin's stay with Vincent in Arles be-

gan on October 23, 1888, but ended with Vincent's tragic bout of madness and self-mutilation, and Gauguin's return to Paris on December 26, 1888.[4]

It is likely that Gauguin's original departure for Pont-Aven was facilitated by a 250-franc sale to the engraver Félix Bracquemond and a 300-franc loan arranged by an acquaintance from the artist's days as a broker.[5] Once at the Pension Gloanec Gauguin managed to secure credit, and he kept hoping that sales by Theo, as well as another dealer, Adolphe Portier, would enable him to repay his creditors. He was still haunted by his earlier misery, however: "In any case I shall be less unsure of the future; I would rather kill myself than live like a beggar, as I did last winter."[6] Besides his financial difficulties, Gauguin had problems with his health, having contracted malaria and other tropical ailments in Panama and Martinique. As he later reported, "I am in bed with a recurrence of dysentery," and "I am weakened by enormous losses of blood."[7]

Gauguin's portrait-studies of artist-friends and of a local notable of this period are sharp, unforgiving evocations that transform the sitters into archetypal character studies, in keeping with a tradition dating back to the seventeenth-century *Caractères* of Jean de La Bruyère, and even beyond to classical antiquity. Indeed, Gauguin had a keen eye for incompetence, pompousness, vanity, and what he regarded as false values. In addition, whenever the opportunity arose, he singled out traits associated with particular social classes. In his portraits of members of the bourgeoisie he emphasizes the sitters' self-importance and false modesty; in a portrait of a villager he conveys peasant canniness and mistrust. All these characterizations are accentuated by the somewhat caricatural handling of expressive features, attitudes, and gestures, as well as by the choice of clothing and accessories.

Stylistically, the earliest works are essentially impressionist, reflecting some of that movement's boldest and most recent experiments. A burst of sustained linearism, sometimes bordering on the caricatural, usually expressive, and evoking suspended rhythmic movement, brings out character in the manner of Edgar Degas, with whom Gauguin had mended fences at Dieppe in 1885 after a quarrel. In the earlier portraits, the juxtaposition of multihued "comma" strokes typical of impressionism is very much in evidence. Often, the bundling of such strokes into clusters of near-parallel touches re-creates the surface vibrancy and rhythmic modulations of Cézanne's constructive manner.[8]

But it is principally in their evolving symbolism and the corresponding approach to form and color that the Brittany works increasingly distinguish themselves from impressionism. In this respect what was for Gauguin a new medium, ceramics, imposed a more simplified modeling because of the requirements of the firing. It also seems to have challenged him into engaging in new and daring plays of associations, now based on pastoral motifs,[9] which in turn broadened and enriched Gauguin's symbolic thought. The cloisonné-type glaze design of vase decoration

was an important first step toward the development of linear simplification; continuous outlines, already associated with the Zunbul-Gauguin mode, now surrounded fairly uniform areas of color in the Japanese manner,[10] and the multihued comma strokes of impressionism gave way to modulated striations. In 1888, the year of the great breakthrough in this development, Gauguin referred to this new style as "the synthesis of a form and a color, taking into consideration [only] the dominant."[11]

In a different vein, the continuous outline also lent itself to the requirements of great caricaturists, who, by emphasizing the dominant traits of their subjects and eliminating superfluous elements, present an awkward situation with such directness and clarity that we become immediately and irresistibly aware of its ludicrous overtones. And because it can be so simply and effectively expressive, the style allows room for the imagination, and thus contributes to making bold associations even more startling.

Gauguin's *Still Life with Profile of Laval* of 1886–87 (fig. 9) was probably executed in Paris after his first stay, of three months, at Pont-Aven. Its principal motif is the profile of the young artist Charles Laval, who had fairly recently arrived in Pont-Aven. The painting, whose symbolic overtones have been hinted at,[12] develops with considerable boldness some of the symbolist features of several earlier works: multiple, complex associative elements loaded with personal, not readily decipherable meaning, which are evoked through the surrounding objects as well as by the expressive power of forms and colors. Indeed, with respect to content the still life is a fully developed symbolist work.

The unglazed pot in the back of the still life ranks among Gauguin's most evocative and expressive early ceramics (the original is no longer extant).[13] It must have been among those that he referred to as "these monstrosities" and "the little creations of my high madness [*haute folie*]."[14] It heralds Gauguin's outspokenness as well as his frequently outrageous facetiousness. Like a character in a fable, moreover, it contributes to the painting's overall meaning—in this case, that there is no substitute for hard work and exceptional talent.

Once referred to by Schuffenecker's daughter, Jeanne, as *Head of a Clown*,[15] the vase suggests the headgear of medieval court jesters—at the root of the word "madcap" in English. The jester (in French: *le fou* [madman]) had the prerogative to deliver biting truths with impunity under the pretense of madness—with the exception, of course, of remarks that might besmirch or offend the ruler and his favorites. The madcap-wearer, presumably Gauguin himself, is not seen; instead of a face there is a gaping hole that suggests a huge, wide-open mouth—an effect that is strengthened by the realization that the sheet of clay that extends from the surface is a

9 *Still Life with Profile of Laval,* 1886–87. Oil on canvas. Indianapolis Museum of Art/Bridgeman Art Library.

human tongue, pulled out as if to hurl vehement, sarcastic invectives. In theory at least, Gauguin's madcap disguise turned any criticism he might express into a harmless joke while confirming his perceived right to be devastatingly honest.

Even before addressing the matter of whether any criticism is directed at Laval, who happened to be a friend, one must inquire whether it was addressed to the viewers beyond the frame. Gauguin had reasons to be resentful; on the one hand, he boasted to his wife from Pont-Aven, "Everyone here (Americans, British, Swedes, French) strives to get my advice." On the other, he added, "It may be that some day, when my art has burst upon [*aura crevé*] everybody's eyes, . . . an enthusiastic soul will rescue me from the gutter."[16]

In keeping with the latter sentiment, it seems as if one of the prime intents of this picture is

to present in the still life, the wallpaper, and even the profile of Laval a sampling of some of impressionism's newest and most daring technical advancements—carried out, as it happens, with masterly skill and considerable feeling. Many features, such as the splendid apples and the table-cloth, pay tribute to the energetic delineations and vibrant hues of still lifes by Cézanne, who had fared more poorly with the critics than the other impressionists but had received the whole-hearted respect of Camille Pissarro; Gauguin as well obviously valued his contributions. The wall-paper itself, with its sweeping, almost baroque fantastic forms, in combination with the energy and consistency of its overall design, brings to mind one of Gauguin's remarks regarding the art of his revered mentor: "[Cézanne's] backgrounds are as imaginative as they are real."[17] And as for the handling of the brush, some of Gauguin's rhythmically repetitive clusters of sweeping, near-parallel, multihued strokes, particularly in the interior of the pot and in the patterns of the wallpaper, are in the manner of the so-called constructive strokes, which Cézanne used extensively in the early 1870s and which, in various guises, increasingly dominated his later works.

The rendering of Laval's face in strict profile and the insistent outlining are likely tokens of neo-impressionist influence. But the energetic and sensitive outlines and contours of Laval's profile are more characteristic of Degas's most vital, sometimes perspicacious and caricatural, evocations. The device of cutting off the young artist's head and lapel at the edge of the picture is also characteristic. Derived from the prints and drawings of the Japanese Ukiyo-e tradition, cultivated by Edouard Manet and particularly Degas among the impressionists, this cropping adds to the spontaneity and immediacy of the presentation.

In keeping with the symbolic role of the vase in the still life, strong associations hint at Gauguin's intense commitment to expressing his new artistic goals, and in particular to breaking down Philistine resistance. The large fruit—green, green-orange, and orange—in front of the vase, must be a sizable mango; it is both a memory of the delights of the tropics he had known first as a child, then as a sailor, and an allusion to dreams of escape in search of a new life and a successful artistic career. Gauguin was indeed to leave for Panama and subsequently Martinique with Laval only a few months after the painting's completion. At the top of the lighter silvery yellow area of the wallpaper near the left edge, Gauguin drew a pinkish yellow pear-shaped area lightly shaded with strips of powder-blue and, just below it, a yellowish turnip-shaped area, shaded along its lower edge with a powder-blue stripe and topped with two cropped leaves. The French noun *poire* ("pear") is used colloquially to mean "gullible" or "ineffectual"; certainly, it was understood in this way by Honoré Daumier in his caricatures of a pear-shaped King Louis-Philippe being hanged by energetic peasants. *Navet*, French for "turnip," is the equivalent of "lemon" in colloquial American English: a person or a mechanism prone to failure. Gauguin himself was to refer to mediocre pictures as *navets*.[18]

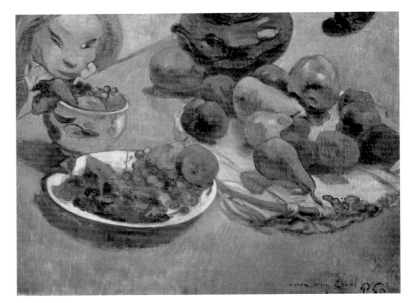

10 *Fruit (Still Life Dedicated to Laval)*, 1888. Oil on canvas. Pushkin Museum of Fine Arts, Moscow/ Giraudon/Bridgeman Art Library.

Laval, for his part, is presented as a nonparticipating witness rather than as a comrade-in-arms. His eyes appear to be shut or almost so, as if unable, metaphorically, to perceive fully the new art. In keeping with Degas's propensity for characterization, Gauguin emphasizes in this image of his new friend a timidity, meekness, and fussiness as well, verging on the calculated modesty and ever-present pedantry of the traditional *instituteur* (elementary school teacher), as well as the lack of empathy and the pettifogging attitude of the much-caricatured *notaire* (a legal and financial official and adviser, often notorious for red tape, obsession with detail, and excessive conservatism). The artist was singling out his friend in order to evoke whole social groups, lampooning their characteristics in the manner of Daumier, and continuing the tradition of such literary caricaturists as La Bruyère.

Gauguin left no evaluations of Laval's work before the time of this picture. He must certainly have had enough respect for Laval as a potential disciple to invite Laval to join him for the voyage to Panama and Martinique—although he must also have been aware of the advantages a companion would offer on such a mission. And he admired Laval's watercolors from the trip well enough to recommend them for Theo van Gogh's gallery at the time of the younger artist's delayed return to Paris—describing this work as "rare and unique, it is art." More critically, however, Gauguin wrote to their mutual friend Emile Bernard, then with Laval at Pont-Aven: "[Laval has] a fine and noble nature despite all his overwhelming failings when the Cossack in him surfaces; you know that we all have some [Cossack traits], you too have terrible ones."

And later: "For the last six months, [Laval] has not touched a brush." Later still: "I fear this poor lad is training himself not to work. Even if one feels incompetent, [one] has a duty in this world." And around June 1890, when Gauguin intended to follow Bernard, then planning to leave for Madagascar to found a "studio of the tropics": "I was [determined] never to do it again, having already tried with Laval. And I know how dearly one pays. And to top it all, Laval believes he owes me nothing; he is close to saying that it was he who sacrificed himself." The most scathing expression of aimlessness and lack of self-confidence—offset by a good resolution—came from Laval himself, who wrote to Bernard in June 1890, "I have led a hateful life and I am profoundly troubled by it as I realize that I have never followed the rightful path—[and yet] I now feel I have more substance than ever (which is not difficult), and I shall seek a reprieve from the stupid life of my past." Gauguin wrote to Schuffenecker in October: "That fool Laval . . . wrote me that with him, everything fails! After all he has not really deserved anything else."[19]

Astute as he was, Gauguin must already have had apprehensions about Laval's character failings at the time of this picture. The subject's depiction, while not actually evincing hostility on Gauguin's part, at least evokes the younger man's limited ability to sympathize with the invectives of the "madcap" (Gauguin) he is observing or to offer the artist much support against the Philistines.

Gauguin broached a similar theme in the splendid *Fruit*, or *Still Life Dedicated to Laval*, of 1888 (fig. 10). The face of a child, her eyes narrowed with greed, appears in the upper left corner.[20] She gazes at the delicious-looking array of fruit with foxlike envy, much as Laval would have admired Gauguin's artistry.

*A*lthough, upon returning from Martinique in November of 1887, Gauguin wrote his wife, "Luckily [Emile] Schuffenecker is offering me shelter and food throughout my much-needed convalescence,"[21] Emile and his spouse, Louise, fared much worse than Laval in their portraits. In 1889, some two years before being expelled from their household, Gauguin ruthlessly and wittily lampooned his friends in *Schuffenecker's Family* (see fig. 12), done fully in the synthetist manner. Earlier, in *Portrait Vase of Louise Schuffenecker* of 1887–88 (fig. 11),[22] he had rendered Louise's face sensitively, not without feminine charm, and endowed it with the quiet dignity of a dutiful bourgeoise. Yet he also included a belt buckle in the form of the head of a snake biting its own tail, which, while it had an esoteric meaning (discussed below), can be seen as a mark of sinfulness on her part and her eventual humiliation. Such overtones would have been even more embarrassing if, as has often been suggested, Gauguin himself had had an affair with her—or even if Gauguin had tried and been rebuffed, as has also been suggested.[23]

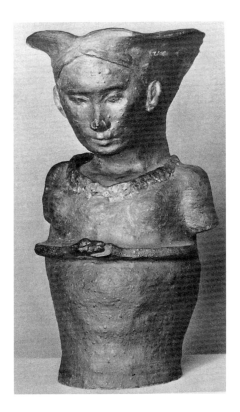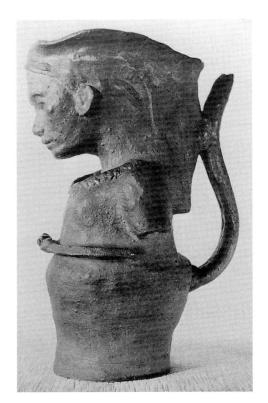

11 *Portrait Vase of Louise Schuffenecker*, 1887–88. Unglazed stoneware.
Front and side view. Present location unknown.

Ironically, as far as Louise's husband was concerned, the symbolism of the serpent biting its tail probably stood for much loftier matters. Indeed, Emile Schuffenecker, a long-standing member of the Theosophical Society, would, in 1892, create a cover design for that society's journal, *Le Lotus Bleu,* to illustrate an article by Hélène Blavatsky that appeared in that issue.[24] Among the symbols appearing in the design are the Tau cross, the Egyptian cross, the swastika, the star of David, and the serpent biting its tail.[25] In keeping with her predilection for Buddhist and Hinduist traditions, Blavatksy recounts the story based on the ancient Indian legend of the wise old holy hermit Ajikarta, seated with the serene detachment and equanimity of Buddha after winning, through sheer spiritual power, a battle against evil and having his son become a king.

Schuffenecker must have known the significance of the serpent biting its tail at the time the portrait of his wife was made, if only from the lectures and writing of the likes of the Magus Papus (Gérard Encausse), a renowned proponent of magic and dabbler in the esoteric and the occult, who was both an admirer of Blavatsky and one of her possible sources. Although Pa-

pus's book *Traité élémentaire de science occulte* was first published only in 1888, Papus had been a frequent speaker on such matters before its publication. He defined the tail-biting serpent symbol in typically arcane language as standing for "a universal force . . . endowed with perpetual movement [which] . . . usually evolves from vital currents in the process of materializing, then spiritualizing, constantly entering [the state] of unity."[26] Circled around the woman's abdomen, the serpent would very probably have been understood by the more enlightened Theosophists, including Louise Schuffenecker's husband, as representing her life-giving potential, in unison with the life-forces of nature.

In sum, where the wife must have seen in the tail-biting snake around her waist a somewhat distasteful allusion to Gauguin's attentions, the husband would have seen a flattering reference to his own esoteric and occultist interests. To add insult to injury, lifting the pot's "black, green, and gold" handle in the form of a cat's tail[27] would have been a frightful metaphorical humiliation. So much for Mme Schuffenecker's bourgeois dignity.

There are strong indications that Louise was generally a surly personality and very disappointed in her marriage. According to the daughter of Gauguin's and the Schuffeneckers' friends, the Molards, who knew them when she herself was a girl: "That harpy, Mme Schuffenecker, exclaims in her sharp voice that her husband is a fool. No one doubts that claim, but it is painful to hear it repeated over and over in his presence."[28] In Gauguin's words: "Unfortunately, [Schuffenecker] is becoming progressively upset by his wife, who, far from being a companion, is turning increasingly into a harpy as far as he is concerned—strange how life in common sometimes succeeds, and sometimes leads to ruination or suicide."[29]

Emile, for his part, for all his repeated acts of generosity toward Gauguin, emerges as a weak individual—greedy, vain, and conniving in petty ways.[30] Referring to Schuffenecker's *arriviste* mentality, Gauguin wrote in 1893: "Born to be a simple workman, or a concierge, or a small shopkeeper, he managed, without having deployed any energy (everything, for him, coming from elsewhere), to become a *Monsieur* and the owner of a five-story building."[31] As to his artistic pretensions: "And what if he were to receive a medal, what a joy that would be: frankly, this would cost the state so little!"[32]

Gauguin must have painted *Schuffenecker's Family* between mid-January and May or June 1889, when he probably added the finishing touches, including the pictures on the wall.[33] Reflecting Schuffenecker's taste as a collector and aspirations as an artist, the pictures convey the most positive message in the composition. A Japanese print shows an interior with a window opening onto a landscape, not unlike that in the setting of the portrait, and a color scheme that, although different from the principal one, also emphasizes uniform areas of color. It attests to the two men's commitment to the linear simplification and intense hues of Japanese wood-

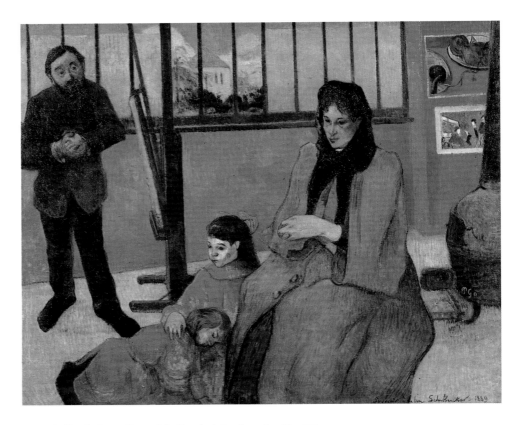

12 *Schuffenecker's Family*, or *Schuffenecker's Studio*, early 1889. Oil on canvas.
Musée d'Orsay, Paris/Giraudon/Bridgeman Art Library.

cuts. The other picture, probably recomposed if not improvised by Gauguin, is Cézannesque in its vibrant depiction of boldly colored apples on a plate—again attesting to the shared taste of the two men—while the equally boldly composed teapot spout and ball of yarn on a wicker tray in a harmonious combination of blues must allude to the housewife's accomplishments. Another peripheral attribute, however, is negative: the dedication "Souvenir for this good Schuffenecker" was originally complemented by the sarcastic "I vote for Boulanggg," later removed.[34] General Georges Boulanger, then at the height of his turbulent political career, had become the leader of powerful French chauvinist and revanchist factions, had dictatorial ambitions, and was the idol of the lower bourgeoisie. By early 1889, he posed a threat to the Republic, but was subsequently humiliatingly defeated in a national vote.

Gauguin and Schuffenecker's acquaintance Jean Brouillon (Gauguin's first biographer, who signed his work Jean de Rotonchamp) evoked the atmosphere of the actual scene: "Schuffenecker

as he appeared in the picture . . . holding a palette. Blinking after every brushstroke, he was articulating paradoxical philosophical or religious opinions—which caused the most nervous of his listeners [Gauguin] to cringe. [He is shown] standing, wearing enormous knitted slippers, in a comically awkward attitude . . . surrounded by his family."[35] Obsequiousness, false modesty, and hypocrisy are certainly reflected in "Schuff's" caricatural effigy. Louise, for her part, bears herself with pride and dignity, dominating her brood as would a mother-hen her chicks—her authority graphically emphasized by her verticality in a right-angle triangle that encompasses her and the children. Her face is overly made-up, and her features somewhat disturbing: the large black eyes, underscored by black shadows, are weary, and the somewhat twisted mouth has a bitter cast. Her black shawl, worn like a mantilla around her head while revealing locks of artfully arranged hair, gives her the appearance of one of Goya's neurotic court ladies.

The figure's aggressive defensiveness is equally noteworthy. Louise's vast overcoat, probably necessitated by the cold, turns her into something of a monument, and the large wedding ring on her extended left hand affirms her marital status as if to caution possible suitors.[36] The hand's strangely contracted fingers, furthermore, give it the appearance of a feline paw, conceivably endowed with sharp claws. Schuffenecker occasionally complained: "Poor, lamentable being whom the cruelty of life has attached to me like a cannonball to the foot of a person serving a life sentence."[37]

The "incandescent stove on which Gauguin, man of fire, has signed ['PGO'] in red" has been pointed out.[38] The stove is brimming with thermal energy: the air vent at the bottom is wide open, and both the loading door and a crack at its side are red-hot and allow flames to come through. And there are sexual overtones in the combination of rounded stove and straight, nearly vertical flue. Metaphorically speaking, Gauguin is providing energy, artistic as well as thermal, to the whole ambience—as if to tease, and perhaps humiliate, Louise.

Vanity, self-delusion, and the devastating weakness of a hen-pecked husband, on the one hand; haughtiness, bitterness, and the aggressiveness of a domineering wife, on the other—Gauguin is once again in the tradition of La Bruyère's *Caractères,* here emphasizing the psychological instability and the social frustrations of an ambitious yet highly circumscribed petit-bourgeois household.

*L*a Belle Angèle *(The Beautiful Angel),* a portrait of Marie-Angélique (Angèle) Satre, the wife of a future mayor of Pont-Aven, done in July or early August 1889 (fig. 13),[39] was also conceived in an ironic mood. The Satres had had a friendly relationship with the artist: "Gauguin was very gentle and very unhappy, and we liked him," Angèle once said. When shown the

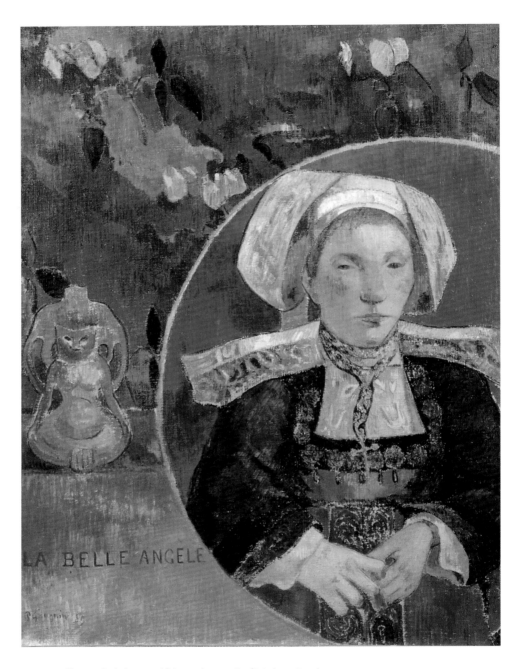

LA BELLE ANGÈLE

13 *La Belle Angèle (The Beautiful Angel: Portrait of Madame Satre)*,
July or early August 1889. Oil on canvas. Musée d'Orsay, Paris/
Giraudon/Bridgeman Art Library.

completed work, however, she exclaimed, "How dreadful!" Her mother was upset about the painting because artists argued over it, thus attracting unwelcome attention.[40]

Gauguin clearly endeavored to paraphrase the Breton craft tradition as well as local taste. The modeling of Angèle's face and hands is patchy and angular, suggesting the cursory modeling of a rough-hewn wood carving. Her clothing, presented in naive frontality, evinces bold contrasts of fairly uniform colors and strong semigeometric outlines in keeping with the colorful patterns of surviving medieval crafts and Gauguin's own synthetist aesthetics. The subject's peasant status is confirmed by vermilion highlights at the cheeks and nose, her stocky appearance, and the awkwardly interlocked stubby hands. Her tight lips and her partly lowered eyelids and inscrutable eyes suggest a foxlike peasant cunning as well as the diffidence that backward villagers sometimes assume in the presence of strangers. In the context of its lively and colorful composition, Theo van Gogh's remark is fully justified: "The woman looks a little like a young cow, but there is something so fresh, and also so country-like that it is a pleasure to the eyes."[41]

The figure stands out against a near-uniform, faintly luminous dark blue background surrounded by a circular yellow-gold strip, which has been linked to Japanese woodcut compositions and described as "a halo encircling the primitive Breton peasant who manifests her cross so conspicuously."[42] Outside the halo, the wallpaper and the pot allude to two of Gauguin's artistic goals. The wallpaper's design, a vibrant and luminous patchwork of vaguely geometric and vegetal elements in a much darker, night-blue ambience, is a looser, more abstract, bolder, more dramatic, and remarkably vital version of designs often found in Cézanne's backgrounds.

As for the pot, it is undoubtedly a ceramic creation imagined, if perhaps never executed, by Gauguin himself.[43] It alludes in a highly stylized way—one might even say streamlined—to a meditating Buddha seated on a lotus pad, a type frequently found in Indian and Indian-influenced medieval Javanese art. Gauguin himself alluded several times to such an effigy during his Polynesian years, for which he seems to have had two specific models among the photographs he had collected. One is the figure of Buddha based on a photograph of the Javanese temple of Borobudur (see fig. 42), which Gauguin had acquired in the winter of 1887–88 together with a photograph of two other friezes from the same temple. More recently, scholars have cited another source for such a seated figure: a Javanese Vishnu in a seated, Buddha-like pose.[44] The head of the figurine consists of a feline party-mask, offering an amusing contrast with the near-bovine quality of Angèle's face. The hermetic quality conveyed by the figurine's slanted eyes seems in keeping with Angèle's rustic inscrutability and diffidence.[45] By linking allusions to two very different religious traditions in this way, Gauguin appears to have echoed the interest in syncretism—the conciliation of different, even conflicting religious traditions—characteristic of much Theosophical literature.

The growing appreciation of Gauguin's work is evident from the fact that *La Belle Angèle* was purchased by Degas through the dealer Paul Durand-Ruel at the auction sale of Gauguin's work organized at the Salle Drouot in Paris on February 22, 1891, intended to help him finance his trip to Tahiti, a few days before his departure. Indeed, interest in the painting was such that it commanded the third highest price at the auction.[46]

The *Portrait of Jacob Meyer de Haan by Lamplight* (fig. 14), completed by December 12, 1889— a pendant to Gauguin's *Self-Portrait with Halo* (see fig. 55) for the dining-room decoration of the Buvette de la Plage, the inn at Le Pouldu, owned by the vivacious Marie Henry[47]—rounds out this series of near-caricatural images of colleagues and acquaintances of the Breton years. An artist of Dutch origin and training and scion of a well-to-do family, de Haan was Gauguin's companion in Pont-Aven; during the months they spent together in Le Pouldu he was, with the exception of Gauguin, among the most technically competent of the Pont-Aven group. A generous soul and a great admirer of the older artist, he defrayed Gauguin's expenses from his modest allowance while they lived together.

In the portrait, the solidly formed and vibrantly colored Cézannesque apples on a nonperspectival plate are symbolic of shared artistic ideals. Indeed, the work's solid and sober style alludes to characteristics of de Haan's own stylistic preferences and skills. As for the man himself, Marie Henry later described him as "diminutive, malformed, and nearly a cripple."[48] In portraying this man, Gauguin gave way to both his facetious verve and his caricatural instincts. There is something diabolical about the features: eyes and eyebrows outlined by rising curves meeting at a point near the temples, suggestive of horns—an effect accentuated by the russet tuft of hair jutting out to one side and a hint of the same on the other. The combination of colors, moreover, dominated by red, orange, and russet, brings to mind hell-like flames. Most disturbing is the shape of the hand, with its short, twisted fingers suggesting animal claws—in the tradition of the devil-monsters of medieval gargoyles. The thoughtful, staring eyes are nonetheless those of a man deep in meditation and evidently worried; his contorted hand scratching his chin, one finger pressing so firmly against his right cheek as to create a hollow, is clearly indicative of anxiety.

De Haan's position in the overall composition also evokes anxiety. The edge of the tabletop fanning out into a yellowish triangle in front of him squeezes him against the vertical left side of the picture—as if to suggest that he is trapped in a wedgelike space. The table's edge, furthermore, appears to be descending, and therefore depressing, according to one of Charles Henry's rules (see chapter 2).

De Haan had been raised an Orthodox Jew; his early education must also have been influenced

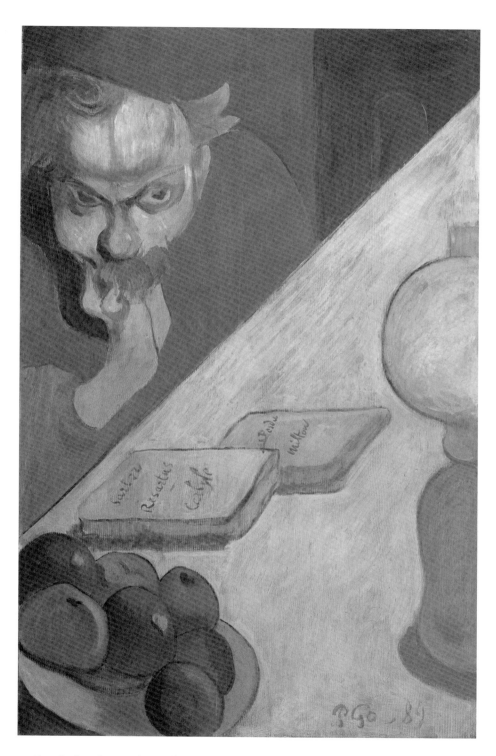

14 *Portrait of Jacob Meyer de Haan by Lamplight*, late 1889. Oil on wood.
Private collection, New York. Photo © 1982 Malcolm Varon, New York.

by the strict Protestant ambience of the Netherlands (he is known to have had his family's twenty-pound Bible with him).[49] Nevertheless, he had developed a liberal mind-set and presumably shared his bedroom with Marie Henry—who normally slept in the washroom—eventually making her pregnant with her second daughter during his second stay at Le Pouldu, in 1890. She gave birth on June 9, 1891.[50] Was Gauguin jealous? A little, one would assume.

At any rate, the combination of diabolical designs and anxiety conveyed by expression and composition is in keeping with de Haan's psychological status at the time: a seducer but a seducer anxious about defying the family's traditional ethics. The association seducer-devil, incidentally, recurs in several later compositions by Gauguin.

The presence on the table of a volume of John Milton's *Paradise Lost* is undoubtedly Gauguin's ironic counsel to follow the straight and narrow path. Milton's work, after all, is a poetic elaboration of Genesis in which good and evil are firmly delineated and Satan is given a prominent role. On the other hand, the import of the presence of Thomas Carlyle's *Sartor Resartus* is not as obvious. It reiterates, in fact, the kind of advice Gauguin sometimes gave younger friends: "Do not love, it hurts,"[51] which did not necessarily preclude seduction. The advice was repeated in the most sarcastic possible interpretation of the title of one of Gauguin's contemporaneous wood carvings, *Be in Love and You Will Be Happy* (see fig. 37), in which a falling and a fallen Eve are distinctly *un*happy.

Sartor Resartus is a satire within a satire, in which the very Teutonic autobiographical narrator, Teufelsdrökh—"Devil's turd" in German—is mocked as a pedantic, verbose, and remarkably unfeeling would-be philosopher, who makes rather jaundiced fun of society's hypocrisy and other failings. Having fallen in love, he is rejected by his Morning-star, as he calls her. After considering suicide, he manages to "look away from his own sorrows, over the many-colored world, and pertinently enough note what is passing there."[52] Gauguin, in other words, was on the one hand teasing his friend by investing him with a satanic temperament, equating him with that figure in *Paradise Lost*, and, on the other, reminding de Haan of how Teufelsdrökh survived the end of his own amorous entanglement, thus hinting that love affairs may be neither beneficial to all concerned nor too painful to break off. However caustic, Gauguin could have a thoughtful and charming side when lampooning a friend he respected.

Another ironic disquisition on de Haan's moral dilemma, this time also evoking the various possible fates of the falling woman, emerges from the painting *Nirvana: Portrait of Jacob Meyer de Haan* of 1889–90 (see fig. 44), analyzed in the next chapter. The resourceful Marie Henry, apparently, was very much a survivor.

The Great Dilemmas of Humanity

I am attempting to invest in these [Breton] figures the savage
I see in them, which is also in me.

<div align="right">To Theo van Gogh, December 8–10, 1889</div>

In evoking peasants at play and at work in their rural setting, Gauguin continued the tradition of the Barbizon artists and also of the impressionist Camille Pissarro, who often focused on the details of life in the fields. But here again, Gauguin's characterizations are essentially caricatural. Moreover, in keeping with a seemingly innate interest in anthropology, Gauguin wanted to bring out some of the unique aspects of that peasant culture, particularly its atavistic roots in a past he considered "savage," and which he associated, at least partially, with his own background—for, as Theo van Gogh reported, he continually asserted that he was "half-Inca, half-European."[1] Gauguin summarized this intent in a letter to Vincent van Gogh from around October 20, 1889:

> As the "trompe l'oeil" approach of the *"plein-air"* school and of whatever
> else does not appeal to me, I try to put into these desolate figures the savage
> I see in them, which I also see in myself. Here in Brittany the peasants have
> a medieval look and seem not to be aware a single instant that Paris exists,
> or that the year is 1889. Quite unlike [France's] South, here all is rough, as
> is the Breton language, very shut-in (forever it would seem). The clothes are
> also almost symbolic, influenced as they are by the superstitions of Catholi-
> cism. Look at the back of the bodice [fig. 15]: a cross, the head enveloped in

paysan, se promenant indifférents sur le bord de la mer avec leurs vaches. Seulement comme le trompe l'œil du plein air et de quoique ce soit ne me plaît pas je cherche à mettre dans ces figures désolées, le sauvage que j'y vois et qui est en moi aussi. Ici en Bretagne les paysans ont un air du moyen âge et n'ont pas l'air de penser un instant que Paris existe et qu'on soit en 1889 - Tout le contraire du midi - Ici tout est rude comme la langue Bretonne, bien fermé (il semble à tout jamais - Les costumes sont aussi presque symbolique influencés par les superstitions du catholicisme - Voyez le dos corsage une croix, la tête enveloppée d'une marmotte noire comme les religieuses - avec cela les figures sont presque asiatiques

jaunes et triangulaires, sévères. Que diable je veux aussi consulter la nature mais je ne veux pas en retirer ce que j'y vois et ce qui vient à ma pensée - Les roches, les costumes sont noirs et jaunes; je ne peux pourtant pas les mettre blonds et coquets - Encore craintifs du seigneur et du curé les bretons tiennent leurs chapeaux et tous leurs ustensiles comme s'ils étaient dans une église; je les peins aussi en cet état et non dans une verve méridionale - En ce moment je fais une toile de 50; des femmes ramassant du goëmon sur le bord de la mer - Ce sont comme des boîtes étagées de distance en distance, vêtements bleus et coiffes noires

15 Sketch of "Breton faces and costumes," in a letter to Vincent van Gogh of December 10, 1889. Rijksmuseum Vincent van Gogh, Amsterdam.

a black hood, just as are nuns. Withal, the figures are almost Asiatic: yellow, triangular [and] severe. What the hell! I also want to consult nature, but I . . . want to draw from it what I see there and not what comes to mind.[2] The rocks, the clothes are black and yellow, so I cannot render them blond and coquettish. Still fearing God and priest, the Bretons continue to hold their hats and all their utensils as if they were in a church;[3] [so that] I also paint them in that state and not with a Southern verve. . . . At the present time I am painting a canvas [*Seaweed Gatherers* of 1889]. . . . When seeing this [setting] every day, I feel in me something like a breath of the struggle for life, of sadness and of submission to the laws of misery [*aux lois malheureuses*]. This breath, I try to put it on the canvas.[4]

Always the fabulist, Gauguin treated peasant character and peasant life with relish and humor, usually indirectly, referring to a moral issue, sometimes cynically. Frequently he opposed the weight of religious and social traditions dating to the Catholicism of the Middle Ages with his own Enlightenment liberalism, colored by the easy morals of contemporary bohemian Paris, and in the process urged the liberation of the oppressed (most particularly, seduced and abandoned women). He did so with a fervor and compassion reminiscent of the writings of Flora Tristan.

Occasionally an element of marked eroticism, even lewdness, appears in Gauguin's peasant scenes. This eroticism was in the tradition of his elder, the Barbizon painter Jean-François Millet, as in his *The Bather* of 1863 (fig. 16), and that of his mentor Camille Pissarro (himself a great admirer of Millet), who sometimes sketched shepherdesses in the field, dressed and undressed. It was also in keeping with the many more or less ribald French popular songs praising pastoral frolics, such as this nostalgic lament of a city-dweller returning from a vacation in the country:

> Ah, les fraises et les framboises,
> Et l'bon vin qu'nous avons bu,
> Et les belles villageoises
> Nous ne les verrons plus . . .
>
> Oh, the strawberries and the raspberries,
> And the good wine we drank,
> And the village beauties
> We will no longer see . . .

Such eroticism had a long tradition. Connoisseurs of eighteenth-century art were familiar with Jean-Honoré Fragonard's and François Boucher's *fêtes champêtres*, with their obliging shep-

16 Jean-François Millet, *The Bather*, 1863. Oil on canvas. The Walters Art Museum, Baltimore.

herdesses and nymphs. And anyone schooled in the prevalent classical education would have known the pastoral frolics of Virgil's country folk, as well as those of the gods in Ovid.

It is no doubt to potential pastoral gallantry and its erotic overtones that Gauguin alludes in the scenes decorating the splendid ceramic *Jardinière* of 1886–87 (fig. 17), one of his earliest works in that medium, executed after his return to Paris on October 13, 1886, from the first stay in Pont-Aven.[5] On the front panel, a reclining, pink-cheeked, barely nubile peasant girl twists her hips and torso, directing her stare behind her, as if anticipating some passerby arriving along the path from outside the frame.[6] She does so with the same vigor, directness, and grace as the cow twisting her neck upward to eat foliage, perhaps also a green apple, and the goose stretching her neck toward the sky—both with energy and insistence, as if in response to a powerful natural urge. The entire composition is further linked to nature's bounty inasmuch as the *Jardinière* itself is intended to contain its future owner's plants.

There is a reverse side to this idyll, however, in that the apple is a reminder of the biblical wages of sin, which would resonate among a population "still fearful of Lord and priest," as Gauguin later put it.[7] Indeed, on the opposite side of the *Jardinière* a naked little girl coquettishly combs her hair. Her compact young body, vibrant to the tip of her bent toes, evokes a budding passionate temperament. Here the wages of possible future sin are suggested by the sinuous

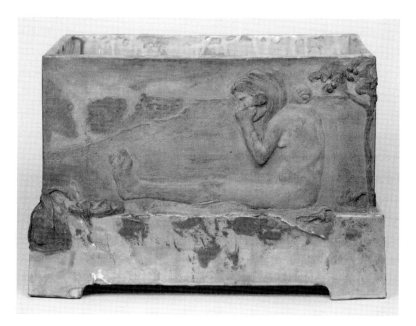

17 *Jardinière*, 1886–87. Front: *The Breton Shepherdess;*
back: *The Toilette*. Stoneware decorated with barbotine,
partially glazed. Private collection, France.

tree behind the girl: well stocked with apples, it symbolically transforms her into an Eve-in-the-making. This last relief derives from an earlier work, a wood carving of 1882, *La Toilette*, or *Nude Girl Combing Her Hair*, in which the tree bears no apples; *Jardinière* reveals Gauguin's new interest in evoking biblical notions of sin, in keeping with the strength of Breton beliefs. The wood carving, incidentally, is dedicated "To my friend Pissarro"—a tribute to that artist's subdued allusions to pastoral gallantry.

The little girl's vibrant body on one side of the *Jardinière* thus prefigures the other side, where an older lass seems aware of her sexuality; both evoke temptation, and both anticipate biblical sin. Together with those of *Two Women Bathing* of 1886–87 (fig. 18), these two figures plant the seeds, so to speak, for the themes of the woman falling into disgrace and the woman who has fallen, which will play major roles in Gauguin's iconography. A related third theme is suggested in *Two Women Bathing*—the sinner impervious to disgrace, or the self-righting woman, who might have fallen into disgrace but was capable of reestablishing herself.

By placing an age-old emblem of lechery, the pig,[8] in the upper right of his *Two Women Bathing*, Gauguin turns this essentially impressionist work of the early Breton years into a psychosocial essay. Here the born-anthropologist and talented fabulist—albeit a sardonic one—questions the traditional moral precepts of deeply Catholic Brittany. The picture also hints at Gauguin's growing empathy with and compassion for the plight of the underprivileged, particularly the seduced and abandoned woman.

As early as 1888, when he saw *Two Women Bathing* at an exhibition, the astute critic Félix Fénéon noted the differences between the two bathers in this work and formulated some of their implications: "one of them develops . . . shoulders in a broad sweep of the brush, the architecture of an opulent *bourgeoise;* on the grass, a frisky little servant, her hair short and stiff, with an ever-stunted snout, shivers as she watches her mistress before taking the last step [into the water], her hand on her knee."[9] Gauguin's emphasis in this painting, however, goes beyond mere social distinctions. The image of women bathing here becomes a metaphor for carnal sin—the opposite of the ritualistic purification of baptism.[10] The corpulent mistress, her hair untied and falling down her back, her muscular arms ready to brave the waves, is well endowed to survive the dip in the water—and any indulgence of the flesh. She heralds two symbolic themes involving bathing Eves that Gauguin would elaborate in connection with the biblical Fall. Standing with her right elbow raised above her shoulder and her forearm folded back toward her face, this matron is the prototype of Eve in the process of entering the water—falling into disgrace. Later examples, in nearly similar attitudes, are shown throwing themselves into the waves, holding their forearms against their mouths as if to repress a scream. At the same time, robust and self-assured, calm and collected, her hair undone and turning her back to the scene as if to tend to

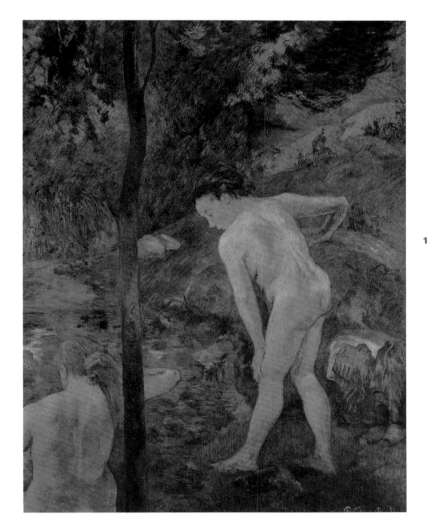

18 *Two Women Bathing*, 1886–87. Oil on canvas. Museo Nacional de Bellas Artes, Buenos Aires/ Bridgeman Art Library.

her own affairs, this matron is the prototype of the "self-righting" Eve, who averts or overcomes social and religious condemnation and ultimate disgrace, perhaps even remaining indifferent to the disappointments of love, and is able and willing to reestablish herself.

For her part, the hesitant maid, with her stunted body, sagging breasts, and crude haircut, initiates the second theme: disgraced—or soon to be—by the dip, she is the prototype of the fallen Eve who cannot overcome social and religious convention and is therefore condemned to disgrace in this world, in a society "still fearing God and priest,"[11] and to Hell throughout eternity. This type of Eve will eventually be evoked by a woman with her elbows planted on her knees, holding her face between her fists or her hands and expressing muted, if profound, dis-

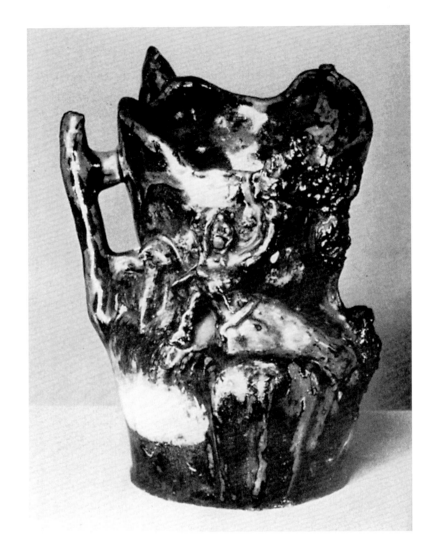

19 *Jug with Half-Clad Breton Eve*,
1886–87. Glazed stoneware.
Private collection, Paris.

tress. All three types appear individually in numerous works by the artist; they are brought together in *Nirvana: Portrait of Jacob Meyer de Haan* (see fig. 44).[12]

The eroticism of Gauguin's Breton works becomes more conspicuous and acquires powerfully dramatic—as well as sardonic—moralizing overtones in a glazed stoneware jug dated 1886–87, in the decoration of which only "a little seated shepherdess with a sheep" has hitherto been noted.[13] The shepherdess in this work (titled here *Jug with Half-Clad Breton Eve* [fig. 19]) is in the process of falling into sin: her legs, one of them folded under the other at knee level, are bare all the way to the groin and speckled with bloodlike stains. With her left hand, this Eve, clad in a

blue bodice, picks a red apple from the biblical tree of knowledge, while the index finger of her caricaturally enlarged right hand firmly points down toward an incandescent area of light-cream glaze symbolizing the depths of Hell: for fallen Breton lasses, the wages of sin were eternal damnation. While implying the terrible human consequences of such a frolic in a Breton village culture still steeped in medieval Catholic strictness, Gauguin, man of the Age of Reason and nineteenth-century sophisticate, also conveys his sardonic, almost good-humored response to the naiveté and narrow-mindedness of the peasant tradition—an instance of symbolist polysemy.

Gauguin embarked with Charles Laval on April 10, 1887, first for Panama and then Martinique, after notifying his wife that their son Clovis could be picked up at his school. He left with the dream of a glorious escape firmly fixed in his consciousness. Remembering an island that he had visited during his travels as a young sailor, he wrote to his wife: "I am going to Panama to live there as a *savage*. I know at one league by sea from Panama a little island, Taboga, in the Pacific. It is almost uninhabited, free and fertile. I am taking my colors and my brushes, and I shall remake myself, far from all men."[14] Sadly, this dream was not to be: "With the piercing of the isthmus, life here has become unbearable . . . [yet] the [West] Indians in the mountains do not cultivate anything and do not do anything."[15]

The two artists did not go to Taboga, and things in Panama went from bad to worse. Gauguin had to work as a ditch-digger for the French company Canal Interocéanique de Panama in the hope of saving enough to survive a few months in the much more pleasant Martinique, that "wonderful land" where their ship had stopped on the way to Panama.[16] In Martinique, Gauguin and Laval lived "in a native hut, off fruit and fish, painting the palm trees, the banana trees, and especially the natives—paradise, finally, after long tortures." And: "it would take very little to be happy [here] and dedicate ourselves to art." Nevertheless, he warned, "in two months we shall be down and out."[17] Tragedy indeed struck when the devastating ailments that felled both men in Panama continued to plague them in Martinique. Gauguin reported that he was "almost coming out of the grave" and had "contracted diseases from the marshy miasmas of the canal," specifically complaining of dysentery, malaria, and severe weight loss. He continued: "Having been very low, ready to pass away every night, I have finally begun to improve, but the stomach has caused me to suffer like a martyr," and "whatever little I eat occasions terrible liver pains [hepatitis?]. . . . Almost daily nervous flare-ups [*crises nerveuses*], and [I was reduced to letting out] atrocious shrieks, such were the burning pains in my chest [heart?]. . . . My legs cannot carry my weight."[18] Desperate, Gauguin decided to return to France, arriving in Paris by mid-November.[19] Laval followed six months later.

Gauguin executed four wood carvings related to memories of that trip between 1887 and 1889, and all refer to the biblical Fall: *Eve and the Serpent, Woman with Mango Fruits, Reclining Tropical Eve with a Fan,* and *Martiniquaises.*[20]

Eve and the Serpent (fig. 20), carved with vigor in an archaizing mode, presents Eve as a strong, self-reliant noble savage. Endowed with wide hips, enormous buttocks, and powerful shoulders, she is something of a primeval mother-goddess. Her short spear, aggressively extended, transforms her into a hunting Diana as well. Apparently interrupted in her hunt by the serpent around the tree, she turns her head toward it and waves with her left hand as if to an old acquaintance. She, like the matron of *Two Women Bathing,* is seen from the rear, her undone hair hanging down her back. Her stature and aggressive stance imply imperviousness to the socioeconomic distress that may befall female sinners in the mean and corrupt West; she seems blissfully unaware of Judeo-Christian blandishments. The various symbols surrounding her have given rise to speculation,[21] but they can readily be unraveled: The owl is the attribute of Athena, the Greek goddess of, among other things, wisdom—a most useful asset for ladies of the jungle. The round face wearing a crescent to one side is none other than the moon, suggesting the importance of the cycles of nature to the hunting woman. The ram is an esoteric symbol with which Gauguin must have become acquainted through his friendship with Emile Schuffenecker, himself an adept of occult traditions. According to Magus Papus, it can be taken as a symbol of the Druid Ram, the "master of the world who was to preside over the civilization of his whole race," who "organized his empire along theocratic and religious principles."[22] It must have stood for the summation of occult beliefs that inspired this primitive soul. A bunch of bananas in the lower right suggests organic vitality. As for the rabbit coming out of a hole at the bottom, it not only symbolizes fecundity but could well constitute the next meal for the woman and her offspring. In sum, bright, wise, and strong female savages—natural women, so to speak—can be fully sexually independent, can provide for and protect their young ones without anyone's help, and can multiply to their heart's content.[23] This woman is clearly impervious to disgrace—let alone the woes of love—and assuredly belongs to the group of "self-righting" Eves.

In the carving entitled *Woman with Mango Fruits* (fig. 21), the spirited female figure wears a tiara, two necklaces, and four bracelets—two of them just below the shoulders in the tradition of classical India (there were apparently numerous settlers from India in Martinique at the time).[24] Her upright torso, no less than the considerable grace of her gestures, confers upon her an aura of aristocratic dignity. She has been identified as "a semi-nude Eve yield[ing] to temptation."[25] And so she is. The serpent on the left is endowed with a human face—a mask in this case—as are some in Christian iconography. Rather than the seductively persuasive female of Hugo van der Goes's *Adam and Eve* (1467–68, Kunsthistorisches Museum, Vienna), however, this serpent

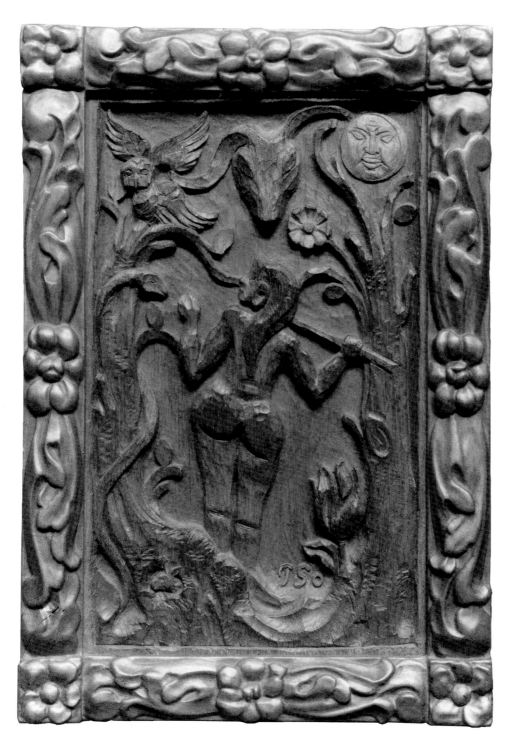

20 *Eve and the Serpent*, 1887–89. Carved and painted oak.
Ny Carlsberg Glyptothek, Copenhagen.

21 *Woman with Mango Fruits*, 1887–89. Carved and painted oak.
Ny Carlsberg Glyptotek, Copenhagen.

22 *Reclining Tropical Eve with a Fan*, 1887–89. Carved and painted oak.
Ny Carlsberg Glyptotek, Copenhagen.

is a wild harridan with diabolical eyes and locks of hair that resemble both flames and baroque acanthus leaves. She may be a first version of the pimpish confidante or duenna. The serpent's body starts horizontally immediately to the left of the mask, curves down and to the right, and circles a tree trunk before disappearing behind the woman's back. In the upper right corner, an eager-looking suitor with an intense slanted eye greedily ogles Eve's groin. The monkeys are actively encouraging sin, picking fruit as if to imply that "everybody does it"; the monkey to Eve's right even casts a conniving look toward the suitor. Finally, a sheep at the woman's feet identifies her as a shepherdess, but she is no ordinary shepherdess. The graceful dignity and rhythm of her pose and her elegantly worn tiara transform the woman into a particularly distinguished noble savage—one who will acquit herself in all matters, sexual dalliance included, with the grace, charm, and experience of her class, and without any plebeian concerns for social or religious restrictions—let alone fear or remorse. Gauguin, it must be remembered, took considerable pride in his partly aristocratic lineage, which, on his maternal grandfather's side, was quite genuine. The work is an ironic tribute to free love as practiced by those best prepared to cope with its consequences: the upper classes of society.

The next carving, which has not previously been associated with the Fall, is here retitled *Reclining Tropical Eve with a Fan* (fig. 22). The floating form in the sky and the three minor figures to the right have not been explained before, but the object in the sky can be seen as a knot of serpents, one head pointing to the right, the other toward the reclining woman's head. The small heads looking toward the woman are those of two suitors; the third, wearing a Martinique-type turban, is once again that of a procuress. The scene takes us to some primitive Xanadu, in which the reclining regal "savage" is wearing a serpent-shaped tiara—an allusion to the biblical serpent—worthy of Cleopatra. The fan the woman holds behind her head resembles a halo, counterpoising the allusion to sin with saintliness. The lines of the landscape have the light grace of an elegant rococo setting—in keeping with the sophisticated jewelry and the proud bearing of the figure. As in *Woman with Mango Fruits*, this Eve is a member of the aristocracy of some barbaric, yet luxury-loving, refined, and hardened society, some of whose female members, impervious to disgrace, are "self-righting." Free love, for those who can afford it and withstand its consequences, can be an aesthetic pursuit, Gauguin implies—never mind if a little pimping is involved. "Woman wants to be free," he asserted in the notebook of 1893 dedicated to his daughter Aline (a notebook that she in fact never saw). "The day when her honor is no longer located below the navel, she will be free, and perhaps the healthier for it."[26]

The wood carving *Martiniquaises* of 1887–89 (fig. 23) can best be interpreted in connection with the zincograph *Les cigales et les fourmis (The Grasshoppers and the Ants)* of 1889 (fig. 24). The title of the latter derives from one of La Fontaine's fables, with a change to the plural. According

23 *Martiniquaises*, 1887–89. Carved oak. Present location unknown.

24 *Les cigales et les fourmis (The Grasshoppers and the Ants: A Memory of Martinique)*, 1889. Lithograph (zinc) in black on imitation japan paper. Rosenwald Collection, National Gallery of Art, Washington, D.C. Image © 2007 Board of Trustees, National Gallery of Art, Washington.

to the fable, the wise, industrious, parsimonious, and unglamorous ant, having worked through the warm season to accumulate stores for the winter, survives its rigors, while the ever-singing, carefree, and lazy grasshopper has to beg for a loan from the ant in the hope of lasting through the winter—only to be told that rather than singing it should spend that season dancing.

The standing women in the zincograph[27] are related to impressions of Martinique described by the artist: "Every day negresses in colorful rags continuously come and go with infinitely graceful movements . . . ceaselessly chatter[ing] as they carry heavy burdens on their heads. Their gestures are very special, and their hands play a major role in harmony with the swinging of their hips."[28] Following the moral logic of La Fontaine's fable, the basket-carrying women should be the ants since they are working; and the idle, seated ones, the grasshoppers. But according to Gauguin's dream-notion, no wise person works in the tropics; it is in fact the idle seated ladies, less attractive than the others, who must be the ants. Conversely, the ones singing, sketching dancing rhythms as they walk, are foolish enough to be carrying baskets and are therefore the grasshoppers.[29] This is fully confirmed by an analysis of the next work, in which similar idle, seated women appear, and in roles whose moral compass is even more explicit.

In the wood carving *Martiniquaises*,[30] the same seated women are more fully characterized. They are apparently engaged in thoughtful conversation, and as in *Woman with Mango Fruits* and *Reclining Tropical Eve with a Fan*, there is a suitor: the young man standing casually to the right, wearing a hat.[31] Above, emerging from a bunch, a large, somewhat phallic banana significantly points toward him, as does, below, a large lotus bud—a Buddhist symbol of fertility.[32] To the left, a robust infant stretches out its left palm, upon which a branch ending in a serpent's head rests—the biblical serpent, no doubt—whispering its inducements into the ear of the nearest woman. The infant itself appears to be an improvised Martinique Eros. Four fertility symbols issue from its body: the two breasts are lotus buds pointed toward the onlooker, and a larger lotus bud, possibly just opening, covers the navel area. By way of an umbilical cord, a lotus stem sweeps down from behind the larger bud, ending in a full lotus blossom, presumably casting its seeds into the soil.[33]

Redolent as it is with symbols of sex and procreation, the composition confirms that these tropical women are engaged in a task much more significant than carrying baskets; their contribution to society derives not from manual labor, but from their dedication to the joys of love and the rewards of procreation. It is a first intimation of themes that recur frequently in Gauguin's work—the consecration of physical love as the guarantor of regeneration and of the survival and prosperity of a population, as well as its spiritual continuity. Ironically, the serpent, symbol here of the Judeo-Christian concept of sin and its attendant anxieties, miseries, and remorse, serves only as a catalyst.

25 *Jar with Figure of a Bathing Girl*, 1887–88.
Glazed stoneware. Present location unknown.

*B*ack in Paris from Panama and Martinique, Gauguin stayed with the Schuffeneckers until late January or early February 1887, when he returned to Pont-Aven.[34] A subsequent work with a Breton subject stresses the ostracism and future misery of the disgraced woman in a traditionalist, profoundly Catholic, and moralistic society: a glazed stoneware *Jar with Figure of a Bathing Girl* of 1887–88 (fig. 25), executed soon after the return from Martinique. The figure has been recognized as the little servant of *Two Women Bathing*,[35] but the features are exaggerated, and she is bending forward more markedly than in the painting. Her clothes, hanging from the tree behind her, stop just short of her posterior, as if to set it off through the contrast in tonal values with the flesh. The ironic tone of earlier works, however, is now offset by a note of compassion on the part of the artist. This Eve is a sensitive, sad-looking, as well as naive and submissive child who now appears even more resigned than her predecessors to being abused by some farmyard bully; she is forever condemned to be a fallen woman, and so a long-suffering victim.

The female figure of another stoneware pot, the *Leda Vase* of 1887–88 (fig. 26), has also been equated with the little servant.[36] Here it is by means of an Ovidian-inspired metaphor that the artist evokes her fall and her subsequent fate. Rather than a swan, the form taken by Jupiter to

26 *Leda Vase*, 1887–88. Unglazed stoneware, decorated slip.
Present location unknown.

seduce Leda, this is a farmyard animal, a gander—standing for a farmhand—that now assaults the girl. Its neck forms the vase's handle, and its beak is pecking her head, as birds are wont to do on such occasions. The outcome is symbolized not by the demigods who burst out of Leda's eggs, but by jaunty goslings, one of whom is monstrously endowed with two heads like the two-headed eagle of the Habsburgs, here drawn on the white slip at the back of the vase—animals, in other words. These animals are drawn with a simple, charmingly caricatural line reminiscent of the style of cartoonists and illustrators of children's books—notably that of Randolph Caldecott,[37] whom Gauguin was known to admire. But Gauguin, under the pretense of alluding to some children's fairy tale or fable, relegates the offspring of this union to the level of farm animals, thus hinting at the tragic fate of seduced and abandoned farm girls.

The motif is even more explicit in *Design for a Plate—Leda and the Swan* (fig. 27), a colored zincograph of 1889 also in Gauguin's caricatural, Caldecott-like style. Here the biblical serpent and apples reappear, as does the gander, now enveloping the servant girl with its wings and also pecking her scalp. Here, too, goslings strut and flap their wings in apparent triumph. Gauguin's effrontery culminates in the inscription derived from the motto of the British Order of the Garter:

27 *Design for a Plate—Leda and the Swan*, 1889. Lithograph (zinc), watercolor, and gouache on paper. Private collection/Christie's Images/Bridgeman Art Library.

"Honni soit qui mal y pense" ("Shame on he who thinks evil of this") here reversed (because of the printing process) and deliberately misspelled: "Homis soit qui mal y pense," the phonetic equivalent of "Homme y soit qui mal y pense," an ironic wager laid for the hypocritical moral censor: "May the man who thinks evil of this partake of it." However raucous the inscription, it nevertheless reflects the inner frailty, passivity, and despondency of an individual in the process of becoming an eternally fallen woman.

On the evidence of its stylistic and iconographic similarities with *The Vision after the Sermon: Jacob Wrestling with the Angel* of around September 25–27, 1888 (see fig. 49), the watercolor *Design for a Carved Bookcase* (fig. 28) was executed in Brittany, probably toward mid-

28 *Design for a Carved Bookcase*, 1888. Graphite, crayon, watercolor, and gouache. Private collection, Papeete. Photo courtesy of Sotheby's Picture Library.

September of 1888.[38] In both paintings Gauguin offers two distinct visions: in *The Vision after the Sermon*, one of the biblical wrestlers in the landscape as imagined by the women, and another of the whole scene, including the women and the priest, as envisioned by the artist. In *Design for a Carved Bookcase*, one vision corresponds to the nude bathers' states of mind. They are apparently unaware that they are being watched; their nudity and their poses evoke instinctual behavior, leading to the biblical Fall and its social and religious consequences. The other vision is that of the fully clothed peasants who, while not directly gazing at the bathers, have nevertheless made mental notes of their predicament and express their disapproval. In both works Gauguin makes a token gesture toward the academic rule of the three unities. The unity of space re-

quires that only one action be depicted; a real and an illusory action, in particular, cannot coexist. Gauguin distinguishes the "real" from the "illusory" parts of the design in the same manner as had J.-A.-D. Ingres in the *Vow of Louis XIII* of 1824 for the Cathedral of Montauban, where a garland of clouds separates the "illusory" vision, the Virgin and Child, from the "real" figure of the young praying king. In the *Design*, Gauguin separates the two scenes by means of the apple tree's foliage. Likewise, the sharply diagonal tree in *The Vision after the Sermon* performs the same function.

The postures of the two bathers in the bookcase design mark turning points in the development of two important themes. The standing bather, seen from the back, seems about to throw herself into the stream. Her raised right elbow suggests both her sense of abandon and the energy of her thrust. Yet her right forearm, bent back toward her mouth as if to shield her face and perhaps also repress a scream, hints at apprehension; and her outstretched left forearm and hand rising from a bent elbow sketch out a universal gesture of fear. The symbol of the falling Eve is here close to its definitive Breton form. The other bather is suffering from the consequences of her fall. She seems unable to maintain her balance and holds the back of her neck in pain—the outcome of an imprudent dive in a shallow stream. Metaphorically, the gesture expresses guilt, as well as distress at the prospect of shame and misery in this world and the next.[39] The apple tree hovering over the scene is a further allusion to the biblical Fall. Impulsiveness under the dictates of the senses today, it seems, brings regrets and pain tomorrow and forever after!

The fully dressed peasant women are passing judgment. Their expressions are marked by a satanic leer in the upper left, virtuous indignation in the lower center right. The two girls who follow the latter figure affect an attitude of virtue. The geese are engaged in their habitual suggestive contortions, reminders of the pervasiveness and potency of animal instincts. For its part, the spindly, scruffy stray dog sniffing for a promising scent at the lower right represents Gauguin himself[40] and thus encompasses the whole scene in his own thoughts, much as the priest (artist) does in *The Vision after the Sermon*. Why is it, his presence implies, that individual instincts clash so strongly with social and religious tradition? How can such natural behavior endanger young women?

These disengaged spectators, dog included, bring to mind the two clothed gossiping female figures in Gauguin's vast Tahitian composition *Where Do We Come From? What Are We? Where Are We Going?* of late 1897 (see fig. 131). Gauguin explained: "Behind a tree, two sinister figures . . . create near the tree of knowledge their dolorous note caused by that very knowledge in contrast to simple beings in a virgin nature that could embody the human concept of paradise [if only] they abandoned themselves to the pleasure of living."[41] Thus, morally and socially laden consciousness stands in opposition to uncontrolled instinctual urges, turning the subject matter

into, as Gauguin put it, "a philosophical theme compared to the Gospels."[42] Such judgmental figures have been characterized as "unsympathetic observers" in later works by the artist,[43] but stylistically Gauguin's potent caricatural linearism in the bookcase design, with the simplification it implies, is close in spirit to the fully synthetist style of *The Vision after the Sermon*. An ironic inscription by the artist to the right in the upper margin draws attention to the deceptive naiveté and simplicity of the composition—and perhaps the limitations of the personages. Instead of the traditional "Gauguin *fecit*," the inscription reads "Gauguin *stupidit*."

The artist developed much more dramatic and moving versions of the fallen woman in *Grape Harvest in Arles*, or *Human Misery* (fig. 29), and *Woman in the Hay with Pigs*, also known as *The Heat of the Day* (fig. 30), which he executed in the second and third weeks of November of 1888, respectively, during his five-week stay with Vincent van Gogh in Arles.[44] Both artists were immediately aware of the paintings' importance. "Your brother [Vincent], who is kind, thinks it fine," Gauguin wrote Theo about *Grape Harvest in Arles*.[45] Vincent, for his part, wrote Theo that Gauguin was painting "a very original nude woman in the hay with pigs. This promises to become very beautiful, and in a great style."[46] Also: "The two canvases [Gauguin] just sent you are thirty times better than [*Breton Girls Dancing*]. . . . [They] are very assured in the treatment of the paint surface; he even used a palette-knife. They will throw his Breton canvases a little in the shade."[47] Gauguin himself expressed great satisfaction with the finished works; he thus wrote Schuffenecker: "I would very much like to see [*Grape Harvest*] at your house. I attach much importance to that piece. You will place it in a simple flat frame. . . . I shall ask you for it for the Brussels exhibition, and I shall list it for a relatively high price: 2,000 francs, so as to ensure that no one will buy it."[48] He took particular pride in the shock-value of the two paintings' subjects, writing to Theo van Gogh when they were on display at his gallery: "These . . . pictures are, I believe, rather virile, but one might say a little gross. Is it the sun of the Midi that causes us to be in heat? Should they scare a purchaser, do not be afraid of setting them aside. For my part, I love them."[49]

Stylistically, *Grape Harvest in Arles* is one of the artist's major works, embodying his fully developed synthetist approach. The horizon line is high, as in Japanese prints; indeed, it is not visible, thus maximizing the expressive arabesque of people and field. In keeping with the inclinations expressed in the Zunbul-Gauguin text of 1886, the work was painted "from memory [*de chic*]," as he put it.[50] The comma strokes of impressionism are subdued but evident in much of the work: in the virtually incandescent hay above the red-orange vines, themselves glowing thanks to light violet and yellow dashes over much of their surface; in the clothes of the young woman, enlivened by gray and blue hatchings over her white blouse, and higher-value hatching over her lightly colored skirt; and in her face and hands, marked by powerful orange-yellow

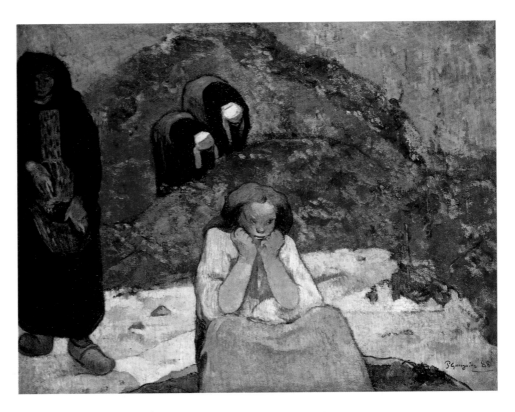

29 *Grape Harvest in Arles*, or *Human Misery*, second week of November 1888. Oil on canvas. Ordrupgaard, Copenhagen / Bridgeman Art Library.

dabs over the flesh colors. But overall, intense hues emerge in a simple pattern: yellow in each of the upper corners, a red triangle between them, an essentially white-gray trapezoid for the young woman with red and yellow for her most expressive areas, and a black and violet vertical strip for the older peasant woman to the left. These various colored areas are separated by fairly linear edges, and the figures themselves are delineated sharply, with almost caricatural vigor. The composition as a whole is flattened by the high horizon line and the strong overall patterning, but the artist adds a nearly horizontal whitish strip at the bottom—probably a path curving slightly across the landscape—as if to erect a stage for a performance. In keeping with the allusions to Charles Henry's theories in the January 14, 1885, letter to Schuffenecker,[51] the nearly symmetrical descending lines of the young woman's forearms and overall outline further accentuate her depressed mood. The black and mauve notes of the garment of the woman walking toward her signal a sinister warning.

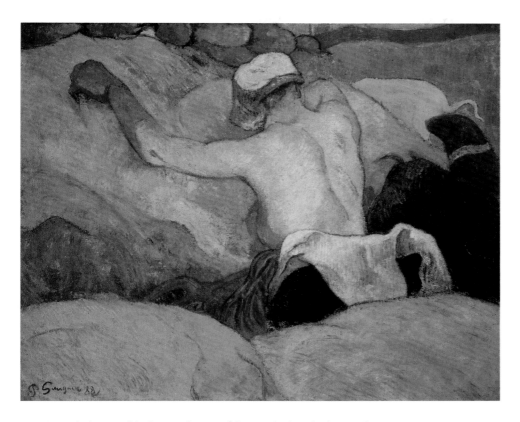

30 *Woman in the Hay with Pigs*, or *The Heat of the Day*, third week of November
 1888. Oil on canvas. Private collection/Peter Willi/Bridgeman Art Library.

A year after completing the painting, Gauguin himself pointed out the originality of the de-
sign, which he referred to as synthetist. He wrote to Vincent: "While at your house at Arles I
undertook a painting [*Grape Harvest*] that was somewhat in that spirit (a work of which you have
a drawing). A seated woman, vines forming a red triangle. Degas does not understand that one.
In this order of abstract ideas I am drawn to seeking the synthesis of form and color."[52] Gau-
guin had already offered a brief and cogent definition of *synthèse* in his letter to Schuffenecker
of August 14, 1888, indicating that the artist should be selective in his approach to nature and
draw on memory in order to visualize the desired impact. "Do not copy too much after nature.
Art is an abstraction; draw it from nature by dreaming in front of it and think more of creation
than of the result. . . . I believe that you will find [in my recent works] a particular note, or rather
the affirmation of my previous research: the synthesis of form and color while considering only
that which is dominant."[53] Here "dominant" once again, and even more pointedly, concerns "a

breath of the struggle for life, of sadness and of submission to the laws of misery [*aux lois malheureuses*]."[54] Gauguin's use of the term "synthesis" in this case is the same as in chemistry: the combination of two elements (color and form) in order to create a third (expression), different from the first two.

Soon after he completed the painting, Gauguin gave a specific clue as to the dramatic situation of the unfortunate central figure, using a colloquialism to define it: "a miserable woman ensnared [*ensorcelée*] in an open field of red vines."[55] The most frequent meaning of *ensorcelée*, "bewitched," would make little sense here, but according to that arbiter of nineteenth-century French usage, Emile Littré, the word "is said facetiously of something apparently caught in a spell-like trap."[56] And a tragic trap it assuredly was!

The dramatic content of the work was further elaborated, still somewhat cryptically, in the letter to Schuffenecker written eight days later:

> Do you notice in *Grape Harvest* a poor, disconsolate being? It is not a creature deprived of intelligence, of grace, and of all the gifts of nature. It is a woman. Her two hands under her chin, she thinks of few things, but feels the consolation of the earth (nothing but the earth), which the sun inundates in the vines with its red triangle. And a woman dressed in black passes by, who looks at her like a sister.
>
> To explain in painting is not the same thing as to describe. This is why I prefer a suggestive color, forms, and in the composition the parable to the painted novel. For many I am wrong, and it may be that all this is in my imagination. Nevertheless, if I arouse in you a feeling of the beyond, it is perhaps through this magnetic current of thought, the absolute path of which we do not know but can guess. In painting, a hand that holds a handkerchief can express the feeling that animates it, the whole of life past as well as life still to come. Since all is convention, and since in French happiness [and] unhappiness are words that convey the state of things, black [likewise expressing] mourning; why should we not come to create diverse harmonies corresponding to the state of our soul? Never mind those who will not be able to decipher them; we must not explain.[57]

Compositionally, the "woman dressed in black" offsets the warmth of the "red triangle." But Gauguin subsequently alludes to the associative value of each: the "red triangle" is linked with the "consolation of the earth," and "black [expresses] mourning." At the very least, one can interpret the juxtaposition as an allusion to death, in opposition to the reassurance offered by the rural setting, discreetly veiled in keeping with the symbolist penchant for mystery in both literature and art.[58]

Gauguin's reference to a handkerchief is also revealing. There is no handkerchief in the picture. It is a reminder of a line of reasoning he had pursued in *Notes synthètiques* some four years

earlier, advocating a departure from the academic rule of the three unities—of action, place, and time (see chapter 2). Gauguin offered the arrival of Othello on stage before the final catharsis as an example of how the rule can and should be flouted: "Whatever talent you may have to recount how Othello arrives, his heart full of jealousy, to kill Desdemona, my soul will never be as impressed as when I shall have seen with my own eyes Othello step forward in the room, his forehead in the grip of a storm." Gauguin thus established that in this way "[one] apprehends at once the prelude, the stage action, and the final outcome."[59]

In the letter to Schuffenecker it is the handkerchief that "can express the feeling that animates [the hand], the whole of life past as well as life still to come." The hand and the handkerchief are clearly those of the innocent and naive Desdemona, who, by inadvertently dropping her handkerchief, triggers the tragic chain of events. In the case of *Grape Harvest* the artist's intention was to allude simultaneously to the young woman's past lapse, the present consolation of the earth, and the prospect of misery and an early death.

The position—and distress—of the young woman in *Grape Harvest* recall, albeit less dramatically, van Gogh's charcoal drawing *Sorrow* of 1882, which was reproduced in a lithograph (fig. 31).[60] Van Gogh's depiction of a nude, withered, crouching woman, her head resting on her forearms and knees, apparently crying and in a state of great distress, may well have inspired Gauguin to seek the same dramatic intensity, albeit less directly. At any rate, the suffering expressed in *Grape Harvest* dwarfs anything Gauguin had done until then—a far cry from the bather holding her neck in pain.

Gauguin also appears to have been influenced by the iconography of an earlier artist, Félicien Rops.[61] Indeed, the young woman in *Grape Harvest*—with her chin between her fists and her elbows firmly planted on her thighs—must have been inspired by the heliogravure and etching after Rops's 1857 drawing *In the Ardenne Country—Now, That Daft Marie-Josèphe Thinks of a Child Who Has Been Buried* (fig. 32), which is itself a brutal Romantic-naturalist rendering of a motif dating back to such erotic themes as Jean-Baptiste Greuze's sweet and well-attired farm girls weeping over the spilled milk jug or the death of a pet bird, both of which were symbols of the loss of virginity. Here the title is explicit: a poor female farmhand has been seduced and abandoned, and a child has died. Bedraggled, yet still youngish and not too unattractive, Marie-Josèphe sits in a daze, her chin between her hands, her elbows against her knees, presumably exhausted after days of wandering in search of work. Her expression conveys suffering, fatigue, sadness, and worry. And the corroborating details are powerfully suggestive: the stick and bundle of the itinerant worker; the jeering urchin, symbolic of society's contempt and resentment, who taunts her by spreading the news of her sin; the severe wall of the church evoking the weight of religious tradition; and the caricaturally scrawny, emaciated, almost ludicrous figure of the

31 Vincent van Gogh, *Sorrow*, 1882. Lithograph on tinted paper. Rijksmuseum Vincent van Gogh, Amsterdam (Vincent van Gogh Foundation).

32 Félicien Rops, *In the Ardenne Country—Now, That Daft Marie-Josèphe Thinks of a Child Who Has Been Buried*, 1857. From Erastène Ramiro, *Félicien Rops* (Paris, 1905). Collections Jacques Doucet, Institut national d'histoire de l'art, Paris.

crucified Christ, alluding to the jeering and suffering to which he himself was subjected, and perhaps also hinting that divine providence might ensure the poor creature's ultimate salvation. Surely, Gauguin must have known this engraving—perhaps through the intermediary of Vincent van Gogh, who greatly admired Rops and collected his prints. Should we not assume the similarly seated, sad and dazed farm girl in Gauguin's *Grape Harvest* is beset by comparable thoughts?

This brings up the matter of Gauguin's own attitude toward love and marriage—and his sense of their shortcomings. He prided himself on a stoic imperviousness to emotion: "I do not know love, and in order to make me say 'I love you,' one would have to knock out all my teeth"[62] Gauguin shared the progressive ideas of some Scandinavian free-thinking intellectuals, themselves influenced by Flora Tristan, Pierre-Joseph Proudhon, and other early utopians: "Marriage should be suppressed," he wrote to Mette, "or one becomes nothing more than an association, etc."[63] At the same time, also in keeping with the ideas of Flora, Gauguin was much concerned about the fate of abandoned women and women abused by their husbands or partners.

The fate of unwanted children was also a major concern. Low farm output, the crowding of cities, and the resulting constant threat of famine and pestilence tended to confirm Thomas R. Malthus's theories that populations rise and fall to the level of available subsistence, so that such calamities are cruel, if inevitable, forms of population control. Orphans, by and large, constituted yet another burden on society, and as a result, particularly in a rigidly moralistic population like that of the strictly Catholic Brittany in Gauguin's time, illegitimacy was abhorrent. Unwanted children would usually be left on the steps of churches, where they would be picked up by a generous soul—or the opposite: left to die of exposure.[64] Throughout Europe working girls who became pregnant were summarily dismissed and faced the choice of aborting the fetus—at enormous physical and legal peril—or abandoning the child. Some went to the city—sometimes pregnant, sometimes with their children in tow—to work as prostitutes. Inexperienced as they were, they were particularly prone to disease and early death.[65]

The gravity of the girl's plight in *Grape Harvest* articulated in Gauguin's December 22, 1888, letter to Schuffenecker is presaged in an allusion earlier in the letter to a Romantic poem: "Do you remember Manfred? Every time I sit on the ground, I see a man dressed in black who looks at me like a brother." In the paragraph following, Gauguin transformed the last part of the sentence into "And a woman dressed in black passes by, who looks at her like a sister."[66] The reference to Manfred, the hero of Lord Byron's epic poem, must have been a private joke, invoked to refer generically to the emotional extremes of Romanticism: Gauguin was in fact alluding to Alfred de Musset's poem "Nuit de décembre." Vincent had misquoted the poem in a letter to his brother Theo toward the end of Gauguin's stay: "Everywhere I touched the earth, a

wretched man dressed in black came to sit near us, who looked at us like a brother." Vincent explained that the lines came to him when he saw Eugène Delacroix's portrait of Alfred Bruyas—a solemn and lugubrious character—at the Musée Fabre in Montpellier, which he and Gauguin had just visited.[67]

Musset's black-clad figure is the traditional *doppelgänger* of Romantic literature. "Friend, I am solitude," the figure says in the last verse, but it is a singularly distressing solitude: The poet's double is ever-present, ever-melancholic—empathetic to the poet's sorrow but never consoling. The double breaks the glass being clicked against its own and at one point, in response to the poet's distress, drops its lute to the ground and reveals rags turned blood-red and its own sword planted in its chest. By referring to "black" as "expressing mourning" Gauguin incontrovertibly added the symbol of death to those hinted at by Musset.

Surely, then, Gauguin is here referring to the grief of the seduced and abandoned young woman in *Grape Harvest*, and conceivably to the possible death of her offspring and her own mortality. Indeed, Gauguin explained to his wife that the somewhat similar woman in black standing behind a lascivious Tahitian girl in *Manao tupapau (The Spirit of the Dead Watches)* of 1892 (see fig. 110) represents "a ghost . . . the spirit of the dead . . . for the [Tahitian] young woman . . . the dead himself, that is a person like herself."[68] In line and color, therefore, *Grape Harvest* is a fully synthetist work, to the same extent that it is fully symbolist in its complex interplay of wide-ranging and momentous associations, its emphasis on musicality, and its obscurity—the roundabout way in which the artist makes his points. It is fully on a par with the slightly earlier *The Vision after the Sermon: Jacob Wrestling with the Angel*.[69]

Is Gauguin's new insistence on the expression of emotion related to Vincent van Gogh's willingness to portray intense suffering? More than likely. Under the influence of Vincent and of their common readings, Gauguin developed at this time a more profoundly humanitarian social philosophy, instilled with spiritual overtones, and he was quite conscious of this development. He wrote a year later: "Let [Degas and Theo van Gogh] look at my last paintings attentively (if they happen to have a heart with which to feel) and they will see what they contained in the way of resigned suffering. Is it nothing, a human cry?"[70]

In *Woman in the Hay with Pigs*, the warm flesh tones of the mature, portly peasant are heightened, and the figure brought into relief, by the contrasting light green shadows and what appear to be mounds of pale yellow-green hay, against which she leans. The diagonally opposite pink-orange masses of the two pigs at the lower left and the upper right add to the harmonious orchestration of colors. An astute observer has referred, without further comment, to the woman's right leg as being "disjointed" (*disloquée*).[71] The leg indeed appears to rise diagonally at an unnatural angle, the clog on the right foot amusingly pointed toward the rump of the pig in the

upper-right corner. It is not so much the leg that is disjointed as the entire hip; the spread of the legs is quite excessive, thus suggesting both a colossal erotic appetite and the relaxation that comes with fulfillment. The slouching shoulders and sloping head, for their part, evoke physical exhaustion and anticipation of miseries to come. "Is it the sun of the Midi that causes us to be in heat?" Gauguin had asked Theo.[72] He could not have made his intention clearer!

The two pictures are pendants to each other: *Woman in the Hay* evoking the bestial delights and eventual letdown occasioned, no doubt, by a passionate encounter in the fields on a scorching harvest day; and *Grape Harvest*, the potentially devastating personal, social, and religious consequences of such an orgy of the senses. Much as the young woman in *Human Misery* is related to Marie-Josèphe in Rops's print, so is the woman in *Woman in the Hay* related to the figure in the print's *remarque*, the small design (etched at the bottom margin) showing an equally voluptuous matron slouching with abandon and apparent weariness. But there is also an allusion to immense suffering in the *remarque:* the death of a baby evoked by a small coffin to the left, barely visible in the glow of a candle. And yet both figures seem reassuringly well fed; both exude sensuousness and appear to find comfort in their familiar surroundings: however grim the context, there is a touch of Epicureanism in both works. Healing is a distinct possibility, as is the women's introduction into the ranks of the "self-righting" Eves.

Grape Harvest was one of Gauguin's entries in the Paris exhibition that he and his friends had organized independently of his regular dealer, Theo van Gogh: *Exposition du groupe impressionniste et synthétiste*, presented at the Café des Arts, across the street from the Fine Arts Pavilion at the 1889 Exposition Universelle and very near the Press Pavilion, where a group of impressionists was also exhibiting. Known to the artists as the Volpini exhibition, after the café's proprietor, it opened its doors on June 8; the exhibition catalogue was still only in manuscript on July 6, although it was eventually printed.[73]

The young woman of *Grape Harvest* was to become one of Gauguin's significant icons of fallen Eves for the remainder of his career. She first reappeared in the zincograph *Human Miseries* of around May 1889 (fig. 33). Here, too, the young woman's mind turns to distressing thoughts as she sits under the biblical apple tree. Her lover, a lad with shifty eyes, seems about to abscond quietly and definitively, while a passing priest (a clearly unsympathetic observer) injects a note of shock and reproach on behalf of church and society.

Some five years later, after Gauguin returned from his first sojourn in Tahiti, the same figure appears in *Village Drama* of 1894 (fig. 34). Its style deliberately emulates that of the Brittany paintings, and the subject resembles that of *Human Miseries*. The shifty-eyed young man of the latter work is replaced by a hulking, middle-aged male who seems to be confronting the girl: the farmer about to dismiss her? Her lover as well?[74] The other figures are, again, unsympathetic

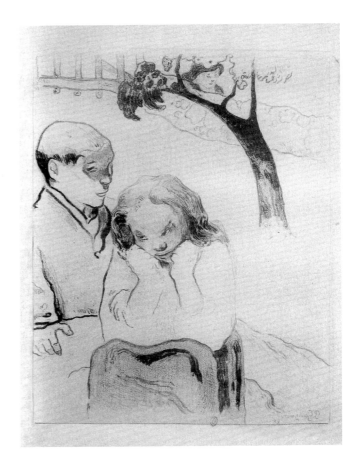

33 *Human Miseries*, 1889.
Zincograph. Collections
Jacques Doucet, Institut
national d'histoire de l'art,
Paris.

observers: already, a group of villagers has gathered to discuss the news and formulate public opinion. High above them in the hills, two horizontally stretched branches of a pine tree form the arms of a cross, suggesting the thrust of moral and religious opprobrium. The two gossiping women passing by to the right of the man form a contingent of unsympathetic observers, as will those gossiping by the tree of knowledge in *Where Do We Come From? What Are We? Where Are We Going?* They are thus symbols of the consciousness of others, which transforms an instinctual act into a pretext for religious and social condemnation.

Gauguin evoked a figure that expressed even more dramatically the deathlike condition and thoughts of the fallen woman in the watercolor and pastel *Pas écouter li . . . li . . . menteur (Don't Listen to the Liar . . .)*, also known as *Eve*, completed by early June 1889 (fig. 35).[75] Gauguin borrowed the pose for the Eve from a Peruvian mummy preserved in its fetal burial position (fig. 36),[76] which was exhibited at the Trocadéro (the future Musée de l'Homme), adjoining the

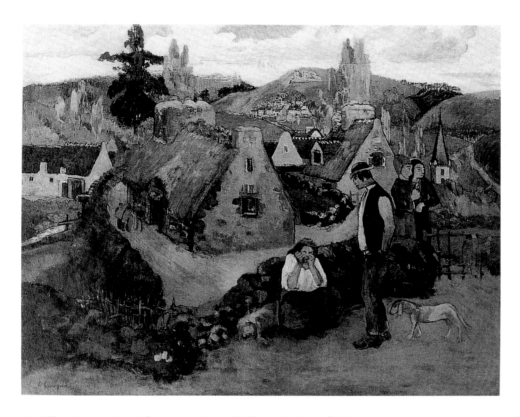

34 *Village Drama*, 1894. Oil on canvas. Formerly The Art Institute of Chicago.
Present location unknown.

1889 Paris Exposition Universelle. The title, given in pidgin French on the painting's label, was noted by a journalist, who added, "On what evidence does Gauguin base his assumption that Eve spoke negro?"[77] "What a silly article!" Gauguin exclaimed in a letter to Emile Bernard. "So Eve did not speak negro; but for heaven's sake what language did Eve speak with the serpent?"[78] This new fallen Eve, wilted and almost corpselike, is seated under an apple tree. Her open mouth and her hands held against her cheeks, temples, and ears evoke a terrified, near-hysterical state of mind.

As in *The Vision after the Sermon*, a tree divides the scene into two parts, each pertaining to a different time frame. Above, and to the right of the tree, the serpent—having whispered its advice into the woman's ear (just as a serpent whispers thoughts of love in *Martiniquaises* [fig. 23])—turns around to disappear, denoting the end of the process of seduction and the beginning of her ordeal. Centrally positioned against the trunk, Eve evokes the disgrace and misery

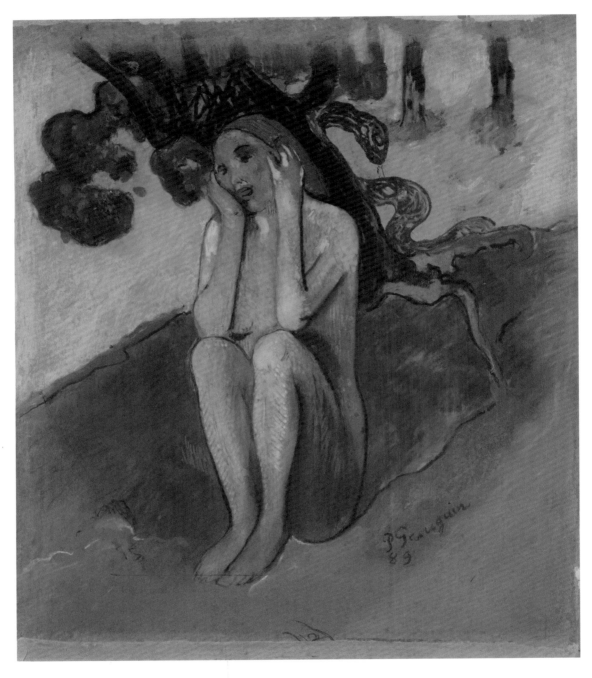

35 *Pas écouter li . . . li . . . menteur (Don't Listen to the Liar . . .)*, or *Eve*,
early June 1889. Watercolor and pastel on paper. Collection of the McNay
Art Museum, San Antonio, Texas, Bequest of Marion Koogler McNay.

36 Peruvian mummy, pre-Columbian
period. Musée du quai Branly, Dépôt
du Musée de l'Homme, Paris. Photo:

that have befallen her and are likely to stretch through eternity—the partly decomposed
mummy in a fetal position alluding both to the fate of sinners in the netherworld in medieval
art and to Gauguin's own ancient Peruvian atavism.

The pidgin-French title, *Pas écouter li . . . li . . . menteur,* has been interpreted as an order com-
ing from the Eve's conscience, urging her to block her ears so as not to hear the serpent's ad-
vice.[79] This cannot be, as the figure is not pressing her ears with her palms, but somewhat loosely
cupping her fingers over them. The title, rather, is an after-the-fact musing on Eve's fate, re-

verting to the irony of the wood carving *Soyez amoureuses vous serez heureuses (Be in Love and You Will Be Happy)* from 1889 (fig. 37).

The motif of the mummylike fallen Eve reappears in numerous other works, including the highly finished wood carving just mentioned, which was affected by Gauguin's experiences with the 1889 Exposition Universelle. The composition was first sketched, presumably in clay, at Le Pouldu by the second half of August 1889,[80] then carved in wood at Le Pouldu after Gauguin's return from Pont-Aven in early October. It was almost completed by October 20 and sent to Paris by early November.[81]

To start with a detail, what appears to be an iris blossom at the lower right[82] caresses the thigh of the large, seated, struggling woman to the left—a falling Eve—as if to hasten the process of seduction. But the iris also has a traditional symbolic meaning: the suffering of the Virgin Mary. Gauguin's large figure has been identified as a mulatto woman he had encountered at the 1889 Exposition Universelle, which had opened on May 6.[83] Her eyes are wide open, and her overall expression sad and somewhat resigned as she attempts—rather unconvincingly—to free her right hand (with some help from the left, adorned with a wedding band) from the grip of a descending male hand—that of the seducer in the upper-right corner. In the process, her right arm, bent at the elbow, rises in the manner of those of the figures of falling Eves plunging into the waves. The seducer is none other than Gauguin, in the same place in the composition as in *Woman with Mango Fruits* and *Reclining Tropical Eve with a Fan*. His eyes are shut, so that he is actually shown dreaming about the scene as he partakes in it. While his features are essentially dolorous, the overall expression is haughty and contemptuous of all that is around him, including the woman.

As in *Self-Portrait in the Form of a Grotesque Head* of 1889 (see fig. 60), "vaguely representing a head of Gauguin the savage,"[84] the male figure's left hand is placed against his chin and his thumb against his mouth, here apparently flattened and curving inward at the lower lip, possibly touching the upper front teeth. The gesture will be discussed more fully in connection with the *Grotesque Head;* suffice it to note here that the hand against the chin, apparently a characteristic gesture on Gauguin's part, seems to imply intellectual concentration; at the same time the thumb touching the mouth suggests instinctual self-indulgence—in other words, the appeal of the senses. Both seem appropriate to such a struggle.

Additional figures are visible behind each of the two protagonists: on Gauguin's side, visible over his distorted and impressively large shoulder, a determined young woman shows concern and indignation—presumably one of the artist's current lady-friends. On the falling Eve's side, a masculine face with powerful Asiatic features—the woman's husband or mate, no doubt—is frowning with pained fury. The bent arm rising behind his back suggests a struggle.

The lower part of the scene, the artist wrote Theo van Gogh, is envisioned "as [if] through

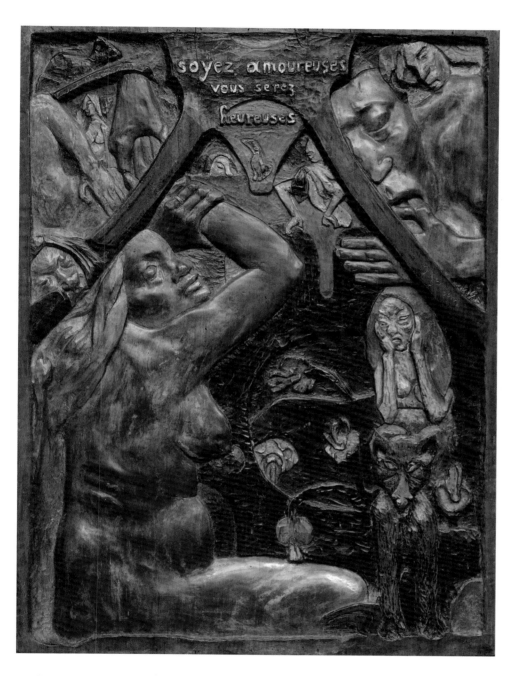

37 *Soyez amoureuses vous serez heureuses (Be in Love and You Will Be Happy)*, 1889.
Carved and painted linden wood. Museum of Fine Arts, Boston, Arthur Tracy
Cabot Fund. Photo © 2007 Museum of Fine Arts, Boston.

a window." There is "the sight of the fields, nature with its flowers. [A] demon takes a simple woman by the hand . . . and [she] resists despite the inscription's tempting piece of good advice. [There is also] a fox (among Hindus a symbol of perversity)."[85] The fact that Gauguin is referring to the seducer in himself as a "demon" is revealing. Although he has defended seduced and abandoned women, while professing his faith in libertinism, this is probably the first time he recognizes himself as an evildoer by virtue of his role as the seducer. He will do so again in later works such as *Manao tupapau* and *Parau na te varua ino*, both of 1892 (see figs. 110 and 114).

In the same letter to Theo, Gauguin mentions "several figures among all this entourage, who express the opposite of the advice (you will be happy) to indicate that it is misleading." The mummy-Eve holding her head between her hands of *Eve*, or *Don't Listen to the Liar*, also dating to 1889, is clearly one of the unhappy ones. In sum, the lower portion of the panel alludes to the unfurling of the falling Eve's personal drama.

The upper portion of the composition, according to the same letter, is "the rotten city of Babylon," evoking society's decadence and hypocrisy and particularly the social and religious opprobrium in large part responsible for the drama's tragic overtones, according to Gauguin's philosophy. Indeed, "little figures in the interstices,"[86] placed above the fence, are playing the same role as the gossips in *Design for a Carved Bookcase*, eventually those of *Village Drama*, and beyond that of *Te arii vahine* (1896; see fig. 126), *Where Do We Come From? What Are We? Where Are We Going?* and other works, transforming the individual's instinctual drives into the subject of social and religious condemnation. A prim little shrew with sadly sagging breasts (undoubtedly a busybody eager to make trouble) is thus seen looking down her long nose below Gauguin's hand. And just to the left of the right-curved diagonal strip, another female, pony-tailed, resting the weight of her head and torso on her hands as if leaning on a windowsill, is straining for a good look. To the left, a middle-aged male similarly peers, sticking his long nose over a wall. Between the last two, a dog lifting its head as if to howl evokes the spreading ruckus.

A jaunty, vigorous little rat appears in the upper-left corner. A similar one, drawn in the same naive style as the figure of Christ, appears in the drawing (see fig. 54) for *The Yellow Christ*[87] of September 1889. There it clearly stands in opposition to the spirit of abnegation and self-sacrifice emanating from the deity, and surely alludes to all that Christ's ordeal was meant to overcome: greed, lethargy, corruption, and sloth. In this wood carving it must stand for similar failings, now associated with the "rotten city of Babylon"—civilization, in other words. Rodents, incidentally, including a Polynesian version of the animal—in the colored print *Te atua (The Gods)* of 1889 (see fig. 133)—frequently appear in Gauguin's work, lively and thriving in the context of social decay and death.

The proverblike inscription at the top in the guise of a title suggests two possible, apparently

contradictory, conclusions to the fable. It could mean giving in to one's instincts, and so encouraging amorous union and reproduction. To those who understood the artist's sarcasm, however, the proverb is a chilling rebuttal of amorous union and ultimately family life. As Gauguin put it to Bernard, "If there is still time, do not love. It hurts."[88] And for those unable or unwilling to accept the apparent dichotomy, Gauguin opined in connection with the original plaster study of the work, "I intend to become increasingly incomprehensible."[89]

The mummylike fallen Eve appears in a beach setting in *Life and Death* of 1889 (fig. 38),[90] shown next to a young woman about to enter the water with poise and ease, apparently unconcerned with the dilemmas pertaining to sexual submission. In view of the title, it is unlikely that Gauguin intended to present her as unconscious or careless. Indeed, a keen consciousness and self-control must have been mandatory qualities for such young women. She is neither a savage, as is the female in *Eve and the Serpent*, nor a princess, as is the Eve of *Reclining Tropical Eve with a Fan*, but a simple, fairly attractive, modern Western self-righting Eve, capable of dealing with love without falling into disgrace—and of recovering if she does.

The mummylike fallen Eve reappears coupled with the falling Eve, now in a more advanced configuration, in a woodcut made in 1895—*Aux roches noires II* (*At the Black Rocks*, fig. 39). Gauguin later used a reversed image of this as the cover for the 1889 Volpini exhibition catalogue. This falling Eve is now a lithe and dynamic version of the analogous figure in the *Design for a Carved Bookcase*. Seen from the back, she is throwing herself into the water and placing her forearm in front of her mouth as if to repress a scream. These two Eves may well constitute Gauguin's starkest evocations of the Fall and its consequences. The image, incidentally, must have been seen by a young Norwegian artist who visited the Paris Fine Arts Pavilion of the Exposition Universelle, across the street from Volpini's Café des Arts, for we find a vibrant version of the near-hysterical mummylike Eve, also against a background of waves, in Edvard Munch's *The Scream* (1893, National Gallery, Oslo).[91]

The "self-righting" Eve reappears in *Female Nude with Sunflowers*, or *Caribbean Woman* (fig. 40), the lower of two panels originally embedded in the entrance door to the dining room of Marie Henry's inn at Le Pouldu and contemporary with the other decorations there, done between mid-November and December 12, 1889.[92] It is executed swiftly in a strongly linear pattern—no doubt an intentional crudeness—that treats features and body with the harsh angularity characteristic of native African and Polynesian wood carvings. The highly stylized face, almost in profile on a strictly frontal body, resembles ancient Near Eastern friezes, as does its impersonal, determined, haughty expression; these features and the flat geometry of the design all contribute to the work's hieratic quality. The gestures themselves, as we shall see, have an East Asiatic quality. The paint on the figure is applied in nearly monochrome color areas

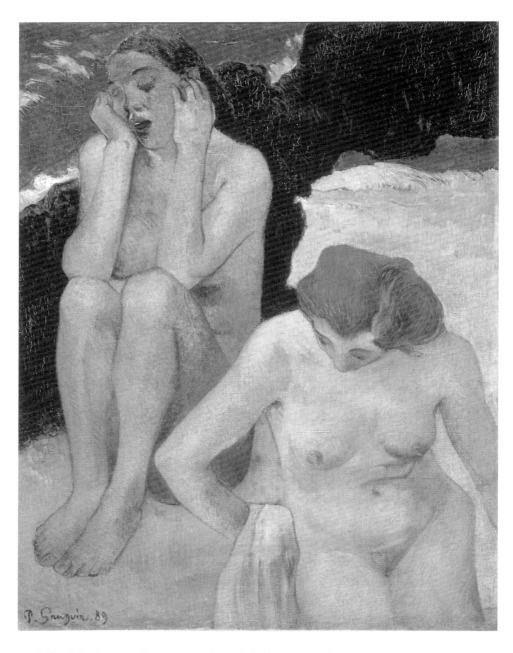

38 *Life and Death*, 1889. Oil on canvas. Mahmoud Khalil Museum, Cairo.
Photo: Erich Lessing/Art Resource, New York.

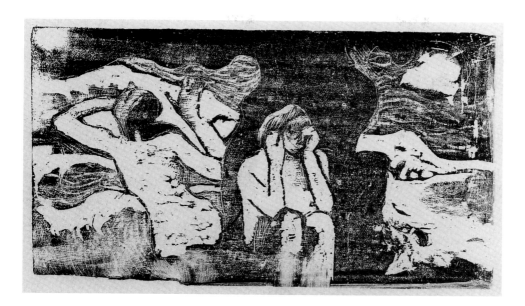

39 *Aux roches noires II (At the Black Rocks)*, in or after 1895. Woodcut. Similar
(reversed) image used for the Volpini exhibition catalogue frontispiece, ca.
May–June 1889. Rosenwald Collection, National Gallery of Art, Washington,
D.C. Image © 2007 Board of Trustees, National Gallery of Art, Washington.

constituted of fine striations in a range of browns, creating an overall effect of flatness, although
subtle variations in value evoke the shallow modeling of individual parts. The sunflowers, also
drawn with apparent crudeness, create rich and subtle variations on the yellow background, con-
tasting with the green leaves and stems of one of the sunflowers and the paler green of the am-
ple hair ribbon undulating down the woman's side. Overall it has a lively art nouveau quality,
perhaps related to the decorative tradition of William Morris.

The figure's posture is very similar to that in two later works: the statuettes *Lechery I*, in clay,
and *Lechery II*, in wood, both dating around 1889.[93] The presence of a fox's head attached to the
pedestal of the wood statuette confirms the identification of both sculptures, and therefore the
woman in *Female Nude with Sunflowers*, as Eves; the motif is the "Indian symbol of perversity"
in such works as *Be in Love and You Will be Happy* and *The Loss of Virginity* of late 1890 to early
1891 (see fig. 64). The finely chiseled features of the woman's masklike face are firm and deter-
mined, proud and uninhibited. The eye, in particular, glows with arrogant intensity. She is as
"self-righting" an Eve as those in the Martinique carvings and as much of an advocate of free,
sophisticated love as, say, the princesslike figure in *Reclining Tropical Eve with a Fan*.

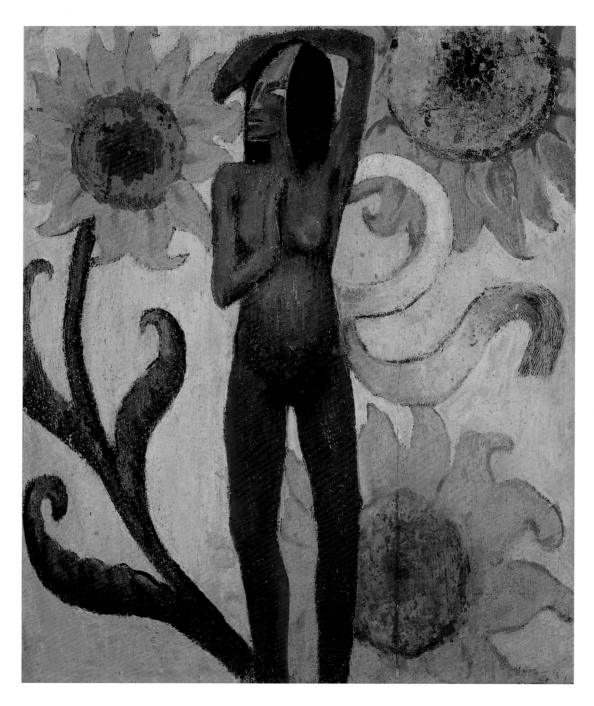

40 *Female Nude with Sunflowers*, or *Caribbean Woman*, late 1889. Oil on panel.
Private collection.

The figure's raised arm with its bent elbow is characteristic, with a few differences, of the Breton falling Eves. The hand is placed behind and above the head rather than in front of it at the level of the mouth, as if to repress a cry, and so it lacks the urgency or the drama of the Eve throwing herself into the water. The second arm, with its hand raised between her breasts, is in near-re-ciprocal relationship to the first, creating a sense of graceful rhythm. The gestures were inspired, directly or indirectly, by professional Javanese dancers that Gauguin saw in Paris at the 1889 Exposition Universelle, as well as by dancing female figures, *devatas,* from a section of the replica of the medieval Cambodian Khmer temple of Angkor-Wat erected there. They may also owe something to the friezes of the eighth-century Javanese temple of Borobudur (figs. 41–42).[94]

The gesture of the right hand with slightly bent fingers, rising between the figure's breasts, came to acquire a very specific meaning in Gauguin's work. It may well have been derived from the last standing figure from the left in *Merchant Maitrakanyaka Greeted by Nymphs* in one of the Borobudur photographs (see fig. 41, bottom). To be sure, only two of the fingers of the statue are pointed upward, but an almost identical gesture can be observed in *Lechery II.* Gauguin may well also have been inspired by similar gestures, with four fingers raised, performed by the dancers in the Javanese village, corresponding to the *kataka mukha* position of Khmer art, in which the fingers are bent forward.[95] Beginning in 1889, the gesture recurs in numerous works in Gauguin's career, such as the wood carving *Be Mysterious* of 1890 (see fig. 47), where it appears to mean something akin to "give in to your instincts, but be prudent."[96] The combination of hieraticism, controlled grace, and rhythm of the figures was an important component of Gauguin's later "tropical" style, and the sensuousness, elegance, and vibrant curlicues, undulations, and colors of these works prefigure those of the Tahitian figures.

The sunflowers themselves are more than simple decorative elements; they are likely related both to memories of Gauguin's stay with Vincent and to the two artists' shared dream of a studio in the tropics. It is significant, for instance, that the only portrait of his friend that Gauguin painted in Arles was *Van Gogh Painting Sunflowers* (1888, Rijksmuseum Vincent van Gogh, Amsterdam), and there are many indications of Gauguin's high opinion of Vincent's sunflowers.[97]

This, in turn, raises the question of whether Gauguin was aware of the various symbolist overtones that Vincent invested in his sunflowers. One such meaning may be gathered from van Gogh's later statement to the symbolist poet and critic G.-Albert Aurier when he thanked him for a most important article on his work: "[Sunflowers] convey an idea symbolizing 'gratitude.'"[98] The notion itself appears to be related to the tradition of emblem books, in which the sunflower, which allegedly turns its corolla to follow the sun as it travels across the sky, becomes a metaphor for the highest level of gratitude and reverence: divine worship. Thus, in one of the most beautifully illustrated and best-known emblem books, the image of a sunflower turning its corolla

41 Top: *The Tathagata Meets an Ajivaka Monk on the Benares Road;* bottom: *Merchant Maitrakanyaka Greeted by Nymphs*, eighth century C.E. Sandstone relief from the Temple of Borobudur, Java. Albumen photograph, ca. 1889, private collection, Tahiti.

42 Top: *The Assault of Mara;* bottom: *Scene from the Bhallatiya-Jataka*, eighth century C.E. Sandstone relief from the Temple of Borobudur, Java. Albumen photograph, ca. 1889, private collection, Tahiti.

toward the sun bears the caption "*Solis ut hunc radiantia lumina versant, dirige sic mentem Christe benigne meam*" (As the flower directs itself toward the sun pouring its radiant light, so does my mind toward gentle Christ).[99] Other emblem books' sunflower imagery includes specimens directed toward an effigy of Christ in the sky rather than the sun.

It is likely, in fact, that Vincent deliberately surrounded Gauguin with symbols of near-worshipful gratitude and admiration by placing pictures of sunflowers on his room's walls: "[It] will have on its white walls a decoration of large yellow sunflowers."[100] Vincent expressed his intention to honor Gauguin when he discussed a second decorative scheme never implemented: "the poet's garden," intended to be based on "the banal public garden [at Arles]."[101] Instead, as Gauguin recalled six years later, in his "yellow room" in Arles there were "flowers of the sun, with purple eyes, detaching themselves against a yellow background."[102] Placed in a circle around Gauguin, the sunflowers must have looked at him with attentive regard and gratitude.

Gauguin must have been struck by the sunflowers' metaphorical sight. When he wrote of their "purple eyes" he was giving a first hint of this new symbolic conception. As has already been pointed out, Gauguin owned a lithograph by Odilon Redon, *Flower-Cyclops* of 1883, in which the undulating flower's corolla is an eyeball surrounded by petal-like eyelashes.[103] Another work by Redon—the endpiece in his 1890 series of lithographs inspired by Baudelaire's *Les Fleurs du Mal*—explicitly turns the corolla of a sunflower into an eye, with the petals mutating into a disheveled set of eyelashes (see fig. 87 in chapter 7).

Finally, and most appropriately with reference to *Female Nude with Sunflowers*, these sunflowers do not refer merely to Gauguin's memories of Vincent himself, but also, and more specifically, to their shared dreams of a studio in the tropics. When they first corresponded about staying together, Vincent must have suggested organizing a studio in the north, presumably with other artists, to which Gauguin responded, "There is no question of my setting up a studio in the north, because everyday I am hoping for a sale that will pull me out of here."[104] Soon after Gauguin's arrival in Arles, however, Vincent wrote his brother: "What Gauguin tells about the tropics sounds marvelous. Surely, the future of a great renaissance in painting is there. Just ask the new Dutch friends [Isaacson and de Haan] if they have ever thought how interesting it would be if some Dutch painters were to found a colorist school in Java." And a little later, "Gauguin would certainly tell [de Haan and Isaacson]: go to Java to do impressionist work. For while Gauguin is working hard here, he is nostalgic for warm climates."[105] Gauguin, for his part, wrote Bernard a little after his arrival: "[Theo] van Gogh hopes to sell all my paintings. If I am that lucky, I shall go to Martinique. I am convinced that now I would do beautiful things. . . . I somewhat share Vincent's opinion that the future belongs to painters of the tropics, which have not yet been painted, and there is need for something new in the way of motifs for the stupid buying

public."[106] Ultimately Gauguin was to endow sunflowers with multiple associations related to his memories of van Gogh as well as to their onetime dream of founding a studio in the tropics and to the desire to proceed with the new art. Thus, during a stay at the Pension Gloanec in Pont-Aven in 1894 between his two Polynesian trips, at a time when he had obtained a promise from two like-minded fellow artists, Armand Séguin and Roderic O'Connor, to follow him there to found a studio, Gauguin had a leather folder crafted bearing their three names and intended to contain the three artists' works on paper; it was to be left behind at the pension for the benefit of future generations of artists. The portfolio was decorated with three large sunflowers and an arabesque in Gauguin's Breton mode (reminiscent of those in his design for the Leda plate); the motif is still visible, albeit very faded.[107] In this case, as in several later works, the sunflowers, aside from being a physical object—and a very decorative one at that—represent the spiritual presence of the artists and their dream of a tropical environment. In the later Polynesian period, the pistils' area develops a differently colored inner circle recalling more forcefully the iris of an eye. In *Female Nude with Sunflowers* the seeing-eye sunflowers represent the artists' tropical dream embodied in the proud and sensuous Eve, an Eve essentially free from Judeo-Christian restraints.

The falling Eve seen from the back, plunging into the water with her bent forearm raised to the level of her mouth as if to repress a scream, appears in its fully developed form in the oil *Woman in the Waves*, sometimes known as *Ondine I*, of spring 1889.[108] The title *Ondine* is in keeping with a passage culled by Gauguin and his friends from Richard Wagner's writings in a recent book—a passage that was itself inspired by Baron Friedrich de la Motte Fouqué's short story by that name about a nymph who became human under the spell of human love and returned to the waves and her prior form when the romance ended. "Woman," Wagner explained, "reaches her full individuality only at the moment that she surrenders herself; it is the Ondine who passes murmuring across the waves of her element."[109] The fall, in other words, can be fulfilling.

A carving of 1889, *Les Ondines* (*Women in the Waves*, fig. 43), shows the falling Eve plunging into the waves, this time accompanied by a new and different type of female bather. She is the Eve fulfilling her dream, here a standing figure emerging from the water at the level of the thighs, stretching her open hand to grasp the attractive, masklike face of a solemn young man emerging from the waves—a man who shows no sign of the arrogance or mischievousness of the suitors in other works. The outline of her stretched arm and hand are echoed in what appears to be a breaking semicircular wave starting between the two female figures and literally caressing the lower abdomen of the standing figure, the foam spreading in five prongs that resemble fingers toward the man's head. Her gesture and its watery echo can only be interpreted as an attempt, with the assistance of the natural order, to "get her man." This may well lead to this little Ondine gaining possession of her "full individuality," in Wagner's words.

43 *Les Ondines (Women in the Waves)*, 1889. Polychromed oak. Private collection.
Photo courtesy of Pierre Gianadda Foundation, Martigny, Switzerland. G75.

The mummylike fallen Eve and the plunging falling Eve of *Aux roches noires II (At the Black Rocks)* reappear together in several works, as in the background of the image of Gauguin's artist-friend, *Nirvana: Portrait of Jacob Meyer de Haan* of late 1889 to February 4, 1890 (fig. 44). De Haan is shown here as a seducer, carrying in his right hand a sinuous creature, part writhing serpent and part lascivious plant—once again a reminder that this once deeply religious Orthodox Jew, given to high-minded metaphysical meditation, was having an affair with his and Gauguin's innkeeper in Pouldu, Marie Henry. Amusingly, Gauguin, using the shape of the serpent as a "G," added "auguin" in letters across the hand,[110] as if to suggest that his own evil spirit was guiding de Haan's misbehavior. The latter's apparent moral slide is given a further ironic twist by Gauguin: continuing the line of the tail of the serpent/plant to the left is a scroll apparently coming loose from the artist's right forearm. It is the philactery, or *tefilin,* used in rabbinic Jewish prayer,[111] here apparently unwinding itself as if in response to divine wrath.

In keeping with the role of the seducer, de Haan has a faun's ears while his diabolically slanted eyes again signify greed and mischief. But the poor man also experiences the pangs of Judeo-Christian guilt, as reflected in his contracted facial features as well as in the yellow-orange coloring of his forehead, a premonition of the intense glow of hellfire. The word *Nirvana* in the title adds pungent irony to the message. According to a leading Theosophist of the day, it stands for "the condition of perfect rest, in which all change is eliminated; the absence of desire, illusion, and suffering; and the total abolition of what constitutes the physical man"[112]—a tranquillity hardly in keeping with the portrait's turmoil.

Indeed, far from experiencing the bliss of Nirvana, poor de Haan was obsessed with the dilemmas of love—his own. Should he ignore his high-minded principles as he subjects a young

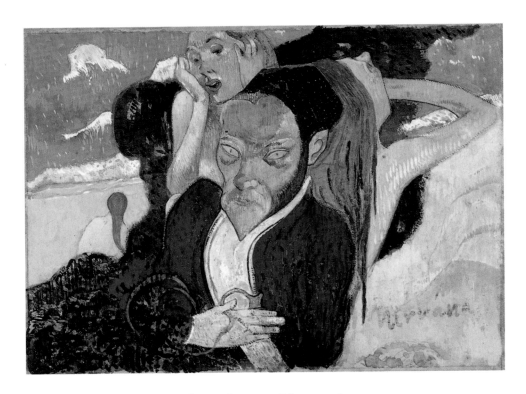

44 *Nirvana: Portrait of Jacob Meyer de Haan*, late 1889 to February 4, 1890.
Oil on canvas. Wadsworth Atheneum, Hartford, The Ella Gallup Sumner
and Mary Catlin Sumner Collection Fund.

woman, Marie Henry, to his desires, as he was then doing, thereby causing her to become a falling
Eve (as shown behind him to the right)? If he then is unwilling or unable to cherish, support,
and honor her, and make her happy, can his conscience bear to see her become a fallen Eve (as
represented behind him in the center), disgraced in the eyes of society and violating her own
religious beliefs? And assuming that he does cherish, support, honor her, and make her happy,
what if she becomes independent from him and takes another lover, or simply asserts her free-
dom from degrading amorous entanglements, thus becoming a self-righting Eve (as depicted
by the figure seen from the back, walking away on the beach, in much the same position as the
portly matron in *Two Women Bathing*)?

It so happens that Marie Henry, a successful businesswoman, was a born "self-righting" Eve.
She became pregnant with de Haan's child during the second season in Le Pouldu. After asking
her to marry him, de Haan broke the engagement under pressure from his family and returned

to Paris in early October. Gauguin, having sold pictures to the organizer of the *Les Vingt* exhibition in Brussels and to friends so that he could pay his hotel bill, returned there on November 7. De Haan and Gauguin stayed in touch in Paris; they lived in the same hotel for a while.[113] Marie Henry went on running her inn, as well as successfully raising her two girls. She eventually entered into a long-lasting union with Henry Mothéré, a man of considerable distinction and some means until, regrettably, he lost his fortune much later in life and the couple separated.[114]

Gauguin's sinners and would-be sinners are by no means exclusively associated with bathing. As with the seated young woman of the *Jardinière* the *Breton Girl Spinning* (fig. 45), completed between mid-November and December 12, 1889, as part of the decoration of Marie Henry's inn at Le Pouldu,[115] is a shepherd. The figure of the spinner was once identified as Joan of Arc,[116] presumably because of her overall prim appearance, and because the angel holding an undulating sword as he descends toward her was assumed to be one of the spirits urging Joan to lead the armies of the frivolous Charles VII against the British invaders during the Hundred Years' War. Joan led the French successfully as the "maid of Orléans," only to be taken prisoner and condemned to be burned alive by an ecclesiastical tribunal sympathetic to the English and to factions hostile to Joan within the French court.[117] Actually, the angel in the picture is based on latter-day versions of Renaissance altarpieces depicting the vengeful Archangel Gabriel in pursuit of a straying soul. The spinner's Buddhist gesture—the right hand raised vertically between her breasts, here with a definite bend of the fingers at the second joint—was inspired by Javanese and Khmer art,[118] and in that context implies surrendering to one's instincts, but with prudence, as suggested in connection with the contemporary *Female Nude with Sunflowers*. The avenging angel is meant to inspire fear among members of a primitive and strictly religious society. The girl's bleary eyes and smirking bow-shaped mouth suggest youthful debauchery, and her awkwardly twisted bare feet, her own discomfiture. The lascivious flowers of the foreground, dark, irregularly shaped, and drooping, hint at inner sorrow and guilt.

The physiognomies and attitudes of other youths, and even children, in the later Brittany works suggest that there is sin in their future and sometimes even in the present. Only a few years will pass before the subjects of *Little Breton Girls by the Sea* of 1889 (National Museum of Western Art, Tokyo) get into mischief of one sort or another—the *Little Breton Boy* of the same year (Wallraf-Richartz Museum, Cologne) seems destined, perhaps even ready, to do so. In the zincograph *Joys of Brittany* also of 1889 (fig. 46), a girl walking with grace and assurance toward a haystack is pulling by the hand another girl, a little stiff and hesitant, while two playful little dogs outside the margin evoke the power of animal instincts.

Gauguin's second major wood carving, *Be Mysterious* (fig. 47), as highly finished as *Be in Love and You Will Be Happy,* was completed at Le Pouldu in late summer 1890.[119] It gives a new

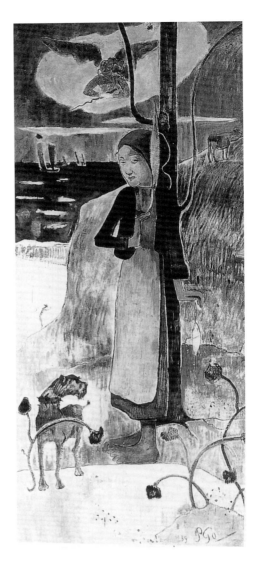

45 *Breton Girl Spinning*, or *Joan of Arc*,
mid-November to December 12, 1889.
Transferred fresco. Private collection.

twist to the theme of the plunging Eve or falling woman. Here, a possible resolution of the falling woman's predicament is adumbrated, although it is far from certain that this particular Eve is capable of taking advantage of it. The head of a young man to the upper right is once again that of a seducer. His slanted eyes—which connote cunning and diabolical instincts—and squat nose are probably intended to depict an Asiatic youth. He looks handsome, vigorous, fatuous, deceitful, and brimming with carnal desire. The circular strip around his face branches out into a lotus bud, which appropriately points toward his genitalia.

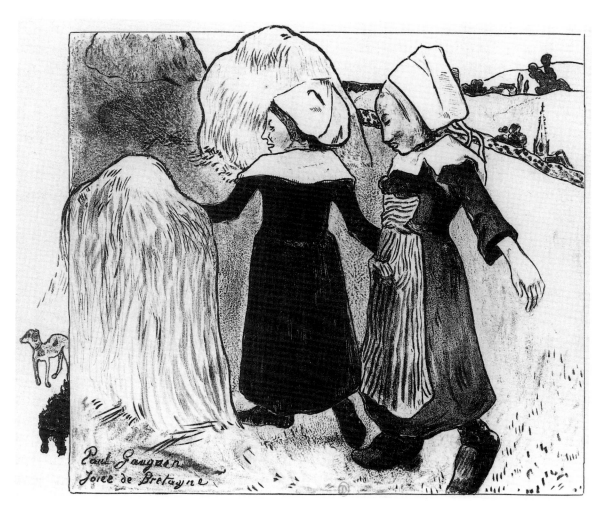

46 *Joys of Brittany*, 1889. Zincograph. Collections Jacques Doucet,
Institut national d'histoire de l'art, Paris.

The young woman plunges into the waves with eyes shut, while instinctively protecting her face with her bent elbow. She has strong limbs, a thick wrist, and relatively broad and undifferentiated fingers. Her raised face with its turned-up nose recalls Edgar Degas's little ballerinas, here somewhat porcine. Clearly this is a young peasant lacking in maturity and sophistication.

The curvature of the young woman's body is powerfully and harmoniously related to the surrounding Japanese-inspired vegetal decorations,[120] whose graceful and animated curlicues complement the lines of the waves. Her primal sexual instincts are thus associated with the ebul-

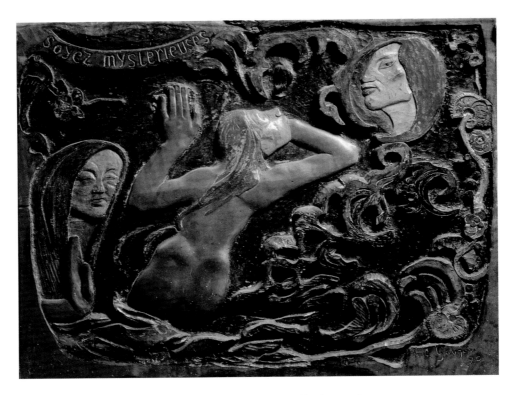

47 *Soyez mystérieuses* (*Be Mysterious*), 1890. Carved and painted linden wood.
Musée d'Orsay, Paris / Bridgeman Art Library.

lient and sensual forces of nature, here further emphasized by the undulating lotus flowers on
the right, evocative of both life force and regeneration in Hindu and Buddhist iconography. The
lower lotus flower is shown upside down, as if casting its seeds into the ground to fertilize it,
and so points to regeneration as justifying the possible disappointments and tragedies of love.
The peacock, just beneath and to the left of the beginning of the title, appropriately stands for
vanity in the symbolic language of art nouveau as well as for eternity in early Christian iconog-
raphy, thus linking the foibles of the individual to the concept of spiritual survival.

The wise-looking matron to the left, far from being an unsympathetic observer, is once again
the duenna or confidante of Renaissance and Baroque drama already observed in *Reclining Trop-
ical Eve with a Fan.* Her piercing, half-closed eyes suggest wisdom as well as an ability to read
the mind and soul of others. The eyelids' contraction reflects a touch of concern. The mouth,
sophisticated and sensuous, suggests sympathy and tolerance but also cynicism. In combination
with the expression of eyes and mouth, the Buddhistic gesture of the woman's right hand sug-

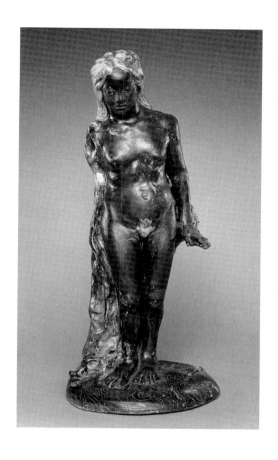

48 *Eve*, 1890. Glazed ceramic. National Gallery of Art, Washington, D.C., Ailsa Mellon Bruce Fund. Image © 2007 Board of Trustees, National Gallery of Art, Washington.

gests surrendering to one's instincts, albeit with prudence. Ultimately, Gauguin's advice to this and other reckless young women—"be mysterious"—is a call for the degree of mature self-control and sophistication necessary to keep a lover; in this case, maintaining a certain reserve will create an aura of mystery, which will, in turn, stimulate the lover's imagination—just as if he were a reader of symbolist poetry.[121] The advice complements and rebuts that of *Be in Love and You Will Be Happy,* since love, it implies, can be artfully cultivated.

Modeled with exquisite care and accuracy, the woman in the glazed ceramic statuette *Eve* of 1890 (fig. 48) is far removed from caricature (her right arm is unfortunately missing).[122] To the contrary, the figure is discreet, charming, sensuous, thoughtful, and endowed with an attractive, somewhat athletic body. The high hairline and elegantly bulbous forehead in the manner of late-quattrocento Florentine virginal maidens give her an aura of purity. The flesh is a reddish dark brown, while the contrasting "glossy yellow-white and grayish-blue glaze" creates an ivory-gold cast to the woman's ankle-length hair, which envelops the back of her body and is visible

along both sides; the effect resembles the mandorla circumscribing medieval saints. Highlights of the same glaze on her nipples, along a circular strip around her navel, and over the loosely rendered fig leaf emphasize her sexuality.

The sensitive features of her face are firm and determined; they could be those of a young man, as could her robust musculature and the ampleness of her bone structure, particularly her "square" shoulders. Her breasts, furthermore, are small and apparently taut; even her posture is unusual for a late-nineteenth-century woman: with her head and torso slightly leaning forward and her one arm firmly by her side, she has something of an athletic stance.[123] The presence of an engraved pattern of waves and lotus plants around her feet situates her at the edge of a pond and confirms her identity as a bather—a bather preparing to plunge—and, in keeping with the general premises of Gauguin's symbolism, an Eve on the verge of sinning.

The masculine elements give us reason to see in this work an echo of Gauguin's occasional musings on hermaphroditism and his associated advocacy of sexual parity for women and men. The figure's stance, in fact, echoes the advice the artist gave Emile Bernard's sister, Madeleine, a pretty, young, devout Catholic for whom he developed some affection:

> In the first place you must consider yourself androgynous, without [a specific] gender. I mean by that that the soul, the heart, all that is divine, in sum, must not be the *slave* of matter, that is, of the body. The virtues of a woman are [entirely] similar to those of a man and are Christian virtues—to have a duty toward one's fellow beings, kindness and always [self-]sacrifice. . . . When, one day, the doll has ceded to the living creature, you will have all high-minded people on your side.

As for sex: "in the natural order, both man and woman give, but in no case sell, themselves. The *whole* chain of bondage was imposed by an inferior order [of humanity] and to accept slavery in this respect is to misunderstand divine laws."[124]

Gauguin was taking a stance partly inspired by a writer whom he greatly admired: Remy de Gourmont, a member of the circle of Stéphane Mallarmé—the leading poet of the symbolist movement—and a regular contributor to that movement's leading literary advocate, the periodical *Mercure de France*. For Gourmont, once love was conceptually detached from the materialities of family life and the dictates of procreation, love became a union between spirits for whom sex was but a symbol, and of little significance in itself—albeit pleasurable and a physical necessity. Conveniently for advocates of free love, once the concept of love is detached from such constraints, sex can become a purely aesthetic experience, and libertinism is thereby raised to the level of art. Gauguin quoted, in particular, Gourmont's statement: "This furious preoccupation with sexual morality is a truly unique spectacle in the history of humanity, which ren-

ders so many gentle men and so many good-natured women dull to the point of stupidity."[125] Gauguin advanced the cause of free love in terms reminiscent of Gourmont, but he also condemned its unintended consequences, as he did when he empathized with seduced and abandoned farm girls.

Gauguin's occasional references to androgyny are directly inspired by the hero/heroine of Honoré de Balzac's Swedenborgian novella *Séraphita* of 1835. He deemed the two protagonists, male and female, symbols of spiritual freedom: "the two germs, Seraphitus, Seraphita, fecund souls constantly allying themselves, emerging from boreal vapors to learn, love, and create throughout the universe."[126] In the process they become the bearers of a message of perfect, spiritual sexuality—a major reward of the Swedenborgian heaven that the fused, hermaphroditic Seraphitus/Seraphita eventually attains.

Seen in this light, this Eve meets Gauguin's criteria for what he conceived as a free and creative woman—indeed, the ideal woman as far as he was concerned. Her independence is postulated. Childbearing is also envisioned: the lotus plants around her feet suggest the regenerating cycles of life, just as they did in *Martiniquaises* of 1887–89, *Be Mysterious* of 1890, and the *Black Venus* of 1889 (see fig. 63). And if she happens to have several masculine characteristics, that is in keeping with both the Seraphitus/Seraphita parallel and ultimately Plato's notions. It may also reflect the fact that Gauguin had himself loved and married a woman with a strongly masculine streak.[127]

It is significant, incidentally, that despite Gauguin's often expressed predilection for life in the tropics and his repeated references to tropical Eves in the work of that particular period, this nude is European and white. Indeed, while her flesh color is a dark reddish-brown, her hair appears to be blond, and her features are definitely Western—if anything, Nordic. A similarly attractive white woman will appear in diverse postures, albeit on a very small scale in, some of Gauguin's Polynesian works.

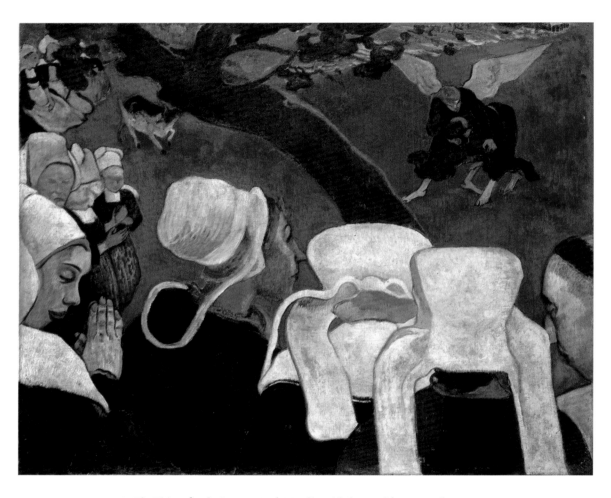

49 *The Vision after the Sermon: Jacob Wrestling with the Angel*, late September 1888.
Oil on canvas. National Gallery of Scotland, Edinburgh/Bridgeman Art Library.

The Artist as Messiah

As does our Divine Master: create.

To Emile Schuffenecker,
August 14, 1888

*T*he weeks that preceded Gauguin's departure for Arles, where he would join Vincent van Gogh, were filled with intense and highly creative activity. By September 25–27, 1888, he wrote to Vincent, describing his first picture with a religious subject, *The Vision after the Sermon: Jacob Wrestling with the Angel* (fig. 49):

> I have just completed a religious painting, very poorly executed, but it has interested me and pleases me. I wanted to give it to the church of Pont-Aven; naturally it was turned down. . . . A group of Breton women pray; [their] clothes [are] a very intense black. Their bonnets [are] a very luminous yellow white. Two bonnets at the right are like monstrous helmets. An *apple tree* divides the canvas, dark violet and the foliage drawn in masses like clouds, *emerald* green with, in the interstices, [the] yellow green of the sun. The ground is pure vermilion. . . . At the church it descends and becomes brown-red. The angel is dressed in violent ultramarine, and Jacob [in] bottle-green. The angel's wings are pure chrome-yellow [no.] 1; the angel's hair, chrome [no.] 2 and the feet flesh-orange.

In keeping with his recently evolved synthetist ideals, Gauguin emphasized the brightness and purity of several hues, which are applied fairly uniformly and delimited by continuous outlines of varying values. And to give maximum effect to the arabesque of figures and field, the horizon line is very high, in the Japanese manner.

Of primary importance is Gauguin's statement regarding the painting's expressiveness: "I believe," he wrote, "that I have attained in the figures a great rustic and *superstitious* simplicity. The whole is very severe." He went on, alluding to the distortions and simplifications: "The cow under the tree is very small in comparison to reality, and it is rearing." He added: "For me, in this picture, the landscape and the struggle exist only in the imagination of people praying in response to the sermon. This is why there is a contrast between the people, who are real, and the struggle, which is in its own landscape, one that is not real and is out of proportion."[1]

In fact, the rendering of the "real" peasants and the priest to their right does not differ stylistically from that of the "imaginary" wrestlers or even the cow. Both groups are distorted insofar as their forms are depicted in the synthetist manner, in this case with uniform, vivid colors and continuous outlines reminiscent of medieval and Japanese art. (To be specific, the implausible arabesque of the bodies and the tense and elongated limbs of the wrestlers were inspired by wrestling bouts depicted by artists of the Japanese Ukiyo-e tradition.)[2] The cow, counted by Gauguin among the "imaginary" figures, is indeed too small under the Western canon of perspective, but there is also a discrepancy in the rendering of the receding women in the foreground, who are disproportionately large in relation to those in the background.

Yet the scene does divide into two sections: the "imaginary" biblical figures and landscape versus the "real" women and priest, separated by the Ukiyo-e diagonal of the fruit tree.[3] This division corresponds to the distinction between the naked bathing sinners, wrapped in their own thoughts, and the clothed gossips, who "see" the bathers in the slightly earlier watercolor *Design for a Carved Bookcase* (fig. 28). And, in a token gesture toward the academic rule of the three unities, Gauguin has emphasized, by means of the tree, the separation between the "imaginary" and the "real" (the cow on the wrong side notwithstanding), much as he took advantage of the apple tree's foliage in the watercolor. One should add, however, that the wrestlers are at least partly derived from the observation of nature: wrestling matches of Breton boys took place in the fields on certain occasions,[4] and the peasant women, enthralled by the sermon, are merely transposing their memories of such games by imagining the "biblical" garments and the angel's wings.

The struggle between good and evil is one of the traditional interpretations of the biblical encounter between Jacob and the Angel.[5] Certainly this seems an important aspect of the meaning envisaged by Gauguin: inasmuch as he was intent on achieving a "great rustic and superstitious simplicity," and indicated that the Breton women were "still fearing Lord and Priest."[6] Indeed, this ethical interpretation of the struggle is corroborated by the fact that Gauguin offered the painting to a church.[7] Another interpretation of the struggle between Jacob and the Angel has been proposed, however. Eugène Delacroix, who had painted a large-scale version of this

theme in his Chapel of the Holy Angels at the Church of Saint-Sulpice in Paris—begun in 1849 and completed in 1861—described the action in the printed invitations to the chapel's opening; his account of the biblical episode concludes: "The Holy Scriptures consider the struggle an indication of the ordeal to which the Lord sometimes subjects his chosen ones."[8] Since Delacroix was essentially an Enlightenment skeptic in religious matters, he was undoubtedly referring to creative artists who, like himself, achieved recognition only through a life-long struggle against nearly overwhelming odds. It is not implausible, therefore, to assume that such a sentiment would have been shared by Delacroix's admirers during Gauguin's own lifetime, and that the symbol was so understood by the artist.[9]

Significantly, the priest does not appear either in the preparatory drawing that illustrated the letter to Vincent (in which Gauguin declares the painting "completed") or in another.[10] The figure must therefore have been an afterthought.[11] Furthermore, the priest's presence at the edge of the picture, almost crowded out by a peasant's bonnet, does little to alter the composition of the painting; the figure's primary contribution must be to the picture's symbolic message. Indeed, on the one hand, it tends to confirm the association between the women's vision and the spell cast by the priest during his sermon. On the other, it expands the overall meaning well beyond a merely anthropological interest in the peasants' religious attitudes, introducing the concept of the artist's ultimate reward. It has already been suggested, and confirmed, that the priest is Gauguin himself,[12] and there is an unmistakable, and deliberate, likeness: the strongly curved nose and the abrupt dip of its arch are characteristic of Gauguin's own profile. Indeed, the face is remarkably similar to that in van Gogh's *Portrait of Gauguin* executed a few weeks later.[13] As a result of this doubling of the figure's personality, just as Gauguin the village-priest is exalting at the triumph of good over evil, inspiring the peasant women to kneel and join their hands in prayer, Gauguin the creative artist alludes, with characteristic humor, to his own creation of a full-blown symbolist work in the synthetist manner—a work also capable of inspiring his public to reverence.

Thus, Gauguin the creative artist is as effective in arousing the aesthetic interest of the untutored masses as is Gauguin the village-priest in arousing their religious feelings. As if to appeal to those still steeped in very ancient popular traditions, Gauguin the artist incorporated in his synthetist style elements appropriated from traditions dating back to the Middle Ages in Europe and Asia, and ultimately to the linear economy and intense, primary colors characteristic of folk art through the ages. In this, Gauguin was suggesting that his new art would appeal to the artistic instincts of people not just within the confines of Pont-Aven, Brittany, or even France, but around the globe. Indeed, both van Gogh and Gauguin ultimately succeeded in achieving their hoped-for global victory over the Philistines. Aesthetics, then, have reached at least equal status with ethics in the symbolism of this work, and have arguably surpassed them.

The symbolist poet and critic G.-Albert Aurier lucidly and powerfully mapped out the theoretical implications of Gauguin's *Vision after the Sermon* just a little over two years after the work's completion in an article titled "Symbolism in Painting: Paul Gauguin." This was probably written following an interview with the artist and published in March 1891, just before Gauguin's departure for Tahiti, in the leading symbolist-leaning periodical, *Mercure de France*. Aurier identified the painting as a manifesto of pictorial symbolism, underlining the visionary unreality of the scene on "that fabulous vermilion hillside in that land of childish dreams where two biblical giants, whom the distant perspective transforms into pygmies, undertake a harsh, fearful combat." Pointing to Gauguin's departure from the impressionists' emphasis on the here-and-now, Aurier saw in the work evidence of a new art "that cannot be the direct representation of objects; the end purpose [being] to express ideas as it translates them into a special language." Whereas realist art "reveals to us, almost by way of a reaction, the soul of the artist, since it exposes the distortions that the object has undergone in its travel across that soul," it nevertheless has failed inasmuch as "the supreme art [is] but the material representation of what is most elevated and divine in the world . . . the idea."[14]

Aurier proceeded to outline pictorial requirements for transforming objects into "signs of ideas"—metaphors that form the basis of the symbol: "a simplification in the writing of the sign." To do so, he claimed, the artist must resort to "all the distortions of a subjective *synthesis*" (the term, with emphasis added, is Gauguin's own). Indeed, the tools at the artist's disposal are "the right to exaggerate, distort . . . (forms, lines, colors, and so forth), not only according to his individual vision, his subjectivity (as happens even in realist art), but also according to the requirements of the idea to be expressed."

Achieving these goals requires a unique genius, specifically, a "sublime gift, *the capacity for emotion* . . . a capacity for emotion so great and so precious that it causes the soul to quiver in the presence of the undulating drama of abstractions." The artist so endowed knows that "the sign . . . is nothing in itself and the idea alone is everything." His eye "can determine the evocative potential of tangible objects." He is the "tamer of the monster illusion, [who] knows how to stroll as a master in this fantastic temple." It is "a temple in which," as Aurier quoted from Charles Baudelaire's *Correspondances*, "living pillars [forming 'forests of symbols'] sometimes emit confused words"—that is, they are covered with hieroglyphs, which can be deciphered by the aesthetic initiate with "a sense of symbolic correspondences." As Aurier continued, "Thanks to this gift, symbols—that is, ideas—rise out of the darkness, become animated, start living a life that is no longer our contingent and relative life, but a life of dazzling light that is the essential life, the life of art, the life of being." In this process, Aurier implied, metaphors are produced, of which the ideas are the signified and the objects the signifiers. In addition to taking advan-

tage of musicality as a means of expression, the artist will select "a few partial symbols [i.e., metaphors] corroborating the general symbol." In conclusion, Aurier pointed to Gauguin's atavistic predisposition for such an achievement: "such is the art . . . this great genius, Paul Gauguin, endowed with the soul of a primitive being and to some extent that of a savage, has endeavored to introduce in our lamentable and putrefied nation."[15]

Noteworthy in Aurier's text is the absence of references to any intrinsic moral or religious message on the part of the artist, although he did refer, somewhat condescendingly, to peasant superstition. Aurier associated spirituality with the creation of the Idea in the Platonic sense, and he was clearly much more concerned with intellectual and artistic creation than with promoting religious practice. In this respect, he was fully in accord with Gauguin's own championing of aesthetic over ethical concerns.

Gauguin himself, in an outburst of sarcasm, stressed the primacy of aesthetics over religious ethics in a letter to Emile Schuffenecker that slightly predates the painting: "Art is an abstraction, draw [that abstraction] from nature by dreaming over it and think more about the [act of] creation than about the results. It is the only way to rise toward God—by doing as does our Divine Master: create. Since you like the small dot [of the neo-impressionists], here is some of that stuff [meaning something to the effect of 'I shall dot the i's and cross the t's for you']."[16] In a Ruskinian sense, then, both Gauguin and Aurier considered the artist's primary calling to be aesthetic rather than ethical.[17]

The same approach to artistic creativity pervades a work started within days of the completion of *The Vision:* Gauguin's *Self-Portrait (Les misérables,* fig. 50), executed between September 25–27 and October 1, 1888, and sent to Vincent in Arles, together with a self-portrait by Emile Bernard, early in October.[18] The two works were exchanged for one done for the occasion by Vincent.[19] A rectangular portion of each of Gauguin's and Bernard's self-portraits was devoted to a self-portrait by the other. The allusion to Victor Hugo in Gauguin's painting is obvious: "*Les misérables*" is inscribed just above the dedication "to [my] friend Vincent." While Gauguin depicted his own features, the figure is clearly also that of the heroic Jean Valjean, a convict with a talent for escaping his captors. Moved by an old prelate's act of exceptional charity and kindness toward him, and after a titanic inner struggle with good and evil, Valjean reinvents himself as a dedicated and energetic humanitarian.

The parallels between Gauguin's self-portrait and Hugo's description of Valjean have been convincingly established:

this mournful galley-slave, serious, silent and pensive, a pariah before the law who looked
at humanity with fury, damned by civilization, who glowered at the sky. . . . He was a man

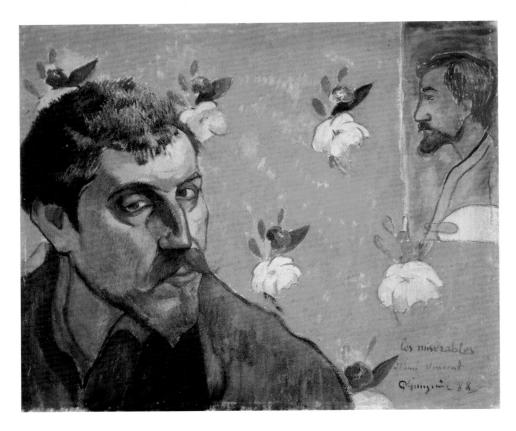

50 *Self-Portrait (Les misérables)*, September 25–27 to October 1, 1888. Oil on canvas.
Rijksmuseum Vincent van Gogh, Amsterdam / Bridgeman Art Library.

of medium height, thickset and robust, at the peak of his strength. He might have been forty-
six or forty-eight . . . his hair was close-cropped, and yet bristled, for it had begun to grow a
little and seemed not to have been cut for some time. . . . [The] sun cast a bloody glow on the
savage face of Jean Valjean. . . . The eye gleamed under his brows like a fire under the brush . . .
his pupil was wild and worried . . . this other aspect—so distressing—conferred by habitual
misery.[20]

Even before work started, Gauguin intimated that *Self-Portrait (Les misérables)* "might be done
from memory, and, in any event [would be] an abstraction," as was the case in *The Vision after
the Sermon*.[21] Gauguin diverged from Vincent's expressed intention in his own *Self-Portrait* of-
fered in exchange. Vincent strove for a sense of superior wisdom and quiet mysticism: "exag-
gerating my personality, I pursued . . . the character of a *bonze* [Buddhist monk], a simple wor-

shipper of the eternal Buddha."[22] He undoubtedly had in mind something like the account of Buddhist worship disseminated at the time by the scholar Emile Burnouf:

Buddhist officiants are not, strictly speaking, priests. Much as there is no personal god, there is no holy sacrifice, no intermediary. This Buddha is not a god one implores; he was a man who had reached the highest degree of wisdom and virtue. . . . The Buddhist does not pray; he meditates over the grave of the master, deposits there a few flowers. Such is the Buddhist cult in all its simplicity.

According to Burnouf, Buddha himself, aside from five basic commandments—"not to kill, nor to steal, nor to commit or conceive adultery, nor to lie, nor to drink intoxicating liquors"— preached "the pursuit of truth; charity toward all, even one's enemies; the secret practice of good deeds; purity in action, word, and thought; visiting the sick; the payment of prisoners' ransoms; teaching."[23] Such a combination of qualities accorded with the serene spirituality, as well as the gentle abnegation and, more broadly, the love of humanity, that sometimes transcended the energy of Vincent van Gogh's vision.

Gauguin's goal, while idealistic, had much more to do with the plight of the avant-garde artist and his personal aspirations. In a letter to Vincent mentioning the completed picture, Gauguin explained: "The mask of a bandit, ill-clad and powerful like Jean Valjean, who has an internal nobility and sweetness. . . . And this Jean Valjean, whom society oppresses, is he not also the image of an impressionist of today? And [because] I gave him my features you have my personal image as well as the portrait of us all, victims of society [who] avenge ourselves by doing good."[24] Vincent approved: "Your conception of the impressionist in general, of which your portrait is a symbol, is striking."[25]

The same emphasis on Gauguin's aesthetic concerns in this painting also emerges in a letter to Schuffenecker of October 8, in which Gauguin describes his intentions and addresses the symbolist significance of various items in the picture. It culminates with a resounding gibe at what he viewed as the high-temple of Philistinism: the French fine arts establishment and its bastion, the Ecole Nationale des Beaux-Arts:

I believe it is one of my best things. Absolutely incomprehensible (among other things) because it is so abstract. The head of a bandit on first impression. A Jean Valjean (*Les misérables*) also personifying an impressionist painter [as Vincent and he still called themselves]; [one] in disrepute and always wearing a chain [in the eyes of] everybody. The drawing is quite special (total abstraction). The eyes, the mouth, the nose are like the flowers of a Persian carpet—also embodying the symbolist side. The color is one sufficiently distant from nature; imagine a vague

memory of my pots twisted in an intense fire [*grand feu*].[26] All the reds, the violets shot through with bursts of fire like a furnace radiating about the eyes—seat of the struggles of painter's thought—the whole [set against] a background of pure chrome strewn with childlike bouquets. The room of a pure maiden.

The impressionist is a pure soul, not yet soiled by the putrid kiss of the Beaux-Arts (the School).[27]

Gauguin, then, in contrast to Vincent, intended a symbolic gesture, and a somewhat ironic one at that, purporting to "avenge" the sins of a Philistine society through the beneficent impact of his new aesthetics. Once again religious and ethical considerations were preempted by aesthetic ones. Yet Gauguin showed a new insistence on expressing emotion during and after his stay with Vincent in Arles during the last weeks of 1888, and his work took on a definite humanitarian turn. According to a student of both artists, henceforth "the altruism of Vincent, the mysticism of Swedenborg popularized by Balzac"—in his *Séraphîta*, which Gauguin had read that fall—"ally themselves to the humanitarian and deistic eloquence of Victor Hugo. It is not solely in his art that he opens himself to mystery. In the measure that there is one, it is that of our presence and our suffering in an unintelligible world. Religion offers a response that the artist hereafter considers in a new light. He does not become converted, but a new breath of spirituality affects him."[28] (One might add that there is a genuine allusion to Christian mercy in a number of Tahitian works evoking the Nativity and other events.) Even Vincent van Gogh blurred the distinction between ethics and aesthetics when he compared the vocation of anyone promoting the highest principles of art with a Ruskinian apostolate: "You will become one, absolutely, with Gauguin and his following," he wrote Theo when they were trying to entice Gauguin to Arles. "In doing so you will become one of the first or even the first merchant-apostle. For my part, I also see my painting progressing and equally my work on behalf of artists. Because you will endeavor to bring money, [and] I will push for production with everything within my reach, and I would myself serve as an example. All this, if we stand firm, to create something more enduring than ourselves."[29]

From the standpoint of style and related symbolist effects, the *grand feu* mentioned in Gauguin's letter to Schuffenecker is suggested by the warm glow emanating from the highlighted areas of the artist's face and neck, here intended as a metaphor for the inner struggle that he linked to creativity. Gauguin uses a symbolist device to which he will also resort in later works: the visual allusion to a material or a technique in order to convey a state of the soul—here the intense heat of a kiln to reflect his anger and frustration toward the artistic establishment, as well as his passion to create. This type of expressiveness far exceeds the concept of "musicality"—

the harmonious and expressive properties of combinations of colors and lines—for it relies on the subconscious impact of specific objects or processes, already adumbrated in the letter to Schuffenecker of January 14, 1885.[30]

But then musicality also plays a role. The vermilion component of the flesh and the warm yellow of the background—no doubt reflected from the imaginary furnace—suggest excitement and exhilaration. Other aspects of the handling of color are in keeping with the precepts of the color theorist Charles Henry; the blue-green of the facial shadows and the coat is the complement to vermilion (according to Wilhelm von Helmholtz's color circle), enhancing, by contrast, the fiery hues. Furthermore, the upward V of the warm area of the face is energetic and uplifting, reflecting the excitement of struggle and creation, while the downward slope of the shoulders, no less than the green cast of the shadows on the side of the face, conveys Gauguin's depression in response to hardships and disappointments.

Gauguin was most effective in this last respect—at least as far as Vincent was concerned: "It gives, above all, the impression of a prisoner," he wrote to his brother. "Not a trace of gaiety. It is not in the least [human] flesh, but one may gamely attribute this to his eagerness to do something melancholy: the flesh in shadows is lugubriously turned into blue. . . . He must not continue like this; he must console himself; he must become once again the richer Gauguin of the [Martinique] Negresses. . . . He seems to be sick, in his portrait, and tortured!! Wait, this won't last, and it will be very interesting to compare this portrait with the one he will make of himself in six months' time."[31]

The allusion to the hieratic quality of ancient Near Eastern art in Gauguin's letter to Schuffenecker is the earliest such reference documented in the artist's career. A comment made by Vincent just after receiving the painting suggests the importance of this relatively new source:

> As for what Gauguin says about the Persian [tradition], it is true. I do not think that placed in the Dieulafoy Gallery [of ancient Mesopotamian art] in the Louvre [*Self-Portrait (Les misérables)*] would shock; one could even place it there without any ill-effect. But, but, but, I do not belong myself to high society, nor even to this world . . . and I prefer the Greeks and the Japanese to the Persians and the Egyptians; for all that, I do not blame Gauguin for working in the Persian manner. But I must get used to it.[32]

This hieratic quality, which was reinforced by Javanese and Khmer art, had a profound effect on Gauguin's whole output and to some extent accounts for the sense of suspended motion and the aura of detachment characteristic of his major compositions throughout his career, much as it facilitated his decorative endeavors.

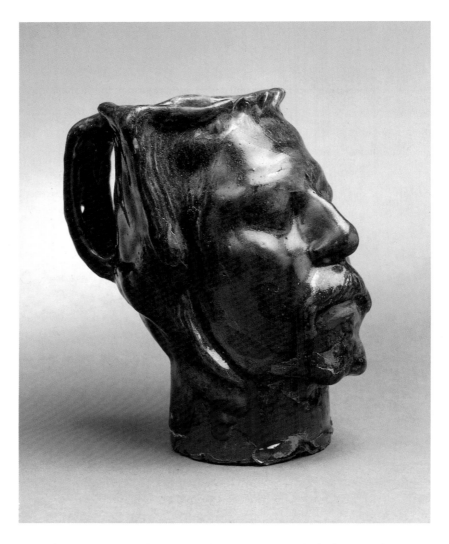

51 *Self-Portrait Jug*, probably 1889. Glazed stoneware, unsigned, Chaplet's workshop. Museum of Decorative Art, Copenhagen (Museum No. 962). Photo: Pernille Klemp.

*T*he Gauguin/Jean Valjean struggle was taken up again in imagery derived from the life of Christ. As if to illustrate this point, Gauguin exclaimed in a letter to Vincent van Gogh, "What a long calvary an artist's life is!"[33] In his *Self-Portrait Jug* (fig. 51), in all likelihood executed in Paris after his sojourn in Arles, early in 1889, the artist's head becomes that of the Messiah on the way to Mount Calvary. It is a most moving work. The cuts in the upper rim suggest the crown

of thorns, from which *sang-de-bœuf* blood was allowed to drip down along the brown and olive glaze of the skin, slowly meandering on and around the features until it dried before reaching the bottom of the vase (in the Japanese manner). The closed eyes and proud lips convey a sense of noble resignation, but also of sadness—the calm expression suggesting the sublimation of suffering through quiet meditation.

Two details are relevant to Gauguin's aesthetic attitudes and principles. The ears are not visible, implying isolation from the jeering and heckling of the Jerusalem mob—metaphorically speaking, the unworthy critics, colleagues, and the indifferent public. The closed eyes, furthermore, evince a state of Buddhist transcendence over the ignominies of everyday life, thus paving the way for the self-absorbed gaze and serenity propitious to inner vision and artistic creativity. Moreover, as if to attest that for the chosen few art can imitate nature, the vase in *Still Life with Japanese Print* of 1889 (Tehran Museum of Contemporary Art) is shown containing flowers, which represent the artistic expression of such inner vision.[34]

The landscape surrounding the Crucifixion in *The Yellow Christ* of September 1889 (fig. 52) is warm and cheerful.[35] The colors, while restrained, have the brightness of folk art and toys. The suggestion of pastoral delight is heightened by a flirtatious note: a young sailor stepping over a low stone wall in pursuit, no doubt, of two girls walking toward a hamlet; love and temptation are ever-present.

Here, too, the women in the field are having a vision: the crucifix is a mildly stylized version of a Baroque folk-art example in painted wood in the Church of Tremalo near Pont-Aven (fig. 53),[36] which Gauguin had already sketched in simplified form, while respecting the overall linear configuration (fig. 54). The figure of the painted sculpture itself, lean, taut, and somewhat desiccated, topped by a pensive, dolorous, compassionate head, is in keeping with late Renaissance prototypes, treated with the solemn naiveté of a provincial artist. In his painting as well as in his drawing, Gauguin has accentuated the resignation and the pathos of the original, as if in a gesture of obeisance to traditional devotional imagery. But he is also a caricaturist documenting the mores of a primitive people, as is evinced by the simple, jaunty, almost toylike style, reminiscent of some of his Brittany watercolor fantasies.[37] Beyond caricature, on the personal level, Gauguin must have conceived the dying Messiah as alluding, with perhaps a touch of self-pity, to his own painful struggle for a higher cause in contrast to the charm of the landscape and the idyllic aspects of Breton life around him.

The drawing also displays a lively sketch of a little rat at the lower left. It is the same rat that appears in the upper-left corner of the 1889 wood carving *Be in Love and You Will Be Happy* (fig. 37), where it symbolizes the corruption and decay of Western society during Gauguin's time, in "the rotten city of Babylon."[38]

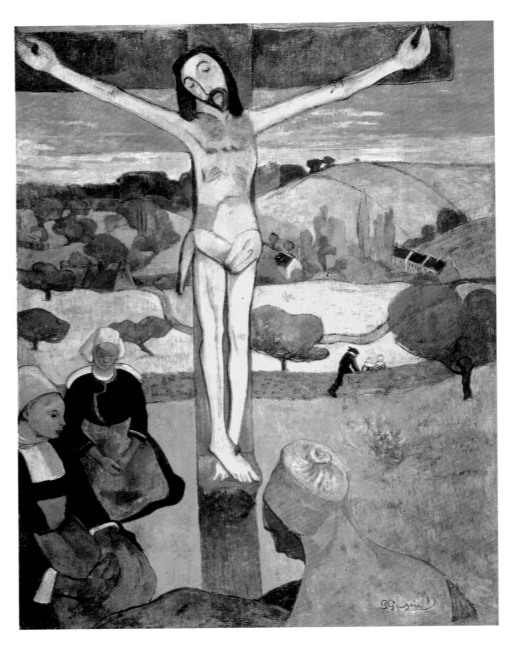

52 *The Yellow Christ*, 1889. Oil on canvas. Albright-Knox Art Gallery,
Buffalo, NY/Bridgeman Art Library.

53 Crucifix, Church of Tremalo, seventeenth century.

54 Sketch for *The Yellow Christ*, 1889. Pencil on yellow paper mounted on board. Private collection/Christie's Images/Bridgeman Art Library.

*S*elf-Portrait with Halo (fig. 55), executed sometime between mid-November and December 12, 1889,[39] was once paired with the *Portrait of Jacob Meyer de Haan* (fig. 14) in the dining room of Marie Henry's inn at Le Pouldu. The overall design is executed in the boldest and simplest synthetist manner. Except for the lines of the face, which are carefully and forcefully detailed, the strokes consist mostly of simple, definite, almost geometric curves. The hues are nearly pure: orange-red, green, yellow, and touches of blue glaze over some flesh areas, creating purple overtones. Charles Henry would have termed the orange-red that dominates the background an "uplifting" hue. By the same principle, the stem bearing the apples, which appears to ascend to the right above the pair of apples, suggests a literally uplifting movement. An element of dynamism is introduced by the rising streamlining of the back of the hair, which seems to propel the head forward.[40] Finally, there is a graceful interplay between the lascivious curves of the flowers and the sweep of the shoulder lines.

From the standpoint of portraiture, the simple, subtle, and powerful caricatural drawing of the face provides a masterly psychological characterization—especially for those familiar with the artist's temperament. There is sensuousness in the undulation of the brows, the leering eyes, and the fleshy lips. There is an aggressive determination in the swift and precise rendering of the powerful arching of brows, nose, and hair and mustache, as well as in the lines beneath the eyes. And there are touches of irony and cynicism in the twist of the mouth. The overall animation of the features, furthermore, reflects the artist's mental agility and wit. It is the effigy of a sensuous—to be sure—but also a subtle, thoughtful, and witty man, someone given to profound reflection, self-assured, decisive, and forceful—a born leader.

In its iconography, the work is a fitting pendant to the portrait of Jacob Meyer de Haan (fig. 14), whose diabolical slanted eyes and hornlike red hair jutting out from under his cap are echoed in the undulating little serpent that Gauguin grasps in his hand. There is also a connection with *Nirvana: Portrait of Jacob Meyer de Haan* (fig. 44), in which both the serpent of *Self-Portrait with Halo* and the work's sensuous floral display are joined in the half-serpent, half–calla lily, writhing creature that de Haan is holding. There are telling differences, however. Whereas de Haan is depicted as a sinner wracked by guilt and concerned about difficult choices he is facing, Gauguin appears confident that he can reconcile his aspiration to sanctity (the halo) with the call of the forbidden apple—as well, of course, as the suggestiveness of the lascivious flowers and the counsel of the animated little serpent aggressively extending its tongue toward any Eve who might come his way.

But then, quite possibly inspired by Vincent van Gogh's 1888 self-portrait as a *bonze*, Gauguin wrapped himself in an ample saffron mantle—saffron being one of the traditional colors worn by some schools of Buddhist monks.[41] The mantle is demarcated at the top by curves that

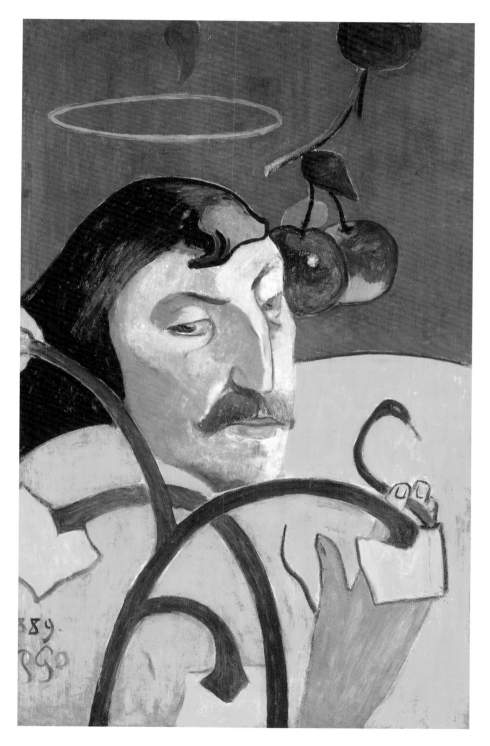

55 *Self-Portrait with Halo,* mid-November to December 12, 1889. Oil on oak. Chester Dale
Collection, National Gallery of Art, Washington, D.C. Image © 2007 Board of Trustees,
National Gallery of Art, Washington. Photographed by Richard Carafelli.

exaggerate the musculature of the shoulders, then sweep down to envelop the chest. The neckline is continued by the curvature of one of the lascivious calla lily stems, which in turn becomes the overlapping mantle's hem.

Is this attribute of Buddhism intended to help the artist transcend some of the stringencies of the Judeo-Christian tradition with regard to the act of love—the Buddhist monk being independent of any organized religious system (his vow of celibacy notwithstanding)? Or, from a much more contemporary perspective, does the work suggest an existential presumption: that, taken literally, the traditional dilemmas of good and evil may verge on the absurd and must be subordinated to one's personal dedication to a great cause, or "engagement"? Artistic creation, for instance?

*E*xecuted mostly at Le Pouldu, *Christ in the Garden of Olives* of June to November 1889 (fig. 56) was started in Pont-Aven, as indicated in a letter from Gauguin to Schuffenecker dated June 10, 1889, which also reveals the painting's intended mood: "I have started a ~~Christ~~ Jesus in the Garden of Olives, which will be fine, I believe. [Charles] Laval and de Haan, the Dutchman, are highly enthusiastic about it. It is marked by abstract sadness, and sadness is my hobby horse [*ma corde*], you know."[42] Gauguin must have set the work aside for months, for he referred to it as if it had just been completed in a letter of around November 8, 1889, to Vincent van Gogh, written at Le Pouldu: "Crepuscular blue-green sky, trees, all bending to form purple masses. Violet ground and Christ wrapped in a somber ochre cloak has vermilion hair. This canvas is not destined to be understood, I shall keep it for a long time. Herewith this drawing, which will give you a vague idea of it."[43] He added on a visiting card intended for Albert Aurier: "*Christ* Special suffering from betrayal and of the heart applicable to Jesus today and tomorrow. Little explanatory group. The whole *somber* harmony, *somber* colors and red—supernatural." A detail of some significance: "Little explanatory group," written alongside the sketch rather than in the principal text, undoubtedly refers to the disciples walking away from Christ to find a resting place, so justifying Gauguin's reference to "treason."[44] Much later, in the course of an interview with the journalist Jules Huret, Gauguin enlarged on both his state of mind at the time of the painting's composition and the disciples' defection: "It is my portrait that I put down on the canvas. . . . But this is also intended to represent the collapse of an ideal, a pain as divine as it is human. Jesus entirely abandoned, his disciples leaving him [a point Gauguin misunderstood], in a setting as distraught as his soul."[45]

By November 1889 Gauguin was particularly bitter and depressed, as attested by several works dating to that period.[46] When the Volpini exhibition opened six months earlier, not only did he

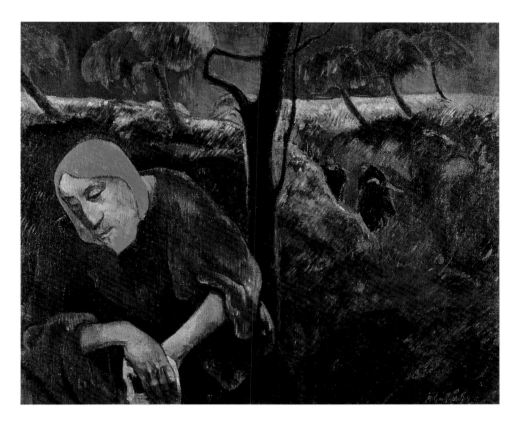

56 *Christ in the Garden of Olives*, June–November 1889. Oil on canvas.
Norton Gallery, Palm Beach, Florida / Bridgeman Art Library.

fail to sell any work at the exhibition, he must also have felt betrayed by his friends and sup-
porters (particularly the impressionists). Indeed, the division between the senior impressionists
and Gauguin and his protégés was becoming increasingly evident. Theo van Gogh, who had
originally agreed to lend several of his brother's works, changed his mind because of the truc-
ulence of some of the organizers (he described them as *casseurs d'assiettes* ("plate breakers").[47]
Theo's words must have been reported to Gauguin: "Yes, there was a little truculence, but had
I been there everything would have been done more simply . . . what I was aiming for was to
show Pissarro and the others that I can act without them."[48] Not surprisingly, he continued, "Pis-
sarro and others are not pleased with my exhibition; it is therefore a good thing for me." A lit-
tle earlier he had hinted at the "betrayal" of his brethren by a senior impressionist: "Claude Monet
exhibits at [the gallery of Georges] Petit with foreigners."[49]

Gauguin attributed his financial distress to the indifference or hostility of longtime support-

ers: "Degas . . . especially with respect to [Theo] van Gogh is the author of all this debacle. . . . Degas is getting old and is angry about not having found the last word [in art]."[50] And, with additional complaints specifically referring to *Christ in the Garden of Olives* in a letter to Bernard: "I will keep this canvas. No need to send it to [Theo] van Gogh; it would be [even] less understood than the rest. I am tired. I have just written [Theo] a sixteen-page letter about all this tempest, the cause of which I now perceive: Our [Volpini] exhibition, yours and mine, has provoked a few storms. I pointed this out to [Theo], explaining to him what we both wanted, what we want to achieve in our work, etc. I told him frankly that he was wrong to listen to Degas and everyone, that he had to arrive at his own personal judgment."[51] Theo, it appears, had been swayed by a letter from Vincent in which he objected to religious paintings on the grounds that they are drawn from the imagination rather than from nature.[52]

In addition, and undoubtedly partly as a result of the situation, Gauguin was very depressed. "Your distressed letter finds me in equally sad territory," he wrote Bernard. "From the efforts I made this year, all that remains are howls coming from Paris. . . . [They] discourage me to the point that I no longer dare paint and I drag my old body along the shores, swept by the north wind, of Le Pouldu. Instinctively, I paint a few studies (if one can call studies brushstrokes in tune with the eye). But the soul is absent; it sadly contemplates the gaping hole in front of it— a hole in which I see [my] family in distress, deprived of a father's support, and without a heart into which I can pour my pain. Since January my total sales have amounted to 942 francs. At age 42, to [have to] live on that, to buy colors, etc. . . . that is enough to upset the work of the staunchest soul."[53]

Thoughts of death kept recurring in Gauguin's letters of the time. Barely a year earlier— and his situation had only worsened—he had confided to Vincent: "Finally, I do not want— inasmuch as this is possible—to think of the promised fruit. [I must] wait for better days unless I am rid of this awful existence, which outside my work weighs on me horribly."[54] An even more ominous hint appeared in the letter to Bernard: "When facing such obstacles in my attempt to live (even miserably) I don't know what course to take."[55]

Gauguin's depression and his identification with the suffering and betrayed Christ are evident in *Christ in the Garden of Olives*. He emphasized the painting's overall pictorial richness by means of powerful multihued effects that stand out in the fairly somber surrounding. The hair is in fact a flaming orange, rather than the "vermilion" that the artist described; and the figure's monkish robe would indeed be "somber" and "ochre" were it not for the striations of orange and Prussian blue occasioned by the multihued luminosities of the storm. The flesh is also enlivened by the vibrant contrasts of orange and Prussian blue, as are the subject's forearms, and particularly his finely articulated, sensitive right hand and wrist. The hands are crossed, recall-

ing those of Eugène Delacroix's *Ecce Homo* of 1830–33, which must have inspired Gauguin.[56] The link with Delacroix, incidentally, accounts for the use of both that master's bold and suggestive striations and his fluid, and equally expressive, linear distortions—as opposed to the more definite and rigid ones of synthetism. The darkling ambience, with its eerie and dramatic luminosities, is also characteristic of some of Delacroix's High Romantic creations.

Christ/Gauguin is stooping. The figure's head, elongated and bearded, reveals almost caricaturally the characteristic recessed bridge of Gauguin's nose and his heavy eyelids. There is dolorous resignation in the downcast, half-closed eyes and the lifeless mouth. The limp, emaciated hands, not at all what one would expect of a former sailor (like Gauguin), are rendered particularly pathetic by the protruding wristbone and knuckles, adding to the overall mournfulness. The spirit of the portrait is in keeping with the image of *The Yellow Christ* in that the subject's meekness and submissiveness, excessive for someone as strong as Gauguin, recall traditional devotional imagery. The work may not reflect Gauguin's usually vigorous, even boisterous, temperament, but it does convey the daze and aimlessness of defeat, and perhaps also a touch of self-pity.

Vincent van Gogh's disappointment in Gauguin's painting must have derived in part from his own reluctance to paint religious subjects.[57] On receiving the drawing of the painting and the description that Gauguin had sent him around November 8, Vincent, in a letter to Theo, raised strong objections to the work as well as to one of the same subject by Bernard seen in a photograph: "I have worked this month in olive groves, because they infuriated me with their Christs in the Garden in which nothing is observed. Of course, as far as I am concerned, there is no question of doing something from the Bible, and I have written Bernard and also Gauguin that I believed it was our duty to think, not to dream, and that I was therefore surprised . . . that they let themselves go that way." Jean-François Millet, for all the biblical overtones of his peasant paintings, was another story: "One should work so that everyone can have at his home pictures or reproductions that might serve as lessons, like the work of Millet."[58] Millet's "lessons," however, were based strictly on figures and objects that he had observed.

This desire to draw the symbol from life itself was a hallmark of the Romantic naturalism of the Barbizon school and very much in keeping with the sentiments of one of their sympathetic critics and onetime mentor: Théophile Thoré. Concerning Delacroix's *Liberty Leading the People* of 1830 (fig. 57), Thoré had written: "It is, if one likes, liberty embodied in a young woman. . . . Real allegory should have this character, all at once a living type and a symbol, as opposed to these old pagan allegories, which are nothing but hollow shells."[59] He was echoing Georg Wilhelm Friedrich Hegel's pronouncement in his *Aesthetik:* "But what must be taken into account in [the context of poetry] is a natural phenomenon, an occurrence, containing a particular relation or an issue, which can be taken as a symbol for universal meaning from the sphere of hu-

57 Eugène Delacroix, *Liberty Leading the People*, 1830. Oil on canvas.
Musée du Louvre, Paris/Bridgeman Art Library.

man activity and doings, for an ethical doctrine, for a prudential maxim."[60] This turned out to
be the credo not only of Millet and the other Barbizon Romantic-naturalist painters, but also of
the social reformers in Romantic literature, from George Sand to Jules Michelet to Victor Hugo,
to mention but a few luminaries.

Aware of Vincent's objections to *Christ in the Garden of Olives*, Gauguin wrote him some
twelve days after sending him the sketch: "Now let's talk about religious paintings. I have painted
only one this year, and [I believe] it a good thing to undertake trials of all kinds so as to exercise
one's imaginative strengths, and one sees nature again with pleasure."[61] Gauguin would nonethe-
less continue to draw symbols from scriptural texts and even from the workings of the imagi-
nation. Indeed, he was to create an imaginative visualization of Polynesian religions on the ba-
sis of his readings, drawing on stylistic appropriations of Asiatic and Polynesian artifacts, as
well as his observations of life in Tahiti and the Marquesas.

Breton Calvary: The Green Christ (fig. 58) was also painted in Le Pouldu, a little before November 20 or 21, 1889.[62] The sculptural group of Christ and the Holy Women is based on the figures of the late medieval sandstone calvary (fig. 59) in the cemetery of Nizon, near Pont-Aven,[63] of which Gauguin must have owned a sketch or a photograph. Gauguin's painting omits two of the three rising columns—the remaining central one being the foot of the cross. His basic intentions were conveyed to Aurier on the back of a visiting card: "*Calvary—cold* stone from the ground—the Breton idea of the sculptor who explains religion through his Breton *soul*, Breton clothes, Breton local color . . . passive sheep. . . . The lot in a Breton landscape, *that is, Breton poetry*. Its starting point (*color*) brings the surroundings in harmony—sky, etc.—sad in execution. In contrast, the human figure represents *poverty*—the stream of life."[64]

The artist is more explicit in a letter to Theo van Gogh: "The hill is guarded by a string of cows disposed as mourners would be in a calvary. I have tried in this painting to make everything breathe belief, passive faith, suffering, primitive religious style, and great nature with its scream. I am wrong not to be strong enough to express it better—but I am not wrong to *think it*. And all this, poor devils that we are, without a home, without models, we resemble *virtuosi* playing a decrepit piano."[65]

Cold stone extracted from the ground, Breton clothes, Breton local color, and Breton landscape—all allude to the material aspects of the work, evoking the mood of the scene and of the living figure sitting at the foot of the monument. Gauguin is once again the innate anthropologist. He is also opening up his heart, the scream of nature echoing the dolorous note of his lament. The picture is in keeping with one of his goals in Brittany: "I love Brittany: I find there the savage, the primitive. When my clogs resonate on this granite ground, I hear the muffled, matte, and powerful tone I look for in my painting."[66]

Much care has gone into the figures' expressions. Drawn in a simplified, almost caricatural, style, the Holy Women, like hardened old villagers, are blandly repressing any emotion; the Virgin looks slightly dazed. The hand of Christ, "stonily" inert, is stretched out, as if to show his wound. The solitary worshiper seated beneath the sculpture seems physically overwhelmed by it. She has the vacuous expression of someone doing a mindless daily task, holding the tether of a black lamb—a sacrificial lamb, no doubt, traditionally symbolic of Christ's martyrdom.

The figures—stone and flesh—and the landscape are masterfully interlinked. The quarter arc formed by the body of Christ (a "depressing" line, according to Charles Henry) connects the russet of the opening onto the ocean with the black sacrificial lamb. The landscape itself contributes a tragic note. Above the ominous somber blue of the ocean with its glaucous luminescent patches, the clouds spread out, purplish pink where the light of the sunset penetrates them—as in the area above the ship—and laced with blue-gray striations in the two massive clouds above.

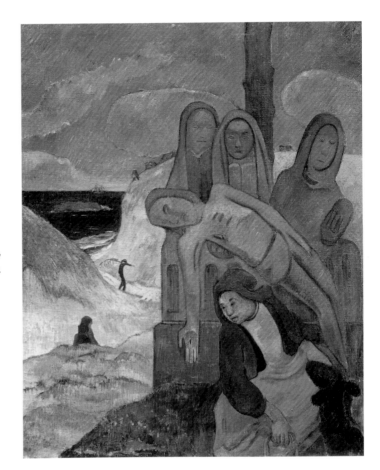

58 *Breton Calvary: The Green Christ*, by November 20 or 21, 1889. Oil on canvas. Musées Royaux des Beaux-Arts de Belgique, Brussels/Giraudon/Bridgeman Art Library.

59 Detail of calvary in Nizon cemetery, near Pont-Aven, sixteenth century (?). Sandstone.

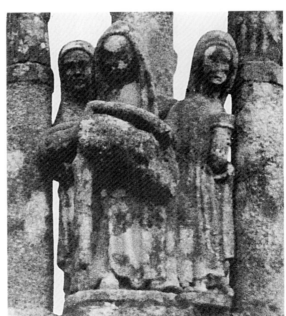

The oval clouds flanking the foot of the cross recall the sun and the moon shown at a standstill on each side of the Crucifixion in medieval illuminations. Gauguin used similar devices in *Bonjour Monsieur Gauguin*, also dating to the autumn of 1889 (see fig. 65).

*B*efore we turn to *Self-Portrait with the Yellow Christ* of late 1889 or early 1890 (fig. 62), we need to analyze the symbolism of the glazed earthenware *Self-Portrait in the Form of a Grotesque Head* (fig. 60), which is represented in the painting. The ceramic was executed early in 1889, when Gauguin was staying at the Schuffeneckers,[67] and it was presented to Emile with the dedication: "The reality of a dream—to the idealist Schuffenecker. Souvenir of Paul Gauguin."[68] Gauguin seems to have given considerable thought to the work later that year. Turning gallant, and forgetting that he had already offered it as a gift, he wrote Madeleine Bernard: "I would like to please you and sign our contract of friendship. Ask Emile to take from Schuffenecker's a large pot he saw me make, it vaguely represents a head of Gauguin the savage, and accept it from me as a modest homage of gratitude for the pleasure your letter gave me in the solitude of Le Pouldu."[69] And to Emile Bernard, a few days later: "Between you and me, I did it a little bit intentionally to challenge in this way [Madeleine's] admiration in such matters, but I also wanted to give her one of my best things even though not entirely successful (as far as firing goes). You know that for a long time . . . I have been seeing the character of each material. Well, the character of stoneware is the feeling of *grand feu* [high-temperature firing]. Carbonized in this hell, this figure expresses, I believe, this character rather strongly. As would an artist glimpsed by Dante during his visit in hell. Poor devil hunched over to bear the suffering. Be that as it may, we can only offer as much as our nature will let us [*la plus belle fille du monde ne peut donner que ce qu'elle a*]."[70] And again to Bernard, in a state of great distress when Gauguin was about to leave Le Pouldu for Paris: "In the end this isolation . . . screams with hunger . . . like an empty stomach; in the end this isolation is a trap, as far as happiness is concerned, unless one is made of ice, totally insensitive. Despite all my efforts to become just that, I am not; [my] original nature comes back ceaselessly. Just like the Gauguin of the pot, [his] hand snuffing in the furnace the scream that wants to escape."[71]

In sum, the pot is intended to convey, not only the harshness of Gauguin's own fate, but also, with some pride on his part, his ability to survive such an ordeal by fire, and presumably to be strengthened by it.[72] Gauguin would rather be made of ice, but his temperament stands in the way. As he himself described in connection with *Schuffenecker's Family* (fig. 12), executed earlier that year, Gauguin conceived himself as a "man of fire."[73] What is more, he claimed the mug to be "the reality of a dream"; despite all his efforts to quell it, the fire persists, much as his "orig-

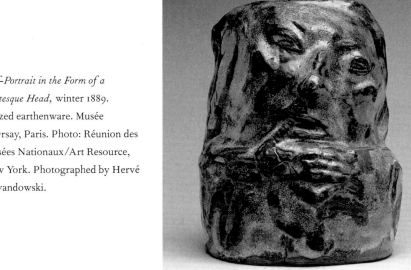

60 *Self-Portrait in the Form of a Grotesque Head*, winter 1889. Glazed earthenware. Musée d'Orsay, Paris. Photo: Réunion des Musées Nationaux/Art Resource, New York. Photographed by Hervé Lewandowski.

inal nature comes back." No false pretenses here: Gauguin conceived himself as being in Dante's hell, together with the worst dregs of medieval Florentine society. In fact, it has convincingly been pointed out that the strikingly ugly and disturbing distortions of the facial features in the self-portrait mug were inspired by a misshapen Hellenistic terra-cotta human mask from Asia Minor at the Louvre, which Gauguin might have known from a contemporary book on human physical deformities and illnesses in art.[74] Gauguin in effect presented Madeleine Bernard with an image of himself as a monster—accompanied by a good deal of sarcasm as well as self-deprecation—under the pretense of testing her aesthetic discrimination. Not surprisingly he added as a postscript to his letter of late November to Bernard: "For Madeleine all my apologies for the roughness of her pot."

Gauguin's reference to his hand "snuffing in the furnace the scream that wants to escape" is purely a figure of speech. In the pot the hand does not even cover the aperture of the mouth. Gauguin is referring not to a physical scream but to deep inner turmoil, something resembling the "human cry" referred to in the last chapter.[75] Accordingly, the gesture of the hand, placed at the level of the chin and pressing against it, can only be interpreted as an emblem of intellectual concentration; indeed, only through serious and disciplined thought can one control, and some-

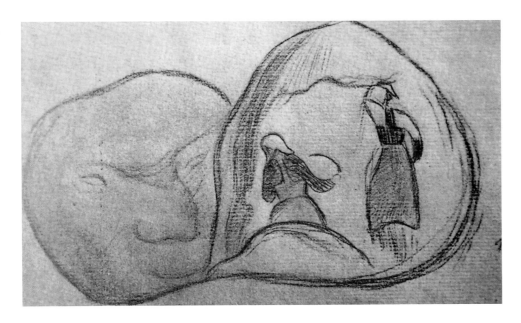

61 *Breton Fantasy,* 1889. Crayon on paper. Musée des Beaux-Arts, Reims.

times even repress, such an outpouring of a tormented soul. The thumb touching the lips, for its part, has rightly been referred to as "fetal,"[76] but the gesture's meaning can be expanded to include the sensory satisfaction that children associate with bringing their thumbs to their mouths.

The sensuous gesture of the thumb, incidentally, is corroborated by a crayon sketch of 1889, *Breton Fantasy* (fig. 61), in which the similar rendering of the artist's face, with its characteristic nose, is also distorted, its small merry eyes somewhat porcine in appearance. The eyes themselves are as asymmetrical as they are in the pot, but here, in place of the thumb, are rising lines enclosing a vignette in which two Breton peasant women are pulling apart a haystack—the subject of the painting *Haymaking* (1889, Courtauld Institute of Art Gallery, London). It is not too difficult to imagine the gross ogling fellow stopped here, struck by the women's graceful backs and dreaming of a tumble in the hay. In other words, in the sketch a libidinous dream substitutes for the thumb, suggesting that the thumb in *Self-Portrait in the Form of a Grotesque Head* in turn refers to the sexual drive. Thought and instinct are both needed to cope with the torment of one's soul, the gesture seems to imply.[77]

In *Self-Portrait with the Yellow Christ*, Gauguin places himself between *The Yellow Christ*, seen in a mirror and therefore reversed, and *Self-Portrait in the Form of a Grotesque Head*. The mug it-

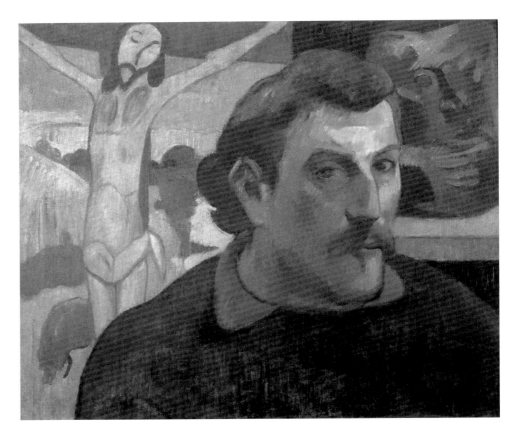

62 *Self-Portrait with "The Yellow Christ,"* late 1889 to early 1890. Oil on canvas. Musée d'Orsay, Paris/Lauros/Giraudon/Bridgeman Art Library.

self, squeezed between Gauguin's head and the right edge of the canvas, and perched on a makeshift shelf, must have been added as an afterthought, after the artist received "a photograph of the pot, well lighted, with reflections that color the face," which he had requested in a letter to Bernard of late November (this also helps date the work).[78] The term "color" might seem odd in describing what could only have been a black-and-white photograph, but it conveys Gauguin's apparent intention in the painting, for the effigy on the pot—in its array of russet-brown, yellow-brown for the highlights, and dark-gray-blue for the shadows—is invested with a warmer appearance than the work itself. It still casts a rather malevolent glance, however, and the mouth, touched by the thumb and aggressively half-opened and twisted, bodes no good. Indeed, the call of instincts was strong. In a letter written at least six months later from Le Pouldu, Gauguin confided to Bernard: "I wander around like a savage with long hair, and I am doing nothing; I haven't even brought

colors or a palette. I have assembled a few arrows, and I practice shooting them on the beach, just like Buffalo Bill [whom Gauguin saw at the 1889 Exposition Universelle]."[79]

In sum, *Self-Portrait with the Yellow Christ* places the malevolent *Self-Portrait in the Form of a Grotesque Head* in opposition to the original message of *The Yellow Christ*, in which Gauguin's dying Messiah reflects his own painful struggle for a higher cause, despite the charm of the landscape and the idyllic aspects of Breton life around him. The religious works of the Brittany period, intended at first simply to reflect peasant mores, assumed a more dramatic quality when Gauguin began to equate the miseries of his life and the sacrifices imposed upon him by his artistic struggle with the ordeal of Christ. Yet in presenting his trials, Gauguin, as always, admitted his venal side.

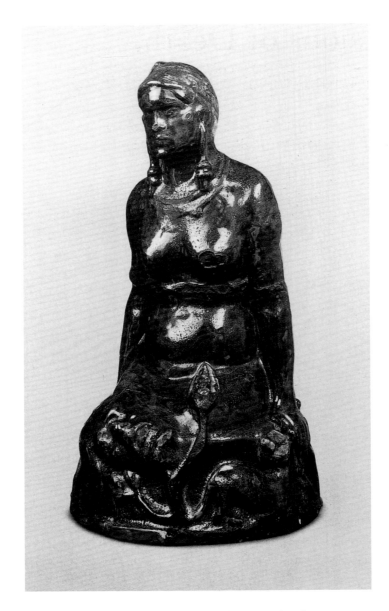

63 *Black Venus*, 1889. Glazed stoneware. Sands Point Park and Preserve,
Port Washington, New York.

CHAPTER 6

Visions of Death,
Visions of Escape

May the day come (and perhaps soon) when I shall go
bury myself [or "find cover"] in the woods of an island
of Oceania.

To Mette, ca. June 24, 1890

*T*he theme of death occurs in a number of Gauguin's works dating to the
late Breton/Paris years. In at least one case, it occurs in connection with a
"self-righting" Eve.

The rather grim figure of the so-called *Black Venus*, a glazed stoneware
statuette of 1889 (fig. 63), is a case in point. It has been identified with the
mulatto woman of the wood carving *Be in Love and You Will Be Happy* of
1889 (fig. 37).[1] The arm bracelets and the very large ear ornaments, as well
as the Buddhist pose, could indirectly point to India, more specifically to the
Indian-inspired art of Java,[2] but perhaps also to the tastes of the East Indian
population of Martinique. The figure is fairly realistically modeled, reveal-
ing not only a woman who is proud, confident, and very determined, but a
non-Western woman likely to be impervious to the Judeo-Christian belief in
original sin and the corresponding need for self-abasement. But this "self-
righting" Eve is also a femme fatale: Gauguin placed his own severed head
on her lap, evoking John the Baptist's on a platter or on Salome's lap, in var-
ious versions of the biblical story. The woman, for her part, stands solemn
and unmoved—a Venus accepting love as a sacrificial offering.

Not all is lost for her lover, however—or at any rate for the survival of

his creative spirit. A large blood vessel descends from the base of the neck and feeds the ground, which in turn provides nourishment to several rising stems, one of which aggressively thrusts a phallic lotus bud on its stem along her flank,[3] while another becomes the tail of a prone mammal. Starting from the area of the lotus flowers, and in line with the prone mammal, a frieze of roughly modeled animals circling the base of the figure extends the work's message to the animal world. The play of metaphors, based essentially on objects from everyday life (albeit marginally so in the case of the severed head!) is brought out by Gauguin in a letter of 1890 in which he compared the symbolism of the *Black Venus* to the more obviously allegorical character of a figure of death in a print he owned, Odilon Redon's *Death: My Irony Surpasses All Others*, from the third lithograph series dedicated "To Gustave Flaubert" (1889).[4] In a letter to Redon dated 1890, Gauguin wrote: "In Europe, this death with its serpent's tail is plausible, but in Tahiti [where, he wrote Redon, he had decided to go] one must see her with her roots growing back into flowers."[5] The association of the death of the artist at the hands of the femme fatale with the simultaneous suggestion that his blood is fertilizing the ground while a vegetal phallus is symbolically impregnating her transforms the *Black Venus* into a symbol of the cycle of death and regeneration—a cycle that, for Gauguin, applies to both biological reproduction and artistic creation.

The notion of the artist's survival through his work recurs frequently in Gauguin's output, and a digression on its origin is in order here. It dates to discussions that he must have had with Vincent van Gogh regarding views expressed by Leo Tolstoy. Indeed, shortly before Gauguin's arrival in Arles, Vincent wrote to his brother: "It appears that [Tolstoy in *My Religion*] does not much believe in [the] resurrection of the body or of the soul. All the more so because he does not believe much in Heaven. So he reasons things out like a nihilist. But in a way he does not agree with the latter. He attaches much importance to doing what one does well, probably because that's all one has. And if he does not believe in resurrection, he seems to believe in its equivalent: the lasting power of life; the forward march of humanity; man and his work continued almost unfailingly through the humanity of the following generation."[6] Gauguin must have heard and absorbed the lesson, for he wrote to Theo in a condolence letter some two weeks after Vincent's death: "You will continue to see [Vincent] in his works. . . . As [he] often said: 'The stone will perish, the word will remain.'"[7]

The Buddhist belief that one perpetuates oneself through one's good deeds—in this case, to be sure, in order to attain a higher status through metempsychosis and eventually reach the state of pure spirituality, or *Nirvana*—was likely a subject of discussion between Vincent and Gauguin. Gauguin wrote to Emile Bernard, also in regard to Vincent's death: "To die at this time is a great happiness for him, it is precisely the end of his suffering, and if he returns in an-

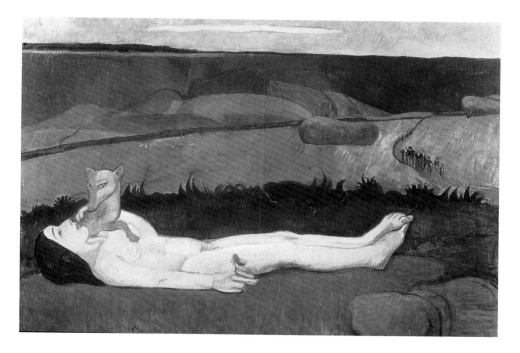

64 *The Loss of Virginity*, late 1890 to early 1891. Oil on canvas. Chrysler Museum, Norfolk, Virginia/Bridgeman Art Library.

other life, he will bring with him the fruit of his fine conduct in this world (according to the law of Buddha)."[8] A similar association between death and regeneration—physical or spiritual—appears symbolically in many of Gauguin's works, such as the series of evocations of Hina and Tefatou in the artist's Polynesian output and, perhaps even more dramatically, in the evocation of that other femme fatale: *Oviri the Savage* of 1894 (see fig. 118).

*I*n late October 1890, after Bernard had informed the Belgian painter Eugène Boch and Octave Maus, secretary of the Brussels avant-garde association Les Vingt, of Gauguin's plight since the death of Theo, Maus responded by inviting Gauguin to participate in Les Vingt's 1891 exhibition. He and a few friends offered the artist 500 francs for five of his works—about a third of what Theo would have obtained. Able to repay Marie Henry, Gauguin left for Paris on November 7.[9]

One of the last large pictures that Gauguin executed before leaving for Tahiti was *The Loss of Virginity* of early 1891 (fig. 64), "a large composition he believed was symbolic."[10] In this work Gauguin suggests what may lie in store for the country girl who has lapsed. Temptation

is here evoked by a fox— the "Indian symbol of perversity," as Gauguin once called it in connection with *Be in Love and You Will Be Happy* —which rests its paw on the girl's heart as it looks around with malice and pride.

This fallen Eve lies on her back atop a ridge overlooking a valley, with her eyes open but unfocused. The deathlike whiteness of her skin, no less than the apparent stillness and rigidity of her body, have led some to see parallels with *The Body of the Dead Christ in the Tomb* (1521, Kunstmuseum Basel) by Hans Holbein the Younger.[11] And while the young woman's overlapping feet "twisted against one another," as remembered by a friend of Gauguin's fifteen years after he saw the painting, convey "nervous turmoil [*énervement*],"[12] which might well imply a coital shiver, they have also been associated with those of Christ nailed on the cross, linking the act of love and the ensuing martyrdom of the fallen woman with Christ's Passion.[13]

The iris that the young woman holds looks a little wilted, and thus appropriately stands for loss of maidenhood (*défleuré*, or "deflowered"); at the same time the iris is the traditional symbol of the Virgin Mary's suffering after the Crucifixion, and thus suggests the girl's distress. That the iris is spotted with red, moreover, probably alludes to the tearing of the hymen. The bundle of wheat at the girl's feet has given rise to some speculation;[14] it probably refers to nothing more complicated than the hardships of a young Breton peasant woman's daily work (young Breton men were mostly equally hard-working, risk-taking sailors).

The most enigmatic item is probably the procession coming down the road in the distance. The same friend of Gauguin's remembered it as a festive, somewhat inebriated wedding party sketching out dance steps, led by two violin players (no violin players, however, appear in the present picture). He concluded that this was "the complement of the allegory of the foreground," that she succumbed to the temptation of losing her virginity.[15] Could the procession, rather, be an allusion to the girl's former lover marrying another woman? This would add bite—in keeping with Gauguin's practice of leavening drama with sardonic humor. Or might the procession consist of friends and relatives about to attend a wake for the martyred woman, who happens to look exceedingly white, rigid, and somewhat like a corpse?

The allusion to the advent of death in *The Loss of Virginity* may be made only in passing, but in *Bonjour Monsieur Gauguin* (fig. 65), executed in 1889,[16] Gauguin is met, while walking in the countryside, by a rustic embodiment of the figure of death. Both this painting and a larger version of the same scene have rightly been associated with Gustave Courbet's *Bonjour Monsieur Courbet* of 1854 (fig. 66) at the Musée Fabre in Montpellier, which Gauguin had visited twice.[17] That painting shows Courbet himself, represented both as a somewhat self-important and arrogant man of genius (which he was) and as a robust and jovial artist-journeyman on a vigorous walk, meeting his friend and patron, the reserved, slightly pompous, here deferential, collector

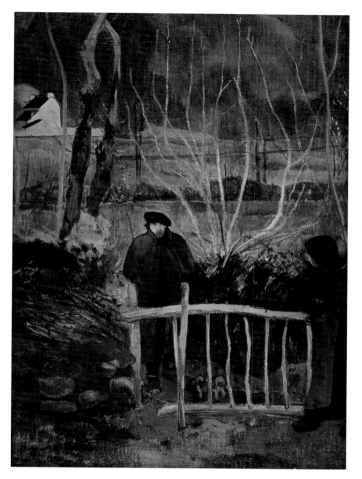

65 *Bonjour Monsieur Gauguin*, 1889.
Oil on canvas. Christie's Images,
London/Bridgeman Art Library.

66 Gustave Courbet, *Bonjour Monsieur
Courbet*, or *La Rencontre (The Meeting)*,
1854. Oil on canvas. Musée Fabre,
Montpellier/Giraudon/Bridgeman
Art Library.

Alfred Bruyas, accompanied by a dog of some breeding and distinction and followed by his obsequious valet. From the standpoint of social symbolism, Courbet's picture opposes the moneyed classes and labor,[18] and possibly also alludes to an eventual reconciliation between the two—here through a journeyman's sale of his work to a well-heeled client.

The symbolic message of *Bonjour Monsieur Gauguin* is decidedly gloomier, if not overtly morbid. The artist himself, his beret cocked to one side, an ample coat with an attached cape over the shoulders, and his feet ensconced in massive clogs, evokes through his stance preparedness in the face of the elements, dignity, endurance, and determination as he walks up the path, while his clothes reflect a certain rugged sartorial flair. His face is grim and wan. There are suggestions of poor health and exhaustion in the reddish recess of the single visible eye, as well as in the skin's paleness and the hollow cheeks. The eye itself, reduced to an irregular V by the heavy upper eyelid, is particularly downcast, and the downturned mouth evokes profound dejection. Yet there is strength in his protruding chin and, all in all, an undercurrent of bitter resolve.

Evidence of Gauguin's deep distress at this time has already been presented in connection with the almost contemporary *Christ in the Garden of Olives* (fig. 56). Suffice it to repeat here that in addition to his loneliness and depression, Gauguin was haunted by the idea that Degas might have disparaged his work to Theo van Gogh, and that this accounted for Theo's hesitant purchases. Gauguin's sense of betrayal grew, and the recurring thought of suicide could not have been far away.

In the picture neither the woman facing the artist across the barrier nor the setting offers any solace.[19] Her dress is grayish mauve, and both the black hood and elbow-length oversleeve sound a note of mournfulness, although neither was, strictly speaking, a funerary garment.[20] Her barely visible face seems somewhat cadaverous in color. The handle of a scythe emerges near her ankles with a blade that arcs upward toward the artist.[21] Although its presence is doubtless in keeping with the agricultural setting, the scythe implies the time-honored symbol of the Grim Reaper. The sinister, eerily lighted gray-blue clouds against a dark blue and mauve sky add to the gloom. Only the small dog sauntering alongside the artist offers a touch of relief.

The case has already been made for associating this encounter with Christina Rossetti's 1861 poem "Uphill," which had much impressed Vincent van Gogh and which he may well have discussed with Gauguin in Arles.[22] It tells, according to Vincent, of "a pilgrim who wants to go to the Holy City; he is already tired, and asks a woman in black who is standing by the road and whose name is 'Sorrowful yet always rejoicing.'"

"Does the road go uphill all the way?"
"Yes, to the very end."

"And will the journey take the whole long day?"

"From morn till night, my friend."[23]

The poem evokes the voyage of life, so that the woman in black appears to herald the pilgrim's death. In combination with the allusion to Courbet's painting, it would have been a significant source of inspiration for the symbolism of *Bonjour Monsieur Gauguin*.[24]

And yet things may not have been entirely black. Despite Gauguin's recent bitter disappointments, the ultimate fateful moment may not yet have come, even in his own mind. After all, Gauguin had proudly written to Schuffenecker only a few months earlier, from Arles, that "Vincent sometimes calls me the man who comes from far and will go far—I certainly hope to be followed by all these good hearts who have loved and understood me."[25] And there are, indeed, some hints of hope in the picture. The body of the woman happens to be a little twisted: her head is turned toward Gauguin while her shoulders are parallel to the gate, but her feet are essentially turned to the right, as if she were poised to walk away in that direction. As a result, the meeting may be no more than a passing encounter—although still a grim reminder of the artist's poor health and poverty and of the passing of time, as well as of the state of dejection that he had to overcome. A very faint, almost invisible rainbow can be spotted: an augury of a better tomorrow.[26]

As in nearly every decision he made regarding his career, there was an element of strategic calculation in Gauguin's decision to leave for the tropics. To be sure, the madness of Theo van Gogh in October of 1890, rapidly followed by his death, was "a serious blow."[27] Gauguin nevertheless must have felt that he could take the risk of leaving Paris for a long sojourn in the tropics, for he was getting to be known and respected in symbolist circles, from which he would receive considerable support when he publicized his departure.

Just as important, France's economy was greatly improving, as was interest among collectors in the impressionists and contemporary art in general. The dealer Paul Durand-Ruel was paying off his debts, and he was able once more to invest significantly in the art of the impressionists and spread their fame through individual exhibitions in Paris and, starting with a show in London in 1883, in several foreign capitals. The competing Georges Petit Gallery, furthermore, had scored considerable successes with its *Expositions internationales* in Paris, to which, starting with Claude Monet in 1885, leading impressionists were invited. Petit also organized solo and small group shows of their work. The gallery's Monet-Rodin exhibition of June 1889, in particular, helped make both artists widely known.

But Gauguin's dreams of escape also played an important role. Together with much recrimination and bitterness about the corrupt West, these dreams manifest themselves in his writings and in his work. He thus wrote his wife in late June 1890:

What would make me unhappy would be to find myself isolated, without a mother, without a wife, without children. Cursed by my whole family. Your silence for the last two years, which had been in the offing since my trip to Martinique, your silence has certainly taken a toll on me, has made me even more unhappy than my financial failures. But it has had a positive effect in that it has forced me to harden myself, to despise everything.

May the day come (and perhaps soon) when I shall go bury myself [or "find cover"] in the woods in an island of Oceania, and live there off ecstasy, calm and art. [I shall be] surrounded by a new family, far from this European struggle for money. There, in Tahiti, in the silence of the beautiful tropical nights, I shall be able to listen to the sweet murmuring music of my own heart in amorous harmony with the mysterious beings around me. Free at last, without financial worries, [I] shall be able to love, to sing and to die.[28]

In addition to calling forth an idyllic vision of his intended escape, Gauguin here elaborates on his psychological makeup at the time. To be sure, when he complained about not having a mother, he was opposing his own situation to that of his wife, whose mother lived in Copenhagen, where she and the children were staying.[29] He was forty-two at the time, and to insist that the absence of his long-dead mother, Aline, created a particular burden for him, was more than a little odd. In fact, Gauguin's desire to escape to the tropics must have been informed both by his memories of her as an exceptionally attractive and loving figure and by his recollections of the five happy childhood years spent in luxurious surroundings with her and his sister in the palatial residence of his grand uncle Don Pio Tristan y Moscoso in Lima—"then in a delicious land."[30]

Upon returning to France, Aline had been handicapped by her very limited means, and her little family had lived in near-poverty. With the help of a small inheritance, however, she had been able to provide a decent education for her children. And she had set herself up as a seamstress in order to support herself and her children, albeit very modestly. While there is no indication that she was anything but a respectable woman, she may nevertheless be classified among those who surmount great difficulties in order to ensure their own and their children's survival—a "self-righting" woman, so to speak.

The artist's memories of a happy childhood in a tropical setting and of his sweet and remarkable mother, who was herself of partly exotic descent, as well as his own plans for the future, are evoked in a small picture probably executed in Pont-Aven in June of 1890,[31] some nine months before Gauguin's departure for Tahiti. His *Exotic Eve* of 1890 (fig. 67) presents one of the proudest, most graceful, and most triumphant of his "self-righting" women. It is clearly related to his intention to return to the tropics.[32] The serpent is there, coiled around the little tree from which Eve picks a fruit. A rooster and a hen are copulating, resulting in a pile of eggs beneath them, as if to suggest the cycles of regeneration.

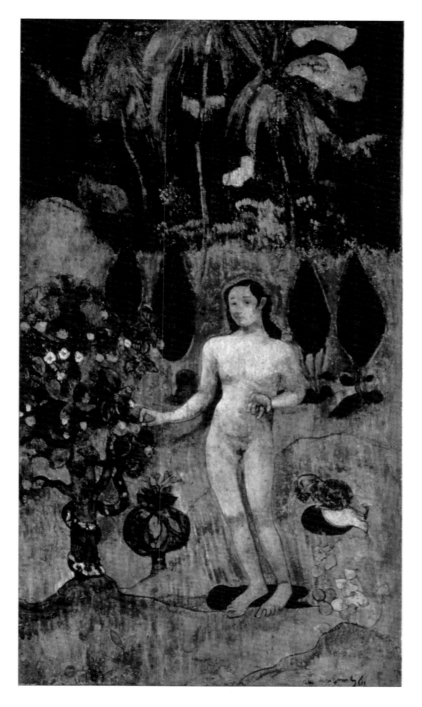

67 *Exotic Eve*, 1890. Gouache on millboard transferred to fabric.
Private collection.

Stylistically, the gouache is executed in the jaunty, fluid, simple, near-caricatural manner that characterized Gauguin's wittiest compositions, such as the *Design for a Plate—Leda and the Swan* of 1889 (fig. 27). But, as already noted in connection with *Female Nude with Sunflowers* of 1889 (fig. 40), Gauguin was influenced by another major artistic tradition, partly derived from the eighth-century Javanese temple of Borobudur, itself closely related to the Indian classical tradition, and partly from medieval Khmer monuments. The swaying figure of Eve is derived from the depiction of the privileged being of Buddhist lore, Maitrakanyaka, in one of the Borobudur photographs that Gauguin owned (fig. 41, bottom). While its outline is swift and sketchy, the rhythmic interplay of curves in the figure, suggesting vigorous, graceful suspended movement, as well as the slight swelling of all surfaces, is in keeping with the classical Indian canon's concept of the inner breath of life—characteristics that will appear in all of Gauguin's Polynesian output. Although, in terms of overall expression, Gauguin's figures had always tended toward the hermetic, this was heightened during the Polynesian phase by a superior detachment and serenity—"ecstasy, calm, and art," to repeat Gauguin's own words—in keeping with Buddha's philosophical outlook. The design as a whole is further characterized by Indian sensuality, rather than anything so distressing as the greed, apprehension, and anxiety of the Judeo-Christian tradition—let alone remorse (or worse). Indeed, making the same gesture as that of Maitrakanyaka in the frieze, Gauguin's figure here holds an apple in her four-fingered left hand, undoubtedly suggesting that the fruit, symbolic of sin in the Judeo-Christian tradition, also carries the seeds of future generations. Almost the same hand, also four-fingered and holding a fruit, is to be found in the figure of Vaïraumati in *Te aa no Areois (The Seed of the Areoi)* of 1892 (Museum of Modern Art, New York), here alluding to the survival and diffusion of the sacred Polynesian Areoi sect, of which the goddess was a patron.[33]

Elegant in her nudity, poised and independent as well as the bearer of the seeds of humanity, this Eve is very much a "self-righting" one. Her face is based on a photograph of Gauguin's mother, Aline (see fig. 2), as if to alleviate Gauguin's expressed fear of finding himself "isolated, *without a mother* [emphasis added], without a family, without children."

Ultimately: "You know that I am partly of Indian, Inca stock, and everything I do reflects it. This is at the very root of my personality: to putrid civilization I try to oppose something more natural, issued from savagery," Gauguin wrote to Theo van Gogh.[34] The painting clearly manifested the artist's intention to indulge his Peruvian "Indian" nature by returning to his atavistic "savagery," albeit with considerable elegance and sophistication.

But Gauguin's vision of this garden of Eden is not altogether blissful. Cypresses, which appear in a row behind Eve, have been associated with death since the days of the emblem books: "*Funestus arbor est . . .*," or "Fatal is the tree . . . ," Alciatus notes.[35] Vincent van Gogh himself

referred to "a funereal cypress"[36] when Gauguin was staying with him, suggesting that he had some acquaintance with emblem-book symbolism—albeit possibly indirectly. The introduction of the cypress is in keeping with a thought that Gauguin addressed to Redon a little later: "I am taking [to Tahiti], by way of photographs, drawings, a whole little world of comrades who will talk to me daily; from you, I have in my head memories of all that you have done, or nearly so, and a little *star*. When I see it in Tahiti, I shall not think of death in life, but life in death."[37] And, once in the tropics, Gauguin would be able "to sing, to love," but also "to die." In psychoanalytic terms, the return to the womb does imply a death wish! The palm trees rising behind the cypresses situate the scene in a tropical paradise. Overall, the picture conveys both a formulation of his artistic program for Polynesia and a poetic vision of the state of his soul before this momentous change in his life.

*I*n response to a commission, Gauguin indulged in a caustic and witty fantasy on the theme of death. In 1890 the play *L'Intruse (The Intruder)* by the Belgian symbolist Maurice Maeterlinck had its première. It revolves around the visitation of Death in the room of a sick person. Death, however, does not appear in the play, its presence is only hinted at by the sound of rustling feathers next door. The theme was transformed into a wittily macabre comedy by the successful Parisian symbolist playwright and novelist Rachilde, spouse of Alfred Valette, the publisher of the symbolist torchbearer *Mercure de France*, in her *Madame la Mort (Madam Death)*, first performed on March 20, 1891, ten days before Gauguin's departure, at the avant-garde Théâtre des Arts. Unlike in *L'Intruse*, Death does appear in this play and partakes in the conversation, but she wears "a dust-gray gauze over a long dress of the same gray . . . she never shows her hands, nor her feet, nor her face."[38]

Rachilde commissioned two drawings from Gauguin, at the suggestion of the artist's friend the critic Jean Dolent. Gauguin wrote him in response: "I shall busy myself with reading the work, . . . otherwise it would be difficult to suggest an idea one does not know."[39] After completing the work, he wrote Rachilde: "I was truly perplexed when I read your drama. . . . How can I convey your thought with a pencil when you conceived it for the stage with far more powerful means—the actress, the word, the gestures? I beg you, therefore, to forgive me if I am far from acceding to your desires in the weak translation I am sending you—and if I send you two instead of one, it is because it might be that when they are seen together (this is possible, is it not?) the one will support the other."[40]

The symbolic meanings of the two drawings do complement one another. In the larger drawing, *Madame la Mort I* of early 1891 (fig. 68), the features of the central, female figure are clearly

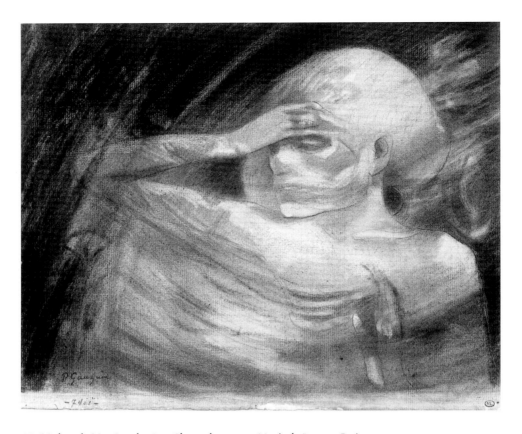

68 *Madame la Mort I*, early 1891. Charcoal on paper. Musée du Louvre, Paris.
Photo: Réunion des Musées Nationaux/Art Resource, New York. Photographed
by C. Jean.

visible, suggesting that however much she may look like Death, she is, rather, a wan, distressed young woman. This is the flighty, self-centered, and attractive "kept woman" who is shattered when her lover dies from smoking a poisoned cigarette that he picked from a box in a variation of Russian roulette. He had lost his money; even worse, he informed his mistress before dying that he was unable to keep his promise to move her to a grander apartment in an upscale section of Paris.

The woman's dress, a diaphanous gauze sheath draped below her bare shoulders and partially wrapped around her raised arm, is gracefully dramatic, her bouffant hair impeccably groomed, and her jewelry most impressive. Clearly, she is a most elegant young Parisienne. She wears a large ring, set with a large and glittering precious stone, on her right hand, and on her chest over her heart, a splendid art nouveau kingfisher-shaped brooch. She is proud of them:

"Look at me, I have all my diamonds," she tells Death. Her hand is raised to her head as if to forestall a headache, while "she repeats in an ever-softer voice: 'Paul'" as her lover expires.[41]

Gauguin must have been familiar with the symbolic meaning assigned by several emblem books to the kingfisher; he is reported to have compared his purportedly blissful existence in Martinique, in relation to his earlier painful and long-lasting struggles, to that of a "bird of prey flying above the waves, defying the tempest, shrieking and laughing at the disaster below."[42] This more or less corresponds to the phlegmatic and rather cryptic phrase *Nobis sunt tempora nota* (We know the times) in emblem books,[43] or the fuller and more broadly reassuring legend *Halcyon in mediis tranquillus construit undis nidum praesidio tutus ubique Dei* (The kingfisher builds its nest in the tranquil center of the waves as God protects all everywhere) that accompanies illustrations of two birds and their chicks huddling by a rock during a destructive ocean storm.[44] The symbol as it is used here is loaded with bitter irony, essentially representing the ability to survive disasters. To the left, alluding to both love and death, a lotus bud, Indian symbol of sensuality and regeneration, rises in front of the woman's bent arm,[45] but almost disappears in the shadow as if to hint at mourning. Behind her and to the right is another bereaved character, a friend in the habit of borrowing from the dead man and not repaying his debts. His features are callous and dejected; a cigarette butt dangles from the corner of his mouth, and his right hand holds a tilted liqueur glass. His left wrist is bent, and the fingers so arranged that his raised hand forms a question mark, thus echoing the theme of a smaller pendant drawing, discussed below.

The composition's haziness, in the manner of the symbolist painter Eugene Carrière, allows such details as the features, hair, and folds in the dress to show through, as well as the long locks of hair that partly conceal the woman's mouth and the tip of her nose—the latter conveying a somewhat deathlike impression as a consequence. And, overall, the haze is evocative of the poisoned cigarette smoke, as it cloaks the advent of death in an aura of mystery. In sum, the drawing alludes to the quandary in which two of the four characters in the play find themselves at the sudden death of a very useful friend.

The second, much smaller charcoal drawing—*Madame la Mort II* (fig. 69), let us call it— shows an attractive, very elegant young woman in a gauze dress, rapidly sketched as if for a fashion plate. The expression on her face with its half-closed eyes is vacuous and nonchalant, exuding a superior, melancholic disdain. The woman's hands, long cadaverous tentacles, seem intended to secure masculine prey. Behind her, a cloudy white swirl extending nearly to her full height suggests a wide, very long, opulent—possibly white sable—stole about to wrap itself around her as if by magic; it recalls the poisoned smoke and, at the same time, it creates a large question mark behind her body. And above, partly covered over by her head, a large skull looms, with black holes at its eye and nose sockets. A relish for the detail of life, in all of its

69 *Madame la Mort II*, early 1891. Charcoal and highlights of gray wash on paper. Musée du Louvre, Paris. Photo: Réunion des Musées Nationaux/Art Resource, New York. Photographed by Gérard Blot.

superficiality and frivolity, combined with the macabre situation, ultimately points to the absurd and an existential "why?"

*B*efore departing for Tahiti, still knowing nothing about ancient Polynesian religion, Gauguin set out to invent the kind of "savage" deity that he was hoping to discover in the course of his voyage. An exotic-looking, rather ridiculous puppet appears next to his own thoughtful, somewhat melancholy and aristocratic figure, shown quizzically looking at the observer outside the frame, in *Portrait of the Artist with the Idol* (fig. 70), variously dated from 1891 to 1894.[46] Because it heralds important Tahitian developments in his art, the precise date of the picture is particularly significant. It was, in fact, painted in Paris before his departure for Tahiti at the end of March 1891.

The idol looks much like the cheap rag dolls of the period, which were made by stuffing textile scraps between two cotton cutouts, which were sewn together along the edges so that the flattish front and back surfaces rounded at the periphery, and then everything painted by hand.

70 *Portrait of the Artist with the Idol*, before late March 1891. Oil on canvas. Collection of the McNay Art Museum, San Antonio, Texas, Bequest of Marion Koogler McNay.

71 Charles Bird King, *Ma-Ka-Tai-Me-She-Kia-Kiah (Black Hawk, a Sauk Brave)*, nineteenth century. Color lithograph from *The Indian Tribes of North America*, vol. 2, by Thomas L. McKenney and James Hall. Photo: Private collection/ Bridgeman Art Library.

The heads were usually circular and disproportionately large, and the necks short and wide so as to be reasonably rigid. The rag dolls sometimes wore dresses, but this idol seems to be unclothed. Gauguin has stressed the geometry of his idol's head, which is essentially circular, if slightly elongated at the top. The features and what can be seen of the arms have a painted-on appearance. The head is shaved, except for a few soft tufts jutting out laterally from the back, below the level of the ears, and a stiff, more plentiful one that resembles horsehair at the top. Today this hair styling could be called a Mohawk, although it is not necessarily associated with that tribe, but is, rather, inspired by such ethnographic works as the early-nineteenth-century portrait of Black Hawk, chief of the Sauk nation (fig. 71). The idol's squat nose and unmodulated, thick, wide lips must be intended to be exotic. And while the large head on a small body is characteristic of rag dolls, as well as of numerous puppets, it is also characteristic of Marquesan ornamentation, as in the oar ornament (see fig. 89) that Gauguin might have seen at the British Museum in London or in similar works at the Musée de l'Homme in Paris. The slanted eyes are feline, but they may also be intended to be exotic. Indeed, their inclination, no less than

MATAMOE MATAMOE

72 Maori *taiaha*, redrawn after a diagram in
C. S. Curtis, "Maori Taiaha," *Journal of the
Polynesian Society*, December 1965, 489.

their elongation, brings to mind Maori designs from New Zealand, such as those on a weapon
called *taiaha*, one side of which shows closed eyes, and the other open eyes (fig. 72). Asiatic
eyes may also have played a part. As for their exceptional size, as well as their height in relation
to the face, these eyes could belong to the realm of toys, on the one hand, or various African
and Oceanic traditions, on the other—the Marquesan oar ornament being a case in point. What-
ever Gauguin's actual sources, such borrowings would have been in keeping with a statement
he made in his *Avant et après* toward the end of his life: "at times I had placed myself far back,
farther back than the horses of the Parthenon, all the way to the hobby horse [*dada*] of my child-
hood, that good rocking horse!"[47]

The rag-doll idol in Gauguin's 1891 self-portrait can be dated in relation to a somewhat sim-
ilar figure, which Gauguin must have executed in Tahiti no earlier than the spring of 1892: the
wood puppetlike statuette *Hina: Goddess of the Moon* (fig. 73). Indeed, Gauguin appears to have
had no knowledge of the names of the ancient Polynesian gods before writing a letter on March
25, 1892, to his friend Paul Sérusier, in which he explained with great excitement that he had be-

73 *Hina: Goddess of the Moon,* 1892. Carved tamanu wood. Present location unknown.

come familiar with the ancient Polynesian religion through reading a book by the Belgian-born traveler and merchant of French culture Jacques-Antoine Moerenhout: *Voyages aux îles du Grand Océan* of 1837.[48] The overall configuration of the two idols, in the painting and the statuette, is fairly similar; the execution of the wood statuette is, however, more sophisticated, reflecting a definite classical Indian influence. The first painting executed in Tahiti that fully showed this kind of Indian influence, drawn from photographs that Gauguin owned of the eighth-century Javanese temple of Borobudur, is *Ia orana Maria (Hail Mary)* of 1891–92 (see fig. 75)[49]—and this influence subsequently became pervasive in his work. Consequently, the rag-doll idol, and therefore the self-portrait, must be earlier. The suggestion that the work was painted before Gau-

guin's departure for Tahiti gains support from the artist's clothing. He wears an undershirt, a sweater, a jacket, and a neckerchief—clothing warmer than anyone but a French official, bound by protocol, could have tolerated in that climate.

In sum, the artist painted adjacent to his own image a precursor of his future iconographic innovations in Polynesia. In many ways, the message here is comparable to that of the 1886 *Madcap/Gauguin Vase* (see fig. 9), in which Gauguin depicted himself as an irrepressible wise fool— an emblem of his vision of a new art, highly expressive from the standpoint of line and color, and loaded with equally telling symbolic associations. The subjectivity of these images also parallels his equally innovative *Exotic Eve*, an Eve with his mother's face.

Since his return from Brittany in early November of 1890, Gauguin had been making considerable efforts to prepare for his forthcoming departure and raise money for the journey. One of his literary acquaintances, the poet Charles Morice, had met him in 1889 "at a little restaurant [La Côte d'Or] near the Odéon, where there met a few of those poets still indistinctly named Symbolists, and already *Décadents*."[50] There the artist engaged in an intense discussion with Jean Moréas, the poet and author of an 1886 manifesto defining some of the goals of symbolist poetry.[51] Morice, who was a regular guest at the "Tuesdays" of the poet Stéphane Mallarmé, recognized by younger symbolists as their elder and leader, arranged for Gauguin to attend these meetings. Mallarmé and Gauguin developed a strong mutual respect, memorialized by the artist in his etched *Portrait of Stéphane Mallarmé* of January 1891 (fig. 74), in which the poet is depicted with a raven over his head, alluding to his translation of Edgar Allen Poe's "The Raven" and inspired by Edouard Manet's celebrated poster advertising the book.[52] Mallarmé arranged for Gauguin and Morice to visit Octave Mirbeau, then enjoying an immense popularity, at the novelist's country estate.[53] A little later, Mirbeau wrote a laudatory article that appeared in two leading Paris dailies.[54] It praised Gauguin's art as "a disquieting and succulent mixture of barbaric splendor, Catholic liturgy, Hindu dream, gothic imagery of obscure and subtle symbolism; there are bitter realities and distraught poetic flights whereby Gauguin creates an absolutely personal art, totally new; [the] art of a painter and a poet, of apostle and of demon, and which arouses anguish." "Extraordinary, your article," Gauguin responded.[55]

Gauguin also gained the support of the painter Ary Renan, a former pupil of the Romantic-symbolist artist Gustave Moreau, and the son of the historian of religion Ernest Renan, who had traveled with the Bonaparte princes on the naval yacht on which Gauguin served.[56] Ary requested and obtained from the ministry of education an unpaid "official mission" so that Gauguin could study and depict the life and mores of Tahiti. For his part, Mirbeau asked for the support of

74 *Portrait of Stéphane Mallarmé,*
January 1891. Etching. Collections
Jacques Doucet, Institut national
d'histoire de l'art, Paris.

Georges Clemenceau, a friend of Manet during that artist's lifetime, as well as of Claude Monet,
and a steady admirer of both artists' work. He was also a physician, the founder and publisher
of an extreme-left paper, *La Justice* (in which Gustave Geffroy's "Paul Gauguin" appeared on
February 22), and a member at that time of France's Chamber of Deputies; later, during World
War I, he would become France's prime minister. Clemenceau was to try to obtain a 30 percent
discount on the price of a steamer ticket for Tahiti.[57] He succeeded.

Mirbeau's article was inserted as a preface in a catalogue accompanying a one-day exhibi-
tion of thirty of Gauguin's works at Boussod et Valadon (the late Theo van Gogh's employ-

ers) on February 22, and their sale at the Hôtel Drouot the following day. All works but one were sold, and the net receipts were 7,000 francs.[58] The exhibition and sale were a memorable success, sufficient to pay for Gauguin's voyage out and ensure his peace of mind for several months in Tahiti. Grateful, Gauguin offered a loan of 500 francs to Morice to thank him. (It was at that sale that Emile Bernard and his sister approached Gauguin angrily, Madeleine accusing him of betrayal.)[59]

The artist then took off for a few days in Copenhagen to see his wife and children. He persuaded Mette that they should resume their married life once he returned with a sufficient number of paintings.

Gauguin scored another professional success when a regular guest at Mallarmé's receptions, the "Tuesdays," the critic Albert Aurier, published "Symbolism in Painting—Paul Gauguin," in the *Mercure de France* issue of March 1891.[60] A banquet hosted by Mallarmé for some thirty guests, including Redon, Carrière, Valette, Rachilde, and a number of young symbolist poets, critics, and painter friends, was organized in Gauguin's honor at one of the symbolists' meeting places, the Café Voltaire, on March 23. Three main courses were served—fillet of brill, ragout of pheasant, and roast lamb; but champagne was omitted, and the wines were humble Beaujolais.[61] Following the artist's departure, a benefit performance for him and the poet Verlaine was presented in a theater: recitations of poems as well as short plays, including Maeterlinck's *L'Intruse*, as well as the disappointing *Chérubin* by Morice.[62] But this time the net receipts of "around 100 francs" were very disappointing, and all went to Verlaine, then in dire straits.[63]

Gauguin may well have felt that his stunning artistic and financial successes augured well for the future. They did not; he would never again be able to count on such dedication on the part of Morice, nor on the convergence of support of three such influential personages as Mallarmé, Clemenceau, and Mirbeau. Aurier died the following year, and his replacement at the *Mercure*, Camille Mauclair, was hostile to Gauguin.

The artist left Paris on March 31, sailing from Marseilles the following day.

First Tahitian Period

From Papeete
to Mataiea

Every day a new link—that's the most important.

To Georges-Daniel de Monfreid, March 11, 1892

Gauguin arrived in Tahiti on June 9, 1891. He found life in Papeete, the partially Gallicized and mostly ramshackle capital of the forty-mile-long island, expensive and disappointing. He was suffering, moreover, from chronic hepatitis and, once again, from what appeared to be a serious heart disorder.[1] In March of 1892 he wrote his wife: "and now I vomit blood by the basin. I receive treatment at the hospital, for 12 francs a day. You can imagine how I feel about that; this is so costly I do not want to stay. The major absolutely refuses to let me go, reasoning that all would be lost if I left. It seems that my heart has undergone serious damage. . . . And yet I left, and have not had a recurrence."[2] In a letter of about the same time to a Parisian friend, the painter Georges-Daniel de Monfreid,[3] Gauguin sounded as distraught as when he executed *Christ in the Garden of Olives* (fig. 56) and *Bonjour Monsieur Gauguin* (fig. 65), both of 1889, and once again alluded to the possibility of suicide: "Well, let's keep going: there is always the great remedy at the end!" Near-despair, in fact, was ever-present—offset only by the artist's extraordinary will to succeed, which kept him working with astonishing determination. In an effort to sustain the morale of his wife, with whom he was still hoping to be reunited upon his return, he wrote Mette a few months later: "I feel myself getting older, and fast. Because I am reduced to depriving myself of food, my stomach is ruining itself and I get thinner by the day. But I must continue

the struggle, always, always. And I hold society responsible for this. You have no confidence in the future; but for my part, I do have confidence *because I want it to be so*. Without it I would have long ago blown my brains out."[4]

A little before Christmas of 1891 Gauguin traveled some fifteen miles from Papeete along the island's southern coast to the village of Paea to stay with a friend of his who taught school there. From Paeia he reached a village (Mataiea?) located another five miles or so farther on the southern coast, roughly halfway along the island. In Papeete he had met the local French-speaking chieftain, who welcomed him warmly. Half the population was Catholic, a very high proportion in a largely Protestant territory, and there was a French school run by nuns, so that part of the population spoke French. Even the Protestant pastor was French. The spot also happened to be spectacularly beautiful. And there was, as in so many other villages, a Chinese purveyor of food and other amenities who sold on credit.[5]

Gauguin undertook to travel further. Asked by a villager about the purpose of his travels, he answered in the hope of avoiding further questioning: "to look for a wife." The response: "If you wish I'll give you one, my daughter." Within a quarter of an hour "there appeared a ravishing girl of thirteen," a good age to marry, at least according to Tahitian mores. Her name was Teha'amana, called Tehura in *Noa Noa*. Low on cash, rather than continuing the trip Gauguin took her back to Mataiea, where she settled pleasantly among their neighbors.[6] She remained by his side until he left her at the pier on his departure in 1893; he would have a one-week-long encounter with her when he returned in 1895.

In Brittany, Gauguin had explored the mores, traditions, and beliefs of a population still steeped in the moral spirit of the Middle Ages; in Oceania he explored those of a population that had come out of the Stone Age barely a century earlier. He did so by observing the inhabitants' daily lives, reading anthropological studies, and studying their sacred texts and, when available, what remained of their ancient monuments. Perhaps even more than he had in Brittany, he endeavored to study these "savages"—the term had positive overtones for Gauguin—with the care and consideration for all that was original in their culture; he was what today's anthropologists would call a sympathetic observer. Inevitably, his symbolic thought attached itself to both the similarities and the differences between near–Stone Age mores and nineteenth-century ones. The romantic in Gauguin took an unambiguous delight in pointing out—albeit indirectly—the horrors of the most blood-thirsty ancient practices. But in the spirit of the Age of Enlightenment, he sought, if not to justify them, then at least to understand them as reflecting the needs and capacities of a society very different from his own.

Endowed with an extraordinarily broad cultural awareness, Gauguin recognized the extent to which the Polynesians' aesthetic sense manifested itself in their clothes, their songs, and their

artifacts, much as he responded to the poetry of their ancient sagas. Once again in keeping with Enlightenment philosophy, he searched for the humanity common to all peoples and all times—and found a good deal of it. He remained a caricaturist at heart, moreover, sometimes seeing humorous elements in some Polynesian practices, even in accounts of the feats of their various divinities.

Gauguin was particularly sensitive to the individual freedoms that the Tahitians appeared to enjoy—especially sexual freedoms—as well as such traditional personal qualities as mutual tolerance and generosity, which made such freedoms possible. He thus wrote to his wife shortly after his arrival: "What a beautiful evening this is! Thousands of individuals do as I do tonight, they are letting themselves live, and their children raise themselves without assistance. All these people go everywhere, to whatever village and on whatever road they wish, sleep in a house, eat, etc. . . . without even saying thank you—they would themselves expect no more in return. And we call them savages? They sing, they never steal, my door is never shut. [They] never murder. Two Tahitian words characterize them: *Iorama* (good morning, goodbye, thank you, etc. . . .), and *Onatu* (I don't care, what does it matter? etc. . . .)." But he added a note of grave concern about their fate under Western influence: "I view the [recent] death of their [last] king, Pomare, with great sadness. The Tahitian soil is becoming totally French, and little by little this age-old state of affairs will fall into oblivion." And he commented: "Our missionaries brought with them a great deal of Protestant hypocrisy, and they [now] take away part of the poetry, not to mention [having contributed to] the venereal diseases that have afflicted the whole race (without having harmed it too much, I must say)."[7]

Gauguin stressed the prevailing climate of sexual freedom and its consequences in a letter to Monfreid. Announcing that his Tahitian companion would soon give birth, he exclaimed: "Good God! I must cast my seed everywhere. It is true that here there is no harm in that; children are welcome and are spoken for in advance by all the parents. They compete as to who might become substitute fathers and mothers. Because you know that in Tahiti the greatest gift one can make is a child."[8] He was also aware at that time of an earlier tradition, infanticide, as a solution to overpopulation, as will soon become apparent.

Stylistically, during his first years in Tahiti, Gauguin maintained his impressionist pursuit of ambient light and its complementary colors, still mostly applied in impressionist strokes. In Tahiti the ambient light can produce hues that are unusual to Western eyes and therefore appear exotic: vibrant mauves at sunset are reflected on sandy beaches and on the surface of the waves, often conveying a sensuous, sometimes languid mood; they are complemented in the shade by

yellow-greens and greens, which can be particularly rich in a subdued way. Under the full sun, orange-yellow is complemented by Prussian blue. Both the ambient light and the complementaries can have tropical intensities, but the vegetation is dense, and in the large areas of shade there can be subtle variations of subdued colorations. In keeping with synthetism, Gauguin defined areas of fairly uniform color in both the flowers and the *pareus* (sarongs), and despite subtle variations of the browns of the bodies. While the modeling is more pronounced in the Brittany paintings, sometimes achieved by means of adjoining planes of slightly different values, linearism is still emphasized, characterized by dancing rhythms inspired by Borobudur and Angkor-Wat and endowed with a hieratic quality.

In several major works, Gauguin emulated ancient reliefs by lining up his figures at the same depth, as if in a religious procession. In a great many cases, the grouping of the figures derives from Gauguin's photographs of the friezes at Borobudur, as well as works from "the Persians, the Cambodians, and a little of the Egyptian," which he would urge his artist friend and regular correspondent Monfreid "always to have in front of him."[9]

The horizon line in the Tahitian paintings is usually lower than in the Breton works but still higher than in the perspective rendering traditional in Western drawing and painting since the early Renaissance. On the one hand, Gauguin still gives himself room to stress the decorative patterns on what appears to be a flattened ground in the Japanese manner. On the other, there is still a receding stage floor, traditional since the introduction of perspective, on which figures can be positioned at various depths, even though this floor is sometimes restricted to a fairly narrow strip. Above that strip, trees and mountains rise like theatrical flats to create a background, but with greater subtlety than in traditional Western art. Finally, while the choice of complementary hues reflects the theories of the impressionists and neo-impressionists, the use of line and color often departs from the theories of Charles Henry.

By the time Gauguin arrived in Tahiti, Christianity already had a strong foothold. The earliest among the Protestant missionaries had been sent under the aegis of the London Missionary Society, its lower ranks consisting mostly of craftsmen-preachers. They began to make serious inroads during and after 1812, the year that Tahiti's king renounced heathenism.[10] A code reflecting Christian principles inspired by the missionaries was approved at a general assembly gathered at the king's behest in May 1819. It was promptly enforced with often cruel determination, which soon provoked anti-Christian agitation, leading to a war of religion that was eventually won by the king.[11] While the Protestant missionaries retained much of their influence, Catholicism gained strength after the island became a French protectorate in the 1840s.

Gifted musicians, the native Tahitians loved the Christian hymns, which they called *hyménées*. They also loved telling stories and were delighted with the new repertory of the Bible. And they loved ceremony, including that of the church, especially Catholic ritual—although Christian self-sacrifice was simply not part of their culture.

By the 1890s Gauguin would not have found many vestiges of the old religion in Tahiti; what the Christian missionaries hadn't destroyed, the subtropical climate would have eroded. A few ancient Polynesian sculptures did remain in small collections on the island, and Gauguin probably saw one collection with Marquesan items; moreover, in all likelihood he had already seen superb examples at the Musée de l'Homme in Paris.[12] He sometimes emulated the massive, abruptly angular forms of Marquesan art and took delight in their decorative patterns, including tattoos. By March 1892 he had come across Jacques-Antoine Moerenhout's *Voyages aux îles du Grand Océan* (1837),[13] which provided abundant detail about the mores of contemporary and "prediscovery" Polynesians, as well as about their ancient religion. Gauguin drew inspiration from such readings for several important symbolic motifs. Earlier themes, however, also reappear in Gauguin's Tahitian oeuvre, and in great abundance: abandoned Eves, for instance, as well as victorious ones, and greedy and mischievous seducers, as well. The cruel and barbaric aspects of ancient Polynesian culture also manifest themselves, in the form of professional killers of children or fierce warriors who destroyed all and sundry in battles characterized by blind, sometimes senseless rage. But Gauguin saw the gentle side of that culture too and could always express compassion and stress the poetry of what he was witnessing or interpreting. As was to be expected, in the new themes as in the old, Gauguin brought out both the barbarity and the freshness and charm of native lore and traditions—and the fundamental humanity of the culture that gave rise to them. He remained an innate anthropologist and psychologist, and always a poet.

*G*auguin was at first overwhelmed by his Tahitian environment: "In the twenty days since I arrived, I have seen so much that I am troubled. It will still take me a little time before I can paint a good picture."[14] A few months later he admitted having opted for an essentially subjective approach as he mapped out the path to follow, while collecting details from life for future use: "So far I have done nothing outstanding. I have contented myself to search within myself rather than searching nature, to learn to draw. Drawing is all there is, and then I accumulate documents."[15] Even by March 11, 1892, he was "working more and more, but until now studies only, or rather documents that are piling up"—nevertheless mentioning his first major undertaking, *Ia orana Maria* (*Hail Mary*, fig. 75), started in 1891 and extensively recomposed in 1892.

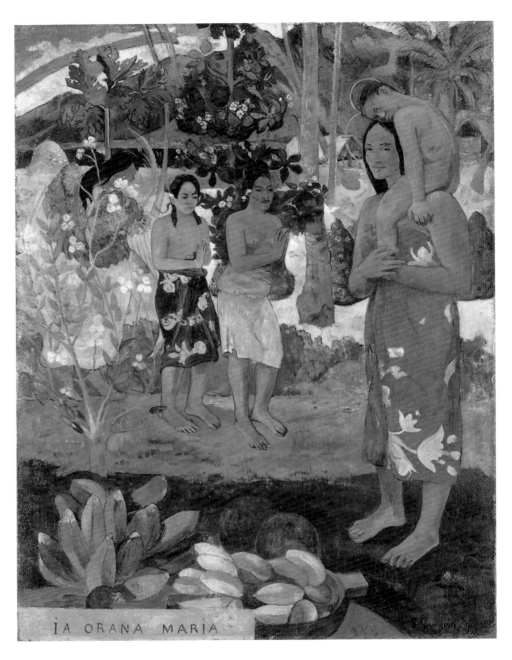

75 *Ia orana Maria (Hail Mary)*, 1891–92. Oil on canvas. The Metropolitan Museum
of Art, New York, Bequest of Sam A. Lewisohn, 1951 (51.112.2). Photo © 1983
The Metropolitan Museum of Art.

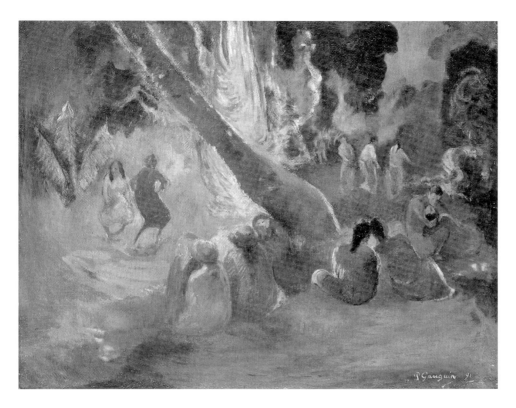

76 *Upaupa (Tahitian Dance)*, 1891. Oil on canvas. Israel Museum, Jerusalem/
Bridgeman Art Library.

Gauguin, in fact, had started producing several other significant works during these early days,
all of which, even at this stage, reflected his determination to develop new themes in keeping
with his new surroundings and to adapt some old ones to a new context. Although more fully
characterized in later versions of the work, the symbolic message of *Upaupa (Tahitian Dance)*
of 1891 (fig. 76) is already quite bold. The title itself is the name of a traditional dance.[16] Judg-
ing from the accounts of travelers, such dances were cheerful, frequently openly lascivious, and
sometimes grossly obscene.[17] They were occasionally performed at night, under conditions that
also elicited fear: "lit by torches . . . in areas in which superstition and puerile fears hardly per-
mitted [others] to wander outside their abodes."[18] The dances had been frequent and well-
attended entertainments— at least until the missionaries' teachings had put a stop to them. Gau-
guin saw Moerenhout's text only after he had completed the painting, but Captain James Cook
had reported on native dances in the eighteenth century, and Gauguin had probably been briefed
by other residents and may even have seen natives performing similar steps. Here, the energy

77 Preparatory drawing for *Upaupa*, 1891. Graphite on paper. Private collection.

of the fire, the frantic steps of the two dancers, and the couple in tender embrace on the right convey the spirit of the action, while the potential for superstitious fear is evoked by the dark ambience and the animation of the shadows. The energy of the fire is also ominous.

In a preparatory drawing for *Upaupa* (fig. 77),[19] an idol-like figure in the dancing area evokes the ancient religious roots of the scene. The figure's head is based on an elegant stylization like that of the rag-doll idol in *Portrait of the Artist with the Idol* (see fig. 70); her wide hips make her something of a mother-goddess. To the left, a lance-bearing fighter in feathered regalia is yet another link with the past. The idol is absent from the finished *Upaupa*, but one can distinguish— barely—in the turbulence of the central flame, two reddish lines hinting at a mouth and three bluish stains suggesting asymmetrical eyes and a nose. It is as if the flame were the embodiment of a seated deity endowed with a large face and a small body. Long, thin undulating fingers of fire rising above it suggest energized hair. The motif is repeated in the related woodcut *Mahna [Mahana] no varua ino (The Evil Spirit Speaks)* of 1893–94 (fig. 78), albeit with less distinct anthropomorphic features. The "evil spirit" is evoked in numerous other works of the Polynesian period, usually with features that Gauguin ascribes to Tefatou, the destructive god of the earth and of earthquakes, but sometimes endowed with the artist's own features. On the positive side, both the energy of the fire and the embrace of the couple of *Te faruru (Here We Make Love)* of 1893–94 (fig. 79) may be associated with the forces of regeneration. The head of Tefatou emerges from lines of swirling smoke above the lovers (see also figs. 112 and 125), bearing the caricatural features of a vain and determined man that Gauguin assigned to Tefatou after reading Moerenhout.

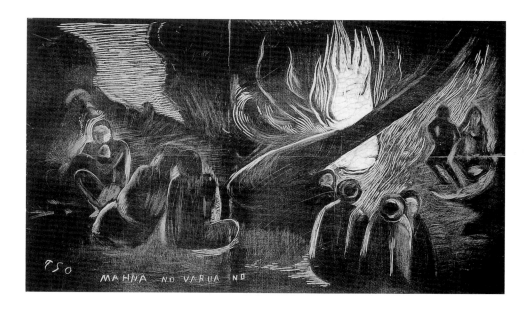

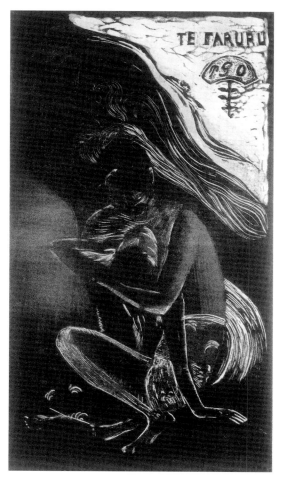

78 *Mahna [Mahana] no varua ino (The Evil Spirit Speaks)*, 1893–94. Woodcut, from the endgrain of a boxwood block, in black on ivory China paper. The Art Institute of Chicago, Gift of the Print and Drawing Club. Photo © The Art Institute of Chicago. Photographed by Greg Williams.

79 *Te faruru (Here We Make Love)*, 1893–94. Woodcut printed from endgrain boxwood in ochre and black on japan paper stained prior to printing with various hand-applied and transferred watercolors and waxy media. Clarence Buckingham Collection, The Art Institute of Chicago. Photo © The Art Institute of Chicago. Photographed by Greg Williams.

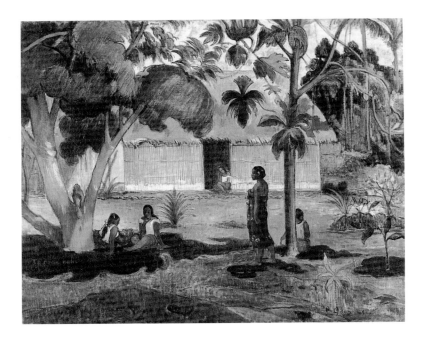

80 *Te raau rahi (The Big Tree)*, 1891. Oil on canvas. © The Cleveland Museum of Art, Gift of Barbara Ginn Griesinger, 1975.263.

In *Te raau rahi (The Big Tree)* of 1891 (fig. 80), two seated women in the left foreground seem to be chatting casually as one bites into a fruit. A standing woman, partly turning her back, appears to be walking toward them with poise and self-assurance. All three constitute links with Gauguin's Breton and Tahitian themes. The standing woman, for instance, continues the tradition of the woman turning her back on love and its woes, first encountered in the figure on the beach walking away from Meyer de Haan and his love entanglements in *Nirvana: Portrait of Jacob Meyer de Haan* (fig. 44). This kind of "self-righting" Eve, which recurs in several works, presages an important element of the powerful and disconcerting iconography of the ceramic statuette *Oviri (The Savage;* see fig. 118).

The seated figure biting into the fruit represents if not quite a falling Eve, then at least an Eve who should be more thoughtful. She suggests a foolish virgin, in keeping with the message conveyed by the falling Eves of the Brittany period, such as the one in the 1890 wood carving *Be Mysterious* (fig. 47). The seated figure leaning on her taut right arm foreshadows the jealous woman in *Aha oe feii? (Are You Jealous?)* of 1892 (see fig. 82), in particular. Countering the woman biting into the fruit, she evokes the disappointments of love in the tradition of Gauguin's fallen Eves. The last two figures, therefore, each correspond to one of the two Eves looming behind Meyer de Haan in *Nirvana*, much as the first, standing figure corresponds to the departing "self-righting" Eve.

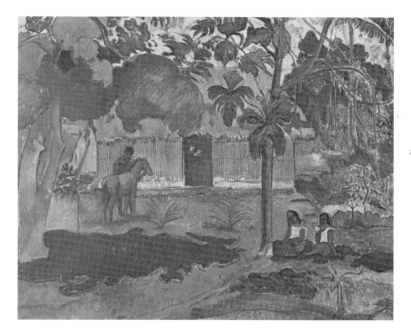

While the standing figure is absent from *Te fare Maorie (The Native Hut)*, also of 1891 (fig. 81), the seated woman eating a fruit—the foolish virgin—appears, and the other seated figure has been transformed into a young woman leaning her head pensively against her right hand, while her elbow is supported by her thigh. She is the prototype of the wise virgin in later works. A little behind them, a vigorous young man has dismounted from his horse, which he seems about to tether to a native hut: a Prince Charming, it would seem, to whose arrival the two seated women are already responding through the expressiveness of their attitudes. The two of them, Eves as foolish and wise virgins, will become the principal characters of *Nave nave moe (Delicious Mystery,* or *Sacred Spring)* of 1894 (see fig. 116), evoking, respectively, the reckless and the prudent approaches to love and its potential woes.

*B*y November of 1891, Gauguin had rented a hut a few miles outside of Papeete and settled there with Teha'amana. By March 11, 1892, according to a letter of that date to Monfreid, he was reworking his first major Tahitian work, *Ia orana Maria* (fig. 75).[20] Clearly the entire composition was rearranged at a late stage; the figures in the sketch are disposed horizontally, whereas the finished painting is in a vertical format. A description follows in the letter: "A yellow-winged angel points to two Tahitian women, Mary and Jesus, also [depicted as] Tahitians . . . I am rather

pleased with it."[21] Like the scene in *Upaupa*, *Ia orana Maria* was clearly intended to evoke atavistic remnants of the ancient religion and mores that had survived the impact of the missionaries—even though the picture appears to have been conceived before Gauguin could have read Moerenhout's book.[22] Struck by the exquisite taste he detected in the Tahitians, by the poetry they infused into a variety of activities,[23] and undoubtedly in this case by their tendency to adapt Christian practice to what was left of their own traditions, Gauguin imagined a graceful and tender Christian sanctification of the ancestral attitudes and eternal feelings that the natives traditionally associated with maternity. This is not, strictly speaking, a supernatural scene, for Gauguin did not believe in the literal aspect of miracles; it merely evokes the inner vision of exalted natives. This fusion of two religious traditions in order to bring out a common characteristic of momentous human import, incidentally, is typical of Theosophical thought.

The traditional social units in Polynesia were large, gregarious groups of families and friends, sometimes cohabiting in large huts. It was customary for women in the group to visit pregnant ones and young mothers needing company, help, and attention.[24] The two figures in the center are such visitors. In the background, unseen by them, is a Florentine Renaissance angel of the same skin color as the natives, wearing a light pink robe and endowed with blue-and-gold wings. The angel is seen in a three-quarter view from the back, turning its head toward the mother and child. Its role here is similar to that of the priest/Gauguin in *The Vision after the Sermon: Jacob Wrestling with the Angel* of 1888 (fig. 49): the priest who inspires the peasant women to envision two young men engaged in a wrestling contest as a biblical struggle, and the artist who exposes the women to a new art, based partly on Japanese and Western medieval precedent. As if in response to these two visionaries, the women clasp their hands and begin to kneel in prayer. In *Ia orana Maria* it is the angel who causes the two visitors to envision mother and child as Mary and the Infant Jesus, and likewise inspires their reverence.

The pale blue and purple of the angel's wings, the light pink skirt, the delicate pattern of the white laurel blossoms, and the golden yellow of the field behind it evoke quattrocento Florentine painting, but Gauguin also relied on avant-garde Parisian religious art to convey the charm and splendor of Catholic ritual. The graceful, somewhat art nouveau delineation of the angel's wings and skirt brings to mind the figures of the Catholic-revivalist Nabi artist Maurice Denis, with whom Gauguin had shared a studio before leaving Paris, together with the Nabis Pierre Bonnard and Edouard Vuillard and the actor and director Aurélien-François-Marie Lugné-Poë.[25]

The angel holds a martyr's palm—apparently a reminder that self-sacrifice was integral to the church's teaching, whether the Tahitians endorsed it or not.[26] Most important, the symbolism of motherhood, the passing of life from one creature to another, and the associated message of compassion, tenderness, and love pertain both to the Judeo-Christian tradition and to primitive tra-

ditions such as the Polynesian one with its emphasis on procreation and child-rearing. There is a gentle moral humanitarianism here, as well as a melding of two religious traditions intended to bring out their common philosophy, in keeping with the principles of Theosophy.

The interplay of the figures' rhythmic curves, inspired by the friezes of Borobudur (figs. 41–42), suggests suspended movement.[27] The slight swelling of the surfaces, in keeping with the Hindu and Buddhist concept of inner breath, is handled with greater authority than in *Exotic Eve* of 1890 (fig. 67). And terms of expressive content, the Borobudur friezes contribute a Buddhist sense of serenity and heightened detachment. All these elements are in keeping with the serene dignity and charm of the traditional Western theme of Madonna and Child—interpreted here in a Polynesian context. The joint introduction of Buddhist and Christian elements is further evidence of Gauguin's consciousness of Theosophical principles.

*M*uch as he had drawn on Breton lore, Gauguin began to use important symbolic elements from ancient Polynesian religion and traditions. He also read with considerable care the very detailed anthropological and historical accounts provided by earlier travelers—most significantly, the work of Moerenhout.

Jacques-Antoine Moerenhout was born in 1797 near Antwerp, in French-occupied Belgium. According to a recent biographer, he received some training in art, architecture, and map-making through an apprenticeship. The portraits that he executed for his book reflect a tame affiliation with the neoclassicism of Jacques-Louis David, as well as considerable psychological acuity.[28] In 1812 he volunteered for the French army, in which he was first assigned to map-making, then took part in Napoleon's later campaigns, witnessing successive defeats. Wounded, he returned to Antwerp in 1814, where he appears to have gained commercial experience, and in 1826 he set out for Valparaiso, Chile, accompanying the representative of a Dutch firm. The two combined their assets in 1828, enabling Moerenhout to establish a trading post in Tahiti.

Moerenhout reached the island in mid-March 1829 with a cargo of clothes and a team of pearl-divers that he had recruited in Pitcairn. Several trips to the Americas and Europe notwithstanding, he remained in Tahiti for seventeen years, during which time he principally traded *copra* (dried coconut), arrowroot wood, and mother-of-pearl in exchange for European and American goods—losing two ships and a fortune in the process. He also was twice appointed honorary consul for Polynesia—by the United States in 1834 and by France in 1838. Primarily devoted to the interests of France, Moerenhout became involved in a bitter contest with George Pritchard, a Protestant missionary and British consul, who was the friend and confident of Tahiti's Pomare IV; at the height of their conflict, ax-wielding assassins killed Moerenhout's wife and se-

riously wounded him. The Belgian nevertheless managed to persuade his friend Tati, who was the provincial chief of Papara, a descendant of the former royal family, and the son of a high priest, as well as other great nobles, to seek France's protection for Tahiti in 1841. In doing so, Moerenhout paved the way for a French landing and the queen's resulting request for French protection in 1842—effectively turning over her country to France. Ruffled British feathers were eventually smoothed in the spirit of an *entente cordiale*.

In return, Moerenhout was promptly—albeit briefly—appointed King Louis-Philippe's representative in Tahiti, as well as one of the three provisional administrators of the new French protectorate. Shortly thereafter, he became chief of Tahiti's police. Expelled by Moerenhout, Pritchard was soon appointed British consul in Samoa. On June 6, 1846, Moerenhout himself set sail for California to serve as French consul in the territory's capital, Monterey, where, with his usual diligence, he studied and profited from the gold rush. He was eventually posted to Los Angeles, where he died in 1879, revered and beloved by the French colony, among others.[29]

Moerenhout had clearly benefited from a strong classical French education. An inveterate student, by the time he wrote *Voyages* he was familiar with reports on Polynesia by James Cook and other travelers. He was a sensitive observer as well, writing at length and with considerable precision on the mores and traditions of the people of Tahiti and other Polynesian islands. In the spirit of the Enlightenment, his interests ranged from anthropology, ethnology, botany, zoology, and geography to comparative religion, history, linguistics, cosmogony, and navigation.

In 1831 Moerenhout managed to gain the confidence of an old Tahitian priest. Diffident at first out of fear of reprisals by the missionaries, the priest warmed up to Moerenhout when the latter assured him, "Everywhere we serve the same God. Taaroa or Jehovah are only names. Divinity is always the same."[30] Soon Moerenhout persuaded the old priest to recite prayers as well as the sagas of the gods, and over several sessions the priest gave detailed accounts of the island's ancient religious traditions. Chief Tati, who had arranged the meeting, must also have provided much information about traditional mores; Moerenhout took careful notes.

During the course of Moerenhout's second sojourn, in the early 1830s, Tati was involved in fierce political and armed contests opposing various factions—the queen and her men, the chiefs and theirs, paganizing rebels to whom the queen was sympathetic, and brutal, disaffected Europeans—which the traveler evoked with an abundance of topical observations in his lively sketches of political and military history.[31]

If one sets aside a huge degree of sexual freedom, especially for men, it does not seem that male-female relations were much different in Tahiti from elsewhere in the world. Yet Moerenhout, following earlier writers, noted, "Mores in all these isles were extremely licentious. . . . [But] it is in the Society Islands [to which Tahiti belongs] that the mores are truly the most de-

praved. Tahiti itself . . . has shown into what excesses ignorant peoples who do not have to contain, or at least control, their passions can fall."[32]

Among most Tahitian couples, Moerenhout reported, marriage was entered into in adolescence, without religious or civil sanction. With the consent of the husband, a union could just as easily be annulled, although this became more difficult once the marriage had produced children.[33] Gauguin himself was amused by the prevalence of promiscuity and, in particular, by the flexibility of the bonds of marriage: "What if we made an exchange?" one bridegroom asked after a double civil ceremony and before going to the church, the artist related.[34] Moerenhout went on to describe how several couples often shared an abode, sometimes a large communal house, and jointly took charge of the children, who were allowed considerable freedom.[35] Traditionally, husbands had the power of life and death over their wives and expected them to remain faithful, but they could also offer them for prostitution.[36] By the time of James Cook's voyage to the islands in the second half of the eighteenth century, such codes of behavior had been weakened almost to the point of extinction. According to Moerenhout, "Few young brides did not have their moment of weakness, and if they maintained a certain reserve before their marriage, they well knew, on the whole, how to make up for lost time as soon as they got married, especially when their husbands were away; as most gave in to temptation, knowing that there would be no ill effects." Cook had noted that a woman who strayed might expect some form of reprisal from her husband or companion, but "no more than . . . a few harsh words, or perhaps, a slight beating." Moerenhout also mentioned "blows" as the price of betrayal, adding, however, that some women were punished for infidelity by death.[37]

Gauguin, for his part, claimed to have shown great magnanimity after accusing his companion, Teha'amana, of infidelity, and receiving as a response, "I must be beaten, beaten a lot." Touched by "the resigned expression of her face, this beautiful body," which aroused in him "the memory of a perfect idol . . . a masterpiece of creation," he kissed her.[38]

While men could be possessive, "to say that women were free of jealousy would be far-fetched," Moerenhout wrote, adding, "It was not so much their attachment to [unfaithful] lovers or husbands that caused them to despair, but rather that a rival should be found more desirable."[39] It is the intensity of this feeling that the critic Achille Delaroche, probably echoing a statement by the artist, recognized in the expressive power of color in *Aha oe feii? (Are You Jealous?)* of 1892 (fig. 82): "If such a work represents jealousy, it is through a conflagration of pinks and violets—the hues of a beautiful Tahitian sunset—in which the whole of nature seemed to participate, as if in full conscience, yet silently."[40]

The overall expressiveness of *Aha oe feii?* was strengthened by the artist's psychological observation and his reliance on symbols. The pose of the seated figure is derived from that of the

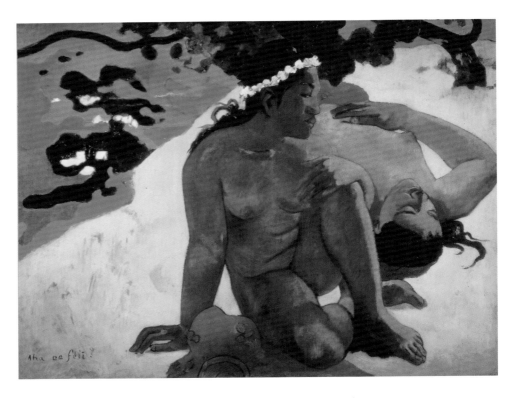

82 *Aha oe feii? (Are You Jealous?)*, 1892. Oil on canvas. Pushkin Museum of Fine Arts, Moscow/Giraudon/Bridgeman Art Library.

figure on the far left in *Te raau rahi (The Big Tree)*, but seen from the front. In contrast to the earlier figure, who seems more restrained than the easygoing fruit eater she is facing, the seated figure in *Aha oe feii?* carries a profound suspicion in her facial features, and the twist of her fleshy mouth is one of disapproval and resentment. And although it may seem relaxed, the woman's body seems poised to manifest her anger, as her powerful right arm might give her a thrust, allowing her muscular legs to unfurl. Much larger in scale than her prototype in *Te raau rahi*, this woman is shown in *repoussoir*, as a dark form in the foreground against a light background—the low-value colors of her body further darkened by the contrast with the vibrant, higher-value colors behind her. The woman's companion is lying down in a state of graceful and seductive relaxation. Her face is turned up, and her clearly delineated breast and prominent nipple point toward the sky, as if in an offering of love. Nature makes a significant symbolic contribution to the painting's expressiveness: amid the colorful play of the reflections on the water's surface, one perceives an incongruous black arabesque—turning into a malevolent lizard-inspired mon-

83 Javanese shadow puppet. Painted animal hide. Private collection, by permission.

ster of Gauguin's invention. Its overall proportions, and, more specifically, its small paw descending from a voluminous midriff, bring to mind the configuration of traditional Javanese leather shadow puppets (fig. 83). The tentacles jutting toward the women suggest menacing front paws or arms, and the ribbonlike extremities at top and bottom resemble the head and tail of an awesome reptile. It is an intriguing cryptogram of jealousy, the jet black contrasting with the rich and varied hues of the reflections on the water and the violet-pink of the beach at sunset.

The interpretation of the arabesque as a malevolent monster is confirmed by the woodcut *Auti te pape (Playing in the Water)*, or *Women at the River*, of 1893–94 (fig. 84) in which the figure of the jealous woman appears alone, to the left, while the other woman, instead of lying down, open to advances, now stands on the nearby bank of a river, thrusting herself into the water. She is the Tahitian equivalent of the Breton falling Eve, plunging into the water, but rather than having one elbow raised to protect her head from the fall, she now raises both forearms in fear or distress. Two black forms in the water evoke fear itself: a malevolent dolphin's head and a

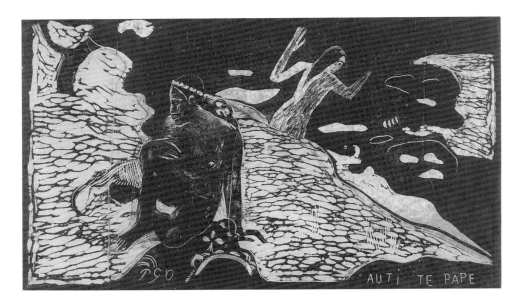

84 *Auti te pape (Playing in the Water)*, or *Women at the River*, winter 1893–94.
Woodcut on boxwood with touches of gouache. Collections Jacques Doucet,
Institut national d'histoire de l'art, Paris.

disquieting skeletal human face that emits an eerie glow through irregular white openings for
the eyes and mouth.

In sum, Gauguin returns in *Aha oe feii?* to an opposition between the themes of the woman
who gives herself, or in this instance dreams of doing so, and of the one who suffers from hav-
ing done so. He is thus invoking, once again, the sardonic theme of the 1889 wood carving *Be
in Love and You Will Be Happy* (fig. 37).

To those who might ask what Tahitian young women dream about, Gauguin responds: *Nafea
faa ipoipo (When Will You Marry?)*—the title of a painting of 1892 (fig. 85). The work, as we
shall see, alludes to the biblical parable of the wise and the foolish virgins, and it may even be a
deliberate reference to the condition of women in Western societies evoked in three treatises—
Les vierges sages of 1842, *Les vierges folles* of 1840, and *Les vierges martyres* of 1842—by Flora
Tristan's friend Alphonse Esquiros.

Virginity, of course, was of no consequence to Gauguin, nor to the Tahitians.[41] Gauguin's
point, in fact, is that women who have control over their emotions and senses—and over those
of their lovers—are more likely to retain their lovers' affections, as he had suggested in the wood
carving *Be Mysterious* of 1890 (fig. 47).

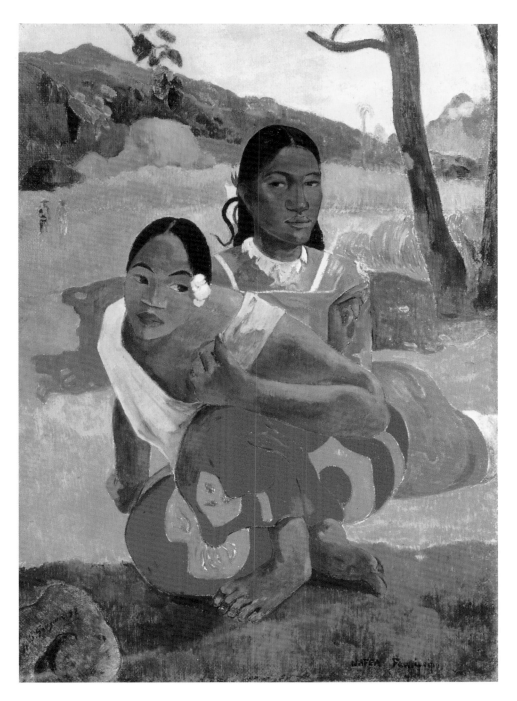

85 *Nafea faa ipoipo? (When Will You Marry?)*, 1892. Oil on canvas. Basel, Switzerland, Rudolph Staechelin Family Foundation, Basel, Switzerland / Bridgeman Art Library.

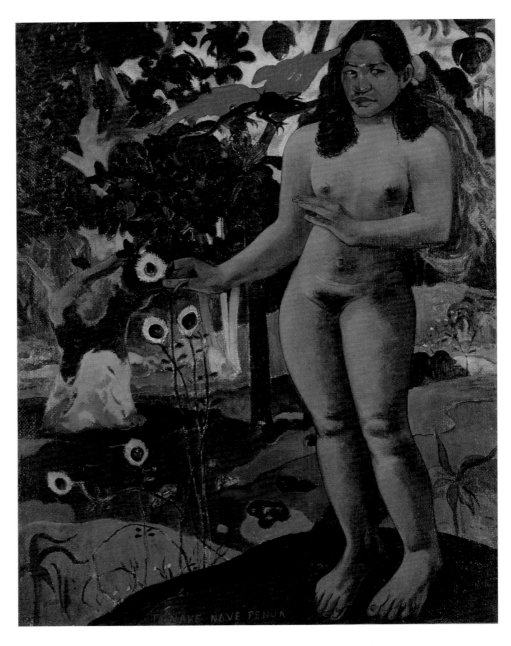

86 *Te nave nave fenua (Delightful Land)*, 1892. Oil on canvas. Ohara Museum of Art,
Kurashiki, Japan.

Here, the young woman immediately in the foreground, crouching with considerable ease, wears a loose, very low-necked white blouse and a lusciously patterned red-orange and yellow skirt. Her very regular facial features are pleasant and her bow-shaped lips richly sensuous. But her expression is passive, her features a little weak, and her glance somewhat hollow. The complex composition of the body has something of the latent dynamism and linear balance and elegance of Edgar Degas's dancers. She seems ready to bare her left shoulder and breast for an admirer outside the frame, graciously and invitingly tilting her head in the process, ready to spring to her feet should he beckon her. She is the foolish virgin of the parable.[42] Her companion, by contrast, sits upright, her pose much more controlled. She is covered up to the neck by a chaste missionary-type dress of a delicate orange-pink with a white collar. Her features are regular, her elongated face a little severe, and her mien quite serious. Her somewhat intent eyes are scrutinizing the unseen onlooker with a gaze not devoid of humor. Her finely modulated, fleshy lips are reserved, but they could well open up into a sensuous smile. With her right hand she makes a gesture resembling that of the figure seated third from the left in the Buddhist frieze from Borobudur, *Merchant Maitrakanyaka Greeted by Nymphs* (fig. 41, bottom). Gauguin has raised the middle finger and straightened it a little more, turning the gesture into a signal pointing toward wisdom and moderation. The woman evokes the "wise virgin," able to control herself and "be mysterious" when the occasion arises.

Gauguin continued to treat the Eve motif much as a musician would compose variations on a theme. In a population that, according to Moerenhout, indulged regularly in ritualistic orgies,[43] if the woman tempted by amorous adventure can be timorous for a second, she can nevertheless also overcome any inhibition with assurance. Such is the case of the Eve in *Te nave nave fenua (Delightful Land)* of 1892 (fig. 86).[44] In the words of Delaroche: "An unreal orchard offers its insidious flowers to the desire of an Eve from the Garden of Eden, whose arm is timorously extended to pick the flower of evil, as the flapping red wings of a chimera whisper near her temple."[45] For both artist and critic, the word "chimera," describing the winged lizard—which substituted for the serpent, unknown in Tahiti—carried a double meaning in French—"monster" and "idle fancy" (the latter including spontaneous carnal desire). The "flower of evil," undoubtedly one of Charles Baudelaire's, suggests both the appeal of sin and that poet's disgust with facile pleasures.[46] The flowers themselves confirm Gauguin's allusion to Baudelaire: their corolla is derived from Odilon Redon's endpiece (fig. 87) for his 1890 lithographic series *Fleurs du Mal (Flowers of Evil)*, a sunflower with disheveled eyelashes instead of petals. Gauguin in turn elongated the "petals" at the top to suggest peacock feathers. The peacock and its feathers have a long-standing emblematic significance, the feather having been defined as a symbol of vanity by pre-Raphaelite and art nouveau masters, and the bird itself, according to

87 Odilon Redon, *Cul-de-lampe (Endpiece)*, 1890. Lithograph, no. IX in a portfolio of prints inspired by Baudelaire's *Fleurs du Mal (Flowers of Evil)*. Rosenwald Collection, National Gallery of Art, Washington, D.C. Image © 2007 Board of Trustees, National Gallery of Art, Washington.

paleo-Christian tradition, an emblem of survival—vanity as an inducement to succumb to temptation and so promoting lovemaking and, by extension, reproduction.

Gauguin reflected on the mental state of such a Tahitian Eve in a passage composed in 1896–97: "The body has remained animal. But the head has progressed with evolution, her thought has acquired subtlety, love has etched its ironic smile on her lips, and she naively seeks in her memory the why of past times, of the present." Regret or remorse hardly grazes her consciousness: "She is Eve after the sin, still able to walk naked with no sense of indecency, conserving all her animal beauty as in the first day, . . . enigmatically, she looks at you."[47]

A gouache of the same subject bears the inscription "Do not listen to the liar," ironically opposing the serene dignity of this Eve to the despair of the Breton Eve–Peruvian mummy of *Don't Listen to the Liar* of 1889 (fig. 35). Relatively unaffected by Judeo-Christian entreaties, Tahitian Eves are "self-righting" at least in theory.

The Polynesian Pantheon

What a religion, this ancient Oceanic religion!

To Paul Sérusier, March 25, 1892

Gauguin's reading of Jacques-Antoine Moerenhout's account of the Polynesian religion sometime before April 25, 1892, caused him to exclaim, "What a religion, this ancient Oceanic religion!" in a letter to his friend and erstwhile disciple, Paul Sérusier. "What a marvel! It bowls me over, and all that it suggests to me will thoroughly frighten [the public]. Indeed, if my earlier works were not welcome in a drawing room, what will be said about the new ones? . . . I am so shaken by what I am doing here that I cannot talk about it; never will the public accept it. It is ugly from every standpoint, and I won't really know what it is like until I get back to Paris and all of you have seen it. . . . What I am doing now is very ugly, very mad. My God, why did you make me the way I am? I am cursed."[1]

It was to the little rag-doll idol of the *Portrait of the Artist with the Idol* of 1891 (fig. 70) that Gauguin turned for the statue in the *Upaupa* drawing of 1891 (fig. 77), executed soon after his arrival in Tahiti. The same prototype, further altered and refined, is at the root of what was probably one of the first Tahitian wood carvings, if not the first, to evoke an important deity of the ancient religion and to reveal its name: the wood statuette *Hina: Goddess of the Moon* of 1892 (fig. 73). According to Moerenhout, one of that deity's most notable achievements, her regenerative powers, was revealed in a dialogue between the goddess and Tefatou, god of the earth, recited by the old

88 "Dialogue between Tefatou and Hina," from the album *Ancien culte mahorie*, folio 7 (recto), 1892–93. Watercolor on paper. Musée du Louvre, Paris. Photo: Réunion des Musées Nationaux/Art Resource, New York. Photographed by Hervé Lewandowski.

priest.[2] Gauguin condensed Moerenhout's translation of the dialogue in his manuscript of 1892–93, *Ancien culte mahorie*, evoking in a watercolor of Hina and Tefatou (fig. 88) the two deities in earnest discussion, each extending a hand as if to cast a spell on the other.[3] Both are drawn in a simple, jaunty, almost childlike manner reminiscent of some of the Brittany water-color fantasies.[4] Nonetheless, the two show strong Polynesian elements: the stylization of the hands, here reduced to two straight, equal-sized, parallel fingers—thumb and index—and the so-called bent eyes, consisting of ovals with pointed ends, bisected by a line, situated at a slight angle to the horizontal. Both devices are derived from Marquesan art, as in the top of a Marquesan oar decoration (fig. 89).

89 Top of a Marquesan oar. Carved wood,
line drawing after the original in the
British Museum, London.

The oversized heads are also typically Marquesan, but, in conjunction with Gauguin's jaunty execution, they transform the figures into puppets, and the deities' momentous exchange turns into a scenario for marionettes. Gauguin is once again a fabulist and a caricaturist, here presenting thoughts about life, death, and the survival of the spirit in the guise of an amusing little tale of childlike simplicity.

In Moerenhout's account of the myth:

Said Hina to Tefatou: "Bring man back to life after his death."

Fatou: "No, I shall not bring him back to life. The earth will die, the vegetation will die;

it will die, as will the men who feed from it; the ground that produces them it will die, the earth will end; it will end never to be reborn."

Hina: "Do as you will; I shall make the moon come back to life." And that which Hina possessed went on being; that which Fatou possessed perished, and man had to die.[5]

Moerenhout added his own commentary, undoubtedly influenced by the seven-volume *Origine de toutes les religions, ou religion universelle*, by Charles Dupuis, of 1795,[6] which, its title notwith-standing, did not treat Polynesian religion. Dupuis, an Enlightenment thinker and a member of the Convention, France's governing body at the height of the 1789–95 Revolution, sought to es-tablish concepts common to all religions such as eternity and spirituality, in keeping with the official consecration of the Supreme Being who transcended all accepted faiths, and in an effort to justify, after the fact, the closing of churches under the Revolutionary government. Dupuis also supported the notion that all ancient religions reflect a common desire to interpret the phe-nomena of nature, thus validating the cult of nature prevalent during his time and continuing into the Romantic period. It is in that spirit that Moerenhout interpreted the dialogue as the as-sertion of a belief in eternity: "The periodic return of [the moon's] phases . . . made [the an-cient Polynesians] rank it among things eternal, and [the moon] only died to reproduce herself, in perpetuity." As for spirituality, it was also present, albeit in strange and erratic ways. In an-other passage Moerenhout explained, "It seems certain that [for the Tahitians] the premises of religion did not extend beyond present life; that they only had a vague idea of another life."[7] To sum up his position, the *varua*—spirit, or soul, or life, which pertains in varying degrees to an-imals and plants as well as to humans—survived. Souls were judged when they left the earth: they might undergo horrendous tortures in hell or enjoy the bliss of heaven, but most Tahitians died "without fear or hope," and most souls merely hovered in *Po*, night or darkness, frequently returning to their earthly families to watch over and protect them, or sometimes to pester, frighten, or wreak vengeance upon the living.[8]

Gauguin essentially accepted Moerenhout's conclusions but added his own twist to the story. There is no mention in the sacred texts quoted by Moerenhout, or in his commentaries, of an amorous relationship between Hina and Tefatou, yet Gauguin presents them as lovers in the wa-tercolor (fig. 88): both figures are naked and in close proximity. Hina's vulva, disproportion-ately large, is fully exposed, and rich and suggestive tattoos adorn the buttocks of both deities. Two twisting peacock feathers-sunflowers, reminiscent of Charles Baudelaire's *Fleurs du Mal*, are placed between them, further adding to the suggestion of impending sexual activity, just as they do in *Te nave nave fenua* (fig. 86). The two deities are shown in an even more intimate re-lationship in another watercolor in the manuscript *Ancien culte mahorie* (fig. 90), in a position

Maoti tau tē' ori ori
A tou tē' marama ora toura
Ta hina pohē' a toura
Ta Tē'fatou o tē' taata.

90 "Dialogue between Tefatou and Hina," from the album *Ancien culte mahorie*, folio 4 (recto), 1892–93. Watercolor and ink on paper. Musée du Louvre, Paris. Photo: Réunion des Musées Nationaux/ Art Resource, New York. Photographed by Hervé Lewandowski.

similar to that of the figures in the Marquesan carved oar ornament in the British Museum (fig. 89): Hina's abdomen is now pressing into Tefatou's back. It might be argued, of course, that such a relationship is not, strictly speaking, sexual, but the figurines of the oar ornament—whose proportions and hands are emulated in the watercolors—are similarly represented, and the amorous nature of their relationship is fully established by its outcome: a swaddled baby resting on both their heads.

For Gauguin, then, the dialogue becomes a symbol of lovemaking, which brings into being the cycles of regeneration, ultimately ensuring the survival of man's spirit through his creations on earth, in keeping with the teaching of Tolstoy (see chapter 6). Indeed, in the second water-

91 *Two Marquesan Women and Design of an Ear Ornament*, 1892. Reed pen and metal pen and brown ink and graphite on velum. The David Adler Collection, The Art Institute of Chicago. Photo © The Art Institute of Chicago.

color evoking Hina and Tefatou, man is suggested by a small rectangular head at the gods' feet, which vaguely recalls Marquesan rectilinear design, as in Gauguin's *Two Marquesan Women and Design of an Ear Ornament* (fig. 91). The head generates a green cloud from the top of its cranium, from which unfolds an undulating musical score (four staves and a fragment of the fifth!) strewn with scraggly notes and clefs. To the right, on a chartreuse ground, is a series of regular geometric shapes suggesting a simple and strongly articulated textile or tattoo design. Clearly, the arts will survive through the cycles of regeneration!

The theme of Hina and Tefatou recurs frequently in Gauguin's work. It appears on the back and front of a nearly cylindrical wood statuette of 1892 that wittily evokes the sequence of their dialogue (fig. 92). Once again the style is caricatural and jaunty, with the oversized heads bringing to mind a puppet theater. The figures are naked and in intimate proximity. In what is clearly the first scene (fig. 92, left), they are seated on their bent legs, literally knee to knee. Hina raises her hand with bent fingers in an attempt to caress Tefatou's chest, imploring him, as might a pet

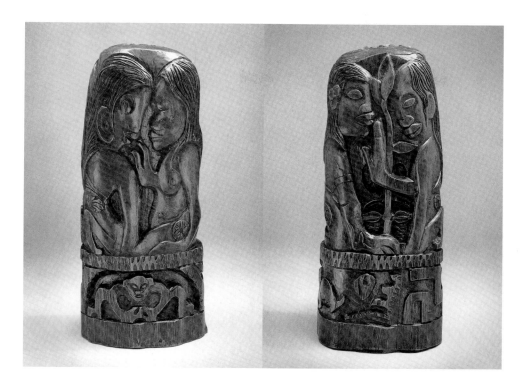

92 *Hina and Tefatou Cylinder* (recto and verso), ca. 1892. Carved tamanu wood.
Art Gallery of Ontario, Toronto, Gift from the Volunteer Committee Fund, 1980.
Photo: Carlo Catenazzi.

seeking human attention, to grant man immortality. Tefatou's round eye and snout are those of a young bull, and his head is lowered as if about to charge. A design detail, however, adumbrates Hina's eventual success: the shape of her breast roughly approximates half a yin-yang sign, the Chinese symbol of eternity.

In a cave or basement, below the horizontal division made by a zigzag line of Marquesan inspiration (as in the oar ornament), Hina's prayer is already raising the hopes of mortals: an energetic primate endowed with large ears, presumably able to follow the gods' debate, fills the space with his curving limbs, apparently delighted by the prospect of shedding the fetters of mortality. The disk behind its left shoulder suggests the protection of the moon.

The positions of god and goddess are reversed on the back of the statuette (fig. 92, right). Raising his hand with authority in a gesture of refusal, Tefatou appears withdrawn and unmovable. Hina, sitting upright and thrusting her chin forward, evinces dignity and quiet determination. The combination of her prominent profile, the near-verticality of her arm, and her

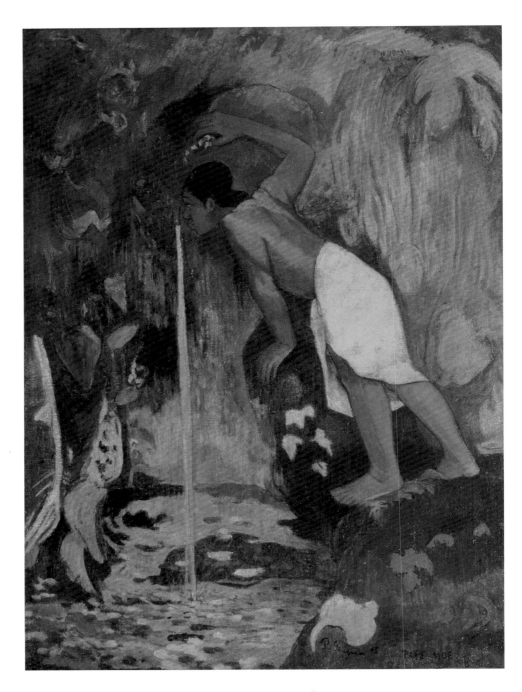

93 *Pape moe (Mysterious Water)*, 1893. Oil on canvas. Private collection.
Photo courtesy Pierre Gianadda Foundation, Martigny, Switzerland.

hand resting like a paw on the ground gives her the appearance of a sphinx—her secret, no doubt, being her belief in saving man, or at least his spirit. The vigorous plant rising centrally in the background further implies that life will somehow continue. A flower bud on a stem bearing two horizontal leaves rises between them, symbolic of the vegetal world that Tefatou wanted to destroy, now expressing a wholesome vitality. Below the horizontal division, in a cave or basement once again, a sheep and a dog symbolize submissive domesticity.

Hina and Tefatou reappear frequently in the Tahitian works. While they are not physically present in the painting *Pape moe (Mysterious Water)* of 1893 (fig. 93),[9] they do show up as a reflection in a circular mirror above the *Pape moe* figure in a watercolor of 1894.[10] An inscription by the artist reads:

Why should the spring matter
If the water is delicious?

This suggests that beyond the physical source and all it offers to the thirsty traveler is the gift of eternity, which derives from the cycles of life and all the good things that come with it, obtained through Hina's intercession with Tefatou.

Pape moe has been linked with a passage titled "Pape moe" in Gauguin's account (in *Noa Noa)* of a trip that he claimed to have taken into the island's interior. Seeing a young woman drinking from a spring, Gauguin hid in a thicket. Suddenly aware of his presence, she dove into a pond, but all he found when he looked for her was a large eel at the bottom.[11] The incident is alluded to in a watercolor showing the water stream and drinker, as well as the eel in the pond.[12] In the final painting the eel is not shown, but another anecdotal detail is: the figure is holding in its right hand the relatively large, characteristically striped gray body of a raw shrimp, in keeping with the "immense shrimp" noted in the Le Garrec-Getty version of *Noa Noa* and the "extraordinarily large river crayfish [*écrevisse*]" in the Musée du Louvre manuscript.

The presence of anthropomorphic, zoomorphic, and botanical forms emerging from the irregularities of the rock has been noted by several commentators. Judging from available reproductions (with the caution that the forms are difficult to decipher), one sees that what has been called "the head of a fish"[13] is, rather, that of an elephant with its mouth partially open.[14] Its abbreviated trunk, bent at an almost ninety-degree angle, terminates in the pipe, forcefully expelling the water jet. If it is indeed the head of an elephant, then it must be that of the jovial Hindu elephant-god Ganesha, endowed with the power of overcoming obstacles as he runs through the forest. From this mysterious spring flows the essential water of life—indeed the "life-force," as it is often referred to in Hindu and Buddhist iconography.

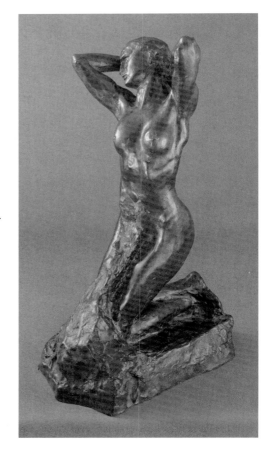

94 Auguste Rodin, *The Awakening*, 1889. Bronze. Musée Rodin, Paris. Photo: Adam Rzepka.

A little to the left, the small figure of a seated nude woman whose right bare buttock and leg emerge from beneath an ample mantle of reddish hair suggests a woodland naiad or nymph. The pallor of the flesh color, no less than silvery highlights along the leg, denote a Caucasian woman. A number of variants of this small-scale white female figure will be discussed in connection with other works.[15] We will refer to it as *The Awakening*, in recognition of the possibility that later versions of that figure were informed by Gauguin's memory of Auguste Rodin's statue of 1889 (fig. 94).[16]

At a higher level on the rock, a barely visible sunflower has what resembles an eye at its center. It could be an allusion to Vincent van Gogh, as in the case of *Tropical Female Nude with Sunflowers* of 1889 (see fig. 40); the eye here takes in the sight of the tropical setting—as well as the life-force symbolism of the stream of water.

The allusion to water as a life-force also pervades *Hina Tefatou* of 1893 (fig. 95). Here the

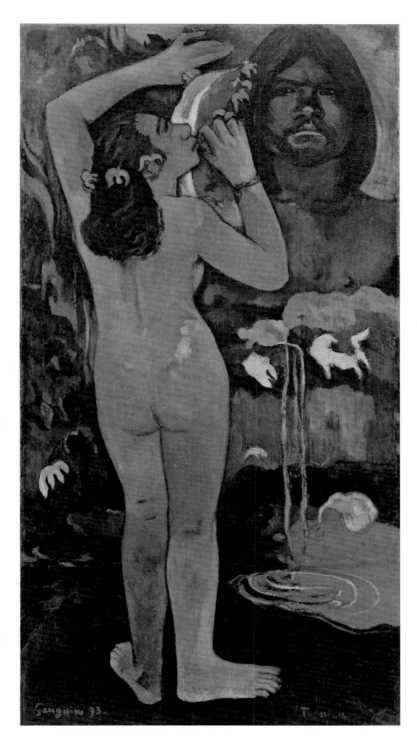

95 *Hina Tefatou (The Moon and the Earth)*, 1893. Oil on burlap. Lillie P. Bliss Collection, The Museum of Modern Art, New York. Digital image © The Museum of Modern Art/Licensed by SCALA/Art Resource, New York.

96 Cover for notebook *A ma fille Aline, ce cahier est dédié*, 1893. Watercolor on paper. Collections Jacques Doucet, Institut national d'histoire de l'art, Paris.

97 Aline Gauguin, daughter of the artist. Photograph from Jean Dorsenne, *La vie sentimentale de Paul Gauguin* (Paris: L'Artisan du livre, Cahiers de la Quinzaine, 1927), following p. 112.

deities are no longer represented as caricatures but as ancient, flesh-and-blood Tahitians. The stream of falling water runs alongside and to the right of Hina's hip and leg. The goddess tenderly raises her arms as if to caress Tetafou's oversize head and shoulders, which seem to emerge from a distant landscape, against a background of orange and white-and-blue clouds, filling nearly a quarter of the picture. The relationship between the supplicating Hina and the resolutely unmovable, oversize god, is not unlike that between the graceful Thetis imploring Jupiter to favor her son, Achilles, in his dispute with Agamemnon and allied kings, and the proud and dour, oversized Jupiter sitting in majesty in Jean-Auguste-Dominique Ingres's *Jupiter and Thetis* of 1811.[17] The juxtaposition again evokes the chasm between apparently immutable forces of nature bent on destruction, symbolized by Tefatou, and humanity's hope for spiritual survival, embodied by the merciful Hina.

In a charming fantasy, Gauguin depicted Hina as an attractive Polynesian adolescent in a watercolor of his daughter Aline (fig. 96). She has shoulder-length, somewhat unkempt hair, with a jaunty lock, evoking unruly bangs, thrusting forward above her forehead; the ribbon intended to tie the strands in the back into a ponytail has come undone. While her nose is somewhat flattened (in keeping with Polynesian features), it is finely modeled at the tip, in the Western mode. She is completely naked, her body adorned with tattoos in the Polynesian tradition; the tattoo on her buttock, presumably a radiating arc of the moon, is reminiscent of the erogenous decorations of Hina and Tefatou in the two *Ancien culte mahorie* watercolors of 1892–93 (figs. 88 and 90). Along the knuckles of her right hand, an orderly series of straight strokes recalls the black keys of endless piano lessons. A diminutive torso and abdomen are sketched out in swift, angular strokes under the much-larger-scale head, shoulder, and armpit, evoking small, pointed breasts and the small ripples of a tight abdomen leading to a tiny raised knee.

The figure adorns the cover of Gauguin's 1893 manuscript inscribed *"A ma fille Aline, ce cahier est dédié"* (the album never reached its dedicatee), and this figure is clearly intended to represent the artist's daughter. The somewhat unruly bangs appear in a photograph of Aline taken some five years earlier (fig. 97); the rather long nose and prominent upper lip are evident both in this and another photo (in which the hair is pulled back into a ponytail).[18]

Reappearing in numerous later paintings, Hina presides over the activities of humanity as goddess of mercy in such major works as *Mahana no atua (The Day of the God [Goddess])* of 1894 (see fig. 125) and *Where Do We Come? What Are We? Where Are We Going?* of 1897 (see fig. 131). As for Tefatou, he also reappears frequently, most often quite unflatteringly as a seducer and mischief-maker—sometimes standing in for Gauguin himself. And the two deities occasionally appear together, symbolic of the cycles of regeneration and the survival of the spirit.

Gauguin had drawn a sketch (fig. 98) for *Vaïraumati tei oa (Vaïraumati Is Her Name)* of 1892

98 Sketch for *Vaïraumati tei oa*, 1892. From a letter to Paul Sérusier in Sérusier's *ABC de la peinture: Correspondance* (Paris: Librairie Floury, 1950).

(fig. 99) in his letter to Sérusier of March 25, 1892, in which he exclaimed, "What a religion this ancient Polynesian religion!"[19] The painting's title comes from an account of Polynesian myths in Moerenhout's *Voyages aux îles du Grand Océan* (1837): "Vaïraumati (such was the name of the young woman). . . ."[20] The story continues with a passage, copied and illustrated by Gauguin in *Ancien culte mahorie*, that represents both deities and humans as ordinary Tahitians. Here, the all-powerful god of war, Oro,[21] who had seen Vaïraumati in Bora Bora and selected her, on the basis of her beauty, to be his spouse, "came down on his rainbow" and was "welcomed by [Vaïraumati], who had a *fata* [multilegged altar] loaded with fruit, as well as a couch made of the richest cloth and the finest plaited mats." Charmed by his new spouse, "Oro returned every morning . . . ," the story continues. Vaïraumati soon "became pregnant." After informing her "that she would give birth to a son," and then that "his time had come and he would have to leave her, [he changed] himself into an immense column of fire." Then "he rose majestically in the air, as high as . . . the highest mountain in Bora Bora, where the distressed Vaïraumati and the astonished populace lost sight of him."

In Gauguin's watercolor (fig. 100), Oro has disappeared, leaving behind a muscular-looking Prussian blue shadow with a black and orange head, its feet near those of Vaïraumati's own black, standing silhouette, indicating that he had kissed her good-bye before vanishing. For a moment at least, Vaïraumati is a seduced and abandoned woman (fig. 101), like so many unfortunate Breton lasses. But after giving birth to a son "who became a great chief" and who, after death, "ascended

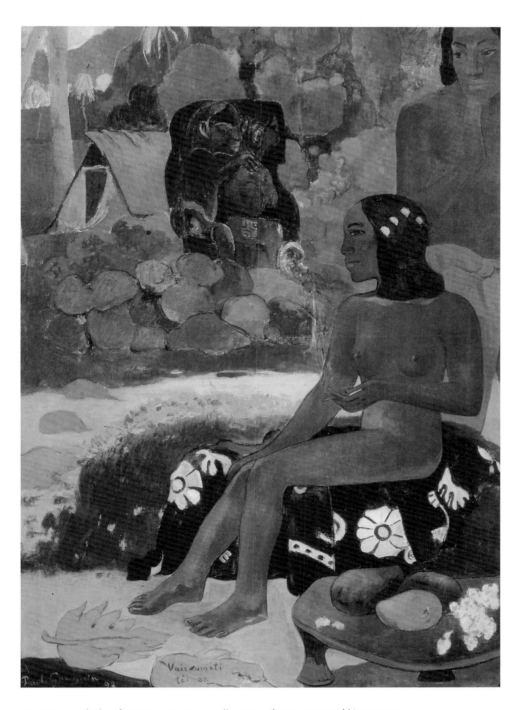

99 *Vaïraumati tei oa (Her Name Is Vaïraumati)*, 1892. Oil on canvas. Pushkin Museum
of Fine Arts, Moscow/Bridgeman Art Library. W450.

100 "Oro Changing Himself into an Immense Column of Fire," from the album *Ancien culte mahorie*, folio 15 (recto), 1892–93. Watercolor and ink on paper. Musée du Louvre, Paris. Photo: Réunion des Musées Nationaux/Art Resource, New York. Photographed by Hervé Lewandowski.

to the . . . celestial resort to join his father, Oro had [her] climb there and take her place amid the goddesses."[22]

Soon after Vaïraumati became pregnant, a sacred association was founded under the patronage of Oro: the Society of the Areoi.[23] Its members, drawn from all classes, were priests, poets, singers, comedians, and prostitutes, who moved from place to place, offering their services. Moerenhout compared them to ancient Celtic and Scandinavian bards, as well as troubadours and minstrels. They "celebrated the marvels of creation, the life and actions of the gods and the heroes, and staged fights . . . inspiring gaiety, enthusiasm, and delirium." They traveled "through all the islands, the soul of pleasures and feasts." Members of the nobility among them were "grave

101 "Tahitian Woman Standing in Profile," from the album *Noa-Noa*, folio 82 (recto), 1893. Musée du Louvre, Paris. Photo: Réunion des Musées Nationaux/ Art Resource, New York. Photographed by Gérard Blot.

and discreet"; on the other hand, "members of the lower classes encouraged without scruple voluptuousness and love, and it was not unusual for young men and women to offer public sacrifices to the goddess of such pleasures . . . evoking through lively imagery . . . nature's two principles [male and female] of generation." Moerenhout viewed the Areoi as aesthetes, but he also called them "monsters." Indeed, in keeping with their sacred rules, "they had to execute all their children, not even sparing one . . . [except that when] a chief was an Areoi, his first son was spared." For the Areoi, Moerenhout explained, citing the account of James Cook, "prostitution was a principle, and infanticide an obligation." The practice of infanticide, furthermore, was by no means restricted to the Areoi: among the rest of the population, "infanticide was so

common that one looked upon the massacre of children with the most revolting indifference; sometimes, the first three female children were regularly killed in every family soon after their birth." Moerenhout added a Malthusian justification that did not absolve the Areoi: because resources were limited and the fertility rate high, "food would not have lasted long; and, in all likelihood, the memory of earlier hardships caused by excess population, such as famine, wars, massacres, even anthropophagy, perhaps, made them adopt this remedy—which, to our eyes is almost as dreadful, and more cruel and horrible, than those evils." Under such conditions, it is likely that these populations "agreed among themselves that it was better to slay their children at birth than to have to slay or devour one another later on."[24] Gauguin too must have seen in the Areoi and like-minded natives murderers as well as aesthetes.

Gauguin's sketch shows Vaïraumati seated on the right and, at some distance to the left, an unpleasant-looking old man, who can be none other than an Areoi officiant. A little above him is a slab on which a large phallus has been engraved: a proper symbol for one of the Areoi's "principles of generation." In the finished painting, the attractive and elegant Vaïraumati is seated in the same pose as in the sketch—her head in profile and frontal shoulders recalling ancient Egyptian art. She has all the aplomb of a sophisticated Parisian young lady, daintily holding a cigarette. Behind her a tall and solemn Oro, with a thoughtful look, touches his chin as if weighing the consequences of a union with a mortal. Much as it highlights feminine appeal, the painting also alludes to the Areoi's tradition of sacrifice: the stone wall behind the figures is a *Marae*, a site enclosed by a stone structure, as described by Moerenhout.[25] In a letter to his wife, Gauguin called it a "temple, a place reserved for the cult of the gods and human sacrifices."[26] In this Polynesian subject, therefore, Gauguin once again opposed allusions to love and fertility with the notion of suffering and the threat of overpopulation—here implied by Areoi sacrifices, thus taking us back to the theme of *Grape Harvest in Arles* of 1888 (fig. 29). In Polynesia, even more than in Brittany, the product of free love was immanently mortal.

But here again Gauguin alludes to the gift of regeneration by placing in the composition's background a monumental statue of Hina and Tefatou. They are once again in the same positions as the figures in the Marquesan carved oar decoration (fig. 89). Indeed, for all their cruelty, the Areoi sought to ensure the continuity of life and the survival of the spirit and the arts—in anticipation, one might speculate, of Tolstoy's notion that man's true bequest to future generations consists of his achievements on earth.[27]

"Too great, too high above the things of this world to become involved in its governance,"[28] the supreme god, Taaroa, creator of the universe, nevertheless also plays a major part in Gau-

1o [in margin top left]

Il les presse, les presse encore; mais ces
Matières ne veulent pas s'unir.
 Alors de sa main droite il lance
les sept cieux pour en former la première
base, et la lumière est créée; l'Obscurité
n'existe plus — Tout se voit; l'intérieur de
l'univers brille. Le Dieu reste ravi en
extase à la vue de l'immensité.
L'immobilité a cessé; le mouvement existe.
 La fonction des messagers est remplie;
L'orateur a rempli sa mission; les pivots
sont fixés; les rochers sont en place; les
sables sont posés. Les Cieux tournent; les
Cieux se sont élevés; la mer remplit ses
profondeurs; l'Univers est créé."

102 "Taaroa: L'Univers est créé"
("The Universe Has Been
Created"), from the album
Ancien culte mahorie, folio 5
(verso), 1892–93. Watercolor
and ink on paper. Musée du
Louvre, Paris. Photo: Réunion
des Musées Nationaux/Art
Resource, New York. Pho-
tographed by Michèle Bellot.

guin's Tahitian pantheon. The artist has represented the god as a puppetlike caricature, with a
large head and small body, in the watercolor "Taaroa: L'Univers est créé" ("The Universe Has
Been Created") in his 1892–93 album *Ancien culte mahorie* (fig. 102). The god's features convey
a sense of supreme calm and self-satisfaction. Naked and ichthyphallic, seated on top of the orb
against a green sky sprinkled with flying bits of celestial matter, his hair extending from each
side of his head as if to broach the confines of the universe, he is a symbol of cosmic power.

The Polynesian "Chant of Creation," most of which was copied by Gauguin from Moeren-
hout, praises the god's power and achievement: "The axes [of the universe] are Taaroa . . . ; the
rocks are Taaroa; the sands are Taaroa. Matter and all that composes the universe were part of

the Divinity. Taaroa is light *[clarté]*; he is the germ; he is the foundation, he is the incorruptible, the strong [creature] that created the universe. The universe, huge and sacred is but the shell of Taaroa." After having repeatedly squeezed together elements that do not naturally unite, "he launches with his right hand the seven skies to create the first platform, and light is created; obscurity is no more. One sees everything, the interior of the universe shines. The god remains enraptured in ecstasy at the sight of immensity. . . . Immobility is no more, movement is created. . . . The hinges, axes, and orbits have been set in their place; so have the foundations, the rocks; so have the sands, atoms of elements; the skies revolve around it; the skies have raised themselves; the sea [has settled] in its depths; the creation of the universe has been completed." (In Gauguin's simplified transcription, the last statement becomes *"L'univers est créé"* [the universe has been created]—the title of one of his later woodcuts.) And the god remains clearly "enraptured at the sight of the universe's immensity."[29]

It is as a seated Buddhist figure that Taaroa appears in Gauguin's wood statuette *Idol with a Pearl* of 1892–93 (fig. 103), together with other deities.[30] The god, in a near-yoga position, is serenely meditating. A pearl is placed at the parting of his hair. The pose is derived from *The Assault of Mara* (fig. 42, top), one of the Borobudur reliefs.[31] The figure's flattened nose, elongated mouth, and protruding brows suggest a non-Western prototype. Taaroa reappears on the back as the gangling figure with bent knees facing Hina and Tefatou. The figure rising above the niche, its left hand raised in a gesture of both encouragement and prudence, as is the right hand of the wise older woman in *Be Mysterious* of 1890 (fig. 47), is "an early prototype for the spiritual being [Buddhist-Christian angel] in *Poèmes barbares* of 1896 [see fig. 128] . . . alluding to the universal spiritual truths behind the literal interpretation of Tahitian and Buddhist legends."[32]

Gauguin here was clearly taking an evolutionist view of the history of religions, distinguishing between more advanced deities, such as the figure above the niche, that are essentially spiritual, and less advanced ones, such as Taaroa, that remain tied to material aspects of the universe's creation. This distinction is in keeping with a statement that Gauguin made in his manuscript *L'esprit moderne et le catholicisme* of 1897–1902 and, incidentally, with the spirit of Theosophy. After quoting excerpts from the "Chant of Creation," the artist continues: "This idea [of a continuity from] the creator-god of the savages all the way to us, the civilized ones, is hardly in keeping with the observations of modern science; [itself] also of very limited relevance for an idealist philosophy. Turned into matter because of this, [this creator-god] can be argued about, so to speak, only in terms of mathematical reasoning. Whereas when it is no longer considered as acting materially, but as symbol pure eternal Spirit, [the] *general Spirit* of the universe, it becomes the principle of all harmonies, the goal to be reached presented by Christ, and earlier by Buddha. And all men shall become Buddhas."[33]

103 *Idol with a Pearl*, 1892. Carved tamanu wood, pearls, and gold. Musée d'Orsay, Paris. Photo: Réunion des Musées Nationaux/ Art Resource, New York. Photographed by Hervé Lewandowski.

An idol seated in similar Buddhist fashion is the central figure of another wood carving, *Idol with a Shell* of 1892–93 (fig. 104). Hina and Tefatou (sporting a beard) appear on its sides, almost in the same position as in *Ancien culte mahorie*.[34] Under their feet is a row of heads in the same style as that of the watercolor (fig. 90). Taaroa's face, rounder and cruder than that of the Buddha-like figure in *Idol with a Pearl*, resembles that of a Marquesan work that Gauguin might have seen in Paris.[35] The teeth are real children's teeth, filed into sharp points like those of a Marquesan cannibal.[36] The body's proportions are less harmonious, however, and the attitude stiff and awkward. Above it, a mother-of-pearl shell alludes to the Polynesian "Chant of Creation": "the universe great and sacred . . . is only Taaroa's shell."[37] Literally as well as symbolically it reflects the light of the universe that Taaroa has created.

104 *Idol with a Shell*, 1892–93. Carved toa (ironwood), mother-of-pearl, and children's teeth. Musée d'Orsay, Paris. Photo: Réunion des Musées Nationaux/Art Resource, New York. Photographed by Gérard Blot.

Gauguin has converted Buddha into a Tahitian deity by drastically primitivizing the style,[38] but the primitive sharp-toothed effigy has also, at least in part, been transformed into an image of Buddha, symbolically generating light. In this work as in the *Idol with a Pearl*, the syncretization of very different religious traditions attests to Gauguin's Theosophical thinking.

Taaroa recurs in many forms. A pen drawing of Taaroa and Hina from *Ancien culte mahorie* of 1892–93 (fig. 105) is a homage to the god's sexual prowess and to its impact on universal creation. Indeed, a genealogical listing in the "Chant of Creation" enumerates the god's various unions, the offspring of each, and the role each child played in the formation and functioning of the universe. For instance: "Taaroa slept with the woman Ohina, goddess of the interior, of

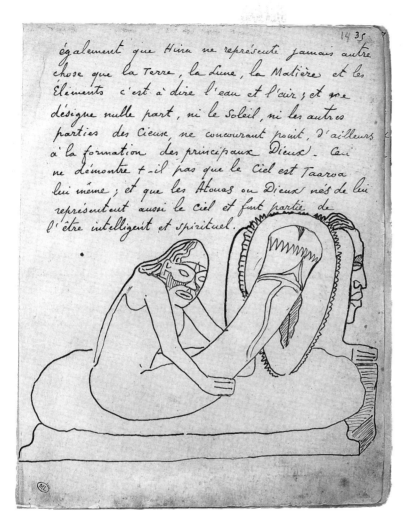

égalment que Hina ne représente jamais autre chose que la Terre, la Lune, la Matière et les Éléments c'est à dire l'eau et l'air; et ne désigne nulle part, ni le Soleil, ni les autres parties des Cieux, ne concourant point, d'ailleurs à la formation des principaux Dieux). Ceci ne démontre t-il pas que le Ciel est Taaroa lui même; et que les Atouas ou Dieux nés de lui représentent aussi le ciel et font partie de l'être intelligent et spirituel.

105 "Taaroa and Hina," from the album *Ancien culte mahorie*, folio 19 (recto), 1892–93. Pen on paper. Musée du Louvre, Paris. Photo: Réunion des Musées Nationaux/Art Resource, New York. Photographed by Hervé Lewandowski.

the breast of earth, she is called. From them is born Tefatou (the genie who animated the earth): underground rumbling or interrupted rest."[39] The face of the long-haired Taaroa reappears as a hairless mask in *Taaroa amid the Seven Skies*,[40] and represents the deity in several other works by Gauguin. It shows affinities with large Marquesan stone deities[41] and is characterized by two higher-value, nearly circular bands around the eyes (somewhat resembling goggles), probably inspired by mother-of-pearl disks for the eyes, or rings around the eyes, of Marquesan wood carvings.[42]

 The god holds with both hands his raised legs, which unite into a giant phallus adorned with graceful anatomical stylizations, its extremity placed near an equally colossal open vulva between

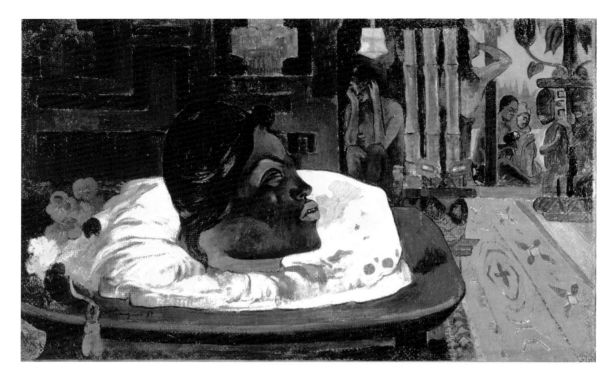

106 *Arii matamoe (The Chief Is Asleep)*, or *The Royal End*, 1892. Oil on canvas. Private
collection. Photograph courtesy of Fondation Pierre Gianadda, Martigny, Switzerland.

the buttocks of a sphinxlike Hina kneeling over a stone pedestal; Gauguin here is alluding iron-
ically to the traditional lovemaking posture of animals and members of some non-Western cul-
tures, as well as of the French working classes of his day, as described in Emile Zola's novels.

*G*auguin informed his friend Georges-Daniel de Monfreid in a letter of June 1892 that he had
completed *Arii matamoe* (*The Royal End* or *The Chief Is Asleep*, fig. 106): "a Kanaka severed
head, well presented on a luscious white fabric, in a palace of my invention, guarded by women
also of my invention. I believe it is a fine piece. It is not entirely mine, as I stole it from a pine
board. Do not mention it, but how can I help [telling you]? One does what one can, and [the
patterns of] marble and wood will sometime suggest the design of a head; stealing [them] is such
a temptation!"[43]

The design may well have been sparked by a fortuitous impression, but the symbolism ap-
pears to be derived from the lore of the Papuan headhunters, and that of Melanesians as well,

whose rites of passage required that a young man decapitate an enemy and keep this trophy head against his genitals for several days so as to acquire the dead man's name and warrior spirit. Only after completing this and other rituals could he be initiated and become a full-fledged warrior.[44] Gauguin must have seen well-preserved Maori severed heads, some splendidly tattooed, which were making their appearance in Western anthropological museums. And a passage related to Marquesan practice in Moerenhout's *Voyage aux îles* probably also attracted his attention: "In the course of the feasts that followed a war, it was not unusual for the victors to wear as ornament, the trophies of their bloody achievement, such as the crania and jawbones of warriors they had vanquished and devoured."[45] The beautiful, slightly mournful, princely head in Gauguin's painting, lying on a fine fabric in its palatial setting, might well have been readied for a victory banquet.

The composition was certainly intended as a metaphor, in keeping with Vincent van Gogh's tenet that whereas there is no afterlife, "man and his work are almost unfailingly continued, by the humanity of the succeeding generation."[46] Accordingly, Gauguin might have seen himself as this decapitated chief, whose warring spirit would soon be transferred to the enemy who had vanquished him in battle. Such an attitude would appear particularly relevant in terms of Gauguin's often-repeated complaint that others, most particularly former disciples, were adopting his innovations without giving him due credit. He thus wrote in November 1892: "I received a letter from Sérusier with a lot of information regarding the painters of the new gang. It appears that Bernard devotes much energy to intrigue."[47] Gauguin grew increasingly fearful of his one-time disciples: "Tomorrow I shall be the pupil of Bernard and Sérusier."[48] In other words, having a competitor usurp one's spiritual achievements can be decidedly unpleasant![49]

The two mourning figures are none other than two Breton Eves: on the right a falling Eve with her elbow raised and on the left a fallen mummy-Eve. Both are destined for an eternity of unhappiness—as was the dead warrior and that other victim of fate: Gauguin himself (or so he thought). On the far right, two sculpted figures standing behind one another have been identified as Hina, behind Tefatou,[50] symbols of cycles of regeneration and the resulting survival of the spirit. Just beyond the right corner of the table, surmounted by three bamboo poles, a mask of Taaroa in the Marquesan style may represent the warrior's generic ancestor.[51] Two figures visible through the hall's opening appear to symbolize death. One wears a red hood, a color often associated in Polynesian art with death,[52] while the other is a dark-skinned male wearing a black cape and holding an ax; he may well be the victorious warrior coming to the morbid celebration. The hall's architecture evinces the rectilinear patterns of Marquesan art (fig. 89) and is a fitting temporary shrine for the remains of a brave Marquesan warrior—and metaphorically speaking, those of a courageous and dedicated artist in exile.

107 "Matatini, Patron of Fishnet Makers," from the album *Ancien culte mahorie*, folio 9 (verso), 1892–93. Watercolor and ink on paper. Musée du Louvre, Paris. Photo: Réunion des Musées Nationaux/Art Resource, New York. Photographed by Gérard Blot.

*E*volutionary views probably inspired by Theosophy are evident in two watercolors from *Ancien culte mahorie* of 1892–93 (figs. 107 and 108), which were eventually incorporated into a woodcut of 1893–94 titled *L'univers est créé* (*The Universe Has Been Created*, or *The Creation of the Universe*, fig. 109)—the last verse in Taaroa's "Chant of Creation," as phrased by the artist.[53] Gauguin's quotation from Moerenhout above the first watercolor (fig. 107) identifies the figure as a lesser god or *Atua:* "Matatini, Patron of Fishnet Makers,"[54] who is represented as a man in profile, clearly harkening back to ancient Egyptian frieze figures, in the appropriate brownish red. He is marching solemnly, his hand raised in the familiar gesture that advocates giving in to one's instincts, albeit prudently. The beautiful striped fish apparently in his charge is holding in its mouth a stylized lotus blossom. The god must be laying the ground for the slowly evolving relationship between two constituents of nature's food chain.

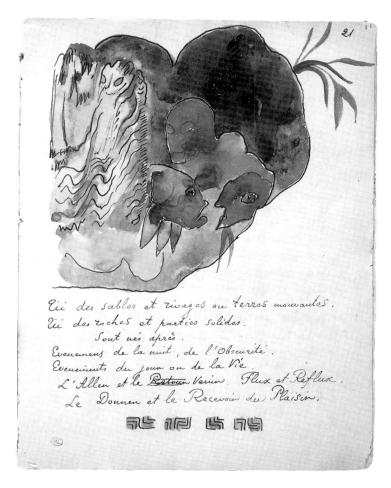



Tii des sables et rivages ou terres mouvantes.
Tii des roches et parties solides.
Sont nés après.
Evenemens de la nuit, de l'Obscurité.
Evenements du jour ou de la Vie.
L'Allen et le ~~Retour~~ Venin. Flux et Reflux.
Le Donner et le Recevoir du Plaisir.

108 "Tiis" ("Spirits"), from the album *Ancien culte mahorie*, folio 11 (recto), 1892–93. Watercolor and ink on paper. Musée du Louvre, Paris. Photo: Réunion des Musées Nationaux/Art Resource, New York. Photographed by Hervé Lewandowski.

The second illustration (fig. 108), according to the accompanying text, also from Moerenhout, presents two *Tiis* (minor deities or spirits). Tiis, according to Moerenhout, served as "intermediaries and lines of demarcation between organic and inorganic beings, whose rights, powers and prerogatives they defined and safeguarded against any attempt of usurpation." As commentary on the watercolor, Gauguin wrote: "Tiis of the exterior or of the sea—guardians of all that is in the sea. Tiis of the sands and the shores or shifting lands. Tiis of the rocks and solid parts. They are born after the events of the night, of Darkness. Events of the day or of Life. The Going and Coming. Flux and Reflux. The Giving and the Receiving of Pleasure."[55] The two Tiis emerge, ghostlike, from stratified rock. The one on the left raises both hands, as if unwilling or unable to tolerate the sight of natural development around him. The one on the right seems more bemused than alarmed by the sight. To their right are the beings to whom they

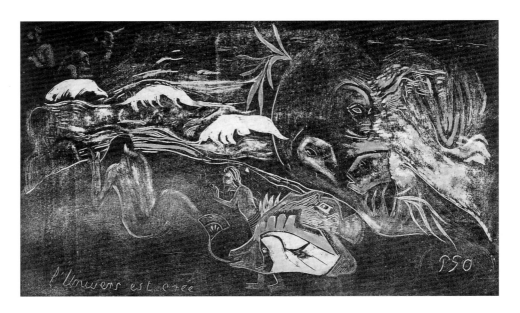

109 *L'Univers est créé (The Universe Has Been Created,* or *The Creation of the Universe),*
1893–94. Woodcut on boxwood with touches of watercolor (recto). Clarence Buckingham
Collection, The Art Institute of Chicago. Photo © The Art Institute of Chicago.

are reacting: three reddish living forms reflecting a fanciful evolutionary development. At the
lower level and center of the page, a fish, endowed with pigs' ears and a beard consisting of three
green pointed leaves, opens its mouth in astonishment as it faces another evolutionary mon-
strosity: a wizened human face endowed with two pointed green leaves for a beard. Above these,
a more clearly anthropoid face emerges from a pinkish cloud, beardless, more impersonal, but
also more recognizably human despite its lack of nose and ears. Whatever their godly powers,
the Tiis do not control the fantasies of evolutionary organic development.

 With slight modifications, each of these figures reappears in the woodcut *L'univers est créé*
(fig. 109). One recognizes Matatini and his lotus-bearing striped fish, as well as variants of the
two fish and the anthropoid head of the second watercolor. Of these, the two fish in the print
are more clearly articulated; one is skeletal and endowed with ferocious teeth, and the other
plump, looking surprised and fearful; the species are clearly engaged in an evolutionary strug-
gle. The human face, hovering above the other two, has a squat nose and altogether negroid fea-
tures. The Tiis have survived, presumably much atrophied by geological evolution, in the form
of two eyes each surmounted by eyebrows discernible at the top of the convoluted rock strati-
fication to the right.

Genesis is also alluded to. On the left, a female figure seen mostly from the back appears to emerge from the ground. Only one of her arms is visible, bent and raised, as were those of the falling Eve in *Auti te pape (Playing in the Water)*, of 1893–94 (fig. 84). Beyond what appears to be a low ridge behind her, cresting waves and streamlines suggest the sea. The male head and bust seen from the back rising from behind the ridge, reminiscent of the man in *Tahitians on the Seashore* of 1892,[56] must belong to Adam. In the latter work, the male figure gazes with interest and appreciation at the standing nude woman behind him. The heads and busts of three observers are barely visible in the upper-left corner. They have beards and look vaguely like priests in ancient Mesopotamian monuments—perhaps suggesting a patriarchal witness.

Spurred, no doubt, by the sense of continuous change conveyed by Polynesian views of the universe and nature, Gauguin's musings must also have been stimulated by recollections of Theosophical thoughts on evolution, and specifically of its ever-present spiritual component, as adumbrated in connection with the *Jewelry Casket* of 1884 (fig. 6). The artist was explicit in *Diverses choses* of 1896–97, claiming that materialists are "imbued with the notion that the life of the soul is derived from the matter of the body. . . . [And thus they] neglect the important, indeed indispensable, influence of the [spiritual] factor, which combines with the corresponding influences [imposed by the need] to adapt to the environment. . . . Indeed, temporarily residing as it does in a [specific] organism, it develops its faculties through exercise, through life's gymnastics. And when this specific organism dissolves itself, [the soul] survives it, [and] it becomes a germ superior to the species it represented, able to develop from metamorphosis to metamorphosis to climb into a general life, [to climb] all the steps, which constitute the life of the soul, all the way to [its] final blossoming."[57] The presumption that the spirit guides the evolution of physical life, the allusion to metempsychosis (the soul developing from metamorphosis to metamorphosis), and the belief that evolution leads to the final blossoming of the soul are all in keeping with the tenets of Theosophy. For the high priestess of Theosophy, Madame Blavatsky, atoms are animated by the "dormant Jiva or life-energy," Jiva being the "*anima mundi*, the universal living soul." "The life [of the] atom," furthermore, undergoes "endless transmigrations" in keeping with "the Hindu doctrine of Metempsychosis."[58] The words may be different, but the ideas are very close. The humor displayed in the Tiis watercolors and the woodcut *L'univers est créé*, not to mention the beauty and poetry of the works, is nevertheless strictly Gauguin's.

Desire of the Night

The memory of a perfect idol . . . a masterpiece of creation.

<div align="right">To Paul Sérusier, March 25, 1892</div>

*M*ost of the Tahitian pictures analyzed so far refer to broad aspects of love: its hopes and its woes as described by Jacques-Antoine Moerenhout—sometimes laced with biblical overtones, as in the references to Eve and Adam and to the wise and foolish virgins. The "idol" mentioned in Gauguin's letter to Sérusier, on the other hand, refers to Gauguin's perception of his first long-term companion in Tahiti, Teha'amana, whose intimate thoughts and perceptions he noted in some detail in *Noa Noa*, occasionally devoting considerable attention to the subtleties of the psychology of love—real or invented—in Tahiti and, as ever, exploring his own.

According to a text attributed to Gauguin, native lovemaking was anything but subtle—remarkable, if anything, for its impulsive vigor, not to say savagery:

THE TAHITIAN WOMAN

Long, flattened cranium. A wide head at the level of the cheekbones. Like that of a cat. Generally the skin is green, in some way related to that of the snake, or copper-yellow (another variety of the snake). Lives almost as do animals.

Never gives herself on an empty stomach, but lets herself go when thoroughly drunk. At that point her aroused senses speak without distrust. Like she-cats, she bites when in heat and claws as if coition were painful. She asks to be raped. She is totally indifferent to any consideration you might have for her.

Do not caress her; she doesn't give a damn. And do not ask her to caress you. Like animals, she accomplishes the act in silence and without frills *[tel quel]*. Many say she is modest; I do not believe it. More or less androgynous. Low-pitched, guttural voice.

Very calculating, but [in a manner that] is incomprehensible and capricious.

Any woman who sleeps with you asks for money; and yet [should you] offer her any to obtain her favors [you obtain] nothing. She lives as [if] she will never be wanting, [and] this prevents her from being unduly calculating.

As far as [her] health goes: born syphilitic, she has the pox, or gonorrhea, or leprosy. . . . Giving her a good beating every week [makes her] obey a little. She thinks very poorly of the lover who does not beat her. She does not consider being slapped to be an insult. This has changed a lot, some (Pierre Loti) say. I do not think a whole people's notions or character change in twenty years. Habits perhaps, and yet! Her politeness will derive more from the savage state than from civilization.

Their existence, [so much like that of] an animal, cannot derive from a habit contracted from the presence of Europeans.[1]

Such an account offers little in the way of intellectual or emotional attachment, but Gauguin sensed—or perhaps in order to bolster his claim that he had found paradise on earth, *wanted* to sense—an innate ability to love. Thus Titi, an early companion who had "a terrible reputation," having "successively buried several lovers," was nevertheless capable of considerable spontaneity and dedication in her lovemaking: "I knew full well," he wrote, "that all her calculating love was made up of elements that in our European eyes would make her a harlot, but for he who knows how to observe, there was something else. Such eyes, such a mouth would not know how to lie. There is in them all a love so innate that, calculating or otherwise, it is always love."[2]

It was in the same spirit that Gauguin elaborated on the atavistic remains of a poetic aura that he associated with the ancient religion in the psychological makeup of Teha'amana. Indeed, rather than crediting Moerenhout as he should have, Gauguin attributed his initiation into the poetry of ancient Polynesian astronomy and the history of creation to her "pillow talk."[3] Through his union with his first wife, the great Roua[4] created the ground, dusk, and darkness. Then taking a second wife, he sailed through the universe to have her give birth to the stars, including "the morning star, King Fauroua, who promulgates the laws of night and day, of the stars, the moon, the sun, and acts as guide to navigators." In those blissful early days of the artist's union with Teha'amana, who "gave more and more of herself," the poetry of the ancient myths, together with "happiness succeeding to happiness" in her company and the ever-present "Tahitian Noa Noa" (delicious fragrance) pervading the landscape, Gauguin "lost consciousness of the days and the hours, of Evil and Good. Everything is beautiful; everything is good." In the rays of

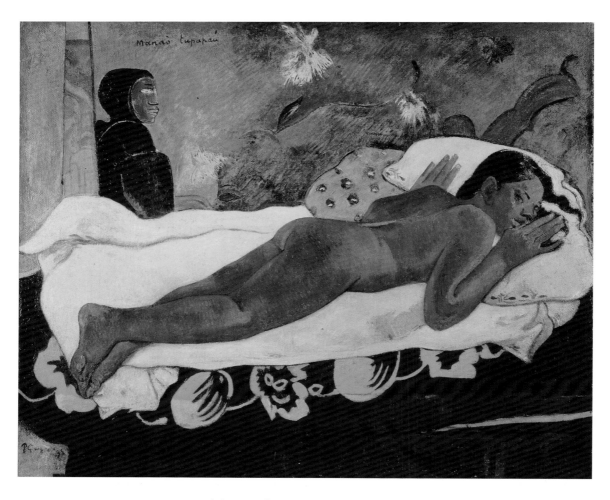

110 *Manao tupapau (The Spirit of the Dead Watches)*, 1892. Oil on canvas. Albright
Knox Art Gallery, Buffalo, New York / Bridgeman Art Library. W457.

the early morning sun "the gold of her face illuminated everything around, and we both natu-
rally, simply strolled to a nearby stream to refresh ourselves, as in Paradise."[5]

Always a keen observer, Gauguin took note of Teha'amana's superstitious beliefs and psy-
chological traits. The old taboos were by no means dead. Still on the subject of cosmogony:
"What she never could admit was that shooting stars, frequent in that land, and which crossed
the sky slowly, melancholy, were not *tupapaus* [spirits of the dead]."[6] The same taboo was as-
sociated with her occasional irrational fears and even her pre- and postcoital sexual inhibitions.
Returning late at night to his hut from a short stay in Papeete, Gauguin recounted: "The room

was dark. I was nearly afraid, and above all distrustful. Surely, the bird had flown away. I lit a match and saw . . . " (here Gauguin describes the scene shown in the painting *Manao tupapau* [*The Spirit of the Dead Watches*, fig. 110]):[7]

> Teha'amana lay motionless, naked, belly down on the bed: she stared up at me, her eyes wide with fear, and she seemed not to know who I was. For a moment I too felt strange uncertainty. Teha'amana's dread was contagious: it seemed to me that a phosphorescent light poured from her staring eyes. I had never seen her so lovely; above all, I had never seen her beauty so moving. And, in the half-shadow, which no doubt seethed with dangerous apparitions and ambiguous shapes, I feared to make the slightest movement, in case the child should be terrified out of her mind. Did I know what she thought I was, in that instant? Perhaps she took me, with my anguished face, for one of those legendary demons or specters, the *Tupapaus* that filled the sleepless nights of her people.[8]

Gauguin provided a similar description in a letter to his wife, intended to prepare her to face the critics at the 1893 *Den frie Udstilling* exhibition in Copenhagen. Because of the ambiguities of Tahitian grammar, *Manao tupapau* means "[She] thinks of, or believes in, the ghost [and] the Spirit [of the dead] or ghost watches over her."[9] In sum: *She Thinks of the Spirit of the Dead, Who Watches Her* would be a more appropriate translation than the shorter title by which the painting is commonly known. The spirits returning to their families to protect or watch over them could be vengeful and frightening,[10] but the ancient texts also opened up the possibility of another kind of association, linking the desires of the flesh to precisely the fear of the dead and of death. According to Gauguin's version: "Tii, a spirit born from the union of Taaroa, creator of the universe, and Hina"—here associated with the moon—unites himself with "the woman Ani (desire, wish)," who gave birth, among others, to "Desire of the night," who was also the "messenger of Darkness, of graves or of Death."[11]

Gauguin continued his explanation in the letter to his wife:

> Naturally, many of my works will be incomprehensible, and you will have a little fun [in your conversations with the critics]. I painted a nude girl. In this position, almost anything might make her look indecent. And yet, this is the way I want her. So I indicate a little awe on her face . . . traditionally, this people has a great fear of the spirit of the dead. General harmony, somber, sad, frightening, resonating in the eye as would a funereal knell. For the Kanaka, will-o'-the-wisps are the spirit of the dead. Finally I present the ghost, simply and directly, a little old woman; because for the young woman . . . the spirit of the dead is associated with the dead [person]. Here is a little text that will make you knowledgeable when faced with the critics, who will bombard you with questions.[12]

111 D. P. G. Humbert de Superville,
Allegory of Onanism, 1801.
Etching. Print Room, University
of Leyden.

The term "indecent" was beside the point; the Tahitian "Eve after the Fall [is] still able to walk naked with no sense of indecency, conserving all her animal beauty as on the first day," Gauguin later wrote.[13] He devised as sexually attractive a young female body as he ever did, in the grip of fear. It is comparable to an etching by D. P. G. Humbert de Superville, *Allegory of Onanism*[14] of 1801 (fig. 111), which Gauguin must have seen, in which a similarly reclining, rotund boy—no doubt alluding to rococo *putti*—is torn between the pull of carnal desire, on the one hand, and remorse and fear of premature death in the form of the head and stretched hand of a skeleton, on the other. For the *tupapau*, Gauguin had not forgotten the "woman dressed in black" representing death in *Grape Harvest in Arles* (fig. 29), nor the dark-clothed peasant woman facing the artist in *Bonjour Monsieur Gauguin* (fig. 65), both harbingers of death.

The sunflower, seeing and sentient, reappears on the golden yellow flower and vegetal design on the blue bedcover: the jeering eyes and a laughing mouth surrounded by petals of a diabolical imp—undoubtedly Gauguin himself—take delight in the seduction scene to come, comparable in this to the encouraging monkeys in the wood carving *Woman with Mango Fruits* (fig. 21). Precoital fears, it seems to say, may be an added inducement to the seducer, and they will be compensated by the promise of human regeneration.

Gauguin took up the same theme, with some variations, in a lithograph executed in Paris in 1894. Nude maiden and *tupapau* are once again juxtaposed in the highly finished black-ink lithograph *Manao tupapau* (fig. 112). Here the *tupapau*, dressed mostly in black with some gray, its contours outlined in white, stretches its forearm horizontally alongside the top of the bedding,

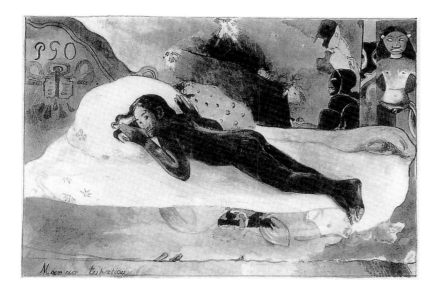

112 *Manao tupapau (The Spirit of the Dead Watches)*, 1894. Lithograph in black on ivory wove paper. The Art Institute of Chicago, Gift of Jeffrey Sheld. Photo © The Art Institute of Chicago.

its head, shoulder, and paw emulating those of a sphinx, and its expression just as hermetic. Above the *tupapau*, a sequence of three symbolic configurations evokes other forces at play. Hina, at the extreme right, stands in full face, both her arms sloping away from her body, her forearm rising, and her right hand, visible beyond the totem pole, vertical with its finger a little bent, in the gesture already used for imploring Tefatou,[15] god of the earth and mischief-maker, to spare the girl. Gauguin (in the guise of a Marquesan mask) is the character on the totem pole between Hina and the *tupapau:* the eyes are represented by higher-value circular strips surrounding a lower-value core. Beneath these, a helical white strip surmounted by an angular protuberance enveloping the pole suggests Gauguin's hand, wound around his chin with his thumb pointing to his lips, as in the effigy of the seducer in such works as *Be in Love and You Will Be Happy* (fig. 37) and *Self-Portrait in the Form of a Grotesque Head* (fig. 60), both dating to 1889, where the gesture suggests a combination of intense concentration and instinctual urges. Gauguin is at once the would-be seducer and the observer bemused by the girl's combination of fright and lust. Finally, in her efforts to rein in the endeavors of the evil spirit Tefatou, Hina becomes a goddess of mercy, presiding with her outstretched arms over the process of regeneration, as she does in *Mahana no atua (The Day of the God [Goddess])* of 1894 (see fig. 125) and *Where Do We Come From? What Are We? Where Are We Going?* of 1897 (see fig. 131).

A woodcut of the same title, *Manao tupapau* of 1893–94 (fig. 113), is remarkable both for the sensuousness of its textures—the flesh has a satiny, somber glow, standing out against the higher-value pale orange bedspread—and for the ominous overtones evoked by the dark background

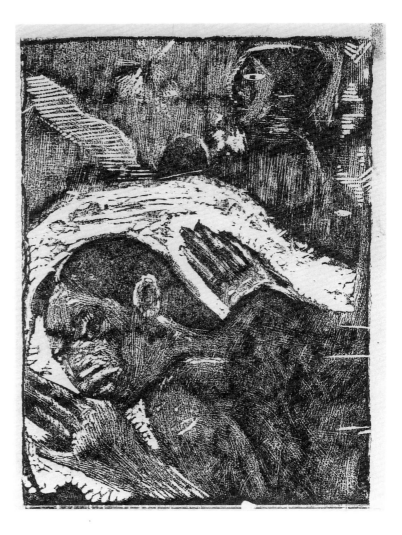

113 *Manao tupapau (The Spirit of the Dead Watches)*, 1893–94. Woodcut. The Art Institute of Chicago, Gift of Carl O. Schniewind. Photo © The Art Institute of Chicago.

with its fireflies, *tupapau,* and totem pole on the right, and the wispy figure incised in a curving bamboo pole on the left. Hina and Tefatou are no longer there. Gauguin's effigy in the Marquesan style on the totem pole, with its two strips around the eyes and the largely sketchily rendered hand and thumb, is barely outlined in that same ground color.

The figure holds a round object, in all likelihood the biblical apple; if so, the fetal position may be related to that of Eve in *Don't Listen to the Liar* of 1889 (fig. 35). The fetal position in this case, however, is at once invitingly sensuous and suggestive of self-protection. It likely reflects precoital anxiety, as did the prototype of the theme, with an added overlay of primal fear. The ambient darkness suggests a dream, and to anyone with a knowledge of the postulations and de-

ductions of Gauguin's younger contemporary in Vienna, Sigmund Freud, the awesome workings of the unconscious.

There is irony in *Parau na te varua ino (Talking about the Evil Spirit;* often translated as *Words of the Devil),*[16] of 1892 (fig. 114), in which sexual indulgence gives rise—temporarily, no doubt—to postcoital anxiety. As he was about to tackle the painting, Gauguin elaborated a complex iconographic theme in a sketch opposing the promise and disappointment of love by means of ancillary masks (fig. 115). The *tupapau* brandishes such a mask, with features suggestive of Maori art. With its broad grin and rounded little eyes, it is essentially caricatural. It is here the inviting face of seduction, the evil spirit of the title. It has just been removed from the *tupapau,* revealing an underlying solemn, saddened, but also rather severe impersonal mask in place of a face, whose vaguely Marquesan features are less caricatural than the precedent. On the ground lies a larger but similarly cheerful mask, apparently discarded. The young woman, somewhat statuesque in her proportions, holds a cloth over her groin, as if to wipe herself after the act of love—this cloth also fulfills the traditional function of the fig leaf. Her barely visible features, like her overall stance, hint at regret.

In the finished work, the two masks are more mysterious and the young woman is more humanly, more movingly, but also more humorously, characterized. The mask in the upper right is now much simpler. Two elongated curvilinear triangles—one red, the other green, with two asymmetrical whitish inclined oblongs for the eyes—meet along the ridge of the nose, terminating in a point. Just below its tip, a brown hand covers the chin, its raised thumb rising past the level of the lips in Gauguin's characteristic gesture, as in *Be in Love and You Will Be Happy* and *Self-Portrait in the Form of a Grotesque Head.* The rounded ridge of the nose is also his. He is once again the seducer.[17]

The other mask is the *tupapau's* actual face. A little more stylized than in the drawing, it now has features close to those of the Marquesan figure in a Buddha-type seated position in *Idol with a Shell* of 1892–93 (fig. 104). Its wide-open eyes, with the pupil gazing downward to meet the lower eyelid and a large expanse of white above it, express terror, as do the splayed fingers of the figure's left hand gripping her knees. Dressed in dark blue rather than black, with a dull violet hem around the neckline, she wears a black scarf around her head, the *tupapau,* embodiment of the spirit of the dead, thus harkening back to the woman in black of *Grape Harvest in Arles.*

For her part, the young woman, although she is faintly smiling, looks sideways with a certain apprehension, pressing, as she does in the drawings, her right hand fingers against the lower part of the cheek. "What have I done?" she seems to imply. The cloth she is holding against her groin suggests that she is wiping out or concealing a shameful memory. The message of the work

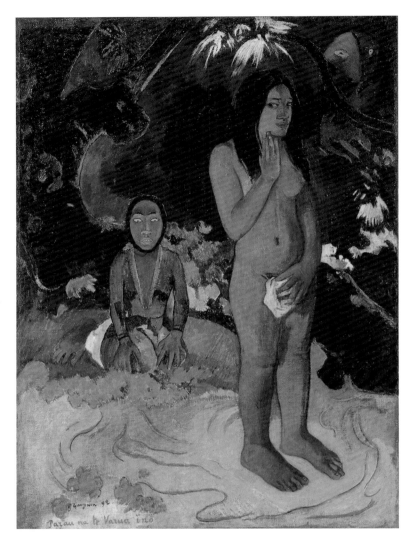

114 *Parau na te varua ino (Talking about the Evil Spirit)*, or *Words of the Devil*, 1892. Oil on canvas. National Gallery of Art, Washington, D.C., Gift of the W. Averell Harriman Foundation in memory of Marie N. Harriman. Image © 2007 Board of Trustees, National Gallery of Art, Washington.

echoes the sardonic advice "Be in Love and You Will Be Happy" of the 1889 wood carving, transforming the picture into a little fable warning against the possible woes of love. And to remind the viewer once more that hearts can be broken even in the paradise of Tahiti, Gauguin returns to a device that he used in his Breton paintings: this Eve's feet dip into a puddle, indicating that her action will have some untoward consequence. The puddle is rendered in a magnificent orange-pink verging on violet, reminiscent of the color associated with pangs of jealousy in *Aha oe feii? (Are You Jealous?)*, also of 1892 (fig. 82). Altogether, the work definitely suggests postcoital anxiety.

115 Sketch for *Parau na te varua ino*, 1892. Graphite on paper. Musée du Louvre, Paris. Photo: Réunion des Musées Nationaux/Art Resource, New York.

From the subjective standpoint, Gauguin's reappearance as the successful seducer, having a little diabolical fun, recalls several earlier works, each reflecting Baudelaire's understanding of the seamier psychological aspects of carnal lust: "As far as I am concerned, the supreme and unique voluptuousness of love lies in the certainty of doing *evil*—and man and woman know from birth that one finds in evil all voluptuousness."[18] It was particularly ironic that Baudelaire was here affirming his belief in original sin, thus returning to the conservative Catholic tradition of his early education. And so, unwittingly and indirectly, was Gauguin—however aggressive and vain the fabulist's jeering and however impish his mode of expression.

CHAPTER 10

Paris Furlough

I must return.

To Paul Sérusier, March 25, 1892

"My health is poor," Gauguin wrote Georges-Daniel de Monfreid in November of 1892, a few months before his return to France; "not that I am ill (the climate is marvelous), but all these money worries are upsetting me, and I have aged a great deal, even astonishingly so, all at once. In addition, in order to hold my own financially and still function, I do not eat—a little bread and tea—which causes me to shed a lot of weight, lose my strength, and ruin my stomach. If I went into the mountains to catch fish and bring back *feii* [wild bananas], I would not be working and I would catch sunstroke. What miseries for the sake of this damned money!"[1] Gauguin had applied several months earlier for a French government grant to cover his proposed return trip.[2] Regarding his financial situation, he noted: "I have fifty francs in the kitty, and see nothing on the horizon. Even if the ministry responds favorably with regard to my trip, I shall know about it only by March at the earliest." And in a fit of depression he remarked: "When I think carefully about it, I must give up painting when I return, since it cannot support me."[3]

Indeed, Gauguin's principal professional mainstays were gone: "Poor Aurier is dead. We are definitely unlucky. [Theo] van Gogh, then Aurier, the only critic who understood as well."[4] A few weeks later Gauguin commanded Monfreid, "Do the *Impossible* to obtain funds," hoping for a little cash to cushion his arrival in France.[5] There were some more auspicious portents, however. Mette had been able to sell several paintings in Denmark, although she kept the proceeds to tend to the needs of her family. An exhibition of Gau-

guin's and Vincent van Gogh's work had been planned for the spring of 1893 at the *Den frie Udstilling* in Copenhagen.[6] And Gauguin got news that "[my] success is growing rapidly in the North" (an English artist had told Mette that Gauguin should have a show in England). "I must return [to France] to take stock of all these matters. My God, how angry it makes me [not to be able to do so]!"[7]

Gauguin received 700 francs from Emile Schuffenecker, and the government, in response to his request, issued an order of repatriation on the grounds of indigence. True to form, Gauguin's first reaction upon receiving the good news was to fantasize about an even more remote retreat: "If I had received [the 700 francs] one or two months earlier, I would have gone to the Marquesas to complete my work. . . . But I am tired."[8] He sailed first to New Caledonia on a warship, in the officers' quarters, then continued his journey, "crammed together with two hundred soldiers amid chains, sheep, and steers for forty days," on a steamer.[9] He reached Paris on August 31, 1893.

An inheritance from his uncle Isidore considerably eased his financial problems—for a while. No sooner did he receive the money than he spent six days in Belgium. As he wrote Monfreid: "Very posh voyage: I saw Memlings in Bruges—What marvels, my friend! and then, when one sees Rubens (the road to materialism) everything falls apart."[10] The stay in France of almost two years was spent mostly in Paris, but Gauguin sojourned in Brittany as well, in Le Pouldu and later in Pont-Aven, from spring to December of 1894.[11] He was as technically and iconographically creative and as productive as he had been in Tahiti—indeed, some of the most important Tahitian masterpieces were executed in France, including a major ceramic piece and an extraordinary series of woodcuts. It was also at that time that he composed the first version of *Noa Noa* and the text of *Ancien culte mahorie*.

Nave nave moe (Delicious Mystery) of 1894 (fig. 116),[12] also known as *Sacred Spring*, alludes once again to the biblical theme of the wise and the foolish virgins. A preparatory drawing for the painting (fig. 117), in black chalk with touches of watercolor, presumably dates to 1893–94; it is linked here to the finished work for the first time. The drawing shows in the right middle ground a standing figure, similar to the independent, "self-righting" Eve who walks away from the entanglements and woes of love in *Te raau rahi (The Big Tree)* of 1891 (fig. 80), tracing her origins to the "self-righting" Eve walking away from Meyer de Haan's love entanglement in *Nirvana: Portrait of Jacob Meyer de Haan* of 1889 (fig. 44), and beyond that to the matron in *Two Women Bathing* of 1886–87 (fig. 18).

To the left in the drawing, another young woman, smaller in scale, is in much the same position—but now no longer partly covered up by her hair and seated on her bent legs. This figure, which relates to the Rodin-like figure in *Pape moe (Mysterious Water)* of 1893 (fig. 93),

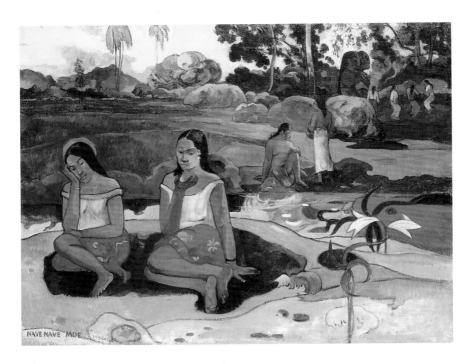

116 *Nave nave moe (Delicious Mystery)*, or *Sacred Spring*, 1894. Oil on canvas. Hermitage, St. Petersburg/Bridgeman Art Library.

117 *Tahitian Landscape with Figures*, preparatory drawing for *Nave nave moe*, 1893–94. Black chalk with touches of watercolor. Photo: © Archives Wildenstein Institute.

is considerably closer to Rodin's *The Awakening* (fig. 94), with an important difference. Gauguin's figure gently bends her upper torso and head forward in a graceful curvature culminating in her raised elbows, exposing the full profile of her youthful breast and ultimately suggesting feminine gentleness and even submission; Rodin's figure, much more detailed in its modeling, also raises her elbows, but she throws her head backward, as if to suggest an eagerness to face the world and, ultimately, a sense of emancipation. Gauguin's figure can be associated with some idyllic nymph, evoking a feminine ideal that traces its origins to classical antiquity. Unmistakably Caucasian, she stands at considerable remove from the ideal of Polynesian beauty that characterizes Gauguin's Tahitian figures.

This figure does not appear in the final painting, but another figure in the drawing does: a swiftly sketched standing figure to the right of the tree trunk, with raised bent arms and slightly bent knees, heralds the dancers performing around the statues of Hina and Tefatou in the painting. A few darker strokes over the foliage of the tree may even be an early allusion to those statues.

In the painting *Nave nave moe* itself, the standing figure in a white skirt, walking away in a graceful, somewhat casual step is the "self-righting" Eve; the seated figure in the middle ground is based on the jealous woman in *Aha oe feii? (Are You Jealous?)* of 1892 (fig. 82) and its predecessors.

The "awakening" figure in the drawing has made way in the painting for the two seated young women in the foreground, both definitely Polynesian: one is casually eating an orange fruit, here standing in for the biblical apple, and the other, her tilted head standing out against a golden halo, leans her head on her right hand, supporting her elbow with her thigh. They are essentially the two foreground figures of *Te fare Maorie (The Native Hut*, fig. 81) and *Te raau rahi* (*The Big Tree*, fig. 80), both of 1891, with one significant difference: the halo. Two graceful lilies to the right, the flower traditionally associated with the Virgin and symbolic of purity, seem to be accompaniments to the halo.

On a watercolor sketch that includes the two foreground figures,[13] Gauguin inscribed the text of Paul Verlaine's poem *Sagesse:*

The night is tender, the pillows fresh,
What is this delight?
What is this ordeal?
We, the damned, and you, the Saints.

Nuit câline aux frais traversins
Qu'est-ce que c'est que ce délice,
Qu'est-ce que c'est que ce supplice,
Nous les damnés et vous les Saints.[14]

Love hurts or pleases, but Verlaine, the perpetually lovelorn, self-pitying poet, implies that those who are hurt are ourselves; those gratified, others. Gauguin, for his part, returned to the theme of the wise and the foolish virgins already broached in *Nafea faa ipoipo? (When Will You Marry?)* of 1892 (fig. 85).[15] Here the wise virgin wears a demure missionary dress, as did the figure in the earlier painting, but instead of appearing thoughtful and self-possessed, she shuts her eyes, as if quietly indulging in peaceful and restful daydreams. Indeed, travelers reported that one of the favored pastimes of contented souls on the island was delicious, endless reverie. Jacques-Antoine Moerenhout, for instance, described this blissful state as "an existence . . . in which people are essentially nonchalant, without destiny, . . . free from cares, worries. [In this state they] enjoy to the full the happiness of thinking of nothing, or rather, nothing very serious; and find themselves for this very reason naturally more inclined to enjoy, to amuse themselves about everything, than to be aggrieved, or saddened by anything."[16] Immediately after arriving on the island, Gauguin himself had observed: "I understand why these creatures can remain for hours, for days, seated without saying a word, looking at the sky with an air of melancholy." That mood affected him as well: "I feel that all that will benefit me, and I find myself sleeping extraordinarily well now."[17] And beyond that, studied detachment, handled wisely and in the tradition of local mores, can be a subtle and effective weapon for a young woman engaged in the battle of love.

It is the other young woman, the foolish virgin eating the fruit, who seems to be thoughtful and in control of herself but who is apparently doomed to unhappiness, as suggested by the woman based on the prototype of the jealous woman in the background. The figures dancing around the statues of Hina and Tefatou seek to propitiate the gods presiding over regeneration; the "self-righting" Eve walking away transcends all such matters.

*I*n the partly glazed stoneware statuette *Oviri (The Savage)* of 1894 (fig. 118), Gauguin evoked a monstrous figure standing on bent legs as if about to collapse; at her feet lie the head and paws of a bleeding dog or wolf that she appears to have crushed, and she holds a lapdog against her left hip and thigh, one hand pressing its rump against her, and the other encircling its neck as if to strangle it. The statuette, we shall see, is intended to symbolize the artist's own pursuit of an ideal that he called "savage" in the hope of fulfilling his tragic destiny.[18] Its mood necessarily reflects the mood of those sister souls—those other "savages"—struggling to fulfill their destiny, with whom Gauguin had identified: the Polynesian natives struggling to preserve their identity against Western encroachments.

The statuette's symbolism is related to several preceding works and ultimately to a theme that emerged during Gauguin's Breton period. The female figure traces its origins to the woman

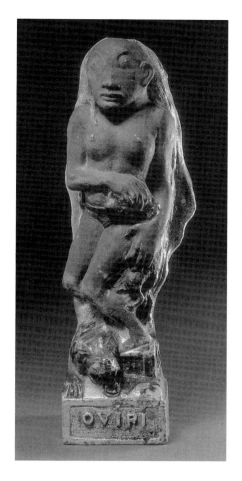

118 *Oviri (The Savage)*, 1894. Partly glazed stoneware.
Musée d'Orsay, Paris. Photo: Réunion des Musées
Nationaux/Art Resource, New York.
Photographed by Hervé Lewandowski.

walking away, or "self-righting" Eve, as far back as *Nirvana: Portrait of Jacob Meyer de Haan*
and the matron in *Two Women Bathing*. But there are two important intermediary steps. The
figure reappears in *Ea haere ia oe (Where Are You Going?)*, or *Woman with Mango* (fig. 119), pos-
sibly dating to 1893, in which she looks somewhat sullen and carries a large fruit. She also is
found in *E haere oe i hia (Where Are You Going?* fig. 120), thought to date to 1892, in which she
carries a small dog against her hip—as does *Oviri*—and has a somewhat dazed and resentful
look that presages the stupor and anger of the figure in the statuette.[19] In both works, ancillary
figures confirm the overall meaning: in *Ea haere ia oe*, or *Woman with Mango*, the seated figure
to the right is derived from the foolish virgin lowering her shoulder strap to bare her breast in
Nafea faa ipoipo (When Will You Marry?), suggesting too great an eagerness in the pursuit of
love, while the other figure, languorous and beguiling, also looks ready for a casual amorous

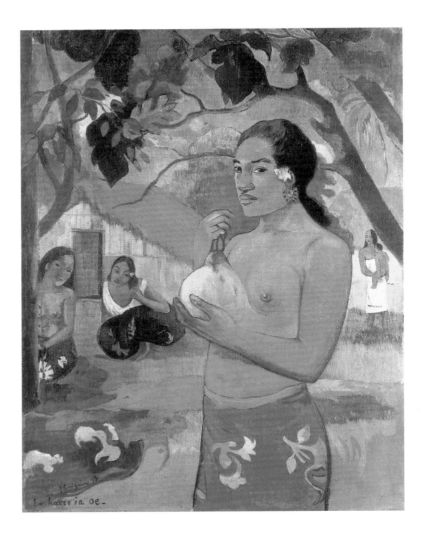

119 *Ea haere ia oe (Where Are You Going?)*, or *Woman with Mango*, 1893 (?). Oil on canvas. Hermitage, St. Petersburg/ Bridgeman Art Library.

entanglement. To the right, a standing woman in white carrying a child evokes the delights of maternity, against which the principal figure expressly turns her back. In *Ea haere oe i hia* only the two seated figures appear, in the same roles. It is the grimmer aspects of the figures walking away from love and its unfortunate consequences in these two paintings that become dramatically exaggerated in the expression and symbolism of the *Oviri* statuette.[20]

The statuette's facial features, it has been observed, "dominated by the great staring empty eyes" associated with Polynesian mummified heads, are based on those of a Marquesan idol, as well as those of "a great chief who has passed beyond death to become a god."[21] At the same time, the face seems a caricature of a specific person, its features revealing definite European

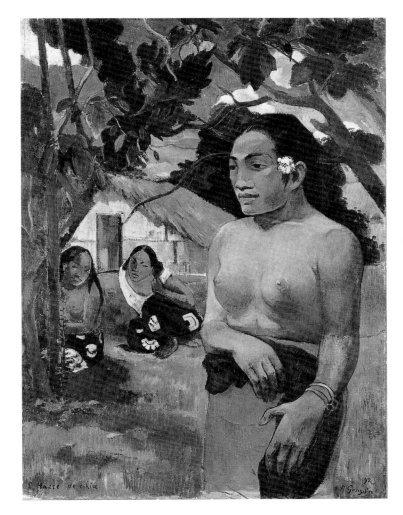

120 *E haere oe i hia (Where Are You Going?)*, 1892 (?). Oil on canvas. Staatsgallerie, Stuttgart.

characteristics. Indeed, the delicately modeled, gently protruding, bow-shaped upper lip, with its broad inverted V in the center, recalls that of the artist's maternal grandmother, the half-Spanish and Peruvian-Indian, half-French Flora Tristan y Moscoso (fig. 1). The broad and fleshy lower lip is also Tristan's, as are the protuberant eyes (also traditionally associated with Marquesan sculpture). As for the nose, while it is flat, the fine modeling of its tip and nostrils is definitely European, as is the daintily formed, firm chin.

Gauguin referred to the *Oviri* figure as "*la tueuse*," or "the killer," in a letter to his Parisian dealer, Ambroise Vollard.[22] The same turn of phrase was used by Flora Tristan's friend, perhaps at some point her lover: the former seminarist "abbé" Alphonse Constant, who dabbled in

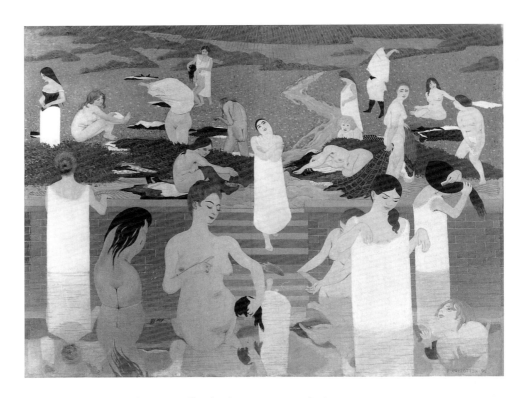

121 Félix Vallotton, *Le bain au soir d'été (Bathers, Summer Evening)*, 1892.
Oil on canvas. © 2007 Kunsthaus Zürich. All rights reserved.

the occult under the pen name Eliphas Lévi. He described Flora in the introduction to his 1846 literary hoax that purported to be her autobiography, *L'émancipation de la femme, ou le testament de la paria:* "Mme Tristan kills those who love her (morally, to be sure). . . . She is cruel, with kindness; she tortures you with a smile; there is the naïveté of a child and the conscience of a saint in her moral homicides. . . . Flora Tristan has suffered a great deal."[23] The genuine nineteenth-century femme fatale, in other words!

Both Flora and her grandson had left their households in pursuit of their careers, and both proudly stressed their unease with the culture of their own milieu, Flora calling herself a "pariah" and Gauguin, a "savage."[24] Finally, much as his grandmother was honored after her death with an impressive marble neoclassical tomb—a broken Doric column around which climbed an ivy tendril, erected in her memory by members of the trade union that she had founded, *Union ouvrière*, Gauguin, in August 1900, requested that the statuette *Oviri* be sent to him to Tahiti, first to adorn his garden and eventually to be placed over his grave.[25]

122 Jean-Honoré Fragonard,
"La Gimblette" (Girl with a Dog), ca. 1770–75. Oil on
canvas. Alte Pinakothek,
Munich/Bridgeman Art
Library.

An apparently innocuous detail of the sculpture has disturbing erotic overtones with significant philosophical implications. The figure carries the lapdog against her nude abdomen, buttock, and thigh, suggesting something of a boudoir intimacy. Gauguin may have seen and remembered a picture in which a similar relationship is hinted at: Félix Vallotton's *Le bain au soir d'été (Bathers, Summer Evening)* of 1892 (fig. 121), in which a pleasantly rotund nude bather carries a lapdog against her thigh as she wades into a pool among equally sensuous females.[26] Was Gauguin reminded here of a much older tradition that hinted at bestiality? In particular, there are examples of eighteenth-century genre paintings such as Jean-Honoré Fragonard's *"La Gimblette"* (*Girl with a Dog*, fig. 122), in which a pubescent girl plays in her bed, swinging a lapdog over her bare groin and letting its long-haired white tail caress her pudendum in a game that might conceivably have a less-than-naive ending.

Gauguin gave two clues regarding the symbolism implied by the placement of the lapdog—both quite indirect and one highly ambiguous. The first is provided by an unsigned proof of a

woodcut printed in a combination of oil and ink of 1894, which depicts a monumental *Oviri* vaguely showing the lapdog, but not the dog/wolf by the woman's feet (fig. 123). The artist mounted two other copies of this print together on a piece of cardboard bearing the dedication: "To Stéphane Mallarmé this strange figure, cruel enigma. P. Gauguin, 1895." Another, more significant, clue is provided by a legend under an ink and wash drawing showing a simplified version of *Oviri* originally inserted in a special hand-copied version of the first issue, dated August 1899, of Gauguin's mimeographed periodical, *Le Sourire*, dedicated to the then-mayor of Papeete.[27] It reads in French: "*Et le monstre étreignant sa créature féconde de sa semence des flancs généreux pour engendrer Seraphitus-Seraphita.*" The verb *étreindre* is in itself ambiguous, its meaning ranging from "hold," to "embrace amorously," to "choke." So the literal translation is "And the monster, holding/embracing/choking its creature, impregnates with its seed a generous abdomen in order to engender Seraphitus-Seraphita." Grammatically the French text is also quite ambiguous: the "monster" could be the woman, or the lapdog, or possibly even the battered dog/wolf at the woman's feet.

A story containing the same sentence in the same issue alludes both to free love tainted by incest and to an unintentional homicide. Gauguin, under the pen name "Paretenia" (purportedly that of a British feminist critic),[28] wrote a review of an imagined fablelike drama by a Polynesian author, *L'Immorale (The Immoral Woman)*, supposedly performed at the National Theater of Bora Bora. Paretenia explains that she was "always ready to applaud . . . another, bolder [woman] . . . fighting to achieve the same sexual freedom as man." The play's heroine, Anna Demonio, is independent and wealthy. "Well-educated, charitable, and devoted to her friends," she believes in friendship rather than love, and as men are wont to do, devotes herself to "sensuality and debauchery." She has "lovers for one day, but friends forever." In other words, she belongs to the ranks of Gauguin's "self-righting" Eves. Being "a serious and devoted girl, she endeavors to open the eyes of her lover," a traditionally minded young man who "wanted something [she] had been ready to give him for a long time, to him and to others, but which this good-natured idiot wanted for himself alone, under the blessing of the sacramental ring." Anna takes him to a wild place in Catalonia and reveals her dark secret: she was her father's (Demonio's) lover. "This criminal ring . . . was sweet. . . . Hell this may well be," she adds, "but . . . my father . . . [is] the only angel who has had my soul; but his own soul, . . . made of bronze, was forged by the hammer of a Titan—a love that burns without torment." There follows the drawing's legend: "And the monster, holding/embracing/choking its creature, impregnates with its seed a generous abdomen to engender Seraphitus-Seraphita." The young man "could no longer hear her; he had died defeated, broken by the shock of the hurricane."

The review concluded: "A furious public was calmed by the theater's manager, who explained

123 *Oviri (The Savage)*, 1894–95. Color woodcut. Rosenwald Collection, National Gallery of Art, Washington, D.C. Image © 2007 Board of Trustees, National Gallery of Art, Washington.

that Anna was not really the daughter of Demonio, who had taken this secret to the grave. Morality was saved!" Paretenia went on: "Men, free us from the bonds of marriage; with the assurance of being able to love without prostituting ourselves, free from our bodies as well as our souls, we would applaud you."[29]

In the play, the "monster" could be Anna, and the "creature" the father, so that she would be impregnating herself with her father's seed. Alternatively, the father could be the monster, impregnating Anna, who would then be the creature, the end result being the same. Or could the young man be the creature and Anna, having caused his death, again be the monster?

In the case of the statuette, the situation is just as ambiguous. The female's right hand rests on the neck of the lapdog and could well be about to strangle it. She would thus be the monster, and the lapdog the creature, conceivably about to impregnate her before its demise. Or the lapdog might well be the monster, here gripping her in an amorous embrace, and she the "creature," about to be impregnated.

As a femme fatale, Flora Tristan could be the monster; as a martyr, sacrificing herself for the noble causes of women's emancipation and the welfare of workers, she was the creature. Gauguin could also fit both roles: Having broken his obligations to his family to pursue his career, antagonized generous friends, and proved himself a unrepentant seducer, he was clearly the monster. On the other hand, as the apostle of his own artistic convictions, struggling relentlessly with the art establishment, persistently impecunious, painfully ill, and plagued with very bad luck, he too could be the creature. Ultimately, both Gauguin and his grandmother were blessed with powerfully creative personalities, and both suffered from society's inability to understand their goals and properly appreciate their endeavors and their achievements.

A good case can be made for seeing in the large, bleeding dog/wolf at Oviri's feet yet another embodiment of Gauguin himself. The artist's propensity for representing himself as a dog has already been mentioned. He was described as a wolf by no less a friend and admirer than Edgar Degas, who (as proudly noted by Gauguin) responded to the queries of two young men at the time of the 1893 Durand-Ruel exhibition in Paris by reciting Jean de la Fontaine's fable "The Dog and the Wolf," in which a famished wolf declines to trade places with a well-fed dog to avoid wearing a collar. "You see," Degas explained, "Gauguin is the wolf."[30] In the statuette, dog/wolf/Gauguin also perishes in the struggle to pursue his destiny in full freedom.

As for the allusion to Seraphitus-Seraphita, the hermaphroditic Swedenborgian angel, it is invoked in praise of those who have steeled themselves in order to rise above sentimentality and domesticity in the pursuit of "a love that burns without torment"—whatever the consequences to those around them.[31]

*I*n *Arearea no varua ino (The Evil Spirit Is Having Fun*, also translated as *Amusement of the Devil)* of 1894 (fig. 124),[32] Gauguin reemphasizes the tragedies of love. It is dedicated to Mme Gloannec, owner of the inn in Pont-Aven where Gauguin stayed between his two sojourns in Tahiti, presumably after his leg was broken during a fight with fishermen in Concarneau. Intended to be seen by the artists frequenting the inn, it is, in effect, a manifesto of the style and iconography that Gauguin had developed in Tahiti. Stylistically, a renewed insistence on fairly uniform color areas, particularly for the flesh of the two women, seems to allude to the heyday of the synthetist style of 1889. Iconographically the work's message may appear particularly abstruse to the uninitiated; indeed, one scholar has referred to it as "stuffed with indecipherable symbolic details."[33]

The composition is divided diagonally by the fallen tree, which separates the gods and representatives of the ancient cult above it from the two mortal Tahitian women below—just as the

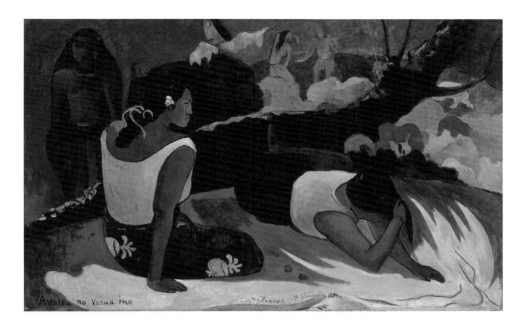

124 *Arearea no varua ino (The Evil Spirit Is Having Fun)*, or *Amusement of the Devil*,
 1894. Oil on canvas. Ny Carlsberg Glyptotek, Copenhagen.

tree in *The Vision after the Sermon: Jacob Wrestling with the Angel* (fig. 49) separated the imaginary and "real" figures. With this device, Gauguin adheres to the academic rule of the three unities, requiring that any scene depict a single action, at one time, in one place.

At the top of the canvas, a little left of center, the bilious blue-green head of the seducer floats above two clouds that suggest wings and casts a malevolent glance upon the scene. This head has been identified as the head of Tefatou,[34] perennial mischief-maker and the evil spirit of the title. To the right, the distant figures engaged in a ritualistic dance are naked to the waist as a sign of respect for the gods.[35] They are priests of the ancient religion, presumably attempting to propitiate the gods. At about the same level, above and to the left of the seated woman's head, a hand with a bent finger rises from behind a bush. It is the hand of Hina imploring Tefatou to take pity on the lovelorn. Further to the left, a monumental figure leaning on what could be a shield, or perhaps an *omoré* or war club,[36] can only be the effigy of Oro—the god who abandoned Vaïraumati, the patron of the terrible Areoi and, as the powerful god of war,[37] responsible for the destruction of entire generations. With its large mustache, this face resembles that of the god in the center of the "war" panel of the wood carving *War and Peace* of 1901 (see fig. 134)—clearly the god presiding over the operations.

Below the fallen tree, between the two mortals, are two small orangish red spots, emphasized by the contrast of their hues with the nearly complementary gray-blue of the shadow on the ground. They evoke the biblical apples that are at the root of the drama. The young woman in the foreground is in the position of the jealous figure in *Aha oe feii? (Are You Jealous?)* of 1892, echoing her preoccupation and anger. Unlike the companion of the jealous woman in that painting, ready and willing to give herself to love, the second woman in this work seems overwhelmed by lassitude and despair. She is lying down, her head facing the ground, holding her hair as if she were about to pull it. Adding a touch of graphic symbolism, the lower section of the picture is dominated by a "conflagration of pinks and violets" evocative of jealousy, as the critic Achille Delaroche had explained in connection with *Aha oe feii?* These flamelike tongues on either side of the reclining woman threaten to engulf her. For these women, the advice of *Be in Love and You Will Be Happy* (fig. 37) could only have been an additional source of bitterness.

*W*hile in France, Gauguin undertook another important Tahitian painting—a grand conclusion, it would seem, to his first Oceanic experience: *Mahana no atua (The Day of the God* or, more accurately, *The Day of the Goddess)* of 1894 (fig. 125).[38] It is a late-afternoon scene, and the orange-pink light reflected by the clouds creates rich and warm yellow-orange effects on the golden sands and their reflections on the intense blues of the water. The body of Hina, goddess of the moon, is blue-gray, suggesting that it is her effigy that is being worshiped. She is also a symbol of eternity, for Moerenhout and for Gauguin at any rate, having wrested from Tefatou humanity's survival through the cycles of regeneration. Her hands posed in the imploring gesture associated with her dialogue with Tefatou, she blesses the scene as Hina, goddess of mercy.

We have already encountered the goddess in that pose in the figure of Hina in the lithograph *Manao tupapao* (fig. 112), also executed in Paris.[39] She is solemn, resembling a hieratic sculpture, perfectly symmetrical and represented frontally; her body retains the fullness and grace of Javanese dancers. Her legs are barely apart, and her arms spread out on each side, with forearms rising a little above the horizontal. She is now in full regalia. Her loins are partly wrapped in a dark, soft-looking skirt held by a belt, opened at the front to reveal her legs. Above Hina, descending on each side to the level of her hands, a crescent-shaped vegetal canopy, derived from an ornament hovering around Buddha in one of the Borobudur friezes (fig. 42),[40] is also dark. Both items render the body more luminous by contrast. Behind her head and shoulders a disk, also dark—a symbol of status no doubt—serves the same pictorial purpose. It is as if Gauguin were trying to suggest that the moon, mostly visible at night, emerges from the darkness with

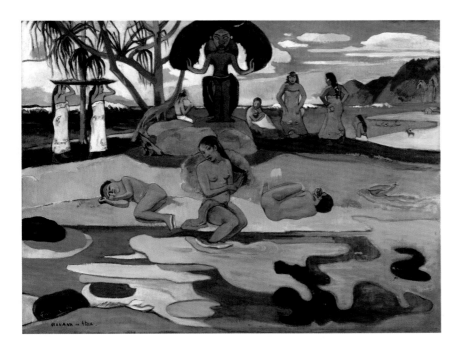

125 *Mahana no atua (The Day of the God [or Goddess])*, 1894. Oil on canvas.
Helen Birch-Bartlett Memorial Collection, The Art Institute of Chicago.
Photo © The Art Institute of Chicago.

all her godly insignias. To the left behind Hina, next to the pandanus tree, a giant piece of drift-
wood suggests some pre–Ice Age animal, its long neck rising to sprout the vegetal crescent that
serves as the goddess's canopy. It is reminiscent of the zoomorphic fantasies of the drawing "Tiis"
in *Ancien culte mahorie* (fig. 108) and the woodcut *L'univers est créé (The Universe Has Been Cre-
ated*, fig. 109) and links the scene to the universe's evolutionary eons.

It is Hina's feast day. The mood is one of quiet meditation and peaceable poetry as the pop-
ulation prepares for an all-night celebration. It is appropriate to bathe, or at least to wash, be-
fore the festivities, Gauguin implies with the woman in the center. To the right of her, a child is
curled in a fetal position holding a round object, very likely the biblical apple, similar to the one
in the woodcut *Manao tupapau* of 1893–94 (fig. 113), adding the concept of original sin to a pri-
mal desire to seek protection through a return to the womb. And symmetrically to the left of the
bather, in a near-fetal position, another child simply rests.

Other figures are more active. Two personages bring plates of food in anticipation of the fes-
tivities; one is playing the *vivo*, or flute, and another two are beginning to dance. Most impor-

tant, the embracing couple of the print *Te faruru (Here We Make Love)* of 1893–94 (fig. 79) provides a touch of tenderness before the party is in full swing. A rider in the distance arrives to take part in the celebrations, as do three men hastening to the shore in a canoe. The work is a fitting meditation on ancient Tahiti's poetry as the artist braced himself for a new escape from the civilized West.

*D*isappointments piled up during Gauguin's stay in France. An exhibition at Durand-Ruel's in Paris in November 1893 attracted significant critical notice but few works sold. In the course of a trip with artist friends and wives to Concarneau near Pont-Aven, urchins jeered at Gauguin's Javanese lady companion; Armand Séguin pulled the ear of one of them; the boy's father and local sailors joined the fray and a fistfight ensued. Gauguin tripped and broke an ankle. The wound never healed properly and caused him to become handicapped for the remainder of his life. The prosecution of his assailants did not cover his medical and legal expenses.[41] He was in dire straits: "For two months I have had to take morphine," he wrote a friend from Brittany, "and I am somewhat dazed at the moment; in order to fight insomnia I must succumb to alcohol, and yet I only sleep four hours a night. But this slows me down and disgusts me. Yes, I walk with a cane and I limp, and it is distressing not to be able walk a short distance in order to paint a landscape." His female companion, moreover, returned to Paris while Gauguin was in the hospital and looted his apartment, although she left the works of art behind. Finally, he lost a lawsuit against Marie Henry, who had refused to return to him works of art he had left at her inn in 1890, on a technicality trumped up by a local judge. Referring to this "succession of misfortunes" in his letter, Gauguin added: "[Given] the difficulty I have in earning a living on a *regular* basis despite my reputation, my taste for the exotic also contributing to it, I have made an irrevocable decision. This is it: In December I shall return [to Paris] and work every day in order to sell, in bulk or piece by piece, all that I possess. Once this capital is in my pocket, I will go back to Oceania, this time with two [artist] comrades [Armand] Séguin and an Irishman [Roderic O'Connor]. No need to admonish me in this regard. Nothing will prevent me from going, and forever. What a stupid existence this European life is!"[42] Gauguin made arrangements with two dealers, Lévy and Chaudet, who assured him that he need not worry about finances even though his work would be hard to sell, and who also stored his works. "I therefore left with confidence on the basis of solid calculations," he wrote later.[43] He gave a friend power of attorney to handle his business affairs. An auction of his work at the Hôtel Drouot brought in only a very modest amount. But Gauguin apparently still had some of his inheritance money and was able to set out for Polynesia once again, leaving Paris on July 2, 1895.[44]

The Last Retreats

CHAPTER 11

The Last Years in Tahiti

Well . . . I am here, I shall stay here, and I must die here.

To Georges-Daniel de Monfreid, May 1899

*A*fter stops in Sydney and Auckland, where he saw magnificent specimens of Maori art, Gauguin landed in Papeete in early September of 1895. "I had to stay in Papeete for a while in order to make a decision," he wrote Georges-Daniel de Monfreid in November 1895.

Finally I had a large Tahitian hut built in the countryside [on rented land, in Punaauia, closer to Papeete than was Mataiea]. My goodness! It is superb, as far as exposure goes: in the shade, alongside the road, and behind me a stunning view of the mountains. Imagine a large starling cage made up of bamboo shoots, with a roof of cocoa-palm, divided by the curtains of my old studio. One of the two parts is the bedroom. It receives very little light so as to keep it cool. The other has a large window, high up, to make a studio. On the floor, matting and my old Persian carpet—the whole decorated with textiles, bibelots, and drawings.

You see that I am not too much to be pitied just now.

Every night diabolically inspired little girls invade my bed; I had three of them to perform with yesterday. I shall put an end to this indolent living, bring in a serious woman, and work my head off! All the more so because I am in high spirits and will do better work than I did in previous years. My former wife got married in my absence, and I was obliged to make her husband a cuckold. But she cannot go on staying with me, despite her eight-day escapade.

So much for the obverse of the medal; the reverse is less reassuring. As always when I have money in my pocket and nurture hope, I spend

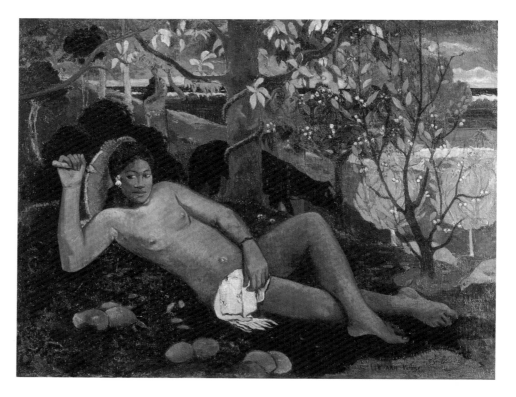

126 *Te arii vahine (The Noble Woman)*, 1896. Oil on canvas. Pushkin Museum of Fine Arts, Moscow/Bridgeman Art Library.

heedlessly, trusting as I do the future and my talent, and I rapidly reach the end of my rope. After paying for my house I had 900 francs left, and I receive *no* news from France. . . . I am owed in all 4,300 francs and I don't receive *even a letter.*

Referring to a problem that would plague him for the remainder of his days, Gauguin complained about one of his many dealers and agents in Paris: "See Levy . . . and tell him that I am very worried about my money and my picture business."[1]

Gauguin must have devoted the early months to building his hut and settling in. He was ill and discouraged: "In the end everything wears out, and my willpower is pretty weak just now: since my arrival, my health grows worse every day. My broken foot causes me terrible suffering; I have two wounds that the physician is unable to heal, and in hot climates that's difficult. When night comes, I experience terrible muscular spasms [*tiraillements*] that keep me awake until midnight. I made extraordinary efforts during my first trip; you saw the results [in the Durand-Ruel exhibition]: What have I achieved? A defeat, that's all." And yet, Gauguin had painted a canvas

that "I believe to be even better than anything earlier: a nude queen lying on a carpet of green-ery."[2] There follows a description of *Te arii vahine (The Noble Woman)* of 1896 (fig. 126).

The painting is a variant of the wood carving *Reclining Tropical Eve with a Fan* of 1887–89 (fig. 22). A spiraling vine around the tree trunk alludes to the biblical serpent. The role of the pimpish dueña or confidante is filled by "a servant," as Gauguin calls her, picking fruit. He also refers to "the two old men discussing the tree of science." They recall the unsympathetic ob-servers who appear, for example, in the *Design for a Carved Bookcase* (fig. 28), *Be in Love and You Will Be Happy* (fig. 37), and *Village Drama* (fig. 34); they also prefigure those of *Where Do We Come From? What Are We? Where Are We Going?* (fig. 131), who inform society of the sexual behavior of individuals. Far from provoking social opprobrium, however, the two in *Te arii vahine* are lost in philosophical palaver. "Two doves are cooing," Gauguin writes, implying that pure love is a distinct possibility for the queen and other "self-righting" Eves. As was the case of the princely figure in the wood carving, free love has its aesthetic rewards for the members of an old and powerful aristocracy who can afford the consequences; and women are as entitled to such freedoms as men.

Gauguin's health and frame of mind a few months later are vigorously evoked in *Self-Portrait, near Golgotha* of 1896 (fig. 127). By the time of the artist's death at Hiva Hoa, the painting was in poor condition; it was purchased for 15 francs at the 1903 sale of Gauguin's belongings in Pa-peete, by the young naval physician Victor Segalen, who had it restored in Paris.[3] A 1958 pho-tograph, taken when the painting was on the New York art market, distinctly shows a large cross rising against the sky to the right of Christ/Gauguin.[4] A New York restorer soon thereafter trans-formed the cross into a meaningless stone needle. A 1991 conservation treatment revealed that the main features are well preserved, but noted some faded peripheral retouchings. The awk-ward position of the neck, located well to the right of the center of the shoulders, is explained by x-ray photographs of the painting, which reveal that the artist changed the direction and po-sition of his original head to go with the face he painted, even though this did not relate to the shoulders.[5] A pentimento next to his right shoulder reveals that he did try to correct this by short-ening the shoulder a little.

The painting is remarkable testimony to the artist's force of character during his final ordeal. The shrewd, partly veiled, staring gray-green eyes are bathed in a uniform half-shade. Faintly animated by a tiny white reflection to the left of each pupil, they nevertheless stand out mourn-fully against the lively contrast of light and shade that informs the fleshy pinks and reds of the eyelids. The overall feeling of sadness and weariness is heightened by the deep shadows under the eyes and the drooping corners of an otherwise firm mouth dominated by a protruding lower lip. The diagonal brown slash on the left cheek suggests scarring caused by some disease.[6]

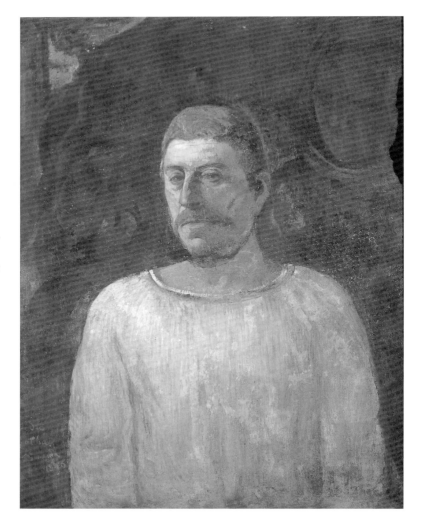

127 *Self-Portrait, near Golgotha*, 1896.
Oil on canvas. Museu de Arte,
São Paulo. Photo: Erich Lessing/
Art Resource, New York.

The artist's shirt worn by the subject is made of very fine, almost translucent, pleated muslin, ensuring maximum comfort in a hot and humid climate. With raglan-cut sleeves for ease of movement, it is a suitable garment for an eminently practical individual. With a mere touch of light blue defining the shading of the pleats, furthermore, the smock's whiteness and stark simplicity recall Christ's traditional garment and add to the dignity of the figure. The picture is indeed that of a Christ remarkably free from the emotional fetters usually ascribed to him in pious imagery: he is resigned and suffering, to be sure, but also strong, shrewd, and determined. He remains a proud leader, even in defeat.

Writing a year or two later, quite possibly from earlier notes, Gauguin asserted his view that

Christ was first and foremost a highly effective social reformer. He thought of him and the apostles, together with Isaiah, Ezekiel, and Daniel, as questioning "this profane Pharisaïcal cult that substitutes itself for the true cult."

> This principle of Christ's, that all men are brothers, that he who wants to be the first shall be the servant of all . . . giving himself as the first-born of human regeneration . . . [promoting] that feeling in his conception of idealism, to the point of martyrdom, [to the point also] of forgiveness for those who victimized him. Is not this principle the most essential prime basis of any social constitution? Of a union [based on] vivifying, conciliatory, devoted, family-oriented, patriotic, humanitarian concord? Is this not the principle consecrating man free, socially as a citizen, within a sovereign democracy?[7]

This view was tantamount to seeing in Christ's message the basis of the reformist humanitarianism preached by Victor Hugo, Jules Michelet, Ernest Renan, Jean-François Millet, Vincent van Gogh, and others, and in its implementation the establishment of an ideal democracy. But, of course, the notion of the artist-Messiah remained.

Two figures carved in the background rock are visible only in some reproductions. To the left one sees the head of a native male in profile, looking away from the artist. Bald, thin, and emaciated, its profile reveals its bone structure, particularly the salient cheekbones. To the right, the nearly frontal head of a hooded woman emerges, delicate, pretty, with a serious expression, and wearing a sumptuous scarf adorned with geometric designs. In the absence of signs relating the figures to indigenous religion, one must see in them an accompaniment to the Cross and its message: these friendly Polynesian figures, capable of humanitarian abnegation and brotherly love, watch over the artist's ascent of Mount Calvary in his endeavor to give substance to his dream of a perfect humanity in a tropical paradise.

Poèmes barbares of 1896 (fig. 128) gives an intimation of the loss of status of god-creators in Gauguin's Polynesian pantheon. The figure to the left, a small monkey with a Marquesan mask for a head, is none other than Taaroa, chief deity and creator of the universe.[8] According to Charles Leconte de Lisle, in "Genèse polynésienne," loosely based on Moerenhout's translation of the "Chant of Creation": unable to create the "axes, rocks, seas full of isles," Taaroa

> The unique being, forthwith, this fount of the gods
> In his right hand rolls and launches the seven skies.

> *L'être unique, aussitôt, cette source des Dieux,*
> *Roule dans sa main droite et lance les sept cieux.*[9]

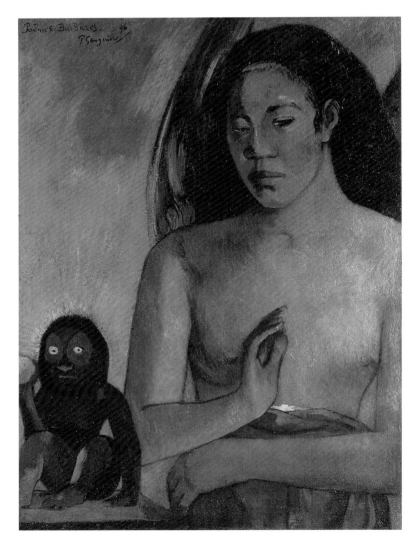

128 *Poèmes barbares (Savage Poems)*, 1896. Oil on canvas. Fogg Art Museum, Harvard University Art Museums, Cambridge, Mass./ Bequest from the Collection of Maurice Wertheim, Class 1906/Bridgeman Art Library.

This is precisely what the monkey-Taaroa in the picture is about to do with the ball he is holding.

Gauguin considered the concept of a creator-god "supernatural, illogical, admitted in times of ignorance up to this day, even by men of science, who, afraid to break with tradition, dared not conclude otherwise on the basis of their own observations—a conclusion that would nevertheless be natural." It is based on a false assumption, that "nothing can exist without a beginning," he argued; and he derided both the Polynesian "Chant of Creation" and the biblical "Let there be light: and there was light" (Genesis 1:3). Instead, he preferred the transformation "from atom to pure spirit," in keeping with the evolutionary views of Theosophy. Turning to another

argument also based on Theosophy, Gauguin claimed that when conceived as a symbol of pure, eternal spirit rather than as a material entity, the god-creator becomes "the principle of all harmonies."[10]

At any rate, the god-creator, here conceived as a physical being, looks decidedly puny. But then, as with *Idol with a Pearl* of 1892 (fig. 103), the gentle angel at Taaroa's side represents "universal spiritual truths behind the literal interpretation of Tahitian and Buddhist legend."[11] Here the angel's right hand is raised in the often encountered Buddhist gesture that implies "give in to your instincts but with prudence," thus introducing once again the Theosophical notion of universal wisdom.

Nevermore of February 1897 (fig. 129) was, according to Gauguin, a nostalgic return to "a certain barbaric luxury of times past. The whole is drowned in willfully somber and sad colors; neither silk nor velvet, nor muslin, nor gold, makes up this luxury, but purely matter that has become rich in the hand of the artist. No f . . . g frills . . . the imagination of man has alone enriched this fantasy."[12] The painting recalls the imagery of the free-loving princesses of the Martinique carving *Reclining Tropical Eve with a Fan* and *Te Arii Vahine (The Noble Woman)*. But it has a dour, bitter tone that reflects Gauguin's amorous disappointments during his second stay in Tahiti.

Gauguin, it should be noted, had secured the services of a new local *vahine* of fourteen, Pau'ura, apparently less desirable than Teha'amana, who entered his house on New Year's Day of 1896.[13] He confided his feelings about her to his friend Armand Séguin in a discursive letter, juxtaposing memories, pleasant and otherwise, and throwing in a strong dose of misogyny for good measure. "You have loved or *wanted to love* Mme . . . no, you see, I prefer fat women, even Julia. Not love—meat, that's all; it is enough. . . . The love of the painter exists only in his work. . . . It is true that there was love! Such throbbing kisses—the whole kaboodle [*tout le bordel*]—what! Love calls for another—Julien Leclerc. . . . And if the poor little Judith were to fall into his arms, pretty as she might be, it would not be half-evil. It is a woman, and women are only flesh; one must befriend them only in order to *lay them* and without the assistance of a banknote." He added, "My young woman of fifteen is good for the daily chow, and does splendid oral sex, and all this for a 10-franc dress every month."[14] The letter's tone is boastful, but it reflects Gauguin's purely physical attraction for very young, attractive, and lively girls such as Judith Gérard [Arlsberg], the daughter of his friends the Molards, and above all attests to the purely imagined as well as the physical aspects of his approach to love: dreaming, and not altogether a pleasant dream.

With regard to the title *Nevermore* that he gave to his just-completed painting, Gauguin explained that it is "not Poe's raven's but the bird of the devil who is on the lookout."[15] There is

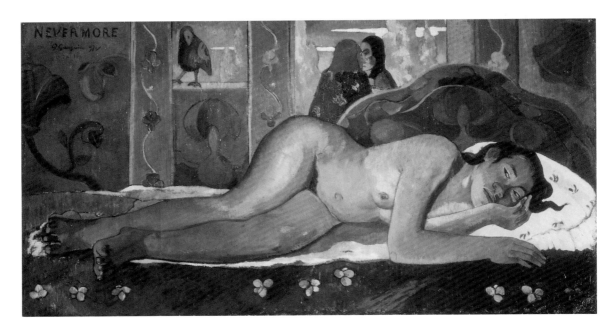

129 *Nevermore*, 1897. Oil on canvas. Courtauld Institute of Art Gallery, Somerset House, London / Bridgeman Art Library.

indeed a miserable-looking bird awkwardly perched on the windowsill, and Gauguin has added to Edgar Allan Poe's quiet and sad nostalgia a touch of prurience: gourds on the back panel of the bed and on the wall under the raven suggest interpenetrating organic forms. The relationship, or the dream thereof, will not end well: two ominous unsympathetic observers are gossiping, subjecting an individual's sexual instincts to social opprobrium. Memories of love can be painful.

Gauguin's health and finances had taken a turn for the worse. "Yes, I am down and out, and I have no energy when I consider the future and present situation. I have no strength, exhausted by sleepless days and nights because of the pain in my foot. [My] whole ankle is but a wound, and this has been going on for five months. When I work, I find distraction and I become strong once again, but without work, almost without food, without money, what am I to become? However even-tempered one may be, there are limits." Gauguin subsequently spent time in the hospital, apparently undergoing treatment for the syphilis that prevented his wound from healing, among other things. He admitted to hoarding arsenic, a standard remedy in those days—and left in much better health and delayed payment of the hospital bill.[16]

Toward the end of April 1897 the owner of Gauguin's rented land died and his heirs sold the

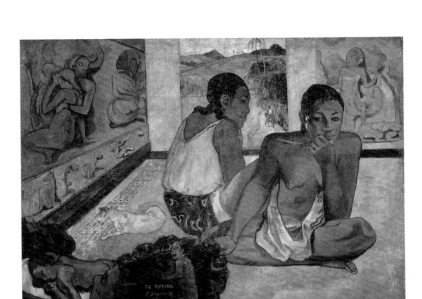

130 *Te rerioa (Day Dreaming;* referred to by Gauguin as *The Dream)*, 1897. Oil on
canvas. Courtauld Institute of Art Gallery, Somerset House, London/Bridgeman
Art Library.

property. Forced to move, Gauguin obtained a mortgage and purchased two plots of land in
Punaauia with a large wooden house, to which he added a studio. The interior depicted in *Te
rerioa (Day Dreaming*, fig. 130), which Gauguin referred to as *The Dream*, was purportedly that
of his new studio, which had all the sophistication and elegance one might expect. Although the
only surviving photograph shows a single painting, judging from his later carvings for his house
in the Marquesas (now in the Musée d'Orsay), it is likely that the studio, too, was richly orna-
mented.[17] The decorations are said to have consisted of large carved panels (the wood was shipped
from Oregon).

The walls in *Te rerioa* are covered with scenes depicted with a slightly mannered elegance
partly inspired by the Javanese shadow theater. To the left the couple of *Te faruru* of 1893–94
(fig. 79) interrupts their embrace, the man looking angrily at the dueña or confidante behind
them, whose advice to "trust your instincts but with prudence" must have gone awry. She is the
epitome of the hard, haughty, and disdainful Parisian society woman, in Javanese guise, dressed
in tailored vegetal strips that might have made a great couturier of the 1930s proud. To the right
of the door, a shadow puppet looking very much like the Hina of Mercy raises both forearms
as if in a blessing, its billowing skirt pulled to the side in the tradition of Javanese shadow pup-

pets. A frieze of animals underlines the figure carvings: beneath Hina, two copulating rabbits are appropriately celebrating regeneration.

On the material level, things had improved for Gauguin, as he wrote Monfreid in November 1896: "Ah, if only I had what was owed me. My life would be extraordinarily calm and happy. I shall soon be the father of a half-Asiatic child; my charming Dulcinea has made up her mind to lay an egg. My studio is very beautiful; I assure you that time goes fast."[18] Tragedy struck, however. Two paintings of early 1896 commemorate the death of Pau'ura's first child, a daughter. *Te tamari no atua* (*The Child of God;* Neue Pinakothek, Munich) and *Bé Bé* (Hermitage, St. Petersburg) are nativities of sorts. In both Pau'ura is lying on a bed in a stable and the child is held in the arms of a *tupapau*. In the first the child and Pau'ura wear halos, while in the second it is the presence of an angel that links the scene to the birth of Christ.

As for his painting *Te rerioa*, as Gauguin described it in a letter to Monfreid dated March 12, 1897: "All is dream in this canvas; [who dreams?] is it the child, is it the mother, is it the rider on the path, or maybe is it the dream of the painter? All this is beyond painting, one might say. Maybe not."[19] It was a sad meditation on yet another disappointment—in actuality, the meaning of the Tahitian title, *Te rerioa*, is "nightmare."[20] And, indeed, there are ominous signs in the painting. The elaborate cradle that Gauguin sculpted, or imagined, for his child takes on a tragic significance. Two small nude figures appear to be assaulting it from the footboard. The expression of one of them is clearly visible: a devilish urchin standing in for a malevolent little *tupapau*. Yet Pau'ura, to the left, and her companion exhibit a mood of soft nonchalance. A native of Punaauia, Pau'ura frequently left Gauguin to spend time with relatives and friends. Later, Gauguin would ask the public prosecutor to charge her with theft. A nightmare indeed!

The death of Pau'ura's newborn tragically foreshadowed an even greater blow for Gauguin. In April 1897 he learned of the death of his daughter Aline at the age of nineteen. His health also took a turn for worse; he complained of being unable to breathe and vomiting blood and was mostly confined to bed. He entered the hospital once again, for a long stay this time.[21]

In December 1897 Gauguin undertook to convey in a large painting his artistic last will and testament, *Where Do We Come From? What Are We? Where Are We Going?* (fig. 131). As he wrote to Monfreid:

No sooner had the mail arrived, having received nothing from [his debtor-dealer Georges] Chaudet, [and with] my health all of a sudden almost restored, that is deprived of the chance of dying naturally, I wanted to kill myself. I went to hide in the mountains, where my corpse would have been consumed by the ants. I had no revolver, but I had arsenic that I had hoarded at the hospital. . . . Was the dose too strong, or did the subsequent vomiting offset the poison? Well, after a night of terrible suffering I returned home. My resolve was set for the month of

December. . . . Before dying I wanted to paint a large canvas I had in my head, and I have worked day and night in an unheard-of fever. To be sure, it is not a canvas executed like a Puvis de Chavannes, with studies after nature, then preparatory sketches, etc. All this is done from memory, from the tip of the brush, on industrial canvas full of knots and imperfections, so that its appearance is terribly rough.[22]

The essential aspects of the picture's symbolism were later explicated in a letter to Charles Morice at a time of a possible sale:

> *Where Are We Going?*
> Near the death of an old woman
> A bird strange and stupid concludes:
> *Who Are We?*
> Daily existence.
> The man of instincts asks himself what all this means.
> Source.
> Child.
> Life begins.
> The bird concludes the poem [through] a comparison between the inferior being and the intelligent one in this large ensemble announced by the title.
> Behind a tree, two sinister figures, dressed in sadly colored clothes, converse near the tree of science, their dolorous aspect caused by this science itself, in comparison to [the feelings of] simple beings in a virgin nature that could be a human concept of paradise [if] they abandoned themselves to the happiness of living.[23]

Additional information was provided in a letter to Monfreid:

> On the lower right, a sleeping baby, then three crouching women. Two figures dressed in purple confide their reflections to one another; an enormous figure crouched deliberately and not in perspective raises an arm in the air and looks, astonished, at the two personages who dare to think about their destiny. A figure in the middle picks a fruit. Two cats are near a child. A white goat. The idol, its two arms raised mysteriously and rhythmically, seems to point to the hereafter. A crouching figure seems to listen to the idol; then, lastly, an old woman near death seems to accept, to resign herself to what she thinks and brings the legend to an end; at her feet a strange white bird, holding a lizard in its foot, represents the uselessness of idle words. Everything takes place on the bank of a stream in the woods. In the background, the sea, then the mountains of a neighboring island. . . . If one were to tell the students of the Beaux-Arts for the Rome competition, "The painting you are to do will represent: 'Where do we come from, what are we, where

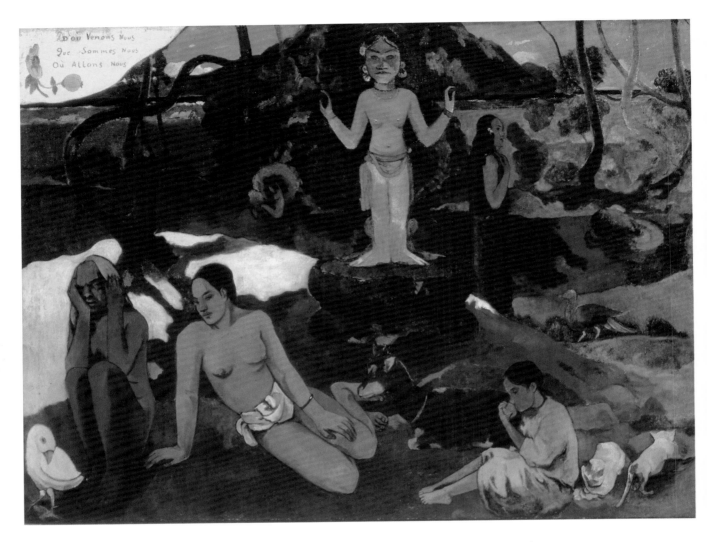

131 *D'où venons nous, que sommes nous, où allons nous (Where Do We Come From? What Are We? Where Are We Going?)*, 1897. Oil on canvas. Museum of Fine Arts, Boston/Tompkins Collection/Bridgeman Art Library.

are we going?'"—what would they do? I have finished a philosophical work on this theme comparable to the Gospel: I think it is good.[24]

The "strange white bird" at lower left must once again be the bird of the devil, cawing, as mechanically as Poe's raven did its "nevermore," the fateful: "What are we?" Judging from the al-

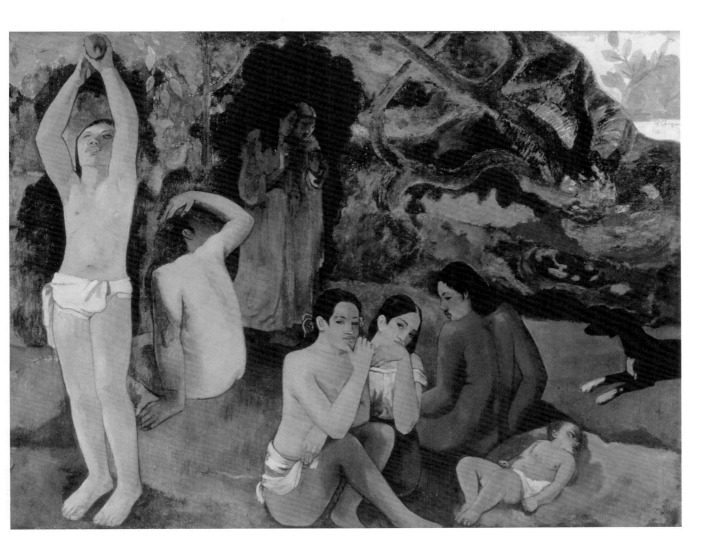

lusion to original sin in the form of the adult man picking a red fruit from a tree in the center foreground, the answer would appear to be "sinners." Gauguin, it would seem, revealed once again the imprint of his early Catholic education.

The cycle of life is laid out in the foreground, from the infant to the right to the mummy-like Eve on the left—the scene evolving under the protection of the Hina of Mercy, shown as a sculpture again, who ensures that the human spirit will survive through its achievements on earth. The psychological tensions occasioned by the contest between man's instinctual call and the forces of society are embodied in the juxtaposition between the "enormous" figure who

"raises its arm" and the "two personages who dare to think about their destiny"—the unsympathetic observers who will convert man's personal drive into a cause for religious and social opprobrium.

The figure who "seems to listen to the idol" will be recognized as the figure of *The Awakening* (fig. 94). Can one see in it Gauguin's feminine ideal? An emancipated, self-righting Eve? Perhaps even his ideal love? Under a canopy resembling that of Hina in *Mahana no atua* of 1894 (fig. 125), to the right of Hina, a tall, Tahitian Eve in an elegant dark dress is at home and stands at ease in the midst of it all. She is fulfilling her feminine role under the blessing hand of Hina and for that reason ranks among the most important personages of the scene.

The scene is idyllic. The motley blues and greens of the background reveal the ocean behind a light screen of trees and, in the distance, a neighboring island against a deep blue sky. The yellow-gold in the two upper corners recalls the gilding of Byzantine mosaics. The painting is a vision of "simple beings in a virgin nature that could be a human concept of paradise [if] they abandoned themselves to the happiness of living." Paradise is indeed attainable in dreams! A near-caricature of a sunflower in the left golden patch attests to the presence of the artist.

Gauguin called the picture "a philosophical work . . . comparable to the Gospels." He was undoubtedly referring principally to the figure who "raises its arm and looks, astonished, at the two personages"—the unsympathetic observers—"who dare to think about their destiny." "The man of instincts asks himself what all this means" when compared with the feelings of "simple beings in a virgin nature," with the possibility of abandoning oneself to "the happiness of living." The figure embodies a great human dilemma—the greatest perhaps—suggested by Gauguin ever since he juxtaposed the tradition of pastoral frolics to the social and religious opprobrium (and worse) to which the unfortunate Breton lasses were exposing themselves. The problem was a profound one, opposing as it did a nature philosophy tied to the cult of freedom and unrestrained argumentation, engendered by the Enlightenment and more or less consecrated by the Revolution, to strictures imposed by the centuries-long process of evolving an organically integrated society—however marred by superstitious, irrational, even barbaric traditions.

At about this time Gauguin wrote his angry anti-Catholic diatribe, *L'esprit moderne et le catholicisme,* eventually sent to the Catholic bishop of Atuona in the Marquesas, who sent him in exchange an expensive tome on French Catholic missionary schools.[25] Gauguin's text, subtitled *Where Do We Come From? What Are We? Where Are We Going?* is hopelessly wordy and repetitious, and suffers from an almost verbatim reliance on prolix passages from the writings of a British poet-spiritist, Gerald Massey,[26] who maintained, with supreme pedantry, that the child Jesus had long been "announced, incarnated, born [as] the pharaonic representative of the Aten sun, the Adon of Syria, and the Hebrew Adonai, the Child Christ of the Aten cult, the miraculous

conception of the ever-virgin mother personated by Mut-em-Ua." And, in near-conclusion, "Seas of human blood have been spilt to keep the bark of Peter afloat. Earth has been honey-combed with the graves of the martyrs of free thought. Heaven has been filled with a horror of great darkness in the name of God."[27] To which Gauguin chimed in, "The church founded by Peter . . . is characterized by absurdity." But true to his earlier pronouncement, Gauguin continued, "The great figure of Jesus nevertheless remains magnificent for its beauty, grandeur, as the most beautiful type of realized ideal . . . offered by destiny to the aspirations of human nature. . . . It is the point of departure of a new philosophy, reuniting all preceding ones (among them those of Buddha)."[28] The Theosophical spirit was still much in evidence.

*B*y May 1898 Gauguin had practically recovered from his suicide attempt, although he was still exhausted by the large canvas.[29] He undertook a number of idyllic works, most prominent among them *Faa iheihe* of 1898 (fig. 132) and *Rupe rupe* of 1899 (Hermitage, St. Petersburg). The words in the title of the first do not exist in the Tahitian language, but *fa'ai'ei'e* means "to embellish oneself" or "dress up," presumably for a feast. The title of the second derives from a song, *Tahiti ruperupe*, meaning "Fragrant Tahiti."[30] Both paintings have a gold background, and both are even more systematic than *Where Do We Come From?* in aligning their figures in a single friezelike ancient Mediterranean or Indian-Borobudur procession. There are allusions, as well, to the subject of *Where Do We Come From?* In each, original sin is implied by a woman picking fruit. Hina of Mercy is no longer present, but the graceful Eve is evident in the first. She wears nothing but a beautifully colored loincloth and raises her right hand in the gesture meaning "follow your instincts but with prudence." In the second picture, two women carrying sumptuous flowers against their breasts fulfill the same purpose. In both works, a nude young horseman, based on the riders on the Parthenon frieze, enters from the right, his scale and energy somewhat out of keeping with the elegant, static sensuousness of the rest of the picture. As we shall see, the horseman's meaning becomes clearer in the context of the symbolism of riders, who represent the forces of destruction inherent in what is left of Polynesian civilization, or rather Gauguin's dream of it.

In the colored print *Te atua (The Gods)* of 1899 (fig. 133), Taaroa, the god-creator, receives an even more drastic demotion than in *Poèmes barbares*. His head, cut off from his body, appears in the lunette, reminiscent of the head of the princely warrior in *Arii matamoe* of 1892 (fig. 106) and of the traditional draining of a vanquished warrior's fighting spirit for the benefit of his victorious opponent.

Taaroa reappears in the lower register, now endowed with a flowing white beard, his left hand

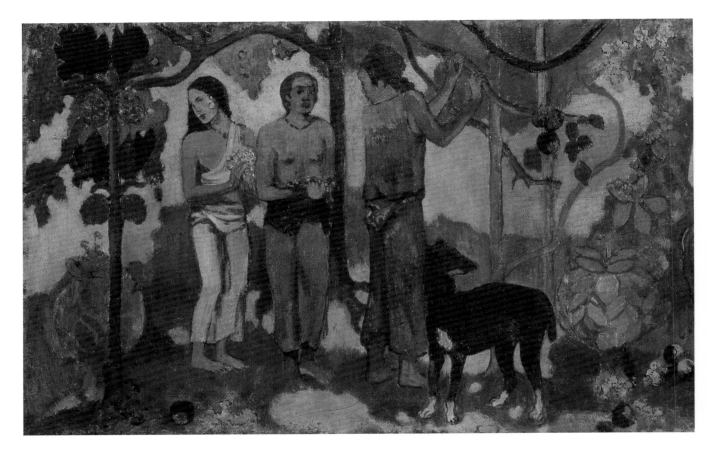

132 *Faa iheihe (To Embellish Oneself)*, or *Tahitian Pastoral*, 1898. Oil on canvas.
Tate Gallery, London. Photo: Tate Gallery, London/Art Resource, New York.

pointing toward a very Asiatic-looking Virgin and Child, as if attempting to engage her in an argument about the validity of his convictions and his powers. His right hand, its fingers bent, recalls the supplicating gesture of Hina in her dialogue with Tefatou. The Virgin seems totally impassive, undoubtedly strengthened by her Christian-Buddhist-Theosophical convictions. To the right, another Buddhist-looking figure, vaguely related to images from Borobudur, turns away from Taaroa, raising her right hand as if contemptuous of his palaver. Above Taaroa struts a peacock, which must be seen in this context as an early Christian symbol of permanence. Below is the fateful biblical serpent, and to its left crouches the rat of corruption, as in *Be in Love and You Will Be Happy*. To the right of the serpent is the diabolical bird, undoubtedly uttering nonsense.

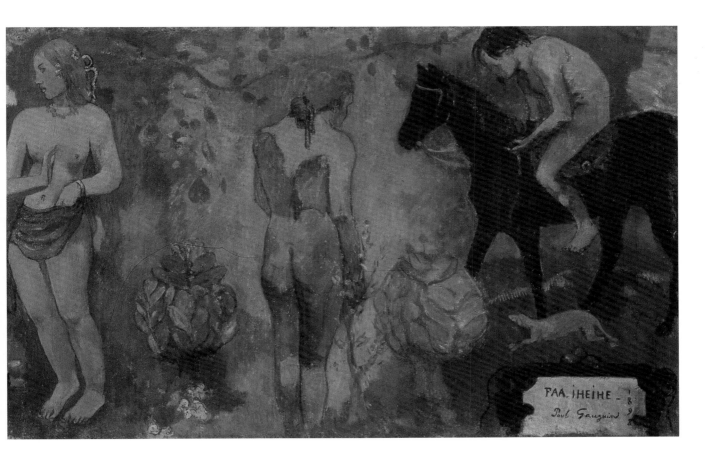

The pose of Taaroa has been compared to that of a Society Islands spear-holder. It is also essentially that of *Otahi*, or *Alone*, of 1892 (private collection), showing a young woman dreaming of love, presumably, in what has been called the sphinx position—ready for the approach of a male. A similar pose is adopted by Hina in "Taaroa and Hina" of *Ancien culte mahorie* (fig. 105), offering her vulva to the god-creator. The proud ichthyphallic figure of *L'Univers est créé*, which also appears in *Ancien culte mahorie* (fig. 102), is now reduced to offering his sexual favors like a female. It is the ultimate emasculation of a once-proud symbol of virility.

*G*auguin had attracted the attention of a businessman-artist from Béziers, Gustave Fayet, who was slowly acquiring his work. Monfreid reported on December 1, 1900: "Your two canvases, whose true artistic value he can appreciate, look admirable between a Cézanne and a Degas. I

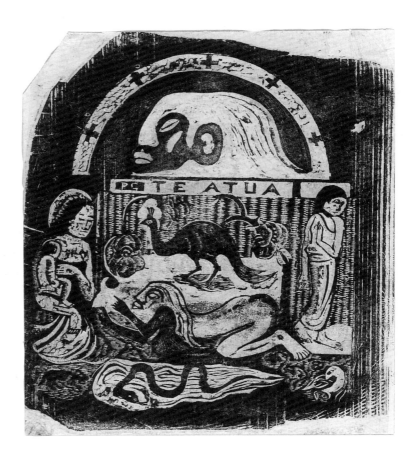

133 *Te atua (The Gods)*, 1899.
Woodcut printed in black with
touches of ochre in two printings
from one block on ivory Japanese
tissue laid down on white wove
paper. The Art Institute of
Chicago, Gift of the Print and
Drawing Club. Photo © The
Art Institute of Chicago.

hear they demolish everything in the neighborhood. . . . Even though he may not have paid as
much as you might have wished, it will not be a wasted sacrifice. Now [he] is very keen to own
one of your *ceramics* or one of your *sculptures*. Could you not execute some beautiful wood sculp-
ture and send it to him?" By February 25, 1901, Gauguin had obtained the wood.[31]

The resulting carving, *War and Peace*, of 1901 (fig. 134) is a fantasy inspired by Moerenhout
and Borobudur. The two panels, which were reversed when mounted by Fayet, are here shown
in their correct position for the first time, with the panel bearing the title, evoking war, at the
top. The foliage and flowers surrounding the central face of Oro, god of war, thus emerge from
the tree trunk of the lower panel.[32]

Several figures of the war panel derive from the *Assault of Mara* in the eighth-century frieze
at Borobudur (fig. 42, top): the archer releasing his bow, in particular, and the huddling women,
unwilling spectators, looking somewhat more distressed in Gauguin's carving. But the artist is

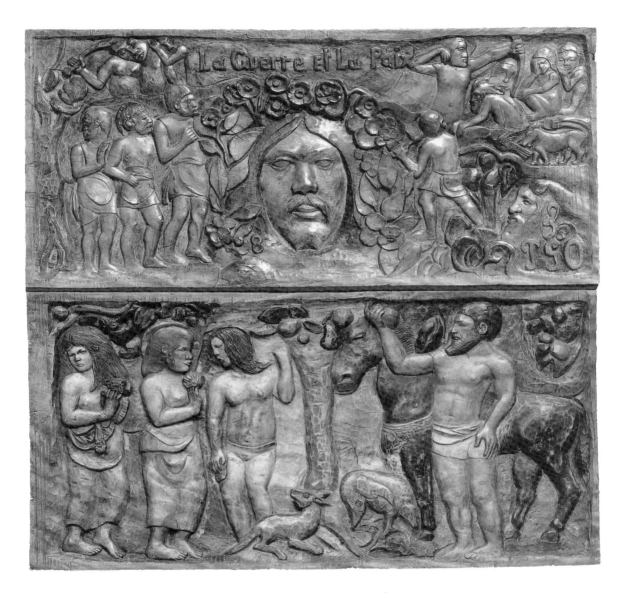

134 *La guerre et la paix (War and Peace)*, 1901. Painted tamanu wood. Museum of
 Fine Arts, Boston, Gift of Laurence K. and Lorna J. Marshall. Photo © 2007
 Museum of Fine Arts, Boston.

alluding to Moerenhout's accounts of war in ancient Tahiti. Battles were frequent among the chiefs' armies, often about land and food, sometimes simply in search of slaves. At the start, the armies were well disciplined, but some chieftains became "inspired," leading their men to act with crazed fury and turning the battle into carnage.[33] It was perhaps to evoke such a destructive streak that Gauguin evoked a simian, hirsute man to the right of the archer, offset by the cheerful, dionysiac, horned and bearded head in the lower-right corner.

The peace panel recalls the serene processionals of *Faa iheihe* and *Rupe rupe*. Here too flower-holding, beautiful Eves are lined up in a row. The stocky man to the left, who raises his right forearm, was inspired by the elegant proctor of the Panathenaic frieze of the Parthenon (of which Gauguin had a photograph) making the same gesture.[34] He is the master of ceremonies, introducing the theme of the return to the dreamlike idyll.

*E*arlier, in late March 1898, soon after he recovered from his botched suicide attempt, Gauguin attempted to obtain the post of secretary-treasurer of the Caisse agricole, the government-controlled agency that underwrote his mortgage. Governor Gallet, chief administrator of the colony, touched by Gauguin's plight, proposed instead a post of draftsman in the department of roads. The artist accepted, moving with Pau'ura to Papeete, where he received regular treatment at the hospital. Pregnant, Pau'ura returned to the Punaauia hut. Gauguin tried to lock her out, but to no avail. Items disappeared, and it was then that he pressed charges, and she was ordered to pay a small fine and spend a week in prison (she was acquitted on appeal). By January 1899, after receiving money from Monfreid, Gauguin left his job to return to Punaauia. Pau'ura joined him as if nothing had happened and gave birth to a boy on April 19. In the meantime atrocious pains in his ankle made it necessary for Gauguin to take morphine regularly.[35]

More objects disappeared from the hut, and trespassing was frequent. Gauguin paid a call on the public prosecutor, Charlier, who ushered him out. This marked the beginning of Gauguin's short career as a polemical journalist. Rather than protesting directly to Charlier, he wrote a blistering letter to the journal *Les Guêpes (The Wasps)*, recently founded with the help of the pharmacist Guardella, mayor of Papeete. Guardella had amassed a fortune through his monopoly of the opium trade, and he took the side of the largely Catholic colonists against the administration. Gauguin's letter ended: "You will admit that you do not have the strength to conduct an investigation. . . . I shall ask the governor to have you sent back to France to start your study of the law all over, as well as the ABCs of your profession." And referring to the governor: "Such men, liars as they may be, are easy to knock over." To make things even racier, Gauguin occasionally signed the letters Tit-oil, "onanism" in Tahitian, the worst sexual insult. His

journalistic talent was so much appreciated that he was made the director of the paper in February of 1900. For a while he also published his own mimeographed sheet, *Le Sourire (The Smile)*, which was very anecdotal, less overtly pungent, more humorous, and amusingly illustrated.[36]

In March 1900 Gauguin signed a contract with the dealer Ambroise Vollard, ensuring monthly payments against the promise of twenty-five paintings a year. Money was coming in regularly, and for the first time Gauguin felt financially secure. The decision to fulfill an old dream, to make a final escape, came around that time.[37]

In June 1901 Gauguin wrote Monfreid, "I am leaving next month to settle in the Marquesas, with great difficulty." He had sold his house but needed his wife's proxy to put through the deal.

> In the Marquesas life is cheaper [than in Tahiti] by more than half . . . in addition one can live by hunting, and on a few vegetables, which I will grow. . . . If all goes well within a year and I have a few thousand franc notes in front of me, I'll manage to make Vollard raise the price of the pictures; otherwise he'll be on his own.
>
> I believe that in the Marquesas, with the ease of obtaining models there (which becomes increasingly difficult here), and with open landscapes—in short, totally new and more savage elements—I shall make beautiful things.[38]

It was not just models that Gauguin needed; his leg sores were so repellent that no woman wanted to sleep with him. In the Marquesas, Gauguin proclaimed triumphantly, a model could be had for a handful of candy. The matter of the proxy was settled through a legal loophole; the house was sold for a slightly lower price. Gauguin's mortgage was repaid in full. On September 10, 1901, the artist left on a swift New Zealand steamer for the five-day crossing to Atuaona, the 500-inhabitant capital of Hiva Hoa, in the most inhabitable section of the archipelago. Pau'ura and her child were left behind—relatives and friends were always around, available as adoptive parents.[39]

CHAPTER 12

Hiva Hoa

The world is so stupid that when canvases are exhibited
showing new and *terrible* elements, Tahiti will become
comprehensible and charming.

To Georges-Daniel de Monfreid, June 1901

*T*he ship arrived in Atuona on September 16, 1901. Gauguin was greeted
by a Vietnamese prince, Ky Dong, exiled for his revolutionary zeal but mis-
takenly sent to Hiva Hoa instead of the penitentiary of Guyana by the French
colonial administration, and now working as a nurse. The prince, in impec-
cable French, offered to be Gauguin's guide and arranged for temporary room
and board. The artist promptly found accommodating women.

Lots were available on the grounds of the Catholic mission, and Gauguin
duly attended Mass at the cathedral in the company of a naval physician (who
had treated him in Tahiti) and a policeman (whom he also knew from Tahiti).
But after the bishop, back from a trip, sold Gauguin a parcel of land for a hefty
price, Gauguin immediately stopped attending Mass. Gauguin hired the two
best carpenters in town to build a remarkable hut; one of the men, Tioka, was
to remain a good friend. The hut was spacious and well suited to the climate.
Gauguin was even able to keep a bottle of water cool by dipping it into the
well in the garden, using a fishing line strung from his studio window. Like
the Maori houses he had seen in Auckland, the front entrance was decorated
with panel strips. Two themes were in evidence, related to *Be in Love and You
Will Be Happy* (fig. 37) and *Be Mysterious* (fig. 47), and so inscribed. The
house was named *Maison du jouir* (House of Orgasm), and some of the par-
ties in the house turned into little orgies, although Gauguin always controlled

himself. He arranged to have a local convent student, Marie-Rose, move in with him in exchange for presents to her and her parents; the girl was delighted that Gauguin had two servants.[1]

The painting *Riders*, also known as *The Ford (The Flight)*, of 1901 (fig. 135), possibly done in Tahiti, sets the tone for an ominous series of Marquesan works. In the background angry waves crash on the beach, where a group of sailors tend to their boat. Two men on horseback are crossing a ford. The design was inspired by Albrecht Dürer's 1513 engraving *The Knight, Death, and the Devil*, a copy of which Gauguin had pasted on the back cover of *Avant et après*. In it a proud knight in armor going to war is flanked by Death, portrayed as a monstrous companion rider atop a humbler mount, carrying an hourglass and with a serpent around his neck; a cow-faced devil follows, carrying a spear. In Gauguin's painting the knight has become, as in *War and Peace* (fig. 134), the already-mentioned proctor of the Panathenaic frieze of the Parthenon, raising his right hand as if to organize the ceremony. Under his horse, as in the Dürer print, a running dog appears. The rider in front of him is none other than a *tupapau*, leading the proctor to his eventual death.[2]

Riders on the Beach (Hiva Hoa) of 1902 (fig. 136) continues the trend. Compositionally it alludes to Edgar Degas's *Racehorses at Longchamp* of 1873–76. The gathering probably takes place late in the afternoon, with the sand already being colored, presumably by pink rays of the sunset from the viewer's side of the picture. Three men are enjoying the ride and the moment. But, here again, as if by accident, two *tupapaus* appear on the left—one dressed in a yellow tunic and hood, the other in red, and both mounted on proud white horses in a way that again recalls the Panathenaic frieze. As noted in the previous chapter, the similar little horsemen in *Faa iheihe* of 1898 (fig. 132) and *Rupe rupe* of 1899, while not necessarily *tupapaus*, have a somewhat disruptive presence, implying the fragility of the idyllic dream.

There is remarkable grace and spontaneity in *Riders on the Beach*, both in the composition and in its iconography—as if Gauguin had proceeded instinctively, and with extraordinary assurance. The artist, in fact, was reassessing his views on symbolism at this time. He explained to Georges-Daniel de Monfreid that he had taken a dislike to artists who tackled symbolism too literally, thereby introducing a system of ideas that was bound to be more descriptive than suggestive:

> You know my thoughts regarding all these false ideas [introduced by] symbolist or other literature in painting. . . . [Besides] healthy works remain all the same, and . . . all the learned critico-literary texts cannot change anything about this. I pride myself, perhaps with too much vanity, at not having been dragged by a flattering press into such traps, like so many others, [Maurice] Denis for instance, [Odilon] Redon perhaps also. And I smiled when I read so many critics who had not understood me.

135 *Cavaliers (Riders)*, or *The Ford (The Flight)*, ca. 1901. Oil on canvas. Pushkin Museum of Fine Arts, Moscow. Photo: Erich Lessing/Art Resource, New York.

136 *Riders on the Beach (Hiva Hoa)*, 1902. Oil on canvas. Museum Folkwang, Essen, Germany. Photo: Interfoto/Bridgeman Art Library.

Besides, my isolation gives me a chance to re-make myself. Here poetry emerges by itself and all one has to do is let oneself be guided by one's dream as one paints to suggest it.

Gauguin took pride in having "freed painting from many of its academic fetters of old, as well as of symbolist fetters (another type of sentimentalism)." What he meant seems echoed by Monfreid in his response: "Almost all those who have wanted to *express ideas* in their painting (that is, as you yourself judiciously observed, became expository [*explicatifs*]) have weakened their work. Example: Maurice Denis, who has weakened his true painter's qualities because of his mystical-literary bent, and whose best works are those that remain moderate in their 'symbolist' or religious preoccupations (besides, what religion!). In sum, one must be symbolist without knowing it, or without wanting to be one; like Courbet, Manet, Rembrandt, etc."[3]

Taken together, these statements allude to a subconscious approach to both iconography and composition, something not unlike the automatic associations of the future surrealists. Not surprisingly, one of the prime advocates of symbolism as well as an apostle of surrealism, the poet and critic Remy de Gourmont, took such concepts to extremes in the *Mercure de France* (which Gauguin received in Tahiti): "The poem must speak as if it did not know what it was going to say, and finally one must be surprised by the logic of its madness and the wisdom of its obscurity."[4]

*G*auguin went on developing the theme of death. It was not just the death of an individual, or even a population; it was the death of an entire culture. In the late eighteenth century, the Marquesas must have had a population of some 80,000. By 1842, when the islands were under French control, the total had dropped to some 20,000. The Marquesans lived in narrow valleys, reduced to a semipermanent state of war. Throughout the century the population had been exposed to constant visits of whalers from all over the world. According to Gauguin's naval physician: "While leprosy and especially syphilis may have decreased in frequency over time, tuberculosis, to the contrary, has only spread and seems poised to deliver the final blow to the last savages of our French Oceania." According to another naval physician: "The Catholic missionaries have succeeded admirably in teaching reading and writing, but they have not managed to introduce their pupils to any morality whatsoever or get them to take an interest in the religion they preach." Worse still, "resigned to their fate, the natives find their sole consolation in alcohol, or in opium, which they do not smoke but eat."[5]

The decline had been more moderate in Tahiti, where the initial level of civilization had been far more advanced, and the missionaries much better organized. But the presence of Westerners had nonetheless provoked a visible decline. The population count must have been around

300,000 at the time of Captain James Cook's arrival late in the eighteenth century, but already the ravages of Western diseases, including alcoholism, were making themselves felt. Population levels shrank dramatically; by 1911 native Tahitians numbered only around 10,000. The increasing political influence of the various commercial agents who spent time in the island destabilized the political system; as a result, the land-owning aristocracy could no longer maintain the ancient slave-driven agricultural system, with its well-tended fields and orchards, much admired by the early travelers.[6]

French administrators were scathing in their assessments of the native people. "A degraded people, not deserving the slightest sympathy," wrote one, describing the Marquesans. "That is our judgment after studying the conditions of the population for three years." As for the Tahitians: "They are libidinous, sadistic even. There is not a refinement, not a perversion of the genital senses that they have ignored, that they have not practiced. Their only subject of conversation is lechery. . . . They had to start early to become such pleasure machines."[7] Despite these complaints, Governor Petit, Gallet's successor, conceived an energetic repopulation plan for the Marquesas: importing "one hundred families of Martiniquais colonists, each averaging five people," and giving each twenty-five acres. The project was not taken up.[8]

A page (fig. 137) from a sketchbook that may well date from the late Tahitian period reflects Gauguin's own perception of the fate of Polynesia—or what it appeared to be in his own day. It evokes a beautiful female native in the humiliating sphinx pose of the degraded god-creator Taaroa in *Te atua* of 1899 (fig. 133).[9] The two robust seated female figures below resemble the figures in the Borobudur friezes (figs. 41–42).

The traced monotype of a *Nativity* of 1902 (fig. 138) is even more troubling, although it contains a message of fervent hope. The composition is divided into two registers: at the top is a version, seen from the front this time, of "the man of instincts"[10] in *Where Do We Come? What Are We? Where Are We Going?* of 1897 (fig. 131). It is a skeletal form, intimating that opposing the satisfaction of man's natural instincts to concerns about the ensuing social and religious opprobrium, as implied by the unsympathetic observers, is ultimately a matter of life and death. To the figure's left, emaciated and faintly visible in the darkness, stands a praying figure. In the lower register is a group of seated Polynesian figures, one of which is the mother carrying the infant Jesus, recognizable by a few dark rays that form a halo. Perhaps more than ever before, the image of Christ introduces a new hope. It may be at such moments that Gauguin was most fully and genuinely religious—even mystical:

> For the new humanity to emerge regenerated from its tomb, from its animal barbarity, for the sepulchres to break, [for] human resurrection to accomplish itself in its sensible testimonies,

137 Sketch of figures and a tree, from the album *Ancien culte mahorie*, folio 37 (verso), 1892–93. Musée du Louvre, Paris. Photo: Réunion des Musées Nationaux/Art Resource, New York. Photographed by Hervé Lewandowski.

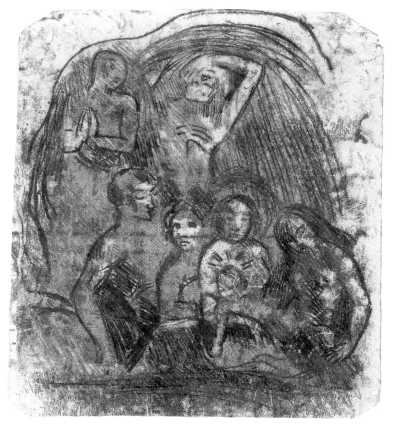

138 *Nativity*, 1902. Traced monotype in brown and black (recto). The Art Institute of Chicago, Gift of Robert Allerton. Photo © The Art Institute of Chicago.

visible, palpable, undeniable, attesting the triumphal event, definitive, full of the glory and majesty of the Son of Man, of the Son of God, as the type of the ideal realized by humanity in its entirety, of this resuscitation [which must] accomplish itself . . . , it is necessary that the new being who transforms animal nature into the divine nature of the Son of God be the product engendered in the human soul, in its integral organic spirituality, if only as a germ, [a] simple divine germ.[11]

Gauguin's life had become very difficult in Hiva Hoa. By February of 1902, the naval physician stationed in Atuona had been recalled to Tahiti. Marie-Rose, about to give birth, returned to her parents for the delivery; Gauguin did not want her back, but the bishop saw to it that no other convent pupil was available. A bitter quarrel between the two ensued. The eczema, as Gauguin called it, had spread to both legs, now both swollen, one of them "gnawed by a horrible wound abuzz with green flies." He also suffered from recurring mild heart attacks and during times of stress spit blood.[12]

For a while Gauguin toyed with the idea of returning to Europe: "I would then settle in your neighborhood, in the Midi, perhaps even in Spain to look for some new elements—bulls, Spanish women with their suet-styled hair. This has been done, overdone: funny though, I imagine them differently," he wrote Monfreid.[13] Monfreid sent back a strongly worded reply: "If you were not seeing things from so far you would not come back to live once again among the civilized infamies, the vile contests of appetites, or gamey and grotesque vices, not to mention our poor climate." He went on after consulting with the dealer Gustave Fayet: "There is a danger that your return might upset an ongoing work, an incubation, which is taking place in the sphere of public opinion as far as you are concerned: you are actually that unheard of, legendary artist, who, from the depth of Oceania is sending his disconcerting, inimitable works—the definitive works of a great man who has, so to speak, disappeared from the world. Your enemies . . . do not dare fight you: you are so far away! You must not come back. . . . In brief, you have the immunity of the great dead, you have passed into *art history*."[14]

Always the reformer, Gauguin took on with even greater vigor than ever the fight against the colonial administration—or more specifically the customs agents and police of Hiva Hoa, who had near-complete control of the island. Holding a copy of the French civil code, Gauguin stepped out on the beach one day to inform the natives that they were neither obligated to send their children to school nor required to pay taxes. The results were swift and severe. A local policeman pressed charges against Gauguin with the authorities in Papeete, accusing him of inciting the natives to disorder, a civil offense.[15] There was worse to come.

Gauguin accused officials of fraudulently unloading two American ships. He also accused the police of arresting the wrong person for the murder of a polyandrous woman: the horrible

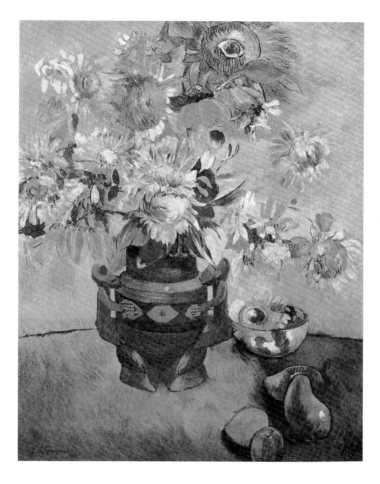

139 *Still Life with Maori Kumete, Sunflowers, and Fruit*, 1901. Oil on canvas. Private collection, Lausanne.

wound in the vagina noted by the Vietnamese prince-nurse Ky Dong was a typical Marquesan act of revenge and must have been perpetrated by the Marquesan lover rather than by the husband, who was a foreign sailor-deserter. And Gauguin couched his accusations in his lucid and articulate journalistic prose, addressed to the authorities in Papeete and sometimes to colonial inspectors, even to the itinerant judge. The response was swift. On March 27, 1903, Gauguin was summoned to appear in court, accused by a policeman of defamation. Four days later, he was sentenced to three months in jail and a 500-franc fine. Determined to appeal the sentence in Papeete, Gauguin probably would have won, but he was found dead in his bed on May 8, 1903, an empty vial of laudanum by his side.[16]

Gauguin had sustained his idyllic dream. The yellow and somber orange tones and green accents of *Still Life with Maori Kumete, Sunflowers, and Fruit* of 1901 (fig. 139), perhaps executed

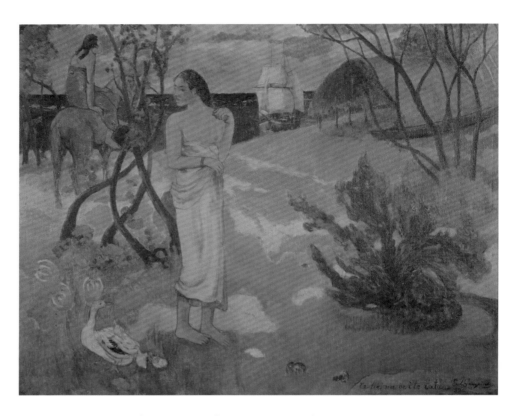

140 *Te tiai na oe ite rata? (Are You Waiting for a Letter?)*, 1899. Oil on canvas. Private
collection. Photo courtesy of Fondation Pierre Gianadda, Martigny, Switzerland.

in Tahiti, where sunflowers must have grown in his garden, evoke a mood of quiet and sober
enjoyment of the visual material available to him. He must have sketched the *kumete* at the museum in Auckland during the course of his stay there. A large cyclopean sunflower in the background, suspended above the artist, suggests the presence of the artist—as did the three sunflowers in the background of *Female Nude with Sunflowers* of 1889 (fig. 40). It is a testimony to
his delight in his achievement in his own studio of the tropics.

A painting from Tahiti dating to 1899, *Te tiai na oe i te rata* (*Are You Waiting for a Letter?* fig.
140), could well be taken as a summing up of the fate of the seduced and abandoned women;
the decimation of the Polynesian culture since the advent of Europeans and their deadly diseases; and eventually the awareness that if there was a solution, it was available somewhere else.
A standing figure seems to be exchanging a confidence with another woman on horseback; a
sailing ship is visible in the distance, confirming the impact of Western civilization. An Areoi

poem suffused with sweet nostalgia, quoted by Jacques-Antoine Moerenhout and copied by Gauguin, may be relevant.

> You light breezes of the South and the East, who fuse in order to caress one another above my head! Hurry and run to the other island; you will see him who has abandoned me, seated under the shade of his favorite tree.
> Tell him that you have seen me in tears because of his absence.[17]

Henri Dorra: Scholar, Exemplar, Friend

GABRIEL P. WEISBERG

I first met Henri Dorra in 1973 at the College Art Association's annual meeting. He immediately treated me as a valued colleague and an equal, and we were friends from that day on. We often ran into each other thereafter, usually during the summertime in France, where he was laboring away in the Cabinet des estampes at the Bibliothèque nationale. He was a tireless archivist, always searching for primary texts—especially early critical reviews—that could illuminate the meaning of works of art and their reception. He was, in short, a humanist of the old school, widely read in fields from aesthetics and philosophy to the classics. These broad interests informed his scholarship: a painting was never just a painting; it was also a repository of ideas, opinions, desires.

That is not to say, however, that he neglected the actual object. On the contrary, he spent endless hours in out-of-the-way collections, seeing pictures at firsthand with the eye of a connoisseur. Only when the painting matched the sum of his accumulated learning was Henri's job complete. His searching examination of works of art reinforced my own passion for objects. In other words, his early training at Harvard—in the galleries of the Fogg Museum—and his later work as a curator at a variety of prestigious institutions informed his scholarly career and inspired a generation of students and colleagues.

Our friendship deepened as we discussed specific works of art, the museum, and exhibition practice far into the night every time our paths happened to cross. There were dinners together in Paris—with the Dorras alone or in the company of other scholars, as Henri and his wife, Mary, often included people who might bring further insights to our discourse—and coffee in New

York. Henri Dorra became a model, to whom I could also look for unfailing encouragement and support.

Among Henri's important writings on the relationship between Japanese art objects and European art in the nineteenth century was an essay titled "Seurat's *Japonisme*," published in the *Gazette des Beaux-Arts* in 1969. In it he provided fresh insight into the ways that Seurat's landscapes may have reflected a knowledge of specific Japanese prints. Another essay, one of the more intriguing and controversial of a series of studies Henri wrote, appeared in *Art Quarterly* in 1970. In it he posited a link between the dotlike technique of the neo-impressionists and the method by which Japanese prints had been made. Titled "Seurat's Dot and the Japanese Stippling Technique," it opened fresh ways of looking at the technical debt emerging Occidental modernism may have owed to the East.

These writing were Henri's contribution to our ongoing discussion of *Japonisme*, which had begun at our first meeting. In 1990 Henri was delighted by an anthology of articles on this subject that my wife, Yvonne, and I published. And he was captivated by our study of Siegfried Bing, the great promoter and marketer of Japanese artifacts in France. Our anthology brought together the kinds of texts Henri loved, to demonstrate how the response to *Japonisme* had changed over a century. The work on Bing paid homage to Henri's own search for actual works of art, primary documents, and the social milieu of the ongoing dialogue between East and West.

As the present volume amply demonstrates, however, Henri Dorra's primary contribution to the history of art has been his years of study of symbolism and especially Paul Gauguin. His earliest articles concerned Gauguin's use of Eve as an iconographic motif; in 1967 he returned to that symbol in "More on Gauguin's Eve" in the *Gazette des Beaux-Arts*, thus marking out as his special terrain the career of one of the nineteenth century's major (and most puzzling) artists.

Gauguin, indeed, became his obsession. He attacked the work from a variety of perspectives, from the personal to the psychosexual. In the 1960s this was a novel approach, matching the artist as a personality and a psyche with the object itself. By 1970, in his "Gauguin's 'Unsympathetic Observers,'" Dorra posits that certain coded figures in the paintings provide evidence for the artist's intense paranoia, which in turn affected the reception of his work. This short article not only laid the foundation for Dorra's own further work but also convinced others—and I was one of them—that his approach to the artistic personality in the painting held great promise.

Dorra's interest in symbolism, evident in his work on Gauguin, continued in a 1973 article on the hitherto neglected Gustave Moreau, who was traditionally treated as an artist important primarily on stylistic grounds. Dorra suggested on the basis of his own humanistic learning that deeper meanings lay in the symbols in Moreau's works. In the early 1970s, scholarship on lesser-known artists was difficult to publish in the United States, but Henri Dorra, because of his early

schooling in Europe, found outlets for his ideas in French journals and in a variety of museum publications.

In this same decade exhibition catalogues became important scholarly outlets too, and Dorra again led the way with his object-based contributions to several such shows. His in-depth analyses of specific works, probing their meaning from a textual perspective, convinced me that similar studies could plot the fever chart of larger movements. A fine example is Dorra's article on the portrait of Péladan by Séon in the Lyon Museum, published by that institution in 1977, which illuminates the whole symbolist movement by close examination of a single painting.

Henri's work remained a stimulating model for me—always innovative, always pertinent. As for Henri himself, he lent real meat-and-potatoes support to my planning of an exhibition of realism in French art of the nineteenth century. In 1978, when I presented myself in California to scout out material for the show, he graciously set up a lecture series for me—the Getty, UC Santa Barbara, UC Riverside—to help defray the costs of the trip. And Henri and Mary Dorra invited me and my wife to stay with them and their two daughters at their home in Santa Barbara. So there we were, laughing, enjoying the beautiful weather, plucking avocados from the trees outside—and debating the social context in which I planned to present realism. I think I convinced him in the end of the need to expand the "canon" of realists beyond Courbet, into the ranks of Salon painters of the midcentury, like Jules Breton.

The realism show caused a fuss among art historians, but Henri remained an ardent supporter throughout the controversy. Afterward, there were meetings in Paris again, discussions of why the show had riled so many. Henri remained convinced that the discourse on nineteenth-century art needed enlarging and set out to add the symbolists to the mix. By the mid-1980s, after years of analyzing texts, Henri believed the time was ripe for a critical anthology of writings on symbolist art. While he continued the flow of articles on symbolist themes, including Nazarene symbolism and the *emblemata*, he went back to the work of the early Romantics and forward to the design work of figures such as Van de Velde. The result was an inclusive, multidimensional volume entitled *Symbolist Art Theories: A Critical Anthology*, published by the University of California Press in 1994.

The selected texts, prefaced by short interpretative essays, made ample use of Dorra's encyclopedic knowledge of the period. The book was a model for the flood of art anthologies that followed. He also added new translations of texts that he had prepared himself. I was, of course, delighted to serve as a reviewer of the manuscript and to urge its publication. The book further established Dorra's position as the leader in the field of symbolist art.

In 1992 Henri took up arms against an especially ill-tempered review of my book *Beyond Impressionism: The Naturalist Impulse*. During a long, hot Paris summer, he closeted himself in the

Bibliothèque nationale, rereading my book and preparing a detailed response. I was deeply touched by his loyalty and the fervor of his prose. Although Henri's defense was never published, his eagerness to enter the fray in defense of freedom of interpretation testified to his commitment to independent thinking. I will always remember Henri poring over *Beyond Impressionism*, a little surprised to find that he actually *liked* the artists I discussed, and flushed with righteous anger that someone would object to a reasoned argument against the standard modernist texts of 1992. Few friends and fewer colleagues would have been so generous. His reaction proved his intellectual courage and the appreciation of experimental scholarship that marked his long career.

As his health deteriorated, Henri raced to complete his definitive statement on the art and life of Paul Gauguin. In many ways, the book is a summation of his scholarly career. He reexamines Gauguin's own writings, contemporary texts, and modern interpretations. But he never loses sight of the paintings, the prints, the sculpture—the full range of Gauguin's creative output. The heart of the matter, however, is the motif: what it meant to the artist, to the time, to our own era. These symbols range from the pantheon of Polynesian deities to common dream images, from the messiah to portents of death, all suffused with a luminous sensuality and an earthy sexuality. *The Symbolism of Paul Gauguin: Erotica, Exotica, and the Great Dilemmas of Humanity* is a fitting capstone to a life of the mind that can serve as an inspiration to others intent on feeling, seeing, and thinking about art in fresh ways. As for myself—no expert on Gauguin—it serves as a reminder of what his ideas have meant to me.

NOTES

All undated letters are listed in brackets.

PREFACE

1. "A Survey of the Universe," *The Economist*, January 5, 2002, 48.

2. To Schuffenecker, October 16, 1888, in Victor Merlhès, ed., *Correspondance de Paul Gauguin* (Paris: Foundation Singer-Polignac, 1984), 1:255 (no. 172).

3. To Mette, [ca. December 8, 1892], in Maurice Malingue, ed., *Lettres de Gauguin à sa femme et à ses amis* (Paris: Grasset, 1949), 237–38 (no. 134).

1. GAUGUIN'S HERITAGE

The epigraph is from Maurice Malingue, ed., *Lettres de Gauguin à sa femme et à ses amis* (Paris: Grasset, 1949), 163 (no. 84).

1. Paul Gauguin, *Avant et après* (1903; facsimile ed., Copenhagen: Scripta, 1951), 85.

2. This and the following biographical items are drawn from Ursula Marks-Vandenbroucke, "Gauguin—Ses origines et sa formation artistique," *Gazette des Beaux-Arts*, January–April 1957, 9–62, as well as from Flora Tristan's own autobiography, *Pérégrinations d'une paria*, 2 vols. (Paris: Bertrand, 1848).

3. Gauguin's genealogical claims, made in *Avant et après*, 84, were fully corroborated by David Sweetman, *Paul Gauguin: A Life* (New York: Simon and Schuster, 1995), 6–11. For a full genealogical table, including ancestry apparently ignored by the artist, see Daniel Wildenstein, Sylvie Crussard, and Martine Heudron, *Gauguin: Premier itinéraire d'un sauvage: Catalogue de l'œuvre peint (1873–1888)*, 2 vols. (Paris: Skira, 2001). The link with the Bourbons is proposed by this author.

4. Tristan, *Pérégrinations*, 2:104.

5. Ibid., 2:123.

6. François Bédarida, preface to Flora Tristan, *Promenades dans Londres,* ed. Bédarida (Paris: Maspéro, 1978).

7. Michael Ryan, *Prostitution in London . . .* (London: Baillère, 1839), and A. J. B. Parent-Duchâtelet et al., *De la prostitution dans la ville de Paris* (Paris: Baillière, 1836), 857. Tristan refers to both works in *Promenades,* ed. Bédarida, 135.

8. Paris: Delloye and Jeffs, 1840.

9. To Mette, December 6, 1887, in Victor Merlhès, ed., *Correspondance de Paul Gauguin, 1873–1888* (Paris: Fondation Singer-Polignac, 1984), 1:167 (no. 137), and to Bernard, ca. November 26–28, 1889, in Malingue, *Lettres,* 175 (no. 92).

10. Gauguin, *Avant et après,* 110.

11. The socialist utopian and social philosopher Pierre-Joseph Proudhon. Unfortunately, the latter's only documented statement referring to Tristan links Flora with other "preachers of gospels . . . cranks" (to M. Maurice, July 17, 1844, in *Correspondance de P.-J. Proudhon* [Paris: Lacroix, 1875], 2:130–31). She was nonetheless in good company: the critic and encyclopedist Pierre Leroux, the Catholic social and religious reformer Félicité de Lamennais, and the celebrated novelist George Sand were included in this group.

12. Prosper Enfantin was a disciple of Henri de Saint-Simon, the advocate of an enlightened industrial socialist meritocracy. He was himself a strong advocate of women's rights and had a mystical bent.

The "religion" was actually called "Mapah," from *mater, pater.* A philanthropic and egalitarian movement with mystical overtones intended to establish the fusion of the sexes, its founder was not Prosper Enfantin but the sculptor Simon Ganneau (Pierre Larousse, *Grand dictionnaire universel du 19ème siècle* [Paris: Larousse, 1890], 10:111). Flora knew Ganneau and for a while was a fervent follower (see letter to Charles Joseph Traviès, June 6, 1836, in Stéphane Michaud, *Flora Tristan: La paria et son rêve: Correspondance* [Fontenay/Saint-Cloud: ENS, 1996], 89, no. 48). What is known of Enfantin's correspondence with Flora, on the other hand, is quite stilted (ibid., 132–34 [nos. 81, 82, and 84])—all dating from February 1843, the year before her death. As for Proudhon, who died in 1865, he was to acquire a vast influence as a social philosopher toward the end of his life. The above statements, somewhat reordered, are from Gauguin, *Avant et après,* 84.

13. Alphonse Esquiros was a friend and onetime journalistic partner of Eliphas Lévi (Alphonse-Louis Constant, or "abbé" Constant), a long-standing friend of Flora's (Michaud, *Flora Tristan,* 272). Tristan, Esquiros, and Lévi were all disciples of Mapah and its founder Ganneau for a while (ibid., 15).

14. Gauguin, *Avant et après,* 84. All of these poets paid warm tributes to her achievements. Young Arthur Rimbaud, for his part, had been introduced to her work by none other than his friend Paul Verlaine, who took him to read some of it at the British Museum Library in London during their 1873 trip.

15. Originally published by André Breton; quoted in Jean Leprohon, *Flora Tristan* (Paris: Corymbe, 1979), 131–32.

16. Gauguin, *Avant et après,* 85. The cultural implications of the word "républicain" may be gathered from the grand encyclopedia of the period: "since Montesquieu, since Voltaire and all the thinkers, all the principles [of the Republic] had been proclaimed" (Larousse, *Grand dictionnaire universel* 13:1015, s.v. *République*).

17. To Edouard de Pompéry, January 1845, in *George Sand: Correspondance*, ed. Georges Lubin (Paris: Garnier, 1964–95), 6:789–90.

18. Gauguin, *Avant et après*, 81, 86, 87.

19. Jean de Rotronchamp [Jean Brouillon], *Paul Gauguin 1848–1903* (Paris: Crès, 1925 [1906]), 3.

20. Gauguin, *Avant et après*, 85.

21. Marks-Vandenbroucke, "Gauguin—Ses origines," 27–28.

22. Gauguin, *Avant et après*, 94.

23. The name of Antonio Escobar y Mendoza, a seventeenth-century Jesuit monk and prolific religious writer, has survived in French to epitomize self-justification.

24. Gauguin, *Avant et après*, 194.

25. Marks-Vandenbroucke, "Gauguin—Ses origines," 30.

26. The Lycée Saint-Louis in Paris, which this author attended, prepared students for the Grandes Ecoles competitions, including the military academies. The students' drawings, sometimes seen on display, were technically very skilled. Classes were taught by retired military officers.

27. Gauguin, *Avant et après*, 149; Merlhès, *Correspondance*, 1:1 (no. 2), 323 n. 4; Wildenstein, Crussard, and Heudron, *Catalogue de l'œuvre peint*, 1:570.

28. Wildenstein, Crussard, and Heudron, *Catalogue de l'œuvre peint*, 2:572.

29. To Pissarro, [April 22 or 23, 1883], in Merlhès, *Correspondance*, 1:42 (no. 33). Information on the Arosas was also gleaned from Marks-Vandenbroucke, "Gauguin—Ses origines," 35–48.

30. This summary biography is drawn from the correspondence between Marie Heegard, Gauguin himself, and Mette, from November 21, 1872, to November 3, 1876, in Merlhès, *Correspondance*, 1:1–11, 320 (nos. 1–7). Merlhès drew some information from Marks-Vandenbroucke's 1956 unpublished University of Paris dissertation: "Paul Gauguin." The above account owes much to Marks-Vandenbroucke, "Gauguin—Ses origines"; Isabelle Cahn, "Chronologie," in Claire Frèches-Thory and Isabelle Cahn, eds., *Gauguin*, exh. cat. (Paris: Galeries nationales du Grand Palais/Réunion des Musées Nationaux, 1989), 32–39; see also the chronology in Wildenstein, Crussard, and Heudron, *Catalogue de l'œuvre peint*.

31. Merlhès, *Correspondance*, 1:42 (no. 33), 323, 331, 327.

32. Ibid., 1:74 (no. 25), 401–3, n. 153

33. According to Jacques Fouquet, a Parisian art dealer who had handled Jeanne Schuffenecker's collection and was her friend, in a conversation with the author in 1972.

34. Helena P. Blavatsky, "What Is Theosophy?" in *H. P. Blavatsky: Collected Writings*, ed. Boris de Zirkoff (Wheaton, Ill., and Madras: Theosophical Publishing House, 1950), 2:97.

35. Marie to Louise Heegard, [mid-July 1873], in Merlhès, *Correspondance*, 1:5 (no. 7).

36. Wildenstein, Crussard, and Heudron, *Catalogue de l'œuvre peint (1873–1888)*, 4 (no. 6), 7:11.

37. Ibid., 15 (no. 12).

38. Marie Heegard to her family, ["a little before" November 3, 1876(?)], in Merlhès, *Correspondance*, 11 (no. 12).

39. The phenomenon of "simultaneous," or complementary, contrasts, incidentally, had already been reported by the eighteenth-century zoologist Georges-Louis Leclerc, compte de Buffon, in the *Encyclopédie*. Henri Dorra, "Valenciennes's Theories . . . " *Gazette des Beaux-Arts*, November 1994, 185–94, n. 35.

40. To Pissarro, April 3, 1879, in Merlhès, *Correspondance*, 1:12 (no. 6), n. 21.

41. Merete Bodelsen: "Gauguin the Collector," *Burlington Magazine*, September 1970, 590–615; Merlhès, *Correspondance*, 1:142 (no. 115), 386–87.

42. To Pissarro, July 8, 1879, in Merlhès, *Correspondance*, 1:14 (no. 7).

43. Victor Merlhès, *Paul Gauguin et Vincent van Gogh: Lettres retrouvées, sources ignorées* (Tahiti: Editions Avant et Après, 1995), 13, and to Pissarro, October 11, 1883, in Merlhès, *Correspondance*, 1:54 (no. 41).

44. To Pissarro, [May–June 1882], in Merlhès, *Correspondance*, 1:29 (no. 23). The last part of the sentence is garbled. The meaning of *désunion* as a break between spouses is confirmed by a statement written a few years later, after Gauguin had left Mette and most of their children in Copenhagen, returning to Paris with one of them, when he claimed that her family had "encouraged a break" between them. To Mette [early April 1887], in Merlhès, *Correspondance*, 1:149 (no. 123).

45. To Pissarro, [early November 1882], in Merlhès, *Correspondance*, 1:35 (no. 28).

46. To Pissarro, October 11, 1883, in Merlhès, *Correspondance*, 1:55 (no. 41).

47. Monet had been selling pictures through, and exhibiting at, the gallery of Georges Petit since 1880 (John Rewald: *The History of Impressionism* [New York: Museum of Modern Art, 1973], 591ff), and was well served by Petit's Exposition Internationale starting in 1885 (Merlhès, *Correspondance*, 1:106 [no. 27]), in addition to continuing his relationship with the impressionists' original dealer, Paul Durand-Ruel, who mounted a series of exhibitions devoted to the senior impressionists in London and other capitals in 1882, and presented a successful one-man show of Monet's work in 1883 (Rewald, *History of Impressionism*, 481–82).

48. Merlhès, *Gauguin et van Gogh: Lettres retrouvées*, 15; Merlhès, *Correspondance:* to Pissarro, [January 12/13, 1884], 1:59 (no. 43); [end of July 1884], 1:65 (no. 50); [end of September 1884], 1:70 (no. 53); [October 1884], 1:70 (no. 54); November 2[8?], 1884, 1:74 (no. 56).

49. Merlhès, *Correspondance:* to Pissarro, [end of May] 1885, 1:106 (no. 79); to Durand-Ruel, June 22, 1885, 1:109 (no. 80); to Mette, [early April 1887], 1:149 (no. 123).

50. Merlhès, *Correspondance:* to Mette, September 19, 1885, 1:112 (no. 84); to Pissarro, October 2, 1885, 1:113 (no. 85); to Mette, October 13, 1885, 1:115 (no. 87); [January 1886], 1:122 (no. 94); [first half of June 1886], 1:127 (no. 99); [ca. July 25, 1886], 1:133 (no. 107); [end of July 1886], 1: 136–37 (no. 110).

51. Merlhès, *Correspondance:* to Pissarro, [August 13, 1887], 1:52 (no. 39); [ca. May 8, 1884], 1:62 (no. 47); to Mette, September 19, 1885, 1:112 (no. 84).

52. Virginia E. Herbert, *The Artist and Social Reform: France and Belgium, 1885–1898* (New Haven: Yale University Press, 1961), 185–89.

53. Camille to Lucien Pissarro, November 10, 1883, in Merlhès, *Correspondance*, 1:58 (no. 23).

54. To Camille Pissarro, January 30, 1885, in Merlhès, *Correspondance*, 1:91 (no. 68).

55. Victor Merlhès, ed., *Paul Gauguin: "A ma fille Aline, ce cahier est dédié,"* facsimile ed. of early 1893 manuscript (Paris: Société des amis de la Bibliothèque d'art et d'archéologie; Bordeaux: William Blake, 1989). Louis XIV, for all his politeness, was an exceptionally haughty and overbearing individual. Was Gauguin aware of Charles Baudelaire's defense of aristocratic leadership? The poet had written: "Only an aristocratic government can be reasonable and measured government—[a] monarchy or republic based on democracy [is] usually equally absurd and weak" (quoted in Octave Uzanne, "Baudelaire inédit," *Le Figaro*, Paris, August 30, 1880, 1–2).

56. Gauguin was referring to the Dreyfus affair: the case of a French intelligence officer of Jewish descent who was falsely accused of treason, eventually found guilty, and condemned in 1894 to hard labor in French Guyana. The trial and subsequent appeal sharply divided the nation and aroused, in particular, strong anti-Semitic feelings. Some maintained that because he was an officer, Dreyfus should not protest let alone appeal his conviction because a reversal would dishonor France and the army. Dreyfus lost the appeal but was eventually rehabilitated.

57. Gauguin, *Avant et après*, 71.

58. Ibid., 131–37.

59. To Vincent van Gogh, [ca. February 29, 1888], in Merlhès, *Correspondance*: 1:172 (no. 142); to Vincent van Gogh, ca. September 25–27, 1888, in Merlhès, *Correspondance*, 1:232 (no. 165); to Emile Bernard, probably mid-June 1890, in Malingue, *Lettres*, 105 (no. 191); to Emile Bernard, ca. January 20–27, 1890, in Victor Merlhès, ed., *De Bretagne en Polynésie: Paul Gauguin, pages inédites* (Tahiti: Editions Avant et Après, 1995), 40.

60. Gossip about an affair with his friend's wife Louise Schuffenecker has never been documented, and recent scholars have seriously questioned its validity, as will be seen in chapter 3.

61. Divorce, suppressed in 1816, had been reinstated in France in 1884. In the intervening years the régime of *séparation de corps* could also lead to unpleasant court confrontations.

62. Gauguin, *Avant et après*, 186.

63. Merlhès, *Gauguin et van Gogh: Lettres retrouvées*, 98. The components and characteristics of this humanitarianism will be analyzed in subsequent chapters.

64. To Emile Bernard, Autumn 1889, in Malingue, *Lettres*, 92 (no. 175).

65. *Diverses choses*, 1896–97, Département des arts graphiques, Musée du Louvre (Orsay), Paris, fol. 271.

66. Ibid., 272–73.

67. In Paris, somewhat amateurish publications fostering a version of spiritism articulated in terms borrowed from the scientific discourse of the time were eventually taken over by the movement: *L'Anti-matérialiste: Organe du mouvement religieux libéral et du spiritualisme moderne* of 1882–86. It made way for *Journal des Hautes Etudes*, which became *Revue théosophique* (undated), presumably superseded by Blavatsky's *Revue théosophique* (1889–90), which then became *Le Lotus Bleu, seul organe de la Théosophie en France* in 1892. Blavatsky's *The Theosophist*, published in Britain since 1879, undoubtedly helped spread her word through English-speaking parts of the world. She was also the author of numerous books.

68. Blavatsky in *La Revue Spirite*, November 1880.

69. De Zirkoff, ed., *Blavatsky: Collected Writings*, 2, no. 96. As for the esoteric side itself, Blavatsky acknowledged that the movement had a "great secret," known only by five members. "Qu'est-ce que la Thésophie?" in ibid., 2:499.

70. Blavatsky, "What Is Theosophy?" *The Theosophist*, October 1879, no. 1, 1.

71. Blavatsky in *La Revue Spirite*, November 1880. The last three excerpts are quoted from Blavatsky, "What Is Theosophy?" in de Zirkoff, *Blavatsky: Collected Writings*, 2:87–97, 500–507.

72. Maria Mariateguy, Duchess of Pomar, *Théosophie universelle: La théosophie chrétienne* (Paris: Carré, 1886), 161.

73. By Lady Caithness: *Fragments glanés dans la théosophie occulte d'Orient* (Paris: Gauthier, 1884);

Théosophie universelle: Théosophie bouddhiste (Paris: Carré, 1886). By Blavatsky's right-hand man in the United States, Col. Henry S. Olcott: *Le bouddhisme selon le canon de l'Eglise du Sud et sous forme de catéchisme* (Paris: Publications théosophiques, 1905 [1881]); and by Alfred Percy Sinnett: *Le bouddhisme esotérique ou positivisme hindou* (Paris: Librairie de l'Art indépendant/Le Lotus Bleu, 1890)—not to mention countless articles on that subject in the movement's various periodicals. At the root of his study, according to Sinnett, was the work of the German scholar Hermann Oldenberg, *Buddha, sein Leben . . .* (Berlin: Hertz, 1881), which appeared in English as *Buddha: His Life, His Doctrine* (London: Williams and Norgate, 1882). Gauguin, as we shall see, was particularly affected by Buddhist concepts of evolution such as one found in studies related to Theosophy, specifically that man is but a particle in a vast process of transformation from inert matter into pure spirit.

74. As established by Merlhès, *Correspondance*, 240 (no. 75), 504 n. 283, and further discussed in *Gauguin et van Gogh*, 117–18.

75. Emile Burnouf, "Le bouddhisme en Occident," *Revue des Deux-Mondes*, July 15, 1888, 840–72.

76. Ibid., 843, 846.

77. Ibid., 866. The adjective "aryenne" reveals the society to have been less than fully universal in the beginning. Indeed, Burnouf added that "the society was drawing apart from the Semitic world, the Jewish component of Christianity had to be reformed, either through simple amputation or, as has happened, by way of interpretation. And yet, one of the principles of the society was neutrality where sects are concerned, and personal freedom with respect to science and virtue" (ibid., 866–67).

78. Ibid., 867. For Olcott's book, see note 73 above.

79. Ibid., 854, 859, 856.

80. Letter 545 in Johanna van Gogh-Bonger, ed., *The Complete Letters of Vincent van Gogh*, 3 vols. (Greenwich, Conn.: New York Graphic Society, 1959).

81. J.-B. de la Faille, *The Works of Vincent van Gogh* (Paris: Raynal, 1970), 476:214.

82. For example, Gauguin's *Jar with Figure of the Bathing Girl* (see fig. 25), dated 1887–88 by Merete Bodelsen, *Gauguin's Ceramics* (London: Faber and Faber, 1964), 79, fig. 62. It is likely that Gauguin was inspired by the composition of a frieze of the eighth-century Javanese Buddhist temple of Borobudur (see figs. 41–42), of which he owned a photograph, as we shall see, rather than by the significance of the subject, which he turned into an Eve, and is therefore Judeo-Christian.

83. Vaughan, quoted in "What Is Theosophy?" in de Zirkoff, *Blavatsky: Collected Writings*, 2:88.

84. To André Fontainas, August 1899, in Malingue, *Lettres* 293 (no. 172).

85. The manuscript (1897–98, transcribed Atuona, 1902) at the Saint Louis Art Museum has been published by Philippe Verdier, editor, as "L'esprit moderne et le catholicisme par Paul Gauguin" in *Wallraf-Richartz Jahrbuch* 46 (1985).

86. Taken to an extreme, the notion that the literal interpretation of accepted precepts and received truths could lead to absurdity was not lost on the Surrealists. In more general terms, the notion that, taken literally, the traditional dilemma of good and evil can verge on the absurd, and so must give way to the consideration of underlying wisdom, heralds the post–World War II existentialism of Jean-Paul Sartre, for whom dedication to a cause, or "engagement," could offer a philosophical escape—of sorts.

87. To Schuffenecker, September 12, 1888, in Merlhès, *Gauguin et van Gogh*, 87.

88. Vincent van Gogh to Emile Bernard, Summer 1888, in Johanna van Gogh-Bonger and V. W. van Gogh, eds., *Verzamelde Brieven van Vincent van Gogh* (Amsterdam: Wereld Bibliothek, 1952–54), vol. 4, B8:209–10. Merlhès established a parallel between these two letters, and has also identified the source of van Gogh's thought: Ernest Renan's "Le règne de Salomon," *Revue des Deux-Mondes*, August 1888, 536–70. Both items in Merlès, *Correspondance*, 1:498 n. 272.

89. John Ruskin, "The Relation of National Ethics to National Arts" (1867), in E. T. Cook and Alexander Wedderburn, eds., *The Complete Works of John Ruskin* (London: George Allen, 1905), 19:164, 168.

90. Seurat to Signac, ca. June 16–17, 1886; Seurat to Signac, June 19 [1886]; Signac to Camille Pissarro, ca. June 20, 1886, in Merlhès, *Correspondance*, 1: 127–28 (nos. 27–29).

91. To Lucien Pissarro, April 20, 1891, quoted in Georges Wildenstein, Daniel Wildenstein, and Robert Cogniat, *Gauguin: Catalogue* (Paris: Les Beaux-Arts, 1964), 245:9. This work is superseded by Wildenstein, Crussard, and Heudron, *Catalogue de l'œuvre peint (1873–1888)*, only until the end of 1888.

92. Victor Merlhès, ed., *Paul Gauguin: Racontars de rapin*, facsimile edition of 1902 manuscript (Taravao: Editions Avant et Après, 1994), 9.

93. Gauguin, *Avant et après*, 185.

94. In addition to those already mentioned, these texts are *Noa Noa*, 1893 (Le Garrec-Getty version), J. Paul Getty Museum, Los Angeles (facsimile ed., Tahiti: Association des amis du Musée Gauguin; New York: Gauguin and Oceania Foundation, 1987); *Noa Noa*, with additions by Charles Morice, 1893–97 (Louvre version), Cabinet des arts graphiques et du dessin, Musée du Louvre (Orsay), Paris (facsimile ed., Stockholm: Peterson, 1947); *Diverses choses*, 1896–97, Département des arts graphiques, Musée du Louvre (Orsay), Paris; *Ancien culte mahorie*, 1892–93, Département des arts graphiques, Musée du Louvre (Orsay), Paris (facsimile ed., Paris: Berès, 1951); *Le Sourire: Journal méchant*, 1899–1900 (facsimile ed., ed. L. J. Bouge, Paris: Maisonneuve, 1952). Gauguin's manuscript notebooks will be referred to by abbreviated titles in the notes.

2. BUDDING SYMBOLISM

1. The identification of Clovis Gauguin as the sleeping child is given in Pola Gauguin, *Paul Gauguin mon père* (Paris: Editions de France, 1938), 100.

2. The presence of the fishing lure would be telling even if the fishhook were not visible; a technical examination of the black line might confirm this identification.

3. Some have seen in this work a protest against the ways of the high bourgeoisie, but Gauguin always considered himself a member of that class.

4. It is an earthenware version of an eighteenth-century carved wood pitcher owned by Gauguin and his wife. In connection with its appearance in *Sleeping Child* of 1884, see Claire Frèches-Thory and Isabelle Cahn, eds., *Gauguin*, exh. cat. (Paris: Galeries nationales du Grand Palais/Réunion des Musées Nationaux, 1989), 63 (no. 13).

5. To Pissarro, [end of May, 1885], in Victor Merlhès, ed., *Correspondance de Paul Gauguin, 1873–1888* (Paris: Fondation Singer-Polignac, 1984), 1:107 (no. 79).

6. Raymond Cogniat and John Rewald, eds, *Paul Gauguin: Carnet de croquis* (New York: Hammer, 1962), 57–64.

7. Gauguin had erroneously written "the reader."

8. See Victor Merlhès in Christie's, Geneva, *Modern Illustrated Books, Manuscripts and Photographs* (May 14, 2001), no. 94, quoting the draft of a text by the artist of late October to early November 1884, presumably intended for Andreas Aubert. This information was kindly communicated by Victor Merlhès.

9. "Salon de 1859," in Charles Baudelaire, *Oeuvres complètes*, ed. Claude Pichois (Paris: Gallimard, 1975–76), 2:611.

10. "L'œuvre et la vie d'Eugène Delacroix" (1863), in Baudelaire, *Oeuvres complètes*, 2:744.

11. "Reflexions sur quelques uns de mes contemporains" (1861), in Baudelaire, *Oeuvres complètes*, 2:131–32.

12. André Joubin, ed., *Eugène Delacroix: Journal* (Paris: Plon, 1960), 3:102–3 (entry for October 26, 1853).

13. Merlhès, in Christie's, *Modern Illustrated Books* (May 14, 2001). Only the passage "in general, mystery begins where poetry is born" appears in that text; the remainder was kindly supplied in a letter from Merlhès to this author. This exceptionally elliptical sentence, even for Gauguin, required a number of additions in translation.

14. "Fusées" (posthumous), in Baudelaire, *Oeuvres complètes*, 1:659. There is a reversal, in that in Gauguin's passage, it is the phenomena that appear supernatural, while in Baudelaire's, it is the states of the soul. But Baudelaire's thought is faithfully corroborated in Gauguin's examples of spider and tree below. The poet's posthumous writings were published only in 1887 by Eugène Crépet, *Oeuvres posthumes et correspondances inédites* (Paris: Quantin); the excerpts published by Uzanne in 1880 did not include this passage. Uzanne nevertheless reveals that he had studied the excerpts, and taken "surreptitious notes" when they were in the possession of Baudelaire's editor and friend, Auguste Poulet-Malassis; he could well have communicated this striking passage to others—perhaps at the Arosas? Edgar Allan Poe, whose writings both men admired, also occasionally treated the aesthetic qualities perceived in ordinary objects during moments of exceptional mental excitement; but none of Poe's writings is closer to either statement than they are to one another.

15. "Salon de 1859," in Baudelaire, *Oeuvres complètes*, 2:620–22.

16. An awareness that our sensations and feelings may be aroused by elements unknown and unknowable, which consequently assume in our estimation a "supernatural" aspect, had been postulated by the likes of Herbert Spencer and John Stuart Mill in Britain and diffused by Hippolyte Taine in France. "What we are conscious of as properties of matter, even down to its weight and resistance, are but subjective affections produced by objective agencies which are unknown and unknowable." Herbert Spencer, *Principles of Psychology* (New York and London: Appleton, 1882), 2:493. For a study—from which this quotation is drawn—on the gleanings of Maurice Denis, when completing his lycée years, from readings in British logical positivist philosophy and their impact on his symbolist theories, see Jean-Paul Bouillon, "Denis, Taine, Spencer: Les origines du mouvement Nabi," *Bulletin de la Société de l'histoire de l'art français*, 1999, 291–306.

17. "Salon de 1846," in Baudelaire, *Oeuvres complètes*, 2:425–26.

18. "Réalisme et idéalisme," in Eugène Delacroix, *Oeuvres littéraires* (Paris: Crès, 1923) 1:63–64.

19. "Salon de 1846," in Baudelaire, *Oeuvres complètes*, 2:425.

20. Gauguin had for a while been a serious student of graphology—the study of character through handwriting. See Merlhès, *Correspondance*, 1:88 (no. 65); 407–8 n. 163.

21. The expression of our feelings, that is, is bound to be somewhat one-sided. All the above Gauguin excerpts are from the letter to Schuffenecker, January 14, 1885, in Merlhès, *Correspondance*, 1:87–89 (no. 65).

22. Ibid. For a more general, if abbreviated, discussion of the impact of Baudelaire's and Delacroix's art theories on the development of symbolism, see Henri Dorra, ed., *Symbolist Art Theories: A Critical Anthology* (Berkeley and Los Angeles: University of California Press, 1994), 1–7.

23. For a brief and cogent discussion of neo-impressionist theory and Henry's impact, see William Innes Homer, *Seurat and the Science of Painting* (Cambridge, Mass.: MIT Press, 1964). For a debunking of some of Henry's pronouncements, see Henri Dorra, "Charles Henry's 'Scientific' Aesthetics," *Gazette des Beaux-Arts*, December 1969, 345–56.

24. The relationship of the two ballerinas and the man with a bulbous nose (treated below) to figures by Degas was established by Ziva Amishai-Maisels, *Gauguin's Religious Themes* (New York: Garland, 1985), 13 n. 7.

25. Published in Paris by Calmann Lévy.

26. Merete Bodelsen, "Paul Gauguin som Kunsthåndvarker," *Kunst og Kultur* 47 (1964), 141–56. A leather rectangle such as one sees in Gauguin's *Jewelry Casket* also appears in the Bronze Age coffin. See Christopher Gray, *Sculpture and Ceramics of Paul Gauguin* (Baltimore: Johns Hopkins University Press, 1963), 12.

27. Tristan wrote in *Promenades dans Londres* (Paris: Maspero, 1978; 1st ed. Paris: Delloye and Jeffs, 1840), 141: "The monsters of both sexes who travel through England and Continental Europe, set traps for the young, then sell them to this virtuous English aristocracy, to the newly rich of commerce, the children alienated from the affection of their parents by arousing in them insidious hopes by means of atrocious lies, or whom they have furtively taken hold of by means of snares especially prepared for them." The fact that the Cardinal parents were eager participants—albeit kindly ones intent on assuring the future of their daughters—merely emphasizes the enormity of the problem. See Paul Gauguin, *Diverses choses*, 1896–97, Département des arts graphiques, Musée du Louvre (Orsay), Paris, fols. 299, 300–301.

28. Excerpted from exceptionally repetitive and convoluted texts, as are most of Gauguin's later writings.

29. Helena P. Blavatsky, "Transmigration of Life Atoms," *The Theosophist*, August 1883, 286–88, in Boris de Zirkoff, ed., *H. P. Blavatsky: Collected Writings* (Wheaton, Ill., and Madras: Theosophical Publishing House, 1950), 5:109–17. Blavatsky's text may not be the actual source for Gauguin's thought, since she presumes that all matter, organic and inorganic, is endowed from the start with a spiritual component, whereas Gauguin postulates an early bonding between spirit and matter. The alteration may be his, or an acquaintance's, or it may have originated in another text in the abundant Theosophical literature of the time.

30. Camille Flammarion: *Le monde avant la création de l'homme* . . . (Paris: Marpon/Flammarion, 1886), 23–135. The work was based on W. F. A. Zimmermann and C. G. W. Vollmer, *Der Mensch, die Räthsel und Wunder seiner Natur* . . . (Berlin: Hempel, 1864). Gauguin's Theosophically inspired views of evolution ran counter to those of the materialists and in particular to the scientifically accepted views of Darwin. This was in keeping with Henri Bergson's claim that some aspects of Darwinian evolution appear to be steps ahead of the mere survival of the fittest in postulating nonmaterial events or influences. Such antimaterialist views were held by some to justify the "spiritualist" approach, and in esoteric circles, a belief in spiritism and the occult.

31. Amishai-Maisels, *Gauguin's Religious Themes*, 13.

32. To Pissarro, [early December 1885], in Merlhès, *Correspondance*, 1:76 (no. 57).

33. Paul Gauguin, *Avant et après* (1903; facsimile ed., Copenhagen: Scripta, 1951), 185.

34. All the excerpts of the "Zunbul" text are taken from *Diverses choses*, 209–12, and from the almost identical text in *Avant et après*, 35–37. The matter of its authorship is discussed by Mark Roskill in *Van Gogh, Gauguin, and the Impressionist Circle* (Greenwich, Conn.: New York Graphic Society, 1970), 267–68; he indicates that except for the introductory paragraph, a manuscript by "Mani Vehbi-Zunbul-Zadé" at the Bibliothèque nationale differs from other versions, while one at the National Library of Ankara does not appear to correspond to either text. Victor Merlhès rightly refers to it as "a hoax" in *Paul Gauguin: "A ma fille Aline, ce cahier est dédié,"* facsimile ed. of early 1893 manuscript (Paris: Société des amis de la Bibliothèque d'art et d'archéologie; Bordeaux: William Blake, 1989), 56 n. 57.

35. Chevreul's theory of "simultaneous," or complementary, contrasts was summarized in the last chapter. Gauguin here refers to the phenomenon of *couleurs accouplées* [colors affected by others]. Chevreul, following Charles Blanc and Isaac Newton, laid out his color circle essentially according to the hues of the rainbow. Helmholtz improved on this circle by laying out the hues according to their wavelengths, which he had carefully measured. Complementary values are symmetrically opposite on a scale from black to white. The neo-impressionists took into account the findings of Helmholtz, but were more systematic in their application of color, believing that brushstrokes should not in any way emulate textures, but take into account only optical effects. For this reason, they chose to apply their paint in small, rounded, almost uniform strokes—later with variations—and much more systematically. The reader is again referred to Homer's *Seurat and the Science of Painting* for a discussion of neo-impressionist theory and technique.

36. Félix Fénéon, "Les impressionnistes en 1886," *La Vogue*, June 13–20, 1886; Fénéon, *Oeuvres plus que complètes*, ed. Joan Halperin (Geneva: Droz, 1970), 1:37.

37. Henri Dorra and Sheila Askin, "Seurat's Japonisme," *Gazette des Beaux-Arts*, February 1969, 81–94.

38. Félix Fénéon, "Le néo-impressionnisme . . . ," *L'Art moderne* (Brussels), May 1, 1887, 138–39; Fénéon, *Oeuvres*, 1:74.

39. To Monfreid, October 1897, in Annie Joly-Segalen, ed., *Lettres de Paul Gauguin à Georges-Daniel de Monfreid* (Paris: Georges Falaize, 1950), 113 (no. 37).

40. "Le peintre de la vie moderne" (1863), in Baudelaire, *Oeuvres complètes*, 2:697.

41. Ibid., 2:698.

42. To Signac, [early August 1886], in Henri Dorra and John Rewald, *Seurat: L'œuvre peint . . .* (Paris: Beaux-Arts, 1959), 196 (no. 166).

43. Homer, *Seurat and the Science of Painting*, 131, quoting Gustave Kahn, "Au temps du pointillisme," *Mercure de France*, May 1924, 16.

3. CARICATURES AND FRIENDSHIPS

The epigraph is quoted in Ursula Marks-Vandenbroucke, "Gauguin—Ses origines et sa formation," *Gazette des Beaux-Arts*, January–April 1957, 34.

1. Bogomila Welsh-Ovcharov, "Paul Gauguin's Third Visit to Brittany," June 1889–November 1890, in

Eric Zafran, ed., *Gauguin's* Nirvana: *Painters at Le Pouldu, 1889–90*, exh. cat. (Hartford, Conn.: Wadsworth Atheneum Museum of Art; New Haven: Yale University Press, 2001), 21; Victor Merlhès, *De Bretagne en Polynésie: Paul Gauguin, pages inèdites* (Tahiti: Editions Avant et Après, 1995), 33–35, 43, 62, 66–67.

2. Victor Merlhès, *Paul Gauguin et Vincent van Gogh: Lettres retrouvées, sources ignorées* (Tahiti: Editions Avant et Après, 1989), 55.

3. To Mette, first week of January 1888, in Victor Merlhès, ed., *Correspondance de Paul Gauguin, 1873–1888* (Paris: Fondation Singer-Polignac, 1984), 1:168, 471 (no. 138) .

4. Merlhès, *De Bretagne en Polynésie*, 26.

5. To Mette, first half of June 1886, in Merlhès, *Correspondance*, 1:126 (no. 98); to Carrey, first trimester of 1886, in Merlhès, *Correspondance*, 1:126 (no. 99).

6. To Mette, ca. July 25, 1886, in Merlhès, *Correspondance*, 133–34 (no. 107).

7. To Mette, August 25, 1887, in Merlhès, *Correspondance*, 1:157, 464 (no. 130); to Theo, October 7 or 8, 1888, in Merlhès, *Correspondance*, 1:247–48 (no. 167).

8. Lionello Venturi, *Cézanne* (New York: Skira/Rizzoli, 1978), 88–89, re *Landscape in Provence* (1875–78, Kunsthaus Zürich): "In the background rises the volume of a mountain . . . a compact mass which seems to concentrate and limit in a space vibrant with color the entire landscape and the emotion it arouses. Everything is built up with color, for despite his concern with structural solidity he was not prepared to give up his chromatic vision. . . . The design is chromatic; color is not laid in over a form previously constructed, but what takes place is the immediate creation of a color-form." Cézanne referred to the process as "constructive style," or, more prosaically, and more specifically: making use of vibrant clusters of multicolored, curved parallel brushstrokes to create elements of surfaces and juxtaposing those elements to create rhythmically modulated forms in space. Venturi perpetrated the myth that Cézanne did not enclose masses with lines; he certainly did, as did Gauguin at this stage, and increasingly as he adopted the synthetist manner.

9. See *Jardinière* of 1886–87 (fig. 17) and *Jug with Half-Clad Breton Eve* of 1886–87 (fig. 19).

10. Merete Bodelsen, *Gauguin's Ceramics* (London: Faber and Faber, 1964), 23–26.

11. To Schuffenecker, August 14, 1888, in Merlhès, *Correspondance*, 1:210 (no. 159). "Synthetist" and "synthetist style," rather than "synthetic" and "synthesis," are used in this text because of the respective meanings that the last two have come to acquire in current language. The shift to this style will be discussed in greater depth in the following chapter, in connection with *Grape Harvest in Arles* of 1888 (fig. 29), and will be considered in relation to Gauguin's theoretical development.

12. While "one may not be justified in supposing a truly symbolist intention in this painting," Bogomila Welsh-Ovcharov notes, "the closed eye profile of Laval further enhances the ambiguity of the multiple subject references," and she alludes to the various artistic developments among the impressionist group that put it in "a special historic context," specifically because "it commemorates the friendship with Laval and the strengthening of the Cézanne-Degas wing of Impressionism" as well as the "mending" of Gauguin's "interrupted friendship with Degas" (*Vincent van Gogh and the Birth of Cloisonism*, exh. cat. [Toronto: Art Gallery of Ontario, 1981], 75 [no. 45]).

13. The vase was first discussed by Merete Bodelsen in *Gauguin Ceramics in Danish Collections* (Copenhagen: Munksgaard, 1960), 5, 25; it has not been located.

14. To Félix Bracquemond, end of 1886 or beginning of 1887, in Merlhès, *Correspondance*, 1:143 (no. 116).

15. Christopher Gray, *Sculpture and Ceramics of Paul Gauguin* (Baltimore: Johns Hopkins University Press, 1963), 122 (no. 9).

16. To Mette, end of July 1886, in Merlhès, *Correspondance*, 1:137 (no. 110).

17. To Schuffenecker, January 14, 1885, in Merlhès, *Correspondance*, 1:87 (no. 65).

18. Paul Gauguin, *Avant et après* (1903; facsimile ed., Copenhagen: Scripta, 1951), 82.

19. In the order in which they are quoted: to Theo van Gogh, ca. July 24 or 25, 1888, in Merlhès, ed., *Correspondance*, 1:200 (no. 158); to Emile Bernard, late October or early November 1888, in Merlhès, *Correspondance*, 1:270 (no. 176) ("Cossack" refers to the fact that while Laval's mother was born a Pole, Poland was then a Russian province. See Merlhès, *Correspondance*, 1:451); to Emile Bernard, Summer 1889, in Maurice Malingue, ed., *Lettres de Gauguin à sa femme et à ses amis* (Paris: Grasset, 1949), 169 (no. 89), redated in Merlhès, *De Bretagne en Polynésie*, 35; to Bernard, [Autumn 1889 (?)], in Malingue, *Lettres*, 175 (no. 92); to Bernard, [1890], in Malingue, *Lettres*, 189 (no. 103); Laval to Bernard, 1890, in Merlhès, *Correspondance*, 1:146, 453 (no. 34). As for a "studio of the tropics," Gauguin mentions the possibility of founding one in Martinique in a letter from Arles to Emile Bernard, ca. November 9–12, 1888, in Merlhès, *Correspondance*, 1:274 (no. 178). Also, he wrote similarly to Schuffenecker, October 25, 1890, in Merlhès, *De Bretagne en Polynésie*, 53.

20. Wayne V. Andersen makes a connection between "the popular concept of the Oriental trafficker in sinful commodities . . . the slanted eyes of the fox . . . and the fox's universal significance as sly evil, together with its sexual connotations from Brittany folklore and Oriental sources" (in "Gauguin and a Peruvian Mummy," *Burlington Magazine*, April 1967, 241). While this author cannot quite accept the broadness of this statement, the link between slanting eyes and greed in Gauguin's iconography seems well founded.

21. To his wife, November 24, 1887, in Merlhès, *Correspondance*, 1:164 (no. 136). Gauguin had been Schuffenecker's colleague at Bertin's brokerage house.

22. Identified by Bodelsen (*Gauguin's Ceramics*, 63), who considered it to have been executed just after the Martinique trip.

23. He perhaps merely experienced "temptation," resulting in "rejection" on her part, according to Bodelsen (*Gauguin's Ceramics*, 119), on the basis of the wedding ring she thrusts forward in *Schuffenecker's Family* of 1889 (fig. 12).

24. Hélène Blavatsky, "La légende du Lotus Bleu," *Le Lotus Bleu* 1, no. 2 (April 7, 1892), 77–85.

25. Such symbols had been listed in that same periodical: J. L. (M. S. T.), "Le maillet du Maître: Aperçus sur la philosophie scandinave," *Le Lotus Bleu* 2, no. 7 (July 1890), 30–40.

26. Papus [Gérard Encausse], *Traité élémentaire de science occulte mettant chacun à même de comprendre et d'expliquer les théories et les symboles employés, par les anciens, par les alchimistes, les astrologues, les E de la V, les Kabbalistes . . .* (Paris: Ollendorff, 1903; 1st ed. Paris: Le Carré, 1888). On Blavatsky: 310; on the serpent biting its tail: 171–74.

27. Gray, *Sculpture and Ceramics*, 162 (no. 29).

28. Judith Gérard [Arlsberg], unpublished manuscript quoted by Merlhès, in *De Bretagne en Polynésie*, 44.

29. To his wife, early July 1886, in Merlhès, *Correspondance*, 1:130–31 (no. 102).

30. Merlhès, *De Bretagne en Polynésie*, 43–44.

31. To Monfreid, April–May (?) 1893, in Annie Joly-Segalen, ed., *Lettres de Paul Gauguin à Georges-Daniel de Monfreid* (Paris: Georges Falaize, 1950), 69 (no. 13).

32. To Monfreid, November 1897, in Joly-Segalen, *Lettres*, 116 (no. 38). "Joy" is spelled "*joye*," as it is in medieval French, in keeping with the sham medievalizing of some of Gauguin's former followers.

33. Françoise Cachin in Claire Frèches-Thory and Isabelle Cahn, eds., *Gauguin*, exh. cat (Paris: Galeries nationales du Grand Palais / Réunion des Musées Nationaux, 1989), 141, on the basis of a laboratory report.

34. According to a mutual friend, Jean de Rotonchamp, *Paul Gauguin, 1848–1903* (Paris: Crès, 1925 [1906]), 78.

35. Ibid.

36. Bodelsen, *Gauguin's Ceramics*, 119.

37. Quoted by Cachin from an unpublished letter in Frèches-Thory and Cahn, *Gauguin*, 14.

38. Ibid.

39. Gauguin was in Le Pouldu for much of August, but Theo van Gogh refers to the picture in his letter to Vincent of September 5, 1889, in Johanna van Gogh-Bonger and V. W. van Gogh, eds., *Verzamelde Brieven van Vincent van Gogh* (Amsterdam: Wereld Bibliothek, 1952–54), vol. 4, T16:274.

40. Charles Chassé, *Gauguin et le groupe de Pont-Aven: Documents inédits* (Paris: Floury, 1921), 24.

41. To Vincent van Gogh, September 5, 1889, in van Gogh-Bonger and van Gogh, *Verzamelde Brieven*, vol. 4, T16:274.

42. Ziva Amishai-Maisels, *Gauguin's Religious Themes* (New York: Garland, 1985), 36–37.

43. So recognized by Amishai-Maisels (ibid., 37 n. 71), but not recorded in Bodelsen, *Gauguin's Ceramics*, nor by Gray, who nevertheless illustrates *La Belle Angèle* as an example of a picture in which a pot is represented (see *Sculpture and Ceramics*, 22, fig. 14).

44. Bodelsen (*Gauguin's Ceramics*, 79) has proposed the date 1887–88 on the basis of the resemblance of the attitude of the nude female figure between two trees on a stoneware jar at the Musée de la France d'Outremer (*Gauguin's Ceramics*, 89, fig. 62), to which she assigns that date, and to the figure of Maitrakanyaka in one of the two photographs of four friezes of the eighth-century, classical Indian-inspired Javanese temple of Borobudur found among Gauguin's possessions after his death (Bernard Dorival, "Sources of the Art of Gauguin from Java, Egypt and Ancient Greece," *Burlington Magazine*, April 1951, 118–22; here figs. 41–42). Douglas W. Druick and Peter Kort Zegers, "Le kampong et la pagode: Gauguin à l'exposition universelle de 1889" (in *Gauguin: Actes du Colloque Gauguin*, Musée d'Orsay, 11–13 janvier 1989 [Paris: La Documentation française, 1991], 101–42), have pointed out that several Buddha images in Gauguin's work are in fact closer to a four-armed stone Javanese Vishnu, seated in a Buddha-like pose "visible in a photograph of Gauguin's studio in Atuana" (ibid., fig. 12b), the location of which is not known. See also Douglas W. Druick and Peter Kort Zegers, *Van Gogh and Gauguin: The Studio of the South*, exh. cat. (Chicago: Art Institute of Chicago; New York: Thames and Hudson, 2001), 279–83.

45. Amishai-Maisel, *Gauguin's Religious Themes*, 37, has noted the "cat-like eyes" of the statuette and referred to "parallels between . . . the primitive Indian arts . . . and the Christian character of the Breton peasant."

46. Frèches-Thory, in Frèches-Thory and Cahn, *Gauguin*, 89.

47. For the dating of the dining-room decoration, "mid-November to December 12, 1889," see Robert P. Welsh, "Gauguin et l'auberge de Marie Henry au Pouldu," *Revue de l'Art*, no. 86 (1989), 37. Welsh's reasoning is based on the letter of de Haan to Theo van Gogh of December 13, 1889, in Van Gogh-Bonger and van

Gogh, *Verzamelde Brieven*, vol. 4, T49:307–9, which mentions the completed decoration, whereas a letter of Gauguin to Vincent of around November 8 (in Douglas Cooper, ed., *Paul Gauguin: Quarante-cinq lettres à Vincent, Theo, et Jo van Gogh* [Amsterdam: Collection Rijksmuseum Vincent van Gogh, 1983], 281–87 [no. 37–1/4]) does not. *Bonjour Monsieur Gauguin I* was executed on canvas, and so may have been painted earlier and applied to the wood of the door. For their part, *Female Nude with Sunflowers* (fig. 40), *Self-Portrait with Halo* (fig. 55), and *Portrait of Jacob Meyer de Haan by Lamplight* were all painted on wood, but it is unlikely that they were actually painted directly on the door of a dining room, which had to be opened and shut to accommodate the room's function. It is much more likely that they were easel paintings inserted into the door structure; they thus could have been painted earlier. *Breton Girl Spinning* (fig. 45) was painted in true fresco before being transferred to canvas, and so could well have been painted directly on the dining-room's plaster wall. On the other hand, all the works are stylistically coherent, and for want of new evidence Welsh's conclusions are accepted in this study. See the beginning of this chapter for the dating of Gauguin's travels during the Brittany years.

48. From notes taken down by Marie Henry's future companion, Henry Mothéré (Charles Chassé, *Gauguin et son temps* [Paris: Bibliothèque des arts, 1955], 7).

49. According to Marie Henry through Mothéré (Chassé, *Gauguin et son temps*, 71).

50. René Guyot and Albert Lafay: "Qui était Marie Henry?" in Marie-Amélie Anquetil, ed., *Le chemin de Gauguin: Genèse et rayonnement*, exh. cat. (Saint-Germain-en-Laye: Musée départemental du Prieuré, 1986), 114–15, 127.

51. To Emile Bernard, [Autumn 1889], in Malingue, *Lettres*, 75 (no. 92).

52. Thomas Carlyle, *Sartor Resartus* (Boston: Monroe, 1840), 149–50, 170, 179.

4. THE GREAT DILEMMAS OF HUMANITY

The epigraph is from Douglas Cooper, ed., *Paul Gauguin: Quarante-cinq lettres à Vincent, Theo, et Jo van Gogh* (Amsterdam: Collection Rijksmuseum Vincent van Gogh, 1983), 275 (no. 36/2), redated by Victor Merlhès, ed., *Paul Gauguin, Vincent e Theo van Gogh: Sarà sempre amicizia tra noi. Lettere 1887–1890* (Milan: Archinto, 1991), no. 141.

1. To Vincent van Gogh, December 22, 1889, in Joanna van Gogh-Bonger and V. W. van Gogh, eds., *Verzamelde Brieven van Vincent van Gogh* (Amsterdam: Wereld Bibliothek, 1952–54), vol. 4, T22:281.

2. The original reads: "mais je ne veux pas en retirer ce que j'y vois et ce qui me vient à la pensée." The first part does not make sense in relation to the second; hence the translation "I . . . want" rather than "I do not want."

3. Gauguin may have remembered the couple in *L'Angelus (Evening Bells)*. The husband holds his hat reverently as his spouse prays at the end of the day.

4. To Vincent van Gogh, in Cooper, *Quarante-cinq lettres*, 274–75, no. 36/2–3; redated December 8–10, 1889, by Merlhès, *Lettere*, no. 141.

5. To Mette, [early October 1886], in Victor Merlhès, ed., *Correspondance de Paul Gauguin, 1873–1888* (Paris: Fondation Singer-Polignac, 1984), 1:140 (no. 113).

6. Merete Bodelsen has linked the clothed shepherdess with the figure in the painting *Breton Shepherdess* (no. 233 in Daniel Wildenstein, Sylvie Crussard, and Martine Heudron, *Gauguin: Premier itinéraire d'un sauvage: Catalogue de l'œuvre peint [1873–1888]*, 2 vols. [Paris: Skira, 2001])—in which there appears to be no specific erotic overtones, incidentally—and a number of drawings dating from the 1886 stay in Brittany. See Bodelsen, *Gauguin's Ceramics* (London: Faber and Faber, 1964), 31–38.

7. To Vincent van Gogh, ca. December 8–10, 1889, in Cooper, *Quarante-cinq lettres*, 275, no. 36/2; redated by Merlhès, *Lettere*, no. 14

8. Claire Frèches-Thory recognized in the pig an inducement to lechery (in Frèches-Thory and Isabelle Cahn, eds., *Gauguin*, exh. cat. [Paris: Galeries nationales du Grand Palais/Réunion des Musées Nationaux, 1989], 106, no. 34). Indeed, for Gauguin himself, the pig in all likelihood already had the symbolic significance that he was to give it in his writings, such as the following of 1896 or 1897, in connection with a picture he intended to paint: "I also want in it adorable pigs sniffing the good things to be eaten, signaling their desire with laughters of the tail" (*Diverses choses*, 1896–97, Département des arts graphiques, Musée du Louvre [Orsay], Paris, fol. 252). And later: "I wish I were a pig: man alone can be ridiculous" (*Avant et après* [1903; facsimile ed., Copenhagen: Scripta, 1951], 82). Frèches-Thory also recognized in the raised bent arm a precursor of the left nude's gesture in *Les Ondines* of 1889 (fig. 43), a type of Gauguin's falling Eves.

9. Félix Fénéon, "Calendrier de février," *Revue indépendante*, February 1888, in *Oeuvres plus que complètes*, ed. Joan Halperin (Geneva-Paris: Droz, 1970), 1:95.

10. This and later discussions of the Eve symbolism in the Breton works and subsequent Polynesian ones were first outlined, and since much altered, in this author's "Von bretonischen Spässen zum grossen Dilemma der Menschheit" and "Ein all-zu-menschliches Paradies: Gauguins Symbolismus in Tahiti," in *Paul Gauguin, Von der Bretagne nach Tahiti: Ein Aufbruch zur Moderne*, exh. cat. (Graz: Landesmuseum Joanneum, 2000), 78–87 and 138–47. Because of multiple errors by last-minute editors of that catalogue, the order of two photographs was reversed: *Jug with Half-Clad Breton Eve* should be on p. 78, and *Jug with Figure of a Bathing Girl*, on p. 79. *Human Miseries*, p. 83, should have been the zincograph of 1889, here figure 33, rather than the woodcut of 1898–99, and the portrait of Aline Gauguin, the artist's mother, p. 86, should have been the one here shown in figure 2, a photograph possibly after a painting of the head by Jules Laure, rather than the photograph of the painting of the ¾-length by that artist.

11. To Vincent van Gogh, ca. December 8–10, 1889, in Cooper, *Quarante-cinq lettres*, 1:275 (no. 36); redated in Merlhès, *Lettere*, no. 141.

12. The three themes, incidentally, reflect the same pattern as do a triad of books by Alphonse Esquiros, the friend of Gauguin's grandmother Flora Tristan (see chapter 1), who, like her, wrote moving social studies dedicated to the fate of women: *Les vierges folles* (Paris: Le Gallois, 1840), *Les vierges sages* (Paris: Delavigne, 1841), and *Les vierges martyres* (Paris: Delavigne, 1842).

13. Bodelsen, *Gauguin's Ceramics*, 235.

14. To Mette, [late March, early April] 1887, in Merlhès, *Correspondance*, 1:147 (no. 122), 150 (no. 123). Writing about Taboga in 1891, a Panamanian health official, Dr. Wolfred Nelson, also evoked the vision of an effortless life in a blissful tropical paradise: "The inhabitants there live happily; nature seems to provide to all their needs, which happen to be modest" (in Merlhès, *Correspondance*, 1:456 n. 220).

15. To Schuffenecker, before May 12, 1887, in Merlhès, *Correspondance*, 1:152 (no. 125).

16. To Mette, [ca. May 12, 1887], in Merlhès, *Correspondance*, 1:153 (no. 126).

17. Summary of a letter of June–July 1887, from Laval and Gauguin to F. Loyen du Puigaudeau, in Merlhès, *Correspondance*, 1:156 (no. 128); to Schuffenecker, ca. August 25, 1887, in Merlhès, *Correspondance*, 1:157 (no. 129).

18. To Mette, ca. August 25, 1887, in Merlhès, *Correspondance*, 1:157 (no. 129); to Schuffenecker, August 25, 1887, in Merlhès, *Correspondance*, 1:158 (no. 130), 1:159 (no. 131).

19. To Bracquemond, mid-November 1887, in Merlhès, *Correspondance*, 1:164 (no. 135).

20. The works were catalogued by Christopher Gray in *Sculpture and Ceramics of Paul Gauguin* (Baltimore: Johns Hopkins University Press, 1963), as no. 71, *Eve and the Serpent;* no. 60, *Martinique;* no. 73, *Les Martiniquaises;* and no. 74, *Reclining Woman with a Fan*. Gray tentatively proposes the *terminus ante quem* date of 1889 for the related carving, no. 72, *Les cigales et les fourmis*. Vojtěch Jirat-Wasiutyński, *Gauguin in the Context of Symbolism* (New York: Garland, 1978), 257–66, discusses all four.

21. Ziva Amishai-Maisels, *Gauguin's Religious Themes* (New York: Garland, 1985), 145.

22. Papus (Gérard Encausse), *Traité élémentaire de science occulte mettant chacun à même de comprendre et d'expliquer les théories et les symboles employés, par les anciens, par les alchimistes, les astrologues, les E de la V, les Kabbalistes. . . .* (Paris: Ollendorff, 1903 [1888]), 252–54.

23. To be compared to the strong, independent-minded, well-armed, tenacious, and brutally effective Peruvian camp-followers, the *Ravanas*, typical of "the infancy of populations," enthusiastically described by Flora Tristan, *Pérégrinations d'une paria* (Paris: Bertrand, 1848), 2:123.

24. Maïotte Dauphite, *Paul Gauguin a rencontré l'Inde en 1887 à la Martinique* (Saint-Pierre: Centre d'art Mémorial Musée Paul Gauguin, 1995).

25. Amishai-Maisels, *Gauguin's Religious Themes*, 145.

26. Victor Merlhès, ed., *Paul Gauguin: "A ma fille Aline, ce cahier est dédié,"* facsimile ed. of early 1893 manuscript (Paris: Société des amis de la Bibliothèque d'art et d'archéologie; Bordeaux: William Blake, 1989), unpaginated.

27. Its composition is a livelier version of *Les mangos*. The title *Martinique*, or *Mangoes, Martinique* (Georges Wildenstein, Daniel Wildenstein, and Robert Cogniat, *Gauguin: Catalogue* [Paris: Les Beaux-Arts, 1964], no. 224), was given by Gauguin in a list he sent Schuffenecker in early June 1888. See Maurice Malingue, ed., *Lettres de Gauguin à sa femme et à ses amis* (Paris: Grasset, 1949), 152 (no. 77). It is ultimately derived from *Creole Women*, a pastel sketch from nature at the Musée des arts africains et océaniens in Paris (Merlhès, *Correspondance*, 1:162, ill.).

28. To Schuffenecker, early July 1887, in Merlhès, *Correspondance*, 1:156–57 (no. 129).

29. Jirat-Wasiutyński, who rightly assigns a superior role to the figures in the foreground, in terms of Gauguin's tropical imperatives, nevertheless calls them "grasshoppers" (*Gauguin in the Context of Symbolism*, 244).

30. Known only through a reproduction of a poor photograph; see *Art et décoration* 52 (February 1928), 57–64.

31. The figure appears in other Martinique compositions: see Wildenstein, Wildenstein, and Cogniat, *Gauguin: Catalogue*, nos. 218, 221, 223, 227.

32. Lotus stems are straight; their undulation here attests to Gauguin's art nouveau propensities at the time.

33. The shape of the stem and flower are reminiscent of those in baroque Near-Eastern tapestries—the stems of which are also curved, whereas in nature they are straight.

34. Merlhès, *Correspondance*, 1:472 n. 239.

35. Bodelsen (*Gauguin's Ceramics*, 82) has dated the work and recognized the figure.

36. Ibid., 66–71.

37. Bodelsen (ibid., 45) refers to the autobiography of Archibald Standish Hartrick, *A Painter's Pilgrimage through Fifty Years* (Cambridge: Cambridge University Press, 1939), 29–33, which recounts that the author had met Gauguin in Pont-Aven in 1886, who showed him drawings of geese inspired by one of Caldecott's color albums.

38. To Vincent van Gogh, [ca. September 25–27, 1888], in Merlhès, *Correspondance*, 1:230–31 (no. 165).

39. Denise Delouche recognized the figure as a woman fallen from grace: *Gauguin et la Bretagne* (Rennes: Apogée, 1996), 54.

40. Gray (*Sculpture and Ceramics*, 81) convincingly proposed that the dog sometimes stood for the artist himself.

41. To Morice, [July 1901], in Malingue, *Lettres*, 301.

42. To Monfreid, [Feb. 1898], in Annie Joly-Segalen, ed., *Lettres de Paul Gauguin à Georges-Daniel de Monfreid* (Paris: Georges Falaize, 1950), 119 (no. 40).

43. Dorra, "Gauguin's Unsympathetic Observers," *Gazette des Beaux-Arts*, December 1970, 367–72; "Gauguin's Dramatic Arles Themes," *Art Journal*, Fall 1978, 12–17.

44. Merlhès, *Correspondance*: to Bernard, [second week of November 1888], 1:275 (no. 179); Vincent van Gogh to Theo [November (12–) 14, 1888], 1:282 (no. 94); to Theo van Gogh [November 22, 1888], 1:288 (no. 183). He arrived in Arles October 23 and left December 25 or 26, 1888 (Victor Merlhès, ed., *Paul Gauguin et Vincent van Gogh: Lettres retrouvées, sources ignorées* [Tahiti: Editions Avant et Après, 1989], 129, 257).

45. To Theo van Gogh, November 14, 1888, in Merlhès, *Correspondance*, 1:283 (no. 181).

46. To Theo van Gogh, [ca. November 12–14, 1888], in Merlhès, *Correspondance*, 1:282.

47. To Theo van Gogh, [ca. November 20, 1888], in Merlhès, *Correspondance*, 1:286. *Breton Girls Dancing* is no. 296 in Wildenstein, Crussard, and Heudron, *Gauguin: Premier itinéraire d'un sauvage*.

48. To Schuffenecker, December 22, 1888, in Merlhès, *Gauguin et van Gogh*, 239.

49. To Theo van Gogh, [ca. November 22, 1888], in Merlhès, *Correspondance*, 1:288 (no. 183).

50. To Theo van Gogh, [November 14, 1888], in Merlhès, *Correspondance*, 1:283 (no. 181). See chapter 2: "Budding Symbolism."

51. Merlhès, *Correspondance*, 1:89 (no. 65).

52. To Vincent van Gogh, ca. November 8, 1889, in Cooper, *Quarante-cinq lettres*, 281 (no. 37/1).

53. To Schuffenecker, August 14, 1888, in Merlhès, *Correspondance*, 1:210 (no. 159).

54. To Vincent van Gogh, December 13, 1889, in Cooper, *Quarante-cinq lettres*, 277 (no. 36/3).

55. To Theo van Gogh, [November 14, 1888], in Merlhès, *Correspondance*, 1:283 (no. 181).

56. Emile Littré, *Dictionnaire de la langue française* (Paris: Hachette, 1875), 2:1416.

57. To Schuffenecker, December 22, 1888, in Merlhès, *Gauguin et van Gogh*, 240–44.

58. Henri Dorra, ed., *Symbolist Art Theories: A Critical Anthology* (Berkeley and Los Angeles: University of California Press, 1994), 154–55.

59. Raymond Cogniat and John Rewald, eds., *Paul Gauguin: Carnet de croquis* (facsimile ed.; New York: Hammer, 1962), 57–64.

60. Gösta Svenæus has linked the two figures ("Gauguin og van Gogh," *Billedkunst*, 1967/4, 27).

61. The connection was proposed by the present author in "Gauguin's Dramatic Arles Themes," *Art Journal*, Fall 1978, 12–17.

62. Gauguin, *Avant et après*, 2. (This point, and others that follow, were made by this author in "Gauguin et l'émancipation de la femme," in *Gauguin: Actes du Colloque Gauguin, Musée d'Orsay, January 11–13, 1989* [Paris: La Documentation française, 1991], 185–89.) Gauguin indeed claimed to have once loved Mette in an attempt to mitigate the growing bitterness of his epistolary exchanges with his wife and in anticipation of a possible reunion: "Because I have loved you alone, and still love you, without hope of your returning my love—except conditionally" (To Mette, [late February–March 1891], in Malingue, *Lettres*, 182 [no. 99]).

63. To Mette, ca. January 22–February 6, 1888, in Merlhès, *Correspondance*, 1:170 (no. 139).

64. William L. Langer, "Checks on Population Growth: 1750–1850," *Scientific American*, February 1972, 93–99. Flora Tristan, for her part, showed much concern for abandoned children. Visiting a hospice in Peru, she described: "miserable little creatures, naked, thin, in deplorable condition . . . a little food provided by charity barely sustained their frail existence . . . they received no education, learned no craft, so that those who survived became vagrants." She nevertheless praised the mode of admission: they had each been "deposited in a box in a cradle-shaped opening on the outside, unseen from within," so that "the unfortunate mother is under no obligation to reveal her identity, an obligation which is the cause of so many crimes!" (*Pérégrinations*, 1:356–57). And she was outraged by the treatment of lower-class children in overpopulated, industrializing England: "in industry and agriculture, it is an atrociously cruel calculation that gives preference to children" (*Promenades dans Londres*, ed. François Bédarida [Paris: Maspéro, 1978], 292).

65. J. B. Parent-Duchâtelet, in *De la prostitution dans la ville de Paris* (Paris: Baillière, 1857), 1:105, and elsewhere gives figures on the emigration from countryside to the city and cites specific examples.

66. Merlhès, *Gauguin et van Gogh*, 240.

67. Vincent van Gogh to Theo Van Gogh, [third week of December 1888], in Merlhès, *Correspondance*, 1:302 (no. 103). Mark Roskill, without specifically referring to death, compared Gauguin's reference to the "woman dressed in black . . . who looks at her like a sister" to Vincent's misquotation of Alfred de Musset's poem, also pointing out that the poet had actually written: "sat in my way" ["*Sur ma route est venu s'asseoir*"] and "resembled me like a brother" (Roskill, *Van Gogh, Gauguin, and the Impressionist Circle* [Greenwich, Conn.: New York Graphic Society, 1970], 97).

68. To Mette, [December 1892], in Malingue, *Lettres*, 236–38 (no. 134).

69. The study of this work is relegated to the next chapter in order to respect the thematic classification. It must be added, as many authors have argued, that the fully synthetist *Breton Women in the Meadow* by Emile Bernard was completed shortly before *The Vision*, and that its synthetist simplifications were fully formed in work of 1887 by Louis Anquetin, to whom Bernard had been close, samples of which Gauguin knew.

70. To Emile Bernard, [Autumn 1889], in Malingue, *Lettres*, 175 (no. 92).

71. Sylvie Crussard, in Wildenstein, Crussard, and Heudron, *Gauguin: Premier itinéraire d'un sauvage*, 531 (no. 32).

72. To Theo van Gogh, [ca. November 22], 1888, in Merlhès, *Correspondance*, 1: 288 (no. 183).

73. Victor Merlhès, ed., *De Bretagne en Polynésie: Paul Gauguin, pages inèdites* (Papeete: Editions Avant et Après, 1995), 28; Bogomila Welsh-Ovcharov, *Vincent van Gogh and the Birth of Cloisonism*, exh. cat. (Toronto: Art Gallery of Ontario, 1981), 42 n. 51.

74. Langer, "Checks on Population Growth," 96, evokes such a situation. So had Flora Tristan (*Promenades*, ed. Bédarida, 267): "The English husband sleeps with the maid, dismisses her when she is pregnant or has given birth, and thinks himself no more guilty than Abraham sending Agar and her son Ishmael into the desert."

75. It was shown at the Volpini exhibition, which opened to the public on June 8.

76. Wayne V. Andersen, "Gauguin and a Peruvian Mummy," *Burlington Magazine*, April 1967, 238–42.

77. Jules Antoine, "Impressionnistes et synthétistes," *Art et Critique*, no. 24, November 9, 1889.

78. To Emile Bernard, [end of January 1890], in Malingue, *Lettres*, 172 (no. 91); redated by Merlhès, *De Bretagne en Polynésie*, 40.

79. Bodelsen, *Gauguin's Ceramics*, 120. Thereby leading "her to physical withdrawal in an effort to contain her hysteria" (Andersen, "Gauguin and a Peruvian Mummy," 238). According to Naomi E. Maurer, this Eve is also "closing her ears to the temptation," so that "it is difficult to avoid the conclusion that the Breton Eve symbolized [Gauguin's] wife." For Mette had "refused, closing her ears, to her husband's offer of a difficult but loving life together, choosing a death-in-life that cut both of them off from the consolations of married love and companionship." And this would be in keeping with "the opinions Gauguin expressed often about the naturalness and beauty of sexuality" (Maurer, *The Pursuit of Spiritual Wisdom: The Thought and Art of Vincent van Gogh and Paul Gauguin* [Teaneck, N.J.: Fairleigh Dickinson University Press; London: Associated University Press, 1998], 125–26, 154).

80. To Emile Bernard, [end of August 1889], in Malingue, *Lettres*, 167 (no. 87); redated by Merlhès, *De Bretagne en Polynésie*, 35.

81. To Theo van Gogh, [ca. October 20, 1889], in Cooper, *Quarante-cinq lettres*, 1:147 (no. 21/1). To Schuffenecker, envelope postmarked November 6, 1889, in Malingue, *Lettres*, 176 (no. 93); redated by Amishai-Maisels, *Gauguin's Religious Themes*, 115, n. 46.

82. The identification was tentatively suggested by Virginia Hayes, curator of Santa Barbara's Lotusland Foundation, given that three petals go up and three curl down. As with Gauguin's rendering of lotus, stems that should be straight are shown curved.

83. Bodelsen, *Gauguin's Ceramics*, 20; to Emile Bernard, [end of May 1889], in Malingue, *Lettres*, 157 (no. 81), redated by Merlhès, *De Bretagne en Polynésie*, 25, 26.

84. To Bernard, [ca. November 22–24, 1889], in Malingue, *Lettres*, 189 (no. 96), redated on the basis of the reference in the letter to the article in *Art et critique*. (The issue containing Jules Antoine's "Impressionnistes et synthétistes" appeared on November 9.) This mug is discussed in chapter 5.

85. To Theo van Gogh, [ca. November 20 or 21, 1889], in Cooper, *Quarante-cinq lettres*, 161–63 (no. 22/7). Gauguin must have had in mind the stories based on the adventures of the two celebrated, clever

jackals attributed to the Sanskrit Vidya-Pati ("chief scholar" but likely compiled by several over a long period), later known as Bidpay, some retold in Arabic literature as the tales of Khalila and Demna. They originated in the Pancha Tantra. Many were adapted in fables by Aesop and La Fontaine.

86. To Emile Bernard, [after mid-August 1889], in Malingue, *Lettres*, 167 (no. 87).

87. John Rewald, *Gauguin Drawings* (New York and London: Bitner/Yoseloff, 1958), 26, no. 19.

88. To Emile Bernard, [Autumn 1889], in Malingue, *Lettres*, 175 (no. 92).

89. To Bernard, after mid-August 1889, in Malingue, *Lettres*, 167 (no. 87). Bodelsen, *Gauguin's Ceramics*, 127, and Gray, *Sculpture and Ceramics*, 43, both identify several symbolic items in the composition.

90. Identified as no. 147 of the 1893 *Frie Udstilling* exhibition, Copenhagen, by Merete Bodelsen in *Gauguin og van Gogh i Kobenhavn i 1893* (Gauguin and van Gogh in Copenhagen in 1983), exh. cat. (Copenhagen: Ordrupgaardsamlingen, 1984), no. 38, where it was so labeled.

91. Henri Dorra, "Munch, Gauguin and the Norwegian Painters in Paris," *Gazette des Beaux-Arts*, November 1976, 175–80.

92. The earlier title, *Caribbean Woman*, was mentioned by Henri Mothéré, Marie Henry's companion of many years, presumably on the basis of the Martinique trip (interview with Charles Chassé, *Gauguin et le groupe de Pont-Aven: Documents inédits* [Paris: Floury, 1921], 40, 48). For the dating of the dining-room decoration of Marie Henry's inn, see *Portrait of Jacob Meyer de Haan by Lamplight* (fig. 14) in chapter 3.

93. See Gray, *Sculpture and Ceramics*, 88a and 88, respectively.

94. At the time of the 1889 Exposition Universelle, Gauguin wrote: "In the village of Java [reconstructed at the Exposition Universelle] there are Hindu dances. All the art of India can be found there, and the photographs I have of Cambodia are literally found there." To Emile Bernard, May 1889, in Malingue, *Lettres*, 157 (no. 81). The photographs Gauguin refers to must have been the friezes from Borobudur, of which he owned several prints (Bernard Dorival, "Sources of the Art of Gauguin from Java, Egypt and Ancient Greece," *Burlington Magazine* 93 [1951], 118–23), as well as the photograph of the Javanese Vishnu in a Buddhist pose. See Douglas W. Druick and Peter Kort Zegers, "Le Kampong et la pagode: Gauguin à l'exposition universelle de 1889," in *Gauguin: Actes du Colloque*, 109–31, and Druick and Zegers, *Van Gogh and Gauguin: The Studio of the South*, exh. cat. (Chicago: Art Institute of Chicago; New York: Thames and Hudson, 2001), 312–15. Incidentally, Amishai-Maisels had already pointed out the influence of a Buddha-like Siva in a similar pose (*Gauguin's Religious Themes*, fig. 178). Druick and Zegers further note that there was no Javanese statuary at the Exposition Universelle; the Cambodian "pagoda" was essentially a replica of one of the towers of Angkor-Wat. The *devatas* were inserted in niches in the masonry of its entrance (*Van Gogh and Gauguin*, 28). The same catalogue, on p. 315, reproduces a frieze with three *devatas* whose gestures are somewhat closer to those of Gauguin's figure. That illustration was drawn from a book of plates, *Le musée indo-chinois . . .* (Paris: Guérinet, 1916) based on a Parisian collection on the fairgrounds (Trocadéro) that Gauguin must have visited. There was also abundant contemporaneous literature on Cambodian art, to which Gauguin must have had access.

95. A photograph of it is reproduced by Druick and Zegers, "Le Kampong et la pagode," 114, and *Van Gogh and Gauguin*, 283. They also point to a Khmer relief of a *devata* showing the gesture, but with the fingers bent forward, in "Kampong," 117, and *Van Gogh and Gauguin*, 314, reproduced from an engraving in Edme Casimir de Croizier, *L'art Khmer* (Paris: Leroux, 1875), 72.

96. Maurer (*Pursuit of Spiritual Wisdom*, 137) has already attributed to it a very similar meaning: "'Do

not fear'—a gesture of protection and reassurance by which Hindu and Buddhist holy figures indicate that humanity need fear neither life nor death," derived from Lydia Aran, *The Art of Nepal* (Kathmandu: Sayahogi Prakashan, 1979), 212.

97. According to Vincent: "What Gauguin thinks of my decoration [the arrangement of paintings in Gauguin's bedroom] in general, I still do not know. I know only that there are already some studies that he really likes, such as the sower, the sunflowers [and] the bedroom." Vincent van Gogh to Theo van Gogh, [October 28 or 29, 1888], in Merlhès, *Correspondance*, 1:268 (no. 89). Also: "Gauguin was telling me the other day that he had seen a picture by Claude Monet of sunflowers in a large Japanese vase. Very beautiful, but he likes mine better" [ca. November 20, 1888], in ibid., 1287 (no. 95). And: "The two pictures of sunflowers . . . you know that Gauguin is extraordinarily fond of them. He told me among other things that . . . it is . . . the [essential] flower" [January 23, 1889], in *The Letters of Vincent van Gogh, 1886–1890*, facsimile ed. (London: Scholar Press; Amsterdam: Meulenhoff International, 1977), 2:7/8 (no. 573).

98. To G.-Albert Aurier, February 11, 1890, in van Gogh-Bonger and van Gogh, *Verzamelde Brieven*, 3:500 (no. 626a), in response to Aurier's article "Les isolés—Vincent van Gogh," *Mercure de France*, January 1890, 24–29.

99. Joachim Camerarius, *Symbola et emblemata, I* (Frankfurt: Ammon, 1654), xlix. It is very likely that Vincent, a passionate reader and an inveterate admirer and collector of prints, was familiar with emblem books, and if so he probably communicated that interest to Gauguin. But was Gauguin independently familiar with them? They were still well known in his day, and some artists continued to refer to them. Félicien Rops, in particular, made use of at least one for the personal emblem he designed for Charles Baudelaire. See Henri Dorra, "Nazarene Symbolism and the Emblem Books," *Emblematica*, Fall 1988, 283–92.

100. Vincent van Gogh to Theo van Gogh, [September 9, 1888], in Merlhès, *Correspondance*, 1:22 (no. 67).

101. Vincent van Gogh to Gauguin, October 3, 1888, in Merlhès, *Gauguin et van Gogh*, 110.

102. Gauguin, "Natures mortes," *Essais d'art libre*, January 1894, 273.

103. Druick and Zegers, *Van Gogh and Gauguin*, 242, pl. 114.

104. To Vincent van Gogh, [ca. September 25–27, 1888], in Merlhès, *Correspondence*, 1:230 (no. 162).

105. To Theo van Gogh, ca. October 28 and mid-November 1888, *Vincent van Gogh: Letters*, 2:3/4 (no. 558b), 2/4, 3/4 (no. 559).

106. To Emile Bernard, [November 9–12, 1888], in Merlhès, *Correspondance*, 1: 274 (no. 178).

107. Recently acquired by the Department of Prints and Drawings of the Metropolitan Museum of Art, New York; kindly shown to the author by the curator Ms Colta Ives.

108. Wildenstein, Wildenstein, and Cogniat, *Gauguin: Catalogue*, no. 336 (Cleveland Museum of Art). It was referred to as *Dans les vagues* in the 1889 Volpini exhibition catalogue. *Une Ondine* was listed in the Hôtel Drouot catalogue for the 1891 exhibition and sale, no. 14, as in *L'Echo de Paris*, February 16, 1891. *L'Ondine* appears in the 1906 Salon d'automne Gauguin retrospective, probably so listed by Monfreid.

109. Henri Dorra, "Le texte 'Wagner' de Gauguin," *Bulletin de la Société de l'histoire de l'art français*, 1984, 281–88.

110. Noted by Alfred Werner, *Paul Gauguin* (New York: McGraw-Hill, 1967), 39–40. Also Eric M. Zafran, "Searching for Nirvana," in *Gauguin's Nirvana—Painters at Le Pouldu 1889–90*, exh. cat. (Hartford, Conn.: Wadsworth Atheneum Museum of Art; New Haven: Yale University Press, 2001), 105.

111. Noted by Vojtěch Jirat-Wasiutyński, who interprets the detail as a *tefilin* "metamorphos[ing]" into the serpent/plant ("Paul Gauguin's *Self-Portrait with Halo and Snake* . . . ," *Art Journal*, Spring 1987, 22–26).

112. Henry Steel Olcott, *Le bouddhisme selon le canon de l'Eglise du Sud et sous forme de catéchisme* (Paris: Publications théosophiques, 1905 [1881]), 52.

113. Merlhès, *De Bretagne en Polynésie*, 60, 62; Bogomila Welsh-Ovcharov, "Paul Gauguin's Third Visit to Brittany June 1889–November 1890," in *Gauguin's Nirvana*, exh. cat. (Wadsworth Atheneum), 59.

114. René Guyot and Albert Lafay, "Qui était Marie Henry?" in Marie-Amélie Anquetil, ed., *Le chemin de Gauguin: Genèse et rayonnement*, exh. cat. (Saint-Germain-en-Laye: Musée départemental du Prieuré, 1986), 115, 127.

115. The dating of the dining-room decoration is discussed in connection with *Female Nude with Sunflowers* (fig. 40), above.

116. The identification is contested by Robert Welsh, "Gauguin et l'auberge de Marie Henry au Pouldu," *Revue de l'Art*, no. 86 (1989), 35–43, but not wholly dismissed by Victor Merlhès in "Labor: Painters at Play in Le Pouldu," in *Gauguin's Nirvana*, exh. cat. (Wadsworth Atheneum), 91–93, as Gauguin might well have conceived her as a symbol of protest against the establishment, artistic as well as political.

117. Joan of Arc became a national icon and was canonized in 1920 after a campaign started in 1850 and originally led, incidentally, by the bishop of Orléans, Monseigneur Dupanloup (who happened to have been associated with, and taught at, the Petit Séminaire of La Chapelle Saint-Mesmin, where Gauguin had studied). See Pierre Larousse, *Grand dictionnaire universel illustré* (Paris: Larousse, 1866), 6:111. A recent theory, which challenges Joan's hagiography, suggests that she was the French king's illegitimate sister, very much a tomboy, the jousting companion of his youth, and a born commander. She was likely ransomed by the French rather than burned alive, retiring at the time of her alleged ordeal to a castle near Frankfurt purchased in the name of Princess Jehanne of France.

118. Regarding derivation of the gesture from Khmer and Javanese statuary, see discussion above in connection with the "seated Buddha" statue of *La Belle Angèle* (fig. 13) and *Female Nude with Sunflowers* (fig. 40), based on Druick and Zegers's comments.

119. To Schuffenecker, envelope postmarked September 9, 1890, in which Gauguin requests "a limewood panel (same size as a canvas of 30) [. . .] for a sculpture" (Malingue, *Lettres*, 165 [no. 86]); and to Emile Bernard, [ca. October–early November 1890]: "I have given birth to a wood carving, the pendant of the first, *Soyez mystérieuses*" (ibid., 203 [no. 112]).

120. Gray, *Sculpture and Ceramics*, 51.

121. Dorra, *Symbolist Art Theories*, 155–54

122. The dating of the work, as well as the description below of the glaze, is from Bodelsen (*Gauguin's Ceramics*, 138), who notes that the figure's right arm is absent.

123. Referred to as a "latent tension" by Bodelsen (ibid.).

124. To Madeleine Bernard, October 15–20, 1888, in Merlhès, *Correspondance*, 1:256 (no. 173).

125. *Avant et après*, 34. Other references to Gourmont: 39, 78, 196. Ultimately, the notion that love can be conceptually detached from the materialities of family life and reproduction, and that sex, most meaningful as a symbol of spiritual union, is intrinsically inconsequential, dates back to Plato's *Symposium*. So does

the notion that, in its highest form, love may not know gender and so be essentially hermaphroditic. Gourmont was deeply influenced by such views.

126. *Avant et après*, 185. The two Swedenborgian spirits reappear in Gauguin's statements regarding the iconography of the statuette *Oviri (The Savage)*, of 1894 (fig. 118).

127. During the course of an interview with the author in 1952, the artist's son, Pola Gauguin, stressed the fact that his mother was often described as very masculine, as she had a very decisive personality, smoked cigars, wore tweeds and sometimes a tie, and sported short hairstyles.

5. THE ARTIST AS MESSIAH

The epigraph is from Victor Merlhès, ed., *Correspondance de Paul Gauguin, 1873–1888* (Paris: Fondation Singer-Polignac, 1984), 1:210 (no. 159).

1. To Vincent van Gogh, [ca. September 25–27, 1888], in Merlhès, *Correspondance*, 1:230–31 (no. 165).

2. Yvonne Thirion, "L'influence de l'estampe japonaise dans l'œuvre de Gauguin," *Gazette des Beaux-Arts*, January–April, 1956, 95–114. Ziva Amishai-Maisels, *Gauguin's Religious Themes* (New York: Garland, 1985), 25, links the wrestlers to earlier examples by Gauguin and convincingly proposes as their source an image from Hokusai's *Mangwa*, of 1817, book 6:52–53.

3. See Merete Bodelsen, *Gauguin's Ceramics* (London: Faber and Faber, 1964), 182.

4. Denise Delouche, "Gauguin et le thème de la lutte," in *Gauguin: Actes du Colloque Gauguin, Musée d'Orsay, 11–13 janvier 1989* (Paris: La Documentation française, 1991), 158.

5. Victor Merlhès, *Paul Gauguin et Vincent van Gogh: Lettres retrouvées, sources ignorées* (Tahiti: Editions Avant et Après, 1989), 91–94. Merlhès posits that Gauguin must have read Victor Hugo's *Les misérables* during the summer of 1888 (92) and analyzes the spiritual influence the novel had on Gauguin (91–97). He also notes Hugo's biblical allusion: ("Jacob only fought with the angel one night. Alas! how many times have we seen Jean Valjean seized in a bodily struggle by his conscience, and desperately fighting against it!" [95, quoting *Les misérables*]), and tends to link the symbolism of the *Vision* with the contest between good and evil. See Merlhès, *Correspondance*, 1:230 (no. 165), 230 n. 277, 501.

6. To Vincent van Gogh, ca. October 20, 1889, in Douglas Cooper, ed., *Paul Gauguin: Quarante-cinq lettres à Vincent, Theo, et Jo van Gogh* (Amsterdam: Collection Rijksmuseum Vincent van Gogh, 1983), 274–75 (no. 36/2–3).

7. To Vincent van Gogh, ca. September 25–27, 1888, in Merlhès, *Correspondance*, 1:230 (no. 165).

8. *Memorial de l'Exposition Eugène Delacroix, Centenaire*, exh. cat. (Paris: Musée du Louvre, 1963), 391 (no. 510).

9. Proposed by the author in *Art in Perspective: A Brief History* (New York: Harcourt Brace Jovanovich, 1973), 190, 221, citing Louis Réau, *Iconographie de l'art chrétien* (Paris: Presses Universitaires, 1955–59). Merlhès, in *Correspondance*, 1:500–501 n. 277, refers to Delacroix's painting as well as to the text of his invitation and, also after Réau, to other interpretations of the struggle against evil, the struggle between Church and Synagogue, and the victory of Christendom over its enemies. With regard to the peasants' reaction in the

picture, the triumph of good over evil in the most general terms seems the most apt; from the point of view of the artist, the parallel with Delacroix seems even more appropriate. As Merlhès puts it, this last interpretation "rids this symbol of all religious character" (*Correspondance*, 1: 501). Not quite, one might answer; artistic ideals might be pursued with religious fervor. In any case, was Gauguin likely to take traditional religious symbols literally?

10. To Vincent van Gogh, ca. October 20, 1889, in Cooper, *Quarante-cinq lettres*, 274–75 (no. 36/2–3); Cahier Walter, Département des arts graphiques (Fonds d'Orsay), Musée du Louvre, Paris.

11. As already noted by Amishai-Maisels, *Gauguin's Religious Themes*, 31.

12. Tentatively by Bodelsen, in *Gauguin's Ceramics*, 182; fully by Amishai-Maisels, in *Gauguin's Religious Themes*, 31.

13. Douglas W. Druick and Peter Kort Zegers, eds., *Van Gogh and Gauguin: The Studio of the South*, exh. cat. (Chicago: Art Institute of Chicago; New York: Thames and Hudson, 2001), 236 (no. 106). J.-B. de la Faille expresses doubts about both the authenticity of the work and the identity of the sitter (*The Works of Vincent van Gogh* [Paris: Raynal, 1970], 231, 593 [no. 546]). The positive attribution was made by Martin Bailey, "Van Gogh's Portrait of Gauguin," *Apollo*, July 1996, 51–54.

14. Realism, as Aurier must have understood it, was essentially an aspect of naturalism, often with symbolist overtones. Unless otherwise noted, the excerpts here and below are from Aurier, "Le symbolisme en peinture: Paul Gauguin," *Mercure de France*, March 1891, 155–64.

15. The Baudelaire quotation is from "Correspondances," in Baudelaire, *Oeuvres complètes*, ed. Charles Pichois (Paris: Gallimard, 1975–76), 1:11. An analysis of the poem with respect to symbolist theory is presented in Henri Dorra, *Symbolist Art Theories: A Critical Anthology* (Berkeley and Los Angeles: University of California Press, 1994), 8–11. The five categories offered by Aurier as a summation of his symbolist theory are not reproduced here for the simple reason that they are peripheral to Gauguin's art and even to Aurier's analysis of it.

16. To Schuffenecker, August 14, 1888, in Merlhès, *Correspondance*, 1: 210 (no. 159).

17. The subordination of ethics to aesthetics is also inherent in Baudelaire's sympathy for the "art for art's sake" tendencies prevalent in much French Romanticism; Baudelaire, however, subsumed such views within his overall philosophy, whereas Ruskin actually preached them and even set up a system of art education intended to implement them.

18. September 25–27 is suggested by Gauguin's remark in a letter of that date to Vincent van Gogh: "I shall do it . . . perhaps tomorrow," in Merlhès, *Correspondance*, 1:230 (no. 165). In a letter of October 1, 1888, Vincent, referring to self-portraits, wrote to Theo van Gogh: "Gauguin has given birth to a picture, and so has Bernard," in ibid., 1:234 (no. 166).

19. Vincent to Theo van Gogh, September 11, 1888, in Merlhès, *Correspondance*, 1:230 (no. 165). For Vincent's *Self-Portrait*, of late-September–early October 1888, see de la Faille, *Works of van Gogh*, 214 (no. 456).

20. Hugo, *Les misérables*, 1:ix, quoted by Merlhès, in *Gauguin et van Gogh*, 103.

21. To Vincent van Gogh, [ca. September 25–27, 1888], in Merlhès, *Correspondance*, 1:230 (no. 165).

22. Vincent van Gogh to Gauguin, October 3, 1888, in Merlhès, *Gauguin et van Gogh*, 109.

23. Emile Burnouf, "Le bouddhisme en Occident," *Revue des Deux Mondes*, July 15, 1888, 840–72. Referred to in Merlhès, *Correspondance*, 1:504, n. 283.

24. To Vincent van Gogh, October 1, 1888, in Merlhès, *Correspondance*, 1:234 (no. 166).

25. Vincent van Gogh to Gauguin, [October 3, 1888], in Merlhès, *Correspondance*, 1:238 (no. 167).

26. A reference to the setting used in high-temperature ceramic kilns, as distinct from the more moderate *petit feu*.

27. To Schuffenecker, October 8, 1888, in Merlhès, *Correspondance*, 1:249 (no. 168). The Ecole Nationale des Beaux-Arts in Paris was the academic cradle of the officially recognized and rewarded artists in France at the time and a bulwark against new tendencies. Despite their departure from impressionism in important respects, Vincent and Gauguin still considered themselves to be impressionists.

28. Merlhès, *Gauguin et van Gogh*, 98.

29. Vincent to Theo van Gogh, [October 3, 1888], in Merlhès, *Correspondance*, 1:236.

30. Merlhès, *Correspondance*, 1:87–88 (no. 65). As quoted in chapter 2: "look at a large spider, [or] the trunk of a tree in a forest; both produce a terrible sensation without your becoming aware of it. . . . no reasoning can withstand such feelings."

31. Vincent to Theo van Gogh, [October (5–) 7, 1888], in Merlhès, *Correspondance*, 1:244.

32. Vincent to Theo van Gogh, [October 5–7 1888], in Merlhès, *Correspondance*, 1:245.

33. To Vincent, [ca. September 7–9, 1888], in Merlhès, *Correspondance*, 1:220 (no. 163).

34. Some of these observations are drawn from Bodelsen, *Gauguin's Ceramics*, 111–19.

35. Regarding the date: Amishai-Maisels has pointed out that it was not shipped to Theo with other works in August, and that it must have been executed in Pont-Aven, which it depicts, before Gauguin's departure for Le Pouldu on October 2 (*Gauguin's Religious Themes*, 41). The coloring of the trees confirms an autumn date.

36. Illustrated in Amishai-Maisels, *Gauguin's Religious Themes*, pl. 14, and Claire Frèches-Thory and Isabelle Cahn, eds., *Gauguin*, exh. cat. (Paris: Galeries nationales du Grand Palais / Réunion des Musées Nationaux, 1989), no. 88:165.

37. As in *Design for a Plate—Leda and the Swan* of 1889 (fig. 27).

38. To Theo van Gogh, [November 20 or 21, 1889], in Cooper, *Quarante-cinq lettres*, 162 (no. 22.8), 161–63 (no. 22/7).

39. As was established by Robert P. Welsh in "Gauguin et l'auberge de Marie Henry au Pouldu," *Revue de l'Art*, no. 86 (1989), 37. See the dating of *Portrait of Jacob Meyer de Haan by Lamplight* (fig. 14) in chapter 3.

40. "The shape of his long hair resembles the ceremonial wigs of Egyptian gods," Vojtěch Jirat-Wasiutyński has justly noted. He has also stressed the magus-like and diabolical aspects of this work ("Paul Gauguin's *Self-Portrait with Halo and Snake* . . . ," *Art Journal*, Spring 1987, 23.

41. Merlhès has already drawn a parallel with the "red and yellow satin" worn by Bonzes during a ceremony at the Exposition Universelle; see his "Labor: Painters at Play," in Eric Zafran, ed., *Gauguin's Nirvana: Painters at Le Pouldu, 1889–90*, exh. cat. (Hartford, Conn.: Wadsworth Atheneum Museum of Art; New Haven: Yale University Press, 2001), 98. Merlhès also notes that the hand "comes directly from ancient Egypt" (ibid.).

42. Victor Merlhès, ed., *De Bretagne en Polynésie: Paul Gauguin, pages inédites* (Tahiti: Editions Avant et Après, 1995), 30. The deletion is Gauguin's.

43. To Vincent van Gogh, ca. November 8, 1989, in Cooper, *Quarante-cinq lettres*, 283 (no. 37/2).

44. Transcribed from a document at the Rijksmusem Vincent van Gogh, Amsterdam, by Amishai-Maisels (*Gauguin's Religious Themes*, 81–82), who noticed that "little explanatory group" was written as a note next to the drawing.

45. Jules Huret, "Paul Gauguin devant ses tableaux," *L'Echo de Paris*, February 23, 1891, 2. Gauguin misunderstood a passage in Mark (14:32, 34, 41). The three disciples in the olive grove did not "leave" Jesus; they merely went to sleep. The betrayer was Judas.

46. See in particular *Bonjour Monsieur Gauguin* (fig. 65), done at the end of 1889.

47. Theo to Vincent van Gogh, June 16, 1889, in Johanna van Gogh-Bonger and V. W. van Gogh, eds., *Verzamelde Brieven van Vincent van Gogh* (Amsterdam: Wereld Bibliothek, 1952–54), vol. 4, T10:267.

48. To Schuffenecker, [ca. July 10, 1889], in Merlhès, *De Bretagne en Polynésie*, 31. Gauguin had left Paris at the end of May for Pont-Aven.

49. To Theo van Gogh, June 16, 1889, in Cooper, *Quarante-cinq lettres*, 1:93 (13B). The reference is to Petit's *Expositions internationales* series, which greatly improved the lot of the leading impressionists.

50. To Bernard, [Autumn 1889], in Maurice Malingue, ed., *Lettres de Gauguin à sa femme et à ses amis* (Paris: Grasset, 1949), 174, 175 (no. 92).

51. To Bernard, ca. November 22–24, 1889, in Malingue, *Lettres*, 178 (no. 95). The "sixteen-page letter" in fact totals only fourteen. It is that of November 20 or 21 in *Quarante-cinq lettres*, 49–79 (22/1–14). It shows resentment toward Degas, no doubt accentuated by an unfavorable comparison between Gauguin and Degas made to de Haan by the Dutch painter Isaacson. It does indicate, however, that Theo must have been conciliatory: "Today you have the feeling that my last works are stronger than the previous ones." And ultimately it was written in a peace-making mood: "I must at one point resolve to speak to the friend [as opposed to the art dealer] . . . and convey my whole thought. Listen to me . . . with an open mind and with your heart." And Gauguin went on with a superb evaluation of his synthetist and symbolist approach as well as thumbnail sketches of works about to be sent. Degas continued to admire Gauguin, buying several of his works. Degas may have been disappointed at the time, but proved himself to be a steady admirer and faithful supporter of the artist over the years.

52. See note 58 below.

53. To Bernard, [Autumn 1889], in Malingue, *Lettres*, 173–76 (no. 92).

54. To Vincent, [ca. September 25–28], in Merlhès, *Correspondance*, 1:230 (no. 165).

55. To Bernard, [Autumn 1889], in Malingue, *Lettres*, 172 (no. 91).

56. See Amishai-Maisels, *Gauguin's Religious Themes*, 83 n. 44 and pl. 24.

57. Van Gogh painted very few images of biblical subjects, all based on illustrations by Rembrandt and Delacroix (see de la Faille, *Works of Van Gogh*, nos. 624, 630, 633, 677, 757).

58. Vincent to Theo van Gogh, [ca. November 16], in van Gogh-Bonger and van Gogh, eds., *Verzamelde Brieven* 3: 478–79 (no. 615). Vincent sent derogatory comments about both Bernard's and Gauguin's work to both: "Vincent has written me about the same thing as he did to you, that we are heading towards the mannered, etc. I responded acerbically." To Bernard, late November 1889, in Malingue, *Lettres*, 194 (no. 105).

59. Théophile Thoré, "Artistes contemporains: Eugène Delacroix (suite)," *Le Siècle*, February 26, 1837.

60. George W. F. Hegel, *Aesthetiks: Lectures on Fine Arts*, trans. T. M. Knox (Oxford: Clarendon, 1975[1830]), 1: 383–84.

61. To Vincent, ca. November 20, 1889, in Cooper, *Quarante-cinq lettres*, 273 (no. 36/1).

62. To Theo van Gogh, November 20 or 21, 1889, in Cooper, *Quarante-cinq lettres*, 163–67 (no. 22/8).

63. Amishai-Maisels, *Gauguin's Religious Themes*.

64. From the document at the Rijksmusem Vincent van Gogh, Amsterdam (Vincent van Gogh Foundation), quoted in ibid.,39–40.

65. To Theo van Gogh, [ca. November 20–21, 1889], in Cooper, *Quarante-cinq lettres*, 165 (no. 22/9).

66. To Schuffenecker, 1889(?), in Malingue, *Lettres*, Appendix, 322.

67. Bodelsen, *Gauguin's Ceramics*, 128.

68. Christopher Gray, *Sculpture and Ceramics of Paul Gauguin* (Baltimore: Johns Hopkins University Press, 1963), 185 (no. 66).

69. To Madeleine Bernard, [ca. November 22–24, 1889], in Malingue, *Lettres*, 180 (no. 96).

70. To Bernard, late November 1889, in Malingue, *Lettres*, 194 (no. 106).

71. To Bernard, end of January 1890, in Malingue, *Lettres*, 173 (no. 91); redated by Merlhès, in *De Bretagne en Polynésie*, 40.

72. Here again, incidentally, the character of the material itself is intended to be expressive.

73. Françoise Cachin in Frèches-Thory and Cahn, eds., *Gauguin*, exh. cat., 141.

74. Charles F. Stuckey, "L'énigme des pieds coupés," in *Gauguin: Actes du Colloque*, 56. Reproduced during Gauguin's lifetime in Jean Martin Charcot and Paul Richer, *Les difformes et les malades dans l'art* (Paris: Lecrosnié and Babbé, 1889).

75. To Bernard, [Autumn 1889], in Malingue, *Lettres*, 175 (no. 92).

76. Frèches-Thory in Frèches-Thory and Cahn, eds., *Gauguin*, exh. cat., 147 (no. 65).

77. This should serve as a fairly consistent explanation of the gesture, starting with *Be in Love and You Will Be Happy* and repeated until the end of the artist's career.

78. To Bernard, late November 1889, in Malingue, *Lettres*, 194 (no. 106).

79. To Bernard, [August 1890], in Malingue, *Lettres*, 200 (no. 110). The earlier reference to Buffalo Bill appears in a letter to Bernard, May 1889, in ibid., no. 80.

6. VISIONS OF DEATH, VISIONS OF ESCAPE

The epigraph is from Maurice Malingue, ed., *Lettres de Gauguin à sa femme et à ses amis* (Paris: Grasset, 1949), 183–84 (no. 100).

1. Merete Bodelsen dated it and identified the figure, as well as noting the male head on the figure's lap (*Gauguin's Ceramics* [London: Faber and Faber, 1964], 120).

2. As pointed out by Douglas W. Druick and Peter Kort Zegers, "Le Kampong et la pagode: Gauguin à l'exposition universelle de 1889," in *Gauguin: Actes du Colloque Gauguin, Musée d'Orsay, January 11–13, 1989* (Paris: La Documentation française, 1991), 121–22, who have noted the similarity with the Javanese stone figure of Vishnu in a Buddhist pose.

3. Ziva Amishai-Maisels, *Gauguin's Religious Themes* (New York: Garland, 1985), 178, appropriately called it "phallic." She also pointed out the Borobudur-type jewelry (see below) worn by the woman and her Martinique cap. She merely referred to "a plant," but the flower coming up against the figure's abdomen looks very much like an opening lotus.

4. André Mellerio, *Odilon Redon, peintre, dessinateur et graveur* (Paris: H. Floury, 1923), 97.

5. To Odilon Redon, shortly before November 8, 1890, in Roseline Bacou, ed., *Lettres de Gauguin, Gide, Huysmans, Jammes, Mallarmé, Verahaeren . . . à Odilon Redon* (Paris: J. Corti, 1960), 193–94.

6. To Theo, ca. September 29, 1888, in *The Letters of Vincent van Gogh, 1886–1890*, facsimile ed. (London: Scholar Press; Amsterdam: Meulenhoff International, 1977), 1:8/8 (no. 543).

7. To Theo, ca. August 2, 1890, in Douglas Cooper, ed., *Paul Gauguin: Quarante-cinq lettres à Vincent, Theo, et Jo van Gogh* (Amsterdam: Collection Rijksmuseum Vincent van Gogh, 1983), 191 (no. 26 /1).

8. To Bernard, [early August 1890], in Malingue, *Lettres*, 201 (no. 111).

9. Victor Merlhès, ed., *De Bretagne en Polynésie: Paul Gauguin, pages inédites* (Tahiti: Editions Avant et Après, 1995), 62.

10. Jean de Rotonchamp, *Paul Gauguin, 1848–1903* (Paris: G. Crès, 1925), 81.

11. Amishai-Maisels, in *Gauguin's Religious Themes*, 153, has linked the position of the arm and hand to those of Holbein's *Dead Christ*.

12. Rotonchamp, *Gauguin*, 81.

13. Wayne Andersen, *Gauguin's Paradise Lost* (New York: Viking, 1971), 100.

14. Ibid., 101–2.

15. Rotonchamp, *Gauguin*, 81–82. Amishai-Maisels has already pointed out that "there are no fiddlers in the background" and that the "description of a procession applies more aptly to a sketch in the Album Walter [Louvre], 43r" (*Gauguin's Religious Themes*, 152–53). Art Institute of Chicago conservators who have examined the painting found no evidence of underlying remains of such figures (communication with the author, January 13, 2002).

16. Two versions of *Bonjour Monsieur Gauguin* exist: the one shown here and a larger version, now in the Nàrdoní Gallery, Prague. Scholars disagree on which version came first. The smaller painting (fig. 65) originally adorned the upper panel of a door in Marie Henry's dining room in Le Pouldu. It may well have been a first draft completed prior to the larger, Prague painting. In any case, the Prague painting is more finished, and Gauguin attached great importance to it. See Charles Chassé, *Gauguin et son temps* (Paris: Bibliothèque des arts, 1955), 74; Françoise Cachin in Claire Frèches-Thory and Isabelle Cahn, eds., *Gauguin*, exh. cat. (Paris: Galeries nationales du Grand Palais/Réunion des Musées Nationaux, 1989), 72–73.

17. In 1888, with Vincent van Gogh (letter to Theo van Gogh, [third week of December 1888], in Victor Merlhès, ed., *Correspondance de Paul Gauguin, 1873–1888* [Paris: Fondation Singer-Polignac, 1984], 1:302 [no. 102]), and before that in 1883, at the time of his trip to the Spanish border to help foment a revolution in Spain (to Pissarro, August 13, 1883, in ibid., 1:52, 388 [no. 39]).

18. Linda Nochlin, "Gustave Courbet's *Meeting*: A Portrait of the Artist as a Wandering Jew," *Art Bulletin*, September 1967, 5–22.

19. The barrier, likely intended to keep cattle inside a field, is of questionable effectiveness.

20. Such black hoods were worn by women working in the fields as well as women gathering seaweed (e.g., *The Seaweed Gatherers* in the Museum Folkwang, Essen). The black oversleeve must have been functional.

21. In the version of the painting in Prague, the female figure presents her back to the viewer and her angular profile seems skeletal. Instead of the scythe, she carries a coil of rope over her left arm that, while essentially functional, may also allude to the gold thread carried by Atropos, the first of the three Fates in classical mythology, who ordered the death of individuals by cutting it.

22. Henri Dorra, "Gauguin's Dramatic Arles Themes," *Art Journal*, Fall 1978, 16. The possible connection was suggested by Hope B. Werness. The association of the woman with death is reinforced by the figure's similarity to the woman in black in *Grape Harvest in Arles* of 1888 (fig. 29), and again in such works of the Tahitian period as *Manao tupapau (The Spirit of the Dead Watches)* of 1892 (fig. 110); ibid., 15–16.

23. Rossetti's poem was inaccurately quoted by Vincent. To Theo van Gogh, [August 26, 1876], in Johanna van Gogh-Bonger and V. W. van Gogh, eds., *Verzamelde Brieven van Vincent van Gogh* (Amsterdam: Wereld Bibliothek, 1952–54), vol. 4, T74:68. Admittedly, the letter was written thirteen years earlier, but Vincent had a good memory and tended to repeat such passages.

24. The case for a linkage with John Bunyan's *Pilgrim's Progress* has already been made. See Douglas W. Druick and Peter Kort Zegers, eds., *Van Gogh and Gauguin: The Studio of the South*, exh. cat. (Chicago: Art Institute of Chicago; New York: Thames and Hudson, 2001), 313. This parallel would have been in keeping with the literary interests and religious speculations of Meyer de Haan, who would have read Bunyan in English, which Gauguin could barely speak. And while de Haan did discuss Milton's *Paradise Lost* with him, Gauguin appears to have made use of the reference ironically, as we have seen. It is very unlikely that Gauguin had read Bunyan, let alone referred to Bunyan's poetic thought. Besides, it is hard to imagine Gauguin thinking of entering the Gate of Good Will, presumably in a very traditional Heaven!

25. To Schuffenecker, [December 22, 1888], quoted in Victor Merlhès, *Paul Gauguin et Vincent van Gogh: Lettres retrouvées, sources ignorées* (Tahiti: Editions Avant et Après, 1989), 240.

26. Ziva Amishai-Maisels has already noted the hint of hope in the rainbow ("Die Dualität in den Selbstportraits von Paul Gauguin," in *Paul Gauguin, von der Bretagne nach Tahiti: Ein Aufbruch zur Moderne*, exh. cat. [Graz: Landesmuseum Joanneum; Tulln: Milleniumsberlag, 2000], 57).

27. To Bernard, [October 1890], in Malingue, *Lettres*, 204 (no. 113).

28. To Mette, [ca. June 24, 1890], in Malingue, *Lettres*, 183–84 (no. 100), as corrected by Amishai-Maisels, *Gauguin's Religious Themes*, 179–80. The letter is here dated on the basis of the wording in a letter to Vincent of June 24, 1890: "I am condemned . . . to continue my path all alone, to an existence without a family, like a pariah. So that solitude in the woods seems in the future to be a new paradise, almost in a dream" (Cooper, *Quarante-cinq lettres*, 237 [no. 42/4]).

29. "Are you deprived of a mother? Are you deprived of the sight of your children?" Gauguin had asked Mette in 1888. To Mette, [mid-June 1888], in Merlhès, *Correspondance*, 1:194 (no. 154), as noted by Amishai-Maisels, *Gauguin's Religious Themes*, 206 n. 22.

30. Paul Gauguin, *Avant et après* (1903; facsimile ed., Copenhagen: Scripta, 1951), 84–86.

31. On the basis of the above-mentioned letter of June 24, 1890, to Vincent.

32. It was recognized to be an Eve by the author in 1952 and dated 1890 by him after he deciphered the

artist's inscription of this date on the picture from the only available source, a defective photograph from a glass plate made by Druet, presumably during Gauguin's lifetime, obtained at Vizzavona's in Paris in 1952. The upside-down signature and the date, "1890," were clearly visible (Henri Dorra, "The First Eves in Gauguin's Eden," *Gazette des Beaux-Arts*, March 1953, 189–202). Ronald Pickvance examined the picture in 1998, reading the date "1894," which he proposed for the work (*Gauguin*, exh. cat. [Martigny, Switzerland: Fondation Pierre Gianadda, 1998], 243, 288 [no. 105]). Amishai-Maisels (in "Die Dualität," 51 n. 39) pointed out that Pickvance had ignored the fact that the edges of the picture had recently been repainted and that neither the signature nor the date matched those of the Vizzavona photograph. Unaware at the time of Amishai-Maisel's observation, this author regrettably accepted Pickvance's proposed new date in the same publication ("Ein all-zu-menschliches Paradies: Gauguins Symbolismus in Tahiti," in *Gauguin, von der Bretagne nach Tahiti*, 85 n. 25). Other misleading errors and claims by Pickvance were also corrected in that text. Vojtěch Jirat-Wasiutyński has proposed that the picture, which was probably known as *The Earthly Paradise* during Gauguin's lifetime, once hung in Marie Henry's inn at Le Pouldu (Jirat-Wasiutyński, "Paul Gauguin's *Self-Portrait with Halo and Snake:* The Artist as Initiate and Magus," *Art Journal* 46, no. 1 [Spring 1987], 27; see also Chassé, *Gauguin et son temps*, 74).

33. The similarity between the left hands of all three figures—but not the distortion—has already been noted by Naomi E. Maurer, *The Pursuit of Spiritual Wisdom: The Thought and Art of Vincent van Gogh and Paul Gauguin* (Teaneck, N.J.: Fairleigh Dickinson University Press; London: Associated University Press, 1998), 153.

34. To Theo van Gogh, November 20 or 21, 1889, in Cooper, *Quarante-cinq lettres*, 167–68 (no. 22). Gauguin's awareness of this duality was discussed by Amishai-Maisels, "Die Dualität," 47–60.

35. Andrea Alciati, *Emblemata* (Padua: Tozzi, 1621).

36. To Theo, ca. September 23, 1888, in *Letters of Vincent van Gogh* (facsimile), 1/6 (no. 541). Amishai-Maisels (*Gauguin's Religious Themes*, 179) had already mentioned the traditional symbolism of the cypress in connection with this painting.

37. To Odilon Redon, [shortly before November 8, 1890], in Bacou, *Lettres à Redon*, 193. Gauguin was referring to a lithograph by Redon that he owned: *"Death: Mine Irony Surpasses All Others": A Gustave Flaubert, no. 3*, 1889.

38. Rachilde (Marguerite Eymery), *Madame la mort* (Paris: Savin, 1891).

39. To Dolent, [early 1891], in Malingue, *Lettres*, 208 (no. 116).

40. To Rachilde, [early February 1891], in Malingue, *Lettres*, 209 (no. 118).

41. Kiki Gounaridou and Frazer Lively, ed. and trans., *Rachilde, Madame La Mort* (Baltimore: Johns Hopkins University Press, 1998), 121, 122, 146, 147.

42. Quoted from a letter by Laval and Gauguin to F. Loyen du Puigaudeau, in Merlhès, *Correspondance*, 1:156 (no. 128).

43. Camerarius, *Symbolorum et Emblematum, Ex Re Volatilibus et Insectis Desumtorum* (Frankfurt: Ammon, 1654), 55.

44. Gabriel Rollenhagen, *Selectorum Emblematorum, Centuria Secunda* (Utrecht: Crispin de Passe, 1613), 72.

45. Noted by Amishai-Maisels, *Gauguin's Religious Themes*, 158.

46. Daniel Wildenstein, Sylvie Crussard, and Martine Heudron date it 1891 in *Gauguin: Premier itinéraire*

d'un sauvage: Catalogue de l'œuvre peint (1873–1888), 2 vols. (Paris: Skira, 2001), no. 415. In *Gauguin: Paintings, Drawings, Prints, Sculpture*, exh. cat. (Chicago: Art Institute of Chicago; New York: Metropolitan Museum of Art, 1959), it is dated 1893; in *Gauguin, von der Bretagne nach Tahiti*, it is ca. 1894 (no. 4). Vojtěch Jirat-Wasiutyński dates it 1893 and rightly sees in the idol the future effigy of Hina ("Paul Gauguin's Self-Portraits and the *Oviri*: The Image of the Artist, Eve and the Fatal Woman," *Art Quarterly*, Spring 1979, 181).

47. Gauguin, *Avant et après*, 16. This thought, incidentally, published in the first facsimile edition of the notebook (Leipzig, 1913), may well have suggested a name for their movement to the future dada artists.

48. The letter appears in Paul Sérusier, *ABC de la peinture: Correspondance* (Paris: Librairie Floury, 1950), 60. See also Jacques-Antoine Moerenhout, *Voyages aux îles du Grand Océan* (Paris: Maisonneuve, 1959 [1837]), 2 vols. in 1. The date of Gauguin's discovery of the book was established by Amishai-Maisels (*Gauguin's Religious Themes*, 341 n. 4, 386), who cites the letter to Sérusier.

49. Bernard Dorival, "Sources of the Art of Gauguin from Java, Egypt and Ancient Greece," *Burlington Magazine* 93 (1951), 118–23.

50. Charles Morice, *Paul Gauguin* (Paris: Floury, 1920), 25.

51. Jean Moréas, "Le symbolisme," *Supplément littéraire du Figaro*, September 1886, 150.

52. Manet's poster is headed "Le Corbeau." Manet also provided five illustrations for Mallarmé's translation of Poe's *The Raven*, published in 1875.

53. Pierre Michel, ed., *Paul Gauguin: Lettres à Octave Mirbeau* (Reims: A l'Ecart, 1992), 7, 8.

54. Octave Mirbeau, "Gauguin," *L'Echo de Paris*, February 16, 1891, and *Le Figaro*, February 18, 1891.

55. To Mirbeau, February 18, 1891, in Michel, *Gauguin: Lettres à Mirbeau*, 23.

56. David Sweetman, *Paul Gauguin: A Complete Life* (London: Hodder and Stoughton, 1995), 53.

57. Michel, *Gauguin: Lettres à Mirbeau*, 8.

58. Rotonchamp, *Gauguin*, 88; Bengt Danielsson, *Gauguin à Tahiti et aux îles marquises* (Papeete: Pacifique, 1975), 47–48. Other details in these pages were also drawn from this last work.

59. Danielsson, *Gauguin à Tahiti*, 47.

60. Already mentioned in connection with *The Vision after the Sermon* of 1888 (fig. 49).

61. Rotonchamp, *Gauguin*, 91.

62. Ibid., 92.

63. Danielsson, *Gauguin à Tahiti*, 93.

7. FROM PAPEETE TO MATAIEA

The epigraph is from Annie Joly-Segalen, ed., *Lettres de Paul Gauguin à Georges-Daniel de Monfreid* (Paris: Georges Falaize, 1950), 54 (no. 3).

1. Bengt Danielsson, *Gauguin à Tahiti et aux îles marquises* (Papeete: Pacifique, 1975), 84.

2. To Mette, [March 1892], in Maurice Malingue, ed., *Lettres de Gauguin à sa femme et à ses amis* (Paris: Grasset, 1949), 222 (no. 127). Vomitus of blood has several main causes independent of cardiac disease. Peptic ulcers, accounting for about 50 percent of cases, can also cause chest pain and are frequently misdiagnosed as cardiac disease. Tears in the gastric mucosal lining or enlarged hemorrhagic blood vessels in the

esophagus, both associated with alcoholism and the latter also with liver disease, account for smaller percentages of cases and constitute more serious illnesses. All three conditions may be self-resolving, but the recurrence of bleeding is frequent. Eugene Braunwald et al., *Harrison's Principles of Internal Medicine* (New York: McGraw-Hill, 2001), 252–54, 1649. I am grateful to Helen Hyde Dorra for this reference.

3. To Monfreid, March 11, 1892, in Joly-Segalen, *Lettres*, 4 (no. 3)

4. To Mette, [Autumn 1892], in Malingue, *Lettres*, 234 (no. 33).

5. Danielsson, *Gauguin à Tahiti*, 87–91.

6. Most of the above discussion is drawn from Danielsson, ibid., 108–9.

7. To Mette, ca. June 29, 1891, in Malingue, *Lettres*, 219 (no. 126). This account in many instances draws from material presented in earlier works by the present author, in particular, "Ein nur allzu menschlichen Paradies: Gauguins Symbolismus in Tahiti," in *Paul Gauguin, von der Bretagne nach Tahiti: Ein Aufbruch zur Moderne*, ed. Brigitte Béranger-Menand and Ziva Amishai-Maisels, exh. cat. (Graz: Landesmuseum Joanneum; Tulln: Milleniumsberlag, 2000), 138–47, here much further developed and augmented.

8. To Monfreid, [August–September 1892], in Joly-Segalen, *Lettres*, 68 (no. 12); redated by John Rewald in *Post-Impressionism: From Van Gogh to Gauguin*, 3rd ed. (New York: Museum of Modern Art, 1978), 537.

9. To Monfreid, October 1897, in Joly-Segalen, *Lettres*, 113 (no. 37).

10. *Encyclopedia Britannica*, 11th ed. (New York, 1911), 26:358.

11. Jacques-Antoine Moerenhout, *Voyages aux îles du Grand Océan* (Paris: Maisonneuve, 1959 [1837]), 2:478–86.

12. Bengt Danielsson mentions a small museum at the Catholic mission and "an important group of Marquesan objects" at the house of a lieutenant in the *gendarmerie* (in *Gauguin à Tahiti*, 79, 94). See also, for more precise details, Jehanne Teilhet-Fisk, "Paradise Revised: An Interpretation of Gauguin's Polynesian Symbolism" (PhD diss., University of California, Los Angeles, 1995), 31 n. 37.

13. Danielsson (*Gauguin à Tahiti*, 101–2) has established that Gauguin obtained the book through an acquaintance, Gustave Goupil, a wealthy French settler. Danielsson maintains that Moerenhout's "interpretations and reconstitutions [are] frequently fanciful or erroneous" (102), and recent scholarship has substantiated elements of that evaluation. Nonetheless, Gauguin clearly had access to the work, and from all evidence, placed strong credence in the account.

14. To Mette, ca. June 29, 1891, in Malingue, *Lettres*, 217 (no. 126).

15. To Monfreid, November 7, 1891, in Joly-Segalen, *Lettres*, 52 (no. 2).

16. The title was recognized by Ziva Amishai-Maisels (*Gauguin's Religious Themes* [New York: Garland, 1985], 346, n. 16), on the basis that it is listed among others in Gauguin's *Carnet de Tahiti (premier voyage, 1891–1893)*, ed. Bernard Dorival (Paris: Quatre Chemins, 1984), 2. A good source for the translations of titles is Bengt Danielsson, "Gauguin's Tahitian Titles," *Burlington Magazine* 109 (April 1967), 228–33. Gauguin favored an element of ambiguity verging on mystery in describing the content of his work. In the same spirit, Gauguin did not seek to make his Tahitian titles easily comprehensible to his public. He added, undoubtedly thinking of the principles of polysemy and mystery so dear to the symbolists, "This language is bizarre and gives several meanings." To Mette, [ca. December 8, 1892], in Malingue, *Lettres*, 236 (no. 134).

17. Moerenhout, *Voyages aux îles*, 2:128, 131.

18. Ibid., 2:126–32.

19. See Amishai-Maisels, *Gauguin's Religious Themes*, 157.

20. To Monfreid, March 11, 1892, in Joly-Segalen, *Lettres*, 54 (no. 3).

21. Ibid.

22. It has been argued (by Charles Stuckey in Claire Frèches-Thory and Isabelle Cahn, eds., *Gauguin*, exh. cat. [Paris: Galeries nationales du Grand Palais/Réunion des Musées Nationaux, 1989], 248) that the fruits at the bottom of the painting *Ia orana Maria* of 1891–92 (fig. 75) are resting on a *fata*, that is, a sacrificial altar with short legs (described by Moerenhout, *Voyages aux îles*, 1:470, 486, and depicted by Gauguin in his album *Ancien culte mahorie*, Département des arts graphiques, Musée du Louvre [Orsay], Paris, 25).

23. "[The queen . . .]," wrote Gauguin, "with the instinct of the Maori race, gracefully adorns and turns into a work of art everything she touches." And, "'Let them do it,' was my response . . . to the director of public works who had asked for my advice to decorate the hall artistically." In *Noa Noa* (Le Garrec-Getty), 2–3 (see chapter 8, n. 11, and the bibliography for information on the different versions of *Noa Noa*). See also Moerenhout, *Voyages aux îles*, 1:26, 2:39, 139.

24. Moerenhout, *Voyages aux îles*, 2:78; 1:535.

25. Aurélien-François-Marie Lugné-Poë, *Le sot du tremplin: Souvenirs et impressions du théâtre*, 8th ed. (Paris: Gallimard, 1931), 189–90.

26. Or, alternatively, does the palm allude to Christ's Passion? Or the death of the picture's mortals? Or the ultimate demise of Polynesian culture? See Amishai-Maisels, *Gauguin's Religious Themes*, 294–96.

27. Bernard Dorival, "Sources of the Art of Gauguin from Java, Egypt and Ancient Greece," *Burlington Magazine* 93 (April 1951), 118–23.

28. Moerenhout, *Voyages aux îles*, 1:256, 280.

29. Derived from Paul de Deckker, *Jacques-Antoine Morenhout (1797–1879)* (Tahiti: Au vent des îles, 1997), as well as Léonce Jore, *Un belge au service de la France dans l'Océan Pacifique* (Paris: Maisonneuve, 1944), and Moerenhout, *Voyages aux îles*, 1:x, 391–94, 495–96; 2:186, 188–89, 194, 219.

30. Moerenhout, *Voyages aux îles*, 1:391–92. For the meeting with the priest, see ibid., 1:382–94.

31. Ibid., 1:313–14.

32. Ibid., 2:56–57.

33. Ibid., 2:62–63, 65, 67.

34. Paul Gauguin, *Avant et après* (1903; facsimile ed., Copenhagen: Scripta, 1951), 6–7.

35. Moerenhout, *Voyages aux îles*, 2:78, 61.

36. Ibid., 2:66, 64.

37. Ibid., 2:65–66; Captain James Cook, quoted by John Hawkesworth in *An Account of the Voyages . . . Byron Wallis, Carteret, Cook* (London: Strathan and Cadell, 1773), 2:207.

38. *Noa Noa* (LeGarrec-Getty), 28.

39. Moerenhout, *Voyages aux îles*, 2:64–65.

40. Achille Delaroche, "D'un point de vue esthétique," *L'Ermitage*, January 1894, 36–39 (review of Gauguin's Durand-Ruel exhibition of 1893), copied by Gauguin in *Avant et après*, 25.

41. Moerenhout, *Voyages aux îles*, 2:66.

42. The same figure appears in a sketchy work of 1891, *Landscape with Black Pigs and Crouching Tahitian Woman* (private collection; no. 445 in Daniel Wildenstein, Sylvie Crussard, and Martine Heudron, *Gauguin: Premier itinéraire d'un sauvage: Catalogue de l'œuvre peint [1873–1888]*, 2 vols. [Paris: Skira, 2001]). It offers another instance of a symbolic theme dating to the first few months of his stay.

43. Moerenhout, *Voyages aux îles*, 2:131.

44. Translated as *Land of Sensuous Pleasure* in Danielsson, "Gauguin's Tahitian Titles."

45. Quoted in Gauguin, *Avant et après*, 25.

46. Gauguin here replaced the biblical serpent with a lizard, following Pierre Loti (*Le mariage de Loti-Rarahu* [Paris: Calmann Lévy, 1891], 69), who, in retelling the story of Adam and Eve, explained that a serpent was a legless lizard, since there were no serpents on the island.

47. Paul Gauguin, *Diverses choses*, 1896–97, Département des arts graphiques, Musée du Louvre (Orsay), Paris, 256; Naomi E. Maurer has already associated this quotation with *Nave nave fenua* in *The Pursuit of Spiritual Wisdom: The Thought and Art of Vincent van Gogh and Paul Gauguin* (Teaneck, N.J.: Fairleigh Dickinson University Press; London: Associated University Press, 1998), 149.

8. THE POLYNESIAN PANTHEON

The epigraph is from Paul Sérusier, *ABC de la peinture: Correspondance* (Paris: Librairie Floury, 1950), 60.

1. Ibid.

2. The *te* in Tefatou, it must be added, means "the," and *fatou*, "underground rumblings" as well as "interrupted rest," identifying the god as the agent of earthquakes and, more generally, destruction. See Jacques-Antoine Moerenhout, *Voyages aux îles du Grand Océan* (Paris: Maisonneuve, 1959 [1837]), 1: 425.

3. Ibid., 1:428–29; Paul Gauguin, *Ancien culte mahorie*, 1896–97, Département des arts graphiques, Musée du Louvre (Orsay), Paris, 13.

4. As in *Design for a Plate—Leda and the Swan* of 1889 (fig. 27), for instance.

5. Moerenhout, *Voyages aux îles*, 1: 428–29; Gauguin, *Ancien culte mahorie*, 13.

6. Charles Dupuis, *Origine de toutes les religions, ou religion universelle*, 7 vols. in 12 (Paris: Agasse, 1795). The impact of Dupuis on Moerenhout has already been noted by Christopher Gray, *Sculpture and Ceramics of Paul Gauguin* (Baltimore: Johns Hopkins University Press, 1980 [1963]), 49. Gray notes that the theme of the duality of matter and spirit, derived from Plutarch's *Osiridae*, was central to Dupuis's work. Mary Lynn Zink Vance has since established that many of Moerenhout's philosophical notions pertaining to the history of religions derived from Dupuis, the association between the cycles of the moon and the notion of eternity, among them. See her "Gauguin's Polynesian Pantheon as a Visual Language" (PhD diss., University of California, Santa Barbara, 1983), 95–100, quoting Dupuis, *Origine*, abridged ed. (Paris: Décembre-Alonnier, 1869), 47–49.

7. Moerenhout, *Voyages aux îles*, 1:563–64, 1:427–28.

8. Ibid., 1:429–36, 454–55, 552, 2:78–79.

9. The title is Gauguin's in the 1893 Durand-Ruel exhibition catalogue, no. 34.

10. Elizabeth C. Childs, "Paradise Redux: Gauguin, Photography, and Fin-de-siècle Tahiti," in *The Artist*

and the Camera: Degas to Picasso, ed. Dorothy Kosinski, exh. cat. (Dallas: Dallas Museum of Art, 1999), 139 (no. 128).

11. This account comes from the Le Garrec-Getty version of Gauguin's Tahitian journal *Noa Noa*, 16; it is more detailed in the Louvre version. *Noa Noa* (which means "fragrance" in Tahitian) exists in three variant manuscripts. The earliest, virtually unillustrated, version seems to be a draft manuscript from 1893 (referred to as the Le Garrec-Getty manuscript), which was given to Charles Morice for emendation. Morice supplied this version to *La Revue Blanche*, which published only the text. By the spring of 1894 Gauguin contacted the printer Louis Roy, who eventually produced twenty-five to thirty impressions of the prints, which were published in an unsystematic way—unmounted and unnumbered. The second manuscript, done in collaboration with Morice and dated 1893–97, is in the Louvre. A third, unillustrated manuscript, in Morice's hand and dated 1897, is now in the Morice Archives, Paley Library, Temple University, Philadelphia. See Richard Brettell et al., eds., *The Art of Paul Gauguin*, exh. cat. (Washington, D.C.: National Gallery of Art; Chicago: Art Institute of Chicago, 1988), 317–21, 515.

12. Douglas Druick and Peter Kort Zegers, eds., *Van Gogh and Gauguin: The Studio of the South*, exh. cat. (Chicago: Art Institute of Chicago, 2001), 55 (no. 17). In actuality, the painting's composition is based on a photograph of a Samoan in the same position about to drink from a similar water stream issuing from what appears to be a pipe jutting out of a rock in a fairly similar landscape, according to Richard S. Field, *Paul Gauguin: The Paintings of the First Voyage to Tahiti* (New York: Garland, 1977), 81 (no. 54). Field attributed the photograph to Charles Spitz, presumably because it appears in the latter's album *Autour du monde* (Paris: Boulanger, 1895). Naomi E. Maurer refers to an edition of this album of around 1889 (*The Pursuit of Spiritual Wisdom: The Thought and Art of Vincent van Gogh and Paul Gauguin* [Teaneck, N.J.: Farleigh Dickinson University Press; London: Associated University Press, 1998], 241). Childs dates the photograph to 1888, attributes it to an unidentified earlier photographer, and locates it in Samoa ("Paradise Redux," 138 [no. 115]).

13. Field, *Gauguin*, 190.

14. Zink Vance ("Gauguin's Polynesian Pantheon," 136) did not put it into words, but sketched an elephant's head next to it for the benefit of this reader.

15. Among these, a little "Picassoesque" version, shown seated over her bent knees, in the ink drawing *Study of Figures, Animals and Plants* of 1892, illustrated in Brigitte Béranger-Menand and Ziva Amishai-Maisels, eds., *Paul Gauguin, von der Bretagne nach Tahiti: Ein Aufbruch zur Moderne*, exh. cat. (Graz: Landesmuseum Joanneum; Tulln: Milleniumsberlag, 2000), 259 (no. 55). A drawing for *Nave nave moe (Delicious Mystery)* of 1894 (fig. 117) shows a vaguely similar woman, seated on bent knees, her raised arms bent behind her head. She appears in reverse, seated with her knees raised in *Where Do We Come From? . . .* of 1897 (fig. 131), and in that position again in *Rave te hiti aamu (The Monster Takes Hold of the Fable)* of 1898 (Hermitage, St. Petersburg).

16. "A small embryonic female nude crouches in the bushes in the background to the left of the *Oviri* figure as if emerging from a shell-like aura," wrote Vojtěch Jirat-Wasiutyński in connection with the apparition of *The Awakening* in *Rave te hiti aamu* ("Paul Gauguin's Self-Portraits and the *Oviri:* The Image of the Artist, Eve and the Fatal Woman," *Art Quarterly*, Spring 1979, 185). The figure had already been noted by Richard Field (in William H. Davenport, Bengt Danielsson, and Richard S. Field, *Gauguin and Exotic Art*,

exh. cat. [Philadelphia: University of Pennsylvania Museum, 1969], 27), who had also recognized it in *Where Do We Come From?*

17. Aix-en-Provence, Musée Granet. This association has been made by Ziva Amishai-Maisels, who also pointed out that Gauguin could have seen that picture at the exhibition *Un siècle d'art*, at the Paris 1889 Exposition universelle (*Gauguin's Religious Themes* [New York: Garland, 1985], 370–71).

18. Victor Merlhès, "Le 'Cahier pour Aline,' histoire et signification," in Gauguin, *A ma fille Aline, ce cahier est dédié* (facsimile ed., Paris: Société des Amis de la Bibliothèque d'art et d'archéologie; London: William Blake, 1989), 14, 25, ills.

19. Sérusier, *ABC de la peinture*, 61.

20. Moerenhout, *Voyages aux îles*, 1:486.

21. According to Douglas L. Oliver, *Ancient Tahitian Society* (Honolulu: University of Hawaii Press, 1974), 2:926 and 1:444: "Oro, most powerful after his father, Taaroa."

22. Gauguin, *Ancien culte mahorie*, 25–29; Moerenhout, *Voyages aux îles*, 1:486–89.

23. Moerenhout, *Voyages aux îles*, 2:489–99.

24. Summarized and quoted from ibid., 1:484–503, 2:129–36, and quoted in part by Gauguin in *Ancien culte mahorie*, 30–31.

25. Moerenhout, *Voyages aux îles*, 1:466–67; Gauguin, *Ancien culte mahorie*, 22.

26. To Mette, [ca. December 8, 1892], in Maurice Malingue, ed., *Lettres de Gauguin à sa femme et à ses amis* (Paris: Grasset, 1949), 236 (no. 134).

27. See chapter 6. Gauguin's attitude toward the combination of the aesthetic sense of the Areoi, their propensity for human sacrifice, and their encouragement of reproduction may have echoed the views of a figure that seems to loom large among the earlier thinkers he admired: Charles Baudelaire. Gauguin might have read the following passage from the poet's posthumous writings in the article "Baudelaire inédit" by Octave Uzanne, in *Le Figaro* of August 30, 1880, 1–2: "There are only three beings worthy of respect: the priest, the warrior, the poet—the man who sings, the man who blesses, the man who sacrifices and sacrifices himself. To know how to kill and to create—the other men are only worthy of paying taxes and being exploited; only good for the professions, that is." The poet's championing of the supremacy of the creative artist, together with the attendant cruelty associated with leadership and domination, found a match in Gauguin's own often cynical view of human motivations.

28. Moerenhout, *Voyages aux îles*, 1:439.

29. Ibid., 1:419–23; Gauguin, *Ancien culte mahorie*, 9–10.

30. It has already been recognized as such in Gray, *Sculpture and Ceramics*, 57.

31. Ibid.

32. Zink Vance, "Gauguin's Polynesian Pantheon," 148.

33. Paul Gauguin, *L'esprit moderne et le catholicisme* (1902, Saint Louis Art Museum), 20; Philippe Verdier, ed., "L'esprit moderne et le catholicisme par Paul Gauguin," *Wallraf-Richartz Jahrbuch* (1985), 305. The distinctions between the material aspects of life, susceptible to measurement and mathematical definition, and the spiritual ones, which are not, echo the philosophy of Henri Bergson.

34. Gauguin, *Ancien culte mahorie*, 3; Gray, *Sculpture and Ceramics*, no. 99.

35. Maurer, *Pursuit of Spiritual Wisdom*, 151, pl. 311.

36. Tattoos are noted in Gray, *Sculpture and Ceramics*, 226.

37. Moerenhout, *Voyages aux îles*, 1:420–21; Gauguin, *Ancien culte mahorie*, 9.

38. Amishai-Maisels, *Gauguin's Religious Themes*, 360.

39. Moerenhout, *Voyages aux îles*, 1:425. Gauguin, *Ancien culte mahorie*, 35. Gauguin does not seem to have noticed it, but Ohina, goddess of the interior, is probably not the same as Hina, goddess of the moon.

40. Identified by Mary Lynn Zink Vance, "Gauguin's *Poèmes barbares* and the Tahitian Chant of Creation," *Art Journal* 38, Fall 1978, 19. There are, in fact, no more than four skies in the watercolor.

41. See in particular his drawings of such a deity in his Auckland sketchbook in Bronwen Nicholson, *Gauguin and Maori Art* (Birkenhead, New Zealand: Godwit, 1996), 47. Gauguin, of course, had been exposed to Marquesan art before those drawings of 1895.

42. Nicholson, *Gauguin and Maori Art*, 53, 43.

43. To Monfreid, June 1892, in Annie Joly-Segalen, ed., *Lettres de Paul Gauguin à Georges-Daniel de Monfreid* (Paris: Georges Falaize, 1950), 57 (no. 5).

44. Hope Werness, *The Continuum Encyclopedia of Native Art* (London and New York: Continuum, 2000), 131.

45. Moerenhout, *Voyages aux îles*, 2:51

46. Vincent to Theo van Gogh, [ca. September 29, 1888], in *The Letters of Vincent van Gogh, 1886–1890*, facsimile ed. (London: Scholar Press; Amsterdam: Meulenhoff International, 1977), 1: 8/8 (no. 543). See also chapter 6.

47. To Monfreid, November 5, 1892, in Joly-Segalen, *Lettres*, 61 (no. 7).

48. To Monfreid, March 12, 1897, in Joly-Segalen, *Lettres*, 103 (no. 30)

49. Zink Vance ("Gauguin's Polynesian Pantheon," 164) has already linked the symbolism of the dead chief's head with "the immortality of spiritual aspects of the Tahitian traditions, as well as . . . of the creative artist."

50. Ibid., 161–62 (cf. fig. 67).

51. Identified as that of Taaroa, and so interpreted in Zink Vance.

52. In Gauguin's Breton works, as in some of his Tahitian works, figures associated with death wear black or dark colors. See *Grape Harvest in Arles* (fig. 29), *Bonjour Monsieur Gauguin* (fig. 65), and *Manao tupapau* (fig. 110).

53. Moerenhout, *Voyages aux îles*, 1:423; Gauguin, *Ancien culte mahorie*, 10.

54. Moerenhout, *Voyages aux îles*, 1:453; Gauguin, *Ancien culte mahorie*, 18.

55. Moerenhout, *Voyages aux îles* 1:459–60; Gauguin, *Ancien culte mahorie*, 20–22.

56. The work does not seem to be entirely by Gauguin: The outline of the central figure is a little mechanical, and its modeling relatively tentative; it may have been "strengthened" or completed by a restorer. But the male figure appears in a watercolor—not identified by the authors—by Gauguin, according to Wildenstein.

57. Paul Gauguin, *Diverses choses*, 1896–97, Département des arts graphiques, Musée du Louvre (Orsay), Paris, 300, 297–98.

58. Helena P. Blavatsky, "Transmigration of Life Atoms," *The Theosophist*, August 1883, 286–88; reprinted in Boris de Zirkoff, ed., *H. P. Blavatsky: Collected Writings* (Wheaton, Ill., and Madras: Theosophical Publishing House, 1950), 5:109–17.

9. DESIRE OF THE NIGHT

The epigraph is from Paul Sérusier, *ABC de la peinture: Correspondance* (Paris: Librairie Floury, 1950), 60.

1. "Probably written in a moment of bad temper," wrote Maurice Malingue, who first published this text (*La vie prodigieuse de Paul Gauguin* [Paris: Buchet/Chastel, 1987], 268–69). According to Victor Merlhès: "I have no reason to cast doubts upon the authenticity of these lines . . . but, like you, I would have liked to check it [against the original]" (to Henri Dorra, August 29 and September 13, 2001).

2. *Noa Noa* (Le Garrec-Getty), 5, 6.

3. René Huyghe has pointed out, however, that Gauguin had referred several times to Jacques-Antoine Moerenhout as the source of his information in *Noa Noa* (Louvre version); see his "Présentation de l'Ancien culte mahorie: La clef de Noa-Noa," in Paul Gauguin, *Ancien culte mahorie*, facsimile ed., ed. René Huyghe (Paris: La Palme, 1951), 25.

4. Moerenhout pointed out that "one often confused this god with Taaroa," *Voyages aux îles du Grand Océan* (Paris: Maisonneuve, 1959 [1837]), 2:206. See also Gauguin, *Ancien culte mahorie* (facsimile ed.), 39.

5. *Noa Noa* (Le Garrec-Getty), 20a, b.

6. *Noa Noa* (Le Garrec-Getty), 20c. The passages on cosmogony are based on the Polynesian texts in Moerenhout, *Voyages aux îles*, 2:206–10.

7. Ibid., 20b.

8. *Noa Noa* (Louvre ms.), quoted in Richard Brettell et al., eds., *The Art of Paul Gauguin*, exh. cat. (Washington, D.C.: National Gallery of Art; Chicago: Art Institute of Chicago, 1988), 280.

9. To Mette, [ca. December 8, 1892], in Maurice Malingue, ed., *Lettres de Gauguin à sa femme et à ses amis* (Paris: Grasset, 1949), 236 (no. 134). Also see Bengt Danielsson, "Gauguin's Tahitian Titles," *Burlington Magazine*, 109, no. 769 (April 1967), 241.

10. Moerenhout, *Voyages aux îles*, 1:429–36, 454–55, 552; 2:78–79.

11. Ibid.; Gauguin, *Ancien culte mahorie* (facsimile ed.), 20.

12. To Mette, [ca. December 8, 1892], in Malingue, *Lettres*, 237–38 (no. 134).

13. Paul Gauguin *Diverses choses*, 1896–97, Département des arts graphiques, Musée du Louvre (Orsay), Paris, 256.

14. Marcel Giry, "Une source inédite d'un tableau de Gauguin," *Bulletin de la Société de l'histoire de l'art français*, 1970, 181–87.

15. First identified by Siegfried Wichtman, in *Welt Kulturen und moderne Kunst* (Munich: Haus der Kunst, 1972), 455.

16. Bengt Danielsson has proposed changing the second word of the title, painted in red letters in the lower left corner, from "na" to "no." This would alter the translated title to *Talk by the Evil Spirit*. The artist himself used "na" in the catalogue of his 1893 Durand-Ruel exhibition.

17. Ziva Amishai-Maisels first recognized the mask as Gauguin/seducer (*Gauguin's Religious Themes* [New York: Garland, 1985], 199–200).

18. Charles Baudelaire, *Fusées, III* (Paris, 1887).

10. PARIS FURLOUGH

The epigraph is from Paul Sérusier, *ABC de la peinture: Correspondance* (Paris: Librairie Floury, 1950), 60.

1. To Monfreid, November 5, 1892, in Annie Joly-Segalen, ed., *Lettres de Paul Gauguin à Georges-Daniel de Monfreid* (Paris: Georges Falaize, 1950), 142 (no. 52).

2. To the director of the Ecole des Beaux-Arts, June 12, 1892, in Bengt Danielsson, *Gauguin à Tahiti et aux îles marquises* (Papeete: Pacifique, 1975), 107.

3. To Monfreid, [end of December 1892], in Joly-Segalen, *Lettres*, 63 (no. 9).

4. To Monfreid, February 11, 1893, in Joly-Segalen, *Lettres*, 66 (no. 10).

5. To Monfreid, March 14, 1893, in Joly-Segalen, *Lettres*, 66 (no. 11).

6. Merete Bodelsen, *Gauguin's Ceramics* (London: Faber and Faber, 1964), 227.

7. To Monfreid, February 11, 1893, in Joly-Segalen, *Lettres*, 65 (no. 10).

8. To Monfreid, [April–May (?)1893], in Joly-Segalen, *Lettres*, 63 (no. 9). This gift has been ascribed to Mette (Danielsson, *Gauguin à Tahiti*, 132), but Gauguin complained in the same letter against the donor: "What a funny man, this Schuffenecker! He could not take advantage of this opportunity to send money for him to write himself?"

9. *Noa Noa* (Le Garrec-Getty), 35–36.

10. To Monfreid, [September (?) 1893], in Joly-Segalen, *Lettres*, 78 (no. 17).

11. To Monfreid, [October–November 1894], in Joly-Segalen, *Lettres*, 79 (no. 19).

12. Gauguin had referred to it as *Eau délicieuse (Delicious Water)* in the sales catalogue of his work (Hôtel Drouot, Paris, sale of February 18, 1895, no. 23, "Navé navé moé [Eau délicieuse]"). But Gauguin's friend the poet and critic Julien Leclercq, in an article of that year ("Sur la peinture, de Bruxelles à Paris," *Mercure de France*, May 1894, 75), referred to it as *Mystère délicieuse (Delicious Mystery)*, which was accepted by Amishai-Maisels as the better title on the basis that Leclercq must have been well informed. See Ziva Amishai-Maisels, *Gauguin's Religious Themes* (New York: Garland, 1985), 316–17.

13. Amishai-Maisels, *Gauguin's Religious Themes*, 318, pl. 149.

14. Paul Verlaine, "Sagesse VIII," in Y.-G. Le Dantec, ed., *Oeuvres poétiques complètes* (Paris: Gallimard 1962), 281. The link to the text on the watercolor was made by Amishai-Maisels, *Gauguin's Religious Themes*, 318, fig. 149.

15. Once again, if, as is likely, Gauguin was familiar with the trio of works by his grandmother's friend, Alphonse Esquiros, *Les vierges sages, Les vierges folles,* and *Les vierges martyres,* this is an instance in which his own categorization seems to have been influenced by the thinking of that social reformer.

16. Jacques-Antoine Moerenhout, *Voyages aux îles du Grand Océan* (Paris: Maisonneuve, 1959 [1837]), 2:74. Pierre Loti, for his part, made numerous references in *The Marriage of Loti* to a life of *dolce far niente* essentially devoted to pleasant reveries.

17. To Mette, [ca. June 29, 1891], in Maurice Malingue, ed., *Lettres de Gauguin à sa femme et à ses amis* (Paris: Grasset, 1949), 218 (no. 126).

18. Vojtěch Jirat-Wasiutyński refers to it as "a 'self-portrait' and summation of Gauguin's 'cruel enigma' [Gauguin's words], of artistic creation and personal rebirth," in "Paul Gauguin's Self-Portraits and the *Oviri*: The Image of the Artist, Eve and the Fatal Woman," *Art Quarterly*, Spring 1979, 186. He was the first to make the link to the passage in *Le Sourire*, see below (184). The present writer attempted to unravel the symbolic meaning of the statuette in an earlier study (Henri Dorra, "Gauguin et l'émancipation de la femme," in *Gauguin: Actes du Colloque Gauguin, Musée d'Orsay, 11–13 janvier 1989* [Paris: La Documentation française, 1991], 185–99), but the painting's Ovidian implications remain elusive.

19. Naomi Maurer has linked the second to *Oviri* (in *The Pursuit of Spiritual Wisdom: The Thought and Art of Vincent van Gogh and Paul Gauguin* [Teaneck, N.J.: Fairleigh Dickinson University Press; London: Associated University Press, 1998], 162).

20. The progression from *Ea haere ia oe* to *E haere oe i hia* to *Oviri* seems consistent, and one wonders whether Gauguin inadvertently reversed the dates of the two paintings.

21. Christopher Gray, *Sculpture and Ceramics of Paul Gauguin* (Baltimore: Johns Hopkins University Press, 1980 [1963]), 65.

22. John Rewald, "The Genius and the Dealer," *Art News*, May 1959, 30–33. Also Bodelsen, *Ceramics*. 146.

23. Alphonse Constant, *L'émancipation de la femme, ou le testament de la paria* (Paris: Bureau de la direction de la vérité, 1846), 118.

24. Flora Tristan, *Les pérégrinations d'une paria*, 2 vols. (Paris: Bertrand, 1838). Gauguin wrote: "I live there [at Pouldu] like a peasant, calling myself 'savage'" (to Mette, [mid-December 1889], in Malingue, *Lettres*, 160 [no. 82]; Victor Merlhès, ed., *De Bretagne en Polynésie: Paul Gauguin, pages inèdites* [Tahiti: Editions Avant et Après, 1995], 38).

25. To Monfreid, October 1900, in Joly-Segalen, *Lettres*, 165 (no. 68). Many decades later, a bronze cast was placed over his grave in Hiva Hoa, in accordance with his wishes.

26. The painting was included in the Paris *Indépendants* exhibition, March 18–April 27, 1893, too early to have been seen there by Gauguin after his return from Tahiti, but he might have seen it at Vallotton's dealer, Le Barc de Boutteville.

27. Paul Gauguin, *Le Sourire; collection complète en fac-similé*, with notes by L.-J. Bouge (Paris: Maisonneuve, 1952), 18. The first issue is not in Bouge. The Département des arts graphiques of the Musée du Louvre has the only existing copy.

28. Meaning "British" in the native language. Verbal communication by Bengt Danielsson to the author at the 1989 Gauguin colloquium in Paris. Might this be Gauguin's allusion to British common sense, so admired by the French? Here, ironically, with reference to both the ethics and reformist social zeal of the heroine?

29. The text of this fictitious review is from the first issue of *Le Sourire*.

30. Paul Gauguin, *Avant et après* (1903; facsimile ed., Copenhagen: Scripta, 1951), 73–74.

31. Can one read in Gauguin's statement a distant echo of Walter Pater's concept of dedication to art as "burning with a gem-like flame"?

32. Gauguin himself translated the terms as *joyeusetés* (merry-making) in the Durand-Ruel catalogue of the 1893 exhibition, no. 8

33. *Gauguin: Actes du Colloque*, 277.

34. Amishai-Maisels, *Gauguin's Religious Themes*, 379.

35. Moerenhout, *Voyages aux îles*, 1:551.

36. Ibid., 2:36.

37. Ibid., 2:48.

38. *The Day of the God*, according to Bengt Danielsson, "Gauguin's Tahitian Titles," *Burlington Magazine* 109, no. 769 (April 1967), 230; but the "god" is clearly Hina, a goddess, and it is not far-fetched to posit that Gauguin simply did not think of using the feminine form.

39. The figure already appears in this position, together with the head of Tefatou, in *Marahi metua no tehamana (Tehamana Has Many Ancestors)* of 1893 (Art Institute of Chicago).

40. Maurer, *Pursuit of Spiritual Wisdom*, 162.

41. Partly derived from Danielsson, *Gauguin. à Tahiti*, 164–67.

42. To William Molard, [ca. September–November 1894], in Malingue, *Lettres*, 259–61 (no. 152).

43. To Monfreid, April 16, 1896, in Joly-Segalen, *Lettres*, 86 (no. 21).

44. Danielsson, *Gauguin à Tahiti*, 181.

11. THE LAST YEARS IN TAHITI

The epigraph is from Annie Joly-Segalen, ed., *Lettres de Paul Gauguin à Georges-Daniel de Monfreid* (Paris: Georges Falaize, 1950), 142 (no. 52).

1. To Monfreid, [November 1895], in Joly-Segalen, *Lettres*, 83 (no. 20).

2. The quotations in this paragraph and the next are all drawn from the letter to Monfreid of April 1896, in Joly-Segalen, *Lettres*, 85 (no. 21).

3. On the poor condition, see Victor Segalen to Monfreid, November 29, 1903, in *Gauguin dans son dernier décor et autres textes* (Fontfroide: Bibliothèque artistique et littéraire, 1986), 18. For the sale of September 2, 1903, see Henri Jacquier, "Histoire locale: Le dossier de la succession Paul Gauguin," *Bulletin de la Société des études océaniennes*, September 1957, 673–711. On the restoration, see Daniel de Monfreid's manuscript diary, cited in a letter from Annie Joly-Segalen to H. Travers Newton Jr., April 17, 1991.

4. John Rewald, *Gauguin* (New York: Hyperion, 1958), 36.

5. H. Travers Newton Jr.'s report of the conservation treatment of the picture he undertook in 1991. The author is most grateful to Mr. Newton for communicating his report.

6. Old paint, in Newton's estimation, implying that it was applied prior to restoration.

7. Philippe Verdier, ed., "L'esprit moderne et le catholicisme par Paul Gauguin," *Wallraf-Richartz Jahrbuch* (1985), 300–301. The words "promoting that feeling" in this translation mask an error by Gauguin, who had written "poussant l'exclusion de ce sentiment." Aware of the error, Verdier wrote "poussant l'extension."

8. As established by Mary Lynn Zink (Vance), who also interprets this gesture in "Gauguin's *Poèmes barbares* and the Tahitian Chant of Creation," *Art Journal*, Fall 1978, 18–21.

9. Charles Leconte de Lisle, *Poèmes barbares* (Paris: Lemerre, n.d. [1862]), 46–47. In the Louvre manu-

script of *Noa Noa*, Gauguin himself, or Morice, linked "Chant of Creation" with this poet, 134. See Zink, "Gauguin's *Poèmes barbares*," 19.

10. Paul Gauguin, *L'esprit moderne et le catholicisme* (1902, Saint Louis Art Museum), 18, 19, 20, 19, 16, 20; see also Verdier, "L'esprit moderne," 304, 305.

11. Mary Lynn Zink Vance, "Gauguin's Polynesian Pantheon as a Visual Language" (PhD diss., University of California, Santa Barbara, 1983), 148.

12. To Monfreid, February 14, 1897, in Joly-Segalen, *Lettres*, 101 (no. 29).

13. Bengt Danielsson, *Gauguin à Tahiti et aux îles marquises* (Papeete: Pacifique, 1975), 190.

14. To Armand Seguin, January 16, 1897 (Bibliothèque nationale, N.A. Fr.14827), quoted by Ziva Amishai-Maisels, in *Gauguin's Religious Themes* (New York: Garland, 1985), 254–55 n. 97.

15. To Monfreid, February 14, 1897, in Joly-Segalen, *Lettres*, 101 (no. 29).

16. To Monfreid, June, July 13, August 1896, in Joly-Segalen, *Lettres*, 90–92 (nos. 22–24).

17. Richard Brettell et al., eds., *The Art of Paul Gauguin*, exh. cat. (Washington, D.C.: National Gallery of Art; Chicago: Art Institute of Chicago, 1988), 381, 414.

18. To Monfreid, November 1896, in Joly-Segalen, *Lettres*, 96 (no. 26).

19. To Monfreid, March 12, 1897, in Joly-Segalen, *Lettres*, 102 (no. 30).

20. Bengt Danielsson, "Gauguin's Tahitian Titles," *Burlington Magazine* 109 (April 1967), 233.

21. Ibid., 202–8.

22. To Monfreid, February 1898, in Joly-Segalen, *Lettres*, 118 (no. 40).

23. To Morice, [July 1901], in Maurice Malingue, ed., *Lettres de Gauguin à sa femme et à ses amis* (Paris: Grasset, 1949), 300–301 (no. 174).

24. To Monfreid, February 1898, in Joly-Segalen, *Lettres*, 119 (no. 40). This translation from Marla Prather and Charles F. Stuckey, eds., *Gauguin: A Retrospective* (New York: Park Lane, 1989), 276.

25. Referred to in Paul Gauguin, *Avant et après* (1903; facsimile ed., Copenhagen: Scripta, 1951), 95. The present from the bishop must have been J. B. Piolet, S.J., *Les missions catholiques françaises au XIXe siècle*, 6 vols. (Paris: Colin, [1901–] 1903), or at least the first volume thereof.

26. His two works, *The Natural Genesis* (London: Williams and Norgate, 1881), and *The Book of Beginnings*, 2 vols. (London: Williams and Norgate, 1884), are compilations of mostly anagogical reasoning purporting to trace "the natural genesis of mythology and typology" in an endeavor to "write a history or present a panorama of man's mental evolution."

27. Gerald Massey, *The Historical Jesus and the Mythical Christ*, originally chapter 13 of *Natural Genesis*. This work was translated by Jules Soury as *Le Jésus historique* (San Francisco: Lacaze, 1896)—the copy Gauguin must have owned.

28. Gauguin, *L'esprit moderne*, 53, 59; see also Verdier, "L'espirt moderne," 314, 315.

29. To Monfreid, March 1898, in Joly-Segalen, *Lettres*, 120–21 (no. 41).

30. Danielsson, "Gauguin's Tahitian Titles," 230, 232.

31. Monfreid to Gauguin, in Joly-Segalen, *Lettres*, 215 and 170 (no. 72).

32. Zink Vance, "Gauguin's Polynesian Pantheon," 353.

33. Jacques-Antoine Moerenhout, *Voyages aux îles du Grand Océan* (Paris: Maisonneuve, 1959 [1837]), 2:30–51.

34. Bernard Dorival, "Sources of the Art of Gauguin from Java, Egypt and Ancient Greece," *Burlington Magazine* 93 (1951), 122, fig. 26.

35. Danielsson, *Gauguin à Tahiti*, 213–22.

36. Bengt Danielsson and P. O'Reilly, *Gauguin journaliste à Tahiti et ses articles des "Guêpes"* (Paris: Société des océanistes, 1966), 24, 33. Biographical information from Danielsson, *Gauguin à Tahiti*, 226, 225, 229.

37. Danielsson, *Gauguin à Tahiti*, 239–40.

38. To Monfreid, June 1901, in Joly-Segalen, *Lettres*, 177 (no. 75).

39. Danielsson, *Gauguin à Tahiti*, 240–41, 247.

12. HIVA HOA

The epigraph is from Annie Joly-Segalen, ed., *Lettres de Paul Gauguin à Georges-Daniel de Monfreid* (Paris: Georges Falaize, 1950), 177 (no. 75).

1. Bengt Danielsson, *Gauguin à Tahiti et aux îles marquises* (Papeete: Pacifique, 1975), 248–54.

2. The linkage of this theme with death was first made by William M. Kane in "Gauguin's *Le Cheval Blanc:* Sources and Syncretic Meanings," *Burlington Magazine*, July 1966, 352–62.

3. Gauguin to Monfreid, November 1901, and Monfreid to Gauguin, undated, in Joly-Segalen, *Lettres*, 185 (no. 78), 220–21.

4. Remy de Gourmont, "Théâtre à idées," *Mercure de France*, September 15, 1895, 343–45.

5. Danielsson, *Gauguin à Tahiti*, 244–45.

6. Jacques-Antoine Moerenhout, *Voyages aux îles du Grand Océan* (Paris: Maisonneuve, 1959 [1837]), 2:30, 95, 400–408; *Encyclopedia Britannica* (1911 ed.) 26:356–57.

7. Dr. Tautain, administrator of the Marquesas, quoted in *L'Anthropologie* 6 (1895): 64–51.

8. Danielsson, *Gauguin à Tahiti*, 276.

9. Field has already made the connection with Taaroa, *Monotypes*, no. 73, 100.

10. To Morice, [July 1901], in Maurice Malingue, ed., *Lettres de Gauguin à sa femme et à ses amis* (Paris: Grasset, 1949), 301 (no. 174).

11. Paul Gauguin, *Diverses choses*, 1896–97, Département des arts graphiques, Musée du Louvre (Orsay), Paris, 289–91.

12. Danielsson, *Gauguin à Tahiti*, 262, 267, 283; to Monfreid, August 25 and October 1902, in Joly-Segalen, *Lettres*, 190 (no. 82) and 192. See Pierre Borel, "Les derniers jours et la mort de Paul Gauguin," *Pro Arte*, September 1942, 14, on the basis of the account of a colonist, the Swiss Grelet, who knew Gauguin well at the time; Danielsson, *Gauguin. à Tahiti*, 285.

13. To Monfreid, August 25, 1902, in Joly-Segalen, *Lettres*, 190 (no. 82).

14. Monfreid to Gauguin, November 14 and December 11, 1902, in Joly-Segalen, *Lettres*, 231, 233.

15. Danielsson, *Gauguin à Tahiti*, 268–69, 287.

16. Ibid., 282, 288, 292.

17. Moerenhout, *Voyages aux îles*, 1:413; Paul Gauguin, *Ancien culte mahorie*, facsimile ed., ed. René Huyghe (Paris: La Palme, 1951), 52.

SELECTED BIBLIOGRAPHY

PAUL GAUGUIN: SKETCHBOOKS AND WRITINGS

Album Walter. 1888–93. Département des arts graphiques, Musée du Louvre, Paris, RF 30569.

A ma fille Aline, ce cahier est dédié. 1893. Collections Jacques Doucet, Bibliothèque de l'Institut national d'histoire de l'art, Paris, MS 227. Facsimile ed., edited by Victor Merlhès. Paris: Société des amis de la Bibliothèque d'art et d'archéologie; Bordeaux: William Blake, 1989.

Ancien culte mahorie. 1892–93. Département des arts graphiques, Musée du Louvre (Orsay), Paris. RF 10.755. Facsimile ed., edited by René Huyghe. Paris: La Palme, 1951. CD-ROM: Musée d'Orsay, edited by Isabelle Cahn. Paris: Edition RMN, 2003.

Avant et après. 1903. Private collection. Facsimile ed. Copenhagen: Scripta, 1951; Papeete: Editions Avant et Après, 2003.

Carnet de croquis. Sketchbook, ca. 1884–88. Armand Hammer Collection, UCLA Hammer Museum, Los Angeles. Facsimile ed., edited by Raymond Cogniat and John Rewald. New York: Hammer Galleries, 1962.

Carnet de Tahiti (premier voyage, 1891–1893). Edited by Bernard Dorival. Paris: Quatre Chemins, 1984.

De Bretagne en Polynésie: Paul Gauguin, pages inèdites. Edited by Victor Merlhès. Papeete: Editions Avant et Après, 1995.

Diverses choses. 1896–97. Département des arts graphiques, Musée du Louvre (Orsay), Paris. CD-ROM: Musée d'Orsay, edited by Isabelle Cahn. Paris: Edition RMN, 2003.

L'esprit moderne et le catholicisme. 1902. Saint Louis Art Museum. Published in Philippe Verdier, ed., "L'esprit moderne et le catholicisme par Paul Gauguin." *Wallraf-Richartz Jahrbuch* 46 (1985).

"Manuscrit tiré du livre des métiers de Vehbi-Zunbul-Zadé." Winter 1885–86. Département des manuscrits, Bibliothèque nationale, Paris.

"Natures mortes." *Essais d'Art libre* 4, no. 24 (January 1894), 273–75.

Noa Noa. 1893. J. Paul Getty Museum, Los Angeles. Le Garrec-Getty version of *Noa Noa*, edited by Berthe
Sagot-le-Garrec. Paris: Sagot-le-Garrec, 1954. Facsimile ed. Tahiti: Association des amis du Musée
Gauguin; New York: Gauguin and Oceania Foundation, 1987.

Noa Noa, with additions by Charles Morice. 1893–97. Département des arts graphiques, Musée du Louvre
(Orsay), Paris. Facsimile ed., Stockholm: Peterson, 1947. CD-ROM: Musée d'Orsay, edited Isabelle Cahn.
Paris: Edition RMN, 2003.

Racontars de rapin. 1898. Josefowitz Collection. Facsimile ed., edited by Victor Merlhès. Paris: Falaize, 1951;
Mercure de France, 2003.

Le Sourire: Journal méchant. 1899–1900. Facsimile ed., edited by L.-J. Bouge. Paris: Maisonneuve, 1952.

CORRESPONDENCE

Complete Letters of Vincent van Gogh. Edited by Johanna van Gogh-Bonger. 3 vols. Greenwich, Conn.: New
York Graphic Society, 1958.

Correspondance de Paul Gauguin, 1873–1888. Edited by Victor Merlhès. Paris: Fondation Singer-Polignac,
1984.

The Letters of Vincent van Gogh, 1886–1890. Facsimile ed., 2 vols. London: Scholar Press; Amsterdam:
Meulenhoff International, 1977.

Lettres de Gauguin à sa femme et à ses amis. Edited by Maurice Malingue. Paris: Grasset, 1949.

Lettres de Gauguin, Gide, Huysmans, Jammes, Mallarmé, Verahaeren . . . à Odilon Redon. Edited by Roseline
Bacou. 3 vols. Paris: J. Corti, 1960.

Lettres de Paul Gauguin à Georges-Daniel de Monfreid. Edited by Annie Joly-Segalen. Paris: Georges Falaize,
1950.

Paul Gauguin: Lettres à Octave Mirbeau. Edited by Michel Pierre. Reims: A l'Ecart, 1992.

Paul Gauguin: Quarante-cinq lettres à Vincent, Theo, et Jo van Gogh. Edited by Douglas Cooper. Amsterdam:
Collection Rijksmuseum Vincent van Gogh, 1983.

Paul Gauguin et Vincent van Gogh: Lettres retrouvées, sources ignorées. Edited by Victor Merlhès. Tahiti:
Editions Avant et Après, 1989.

Paul Gauguin, Vincent e Theo van Gogh: Sarà sempre amicizia tra noi. Lettere 1887–1890. Edited by Victor
Merlhès. Milan: Archinto, 1991.

Verzamelde Brieven van Vincent van Gogh. Edited by Johanna van Gogh-Bonger and V. W. van Gogh. 4 vols.
Amsterdam: Wereld Bibliothek, 1952–54.

CATALOGUES RAISONNÉS

Bodelsen, Merete. *Gauguin's Ceramics: A Study in the Development of His Art.* London: Faber and Faber, 1964.

Gray, Christopher. *Sculpture and Ceramics of Paul Gauguin.* Baltimore: Johns Hopkins University Press, 1963;
repr. 1980.

Guérin, Marcel. *L'oeuvre gravé de Gauguin*. Paris: H. Floury, 1927.

Wildenstein, Daniel, Sylvie Crussard, and Martine Heudron. *Gauguin: Premier itinéraire d'un sauvage: Catalogue de l'oeuvre peint (1873–1888)*, 2 vols. Paris: Skira, 2001.

———. *Gauguin: A Savage in the Making: Catalogue Raisonné of the Paintings, 1873–1888*, 2 vols. Milan: Skira, Wildenstein Institute, 2002.

Wildenstein, Georges, Daniel Wildenstein, and Robert Cogniat. *Gauguin: Catalogue*. Paris: Beaux-Arts, 1964.

EXHIBITION CATALOGUES AND COLLOQUIA

Anquetil, Marie-Amélie, ed. *Le chemin de Gauguin: Genèse et rayonnement*. Saint-Germain-en-Laye: Musée départemental du Prieuré, 1986.

Béranger-Menand, Brigitte, and Ziva Amishai-Maisels, eds. *Paul Gauguin, von der Bretagne nach Tahiti: Ein Aufbruch zur Moderne*. Graz: Landesmuseum Joanneum; Tulln: Milleniumsberlag, 2000.

Bodelsen, Merete, ed. *Gauguin og van Gogh i København i 1893* (Gauguin and van Gogh in Copenhagen in 1893). Copenhagen: Ordrupgaardsamlingen, 1984.

Brettell, Richard, Françoise Cachin, Claire Frèches-Thory, and Charles F. Stuckey, eds., with Peter Zegers. *The Art of Paul Gauguin*. Washington, D.C.: National Gallery of Art; Chicago: Art Institute of Chicago, 1988.

Davenport, William H., Bengt Danielsson, and Richard S. Field. *Gauguin and Exotic Art*. Philadelphia: University of Pennsylvania Museum, 1969.

Druick, Douglas W., and Peter Kort Zegers, eds., with Britt Salvesen. *Van Gogh and Gauguin: The Studio of the South*. Chicago: Art Institute of Chicago; New York: Thames and Hudson, 2001.

Frèches-Thory, Claire, and Isabelle Cahn, eds. *Gauguin*. Paris: Galeries nationales du Grand Palais/Réunion des Musées Nationaux, 1989.

Gauguin: Actes du Colloque Gauguin, Musée d'Orsay, 11–13 janvier 1989. Paris: La Documentation française, 1991.

Kosinski, Dorothy, ed. *The Artist and the Camera: Degas to Picasso*. Dallas: Dallas Museum of Art, 1999.

Paul Gauguin: Héritage et confrontations: Actes du Colloque du 6, 7, et 8 mars 2003 à l'Université de la Polynésie Française. Papeete: Motu, 2003.

Pickvance, Ronald, ed. *Gauguin*. Martigny, Switzerland: Fondation Pierre Gianadda, 1998.

Welsh-Ovcharov, Bogomila, ed. *Vincent van Gogh and the Birth of Cloisonism*. Toronto: Art Gallery of Ontario, 1981.

Zafran, Eric. *Gauguin's Nirvana: Painters at Le Pouldu, 1889–90*. Hartford, Conn.: Wadsworth Atheneum Museum of Art; New Haven: Yale University Press, 2001.

PRIMARY SOURCES

Antoine, Jules. "Impressionnistes et synthétistes." *Art et Critique*, no. 24, November 9, 1889.

Aurier, Albert. "Les isolés—Vincent van Gogh." *Mercure de France*, January 1890, 24–29.

————. "Le symbolisme en peinture: Paul Gauguin." *Mercure de France*, March 1891, 155–64.

Baudelaire, Charles. *Fusées*. Paris, 1887.

————. "L'oeuvre et la vie d'Eugène Delacroix" (1863). In Baudelaire, *Oeuvres complètes*, edited by Claude Pichois, 2:744. Paris: Gallimard, 1975–76.

————. *Oeuvres complètes*. Edited by Claude Pichois. 2 vols. Paris: Gallimard, 1975–76.

————. *Oeuvres posthumes et correspondances inédites*. Edited by Eugène Crépet. Paris: Quantin, 1887.

————. "Reflexions sur quelques uns de mes contemporains" (1861). In Baudelaire, *Oeuvres complètes*, edited by Claude Pichois, 2:131–32. Paris: Gallimard, 1975–76.

————. "Salon de 1859." In Baudelaire, *Oeuvres complètes*, edited by Claude Pichois, 2:611. Paris: Gallimard, 1975–76.

Blavatsky, Hélène (Helena P.). "La légende du Lotus Bleu." *Le Lotus Bleu* 1, no. 2 (April 7, 1892), 77–85.

————. "Transmigration of Life Atoms." *The Theosophist*, August 1883, 286–88. Reprinted in *H. P. Blavatsky: Collected Writings*, edited by Boris de Zirkoff, 5:109–17. Wheaton, Ill., and Madras: Theosophical Publishing House, 1950.

————. "What Is Theosophy?" *The Theosophist*, October 1879, 1. Reprinted in *H. P. Blavatsky: Collected Writings*, edited by Boris de Zirkoff, 2:97. Wheaton, Ill., and Madras: Theosophical Publishing House, 1950.

Burnouf, Emile. "Le bouddhisme en Occident." *Revue des Deux Mondes*, July 15, 1888, 840–72.

Caithness, Marie Sinclair, Countess of. *Fragments glanés dans la Théosophie occulte d'Orient*. Paris: Gauthier, 1884.

————. *Théosophie universelle: Théosophie bouddhiste*. Paris: Carré, 1886.

Delacroix, Eugène. *Eugène Delacroix: Journal*. Edited by André Joubin. 3 vols. Paris: Plon, 1960.

Delaroche, Achille. "D'un point de vue esthétique." *L'Ermitage*, January 1894, 36–39.

Dupuis Charles. *Origine de toutes les religions, ou Religion universelle*. 7 vols. in 12. Paris: Agasse, 1795.

Esquiros, Alphonse. *Les vierges folles*. Paris: Le Gallois, 1840.

————. *Les vierges martyres*. Paris: Delavigne, 1842.

————. *Les vierges sages*. Paris: Delavigne, 1841.

Fénéon, Félix. "Calendrier de février." *Revue Indépendante*, February 1888. Reprinted in Fénéon, *Oeuvres plus que complètes*, edited by Joan Halperin, 1:95. Geneva: Droz, 1970.

————. "Les impressionnistes en 1886." *La Vogue*, June 13–20, 1886.

————. *Oeuvres plus que complètes*. Edited by Joan Halperin. 2 vols. Geneva: Droz, 1970.

Flammarion, Camille. *Le monde avant la création de l'homme . . .* Paris: Marpon/Flammarion, 1886.

Gourmont, Remy de. "Théâtre à idées." *Mercure de France*, September 15, 1895, 343–45.

Hartrick, Archibald Standish. *A Painter's Pilgrimage through Fifty Years*. Cambridge: Cambridge University Press, 1939.

Hawkesworth, John. *An Account of the Voyages Undertaken by Order of His Present Majesty for Making Discoveries in the Southern Hemisphere*. 3 vols. London: Strathan and Cadell, 1773.

Hegel, Georg W. F. *Aesthetics: Lectures on Fine Art* (*Ästhetik*, 1830). Translated by T. M. Knox. 2 vols. Oxford: Clarendon, 1975.

Huret, Jules. "Paul Gauguin devant ses tableaux." *L'Echo de Paris*, February 23, 1891, 2.

J.L. (M.S.T.). "Le maillet du Maître: Aperçus sur la philosophie scandinave." *Le Lotus Bleu* 2, no. 7 (July 1890), 30–40.

Larousse, Pierre. *Grand dictionnaire universel du XIXème siècle*. 17 vols. Paris: Larousse, 1890.

Leconte de Lisle, Charles. *Poèmes barbares*. Paris: Lemerre, n.d. (1862).

Loti, Pierre. *Le mariage de Loti-Rarahu*. Paris: Calmann Lévy, 1891.

Lugné-Poë, Aurélien-François-Marie. *Le sot du tremplin: Souvenirs et impressions du théâtre*. 8th ed. Paris: Gallimard, 1931.

Mallarmé, Stéphane, trans. *Edgar Allan Poe, Le Corbeau (The Raven), poëme; traduction française de Stéphane Mallarmé, avec illustrations par Edouard Manet*. Paris: Lesclide, 1875.

Mariateguy Maria, duchesse de Pomar. *Théosophie universelle: La théosophie chrétienne*. Paris: Carré, 1886.

Massey, Gerald. *The Book of Beginnings*, 2 vols. 1: *The Book of Beginnings; 2: Natural Genesis, or, Second part of a* Book of Beginnings, *containing an attempt to recover and reconstitute the lost origins of the myths and mysteries, types and symbols, religion and language, with Egypt for the mouthpiece and Africa as the birthplace*. London: Williams and Norgate, 1883.

———. *The Historical Jesus and Mythical Christ*. ca. 1880. Translated by Jules Soury as *Le Jésus historique*. San Francisco: Lacaze, 1896.

Mellerio, André. *Le movement idéaliste en peinture*. Paris: Floury, 1896.

Mirbeau Octave. "Gauguin." *L'Echo de Paris*, February 16, 1891, and *Le Figaro*, February 18, 1891.

Moerenhout, Jacques-Antoine. *Voyages aux îles du Grand Océan*. 2 vols. in 1. Paris: Maisonneuve, 1959 (1st ed. 1837).

Moréas, Jean. "Le symbolisme." *Supplément littéraire du Figaro*, September 1886, 150.

Olcott, Henry S. *Le bouddhisme selon le canon de l'Eglise du Sud et sous forme de catéchisme*. Paris: Publications Théosophiques, 1905 (1881).

Oldenberg, Hermann. *Buddha: sein Leben, sein Lehre, sien Gemeinde*. Berlin: Hertz, 1881. English ed., trans. William Hoey, *Buddha: His Life, His Doctrine, His Order*. London: Williams and Norgate, 1882.

Papus (Gérard Encausse), *Traité élémentaire de science occulte mettant chacun à même de comprendre et d'expliquer les théories et les symboles employés, par les anciens, par les alchimistes, les astrologues, les E de la V, les Kabbalistes. . . .* Paris: Ollendorff, 1903 (1888).

Parent-Duchâtelet J. B. *De la prostitution dans la ville de Paris*. 2 vols. Paris: Baillière, 1857.

Piolet J. B., S.J. *Les missions catholiques françaises au XIXe siècle*. 6 vols. Paris: Colin, 1901–3.

Proudhon, P.-J. *Correspondance de P.-J. Proudhon*. 14 vols. Paris: Lacroix, 1875.

Rachilde (Marguerite Eymery). *Madame la mort*. Paris: Savin, 1891. Edited and translated by Kiki Gounaridou and Frazer Lively as *Rachilde: Madame La Mort*. Baltimore: Johns Hopkins University Press, 1998.

Renan, Ernest. "Le règne de Salomon. " *Revue des Deux Mondes*, August 1888, 536–70.

Ruskin, John. "The Relation of National Ethics to National Arts" (1867). In *The Complete Works of John Ruskin*, edited by E. T. Cook and Alexander Wedderburn, vol. 19 of 39. London: George Allen, 1894.

Ryan, Michael. *Prostitution in London, with a Comparative View of That of Paris and New York*. London and Paris: Baillière, 1839.

Sand, George (Amandine-Aurore-Lucile Dupin, Baroness Dudevant). *Correspondance*, edited by Georges Lubin. 26 vols. Paris: Garnier, 1964–95.

Sérusier, Paul. *ABC de la peinture: Correspondance*. Paris: Librairie Floury, 1950.

Sinnett, Alfred Percy. *Le bouddhisme esotérique ou Positivisme hindou*. Paris: Librairie de l'Art indépendant/Le Lotus Bleu, 1890.

Spencer, Herbert. *Principles of Psychology*. 2 vols. in 3. New York and London: Appleton, 1882.

Thoré, Théophile. "Artistes contemporains: Eugène Delacroix (suite)." *Le Siècle*, February 26, 1837.

Tristan, Flora. *Pérégrinations d'une paria, 1833–1834*. 2 vols. Paris: Bertrand, 1838.

———. *Promenades dans Londres*. Paris: Maspero, 1978 (1840).

Uzanne, Octave. "Baudelaire inédit." *Le Figaro*. August 30, 1880, 1–2.

Verlaine, Paul. *Oeuvres poétiques complètes*. Edited by Y.-G. Le Dantec. Paris: Gallimard 1962.

Zimmermann, W. F. A., and C. G. W. Vollmer. *Der Mensch, die Räthsel und Wunder seiner Natur* [. . .] Berlin: Hempel, 1864.

SECONDARY SOURCES

Amishai-Maisels, Ziva. "Die Dualität in den Selbsportraits von Paul Gauguin." In *Paul Gauguin, von der Bretagne nach Tahiti: Ein Aufbruch zur Moderne*, exh. cat. Graz: Landesmuseum Joanneum; Tulln: Milleniumsberlag, 2000, 47–60.

———. *Gauguin's Religious Themes*. New York: Garland, 1985.

Andersen, Wayne V. "Gauguin and a Peruvian Mummy." *Burlington Magazine*, April 1967, 238–42.

———. *Gauguin's Paradise Lost*. New York: Viking, 1971.

Bailey, Martin. "Van Gogh's Portrait of Gauguin," *Apollo*, July 1996, 51–54.

Bodelsen, Merete. *Gauguin Ceramics in Danish Collections*. Copenhagen: Munksgaard, 1960.

———. "Gauguin the Collector." *Burlington Magazine*, September 1970, 590–615.

———. "Paul Gauguin som Kunsthåndvarker." *Kunst og Kultur* 47 (1964), 141–56.

Borel, Pierre. "Les derniers jours et la mort de Paul Gauguin." *Pro Arte*, September 1942.

Bouillon, Jean-Paul. "Denis, Taine, Spencer: Les origines du mouvement Nabi." *Bulletin de la Société de l'histoire de l'art français*, 1999, 291–306.

Chassé, Charles. *Gauguin et le groupe de Pont-Aven: Documents inédits*. Paris: Floury, 1921.

———. *Gauguin et son temps*. Paris: Bibliothèque des arts, 1955.

Childs, Elizabeth C. "Paradise Redux: Gauguin, Photography, and Fin-de-siècle Tahiti." In *The Artist and the Camera: Degas to Picasso*, exh. cat., edited by Dorothy Kosinski. Dallas: Dallas Museum of Art, 1999, 116–41.

Danielsson, Bengt. *Gauguin à Tahiti et aux îles marquises*. Papeete: Pacifique, 1975.

———. "Gauguin's Tahitian Titles," *Burlington Magazine* 109 (April 1967), 228–33.

Dauphite, Maïotte. *Paul Gauguin a rencontré l'Inde en 1887 à la Martinique*. Saint-Pierre: Centre d'art Mémorial Musée Paul Gauguin, 1995.

Deckker, Paul de. *Jacques-Antoine Morenhout (1797–1879)*. Tahiti: Au Vent des Iles, 1997.

Delouche, Denise. *Gauguin et la Bretagne*. Rennes: Apogée, 1996.

———. "Gauguin et le thème de la lutte." In *Gauguin: Actes du Colloque Gauguin, Musée d'Orsay, 11–13 janvier 1989*. Paris: La Documentation française, 1989.

Dorival, Bernard. "Sources of the Art of Gauguin from Java, Egypt and Ancient Greece." *Burlington Magazine* 93 (1951), 118–23.

Dorra, Henri. *Art in Perspective: A Brief History*. New York: Harcourt Brace Jovanovich, 1973.

———. "Charles Henry's 'Scientific' Aesthetics." *Gazette des Beaux-Arts*, December 1969, 345–56.

———. "Ein all-zu-menschliches Paradies: Gauguins Symbolismus in Tahiti." In *Paul Gauguin, von der Bretagne nach Tahiti: Ein Aufbruch zur Moderne*, exh. cat. Graz: Landesmuseum Joanneum; Tulln: Milleniumsberlag, 2000, 138–47.

———. "The First Eves in Gauguin's Eden." *Gazette des Beaux-Arts*, March 1953, 189–202.

———. "Gauguin et l'émancipation de la femme." In *Gauguin: Actes du Colloque Gauguin, Musée d'Orsay, 11–13 janvier 1989*. Paris: La Documentation française, 1991, 185–89.

———. "Gauguin's Dramatic Arles Themes." *Art Journal*, Fall 1978, 12–17.

———. "Gauguin's Unsympathetic Observers." *Gazette des Beaux-Arts*, December 1970, 367–72.

———. "Munch, Gauguin and the *Norvegian* Painters in Paris." *Gazette des Beaux-Arts*, November 1976, 175–80.

———. "Nazarene Symbolism and the Emblem Books." *Emblematica*, Fall 1988, 283–92.

———. "Le texte 'Wagner' de Gauguin." *Bulletin de la Société de l'histoire de l'art français*, 1984, 281–88.

———. "Valenciennes's Theories: From Newton, Buffon, and Diderot to Corot, Chevreul, Delacroix, Monet, and Seurat." *Gazette des Beaux-Arts*, November 1994, 185–94.

———. "Von bretonischen Spässen zum grossen Dilemma der Menschheit." In *Paul Gauguin, von der Bretagne nach Tahiti: Ein Aufbruch zur Moderne*, exh. cat. Graz: Landesmuseum Joanneum; Tulln: Milleniumsberlag, 2000, 78–87.

Dorra, Henri, ed. *Symbolist Art Theories: A Critical Anthology*. Berkeley and Los Angeles: University of California Press, 1994.

Dorra, Henri, and Sheila Askin. "Seurat's Japonisme." *Gazette des Beaux-Arts*, February 1969, 81–94.

Dorra, Henri, and John Rewald. *Seurat: L'œuvre peint, biographie et catalogue critique*. Paris: Beaux-Arts, 1959.

Druick, Douglas W., and Peter Kort Zegers. "Le kampong et la pagode: Gauguin à l'exposition universelle de 1889." In *Gauguin: Actes du Colloque Gauguin, Musée d'Orsay, 11–13 janvier 1989*. Paris: La Documentation française, 1991, 109–31.

Faille, J.-B. de la. *The Works of Vincent van Gogh*. Paris: Raynal, 1970.

Field, Richard S. *Paul Gauguin: The Paintings of the First Voyage to Tahiti*. New York: Garland, 1977.

Gauguin, Pola. *Paul Gauguin mon père*. Paris: Editions de France, 1938.

Giry, Marcel. "Une source inédite d'un tableau de Gauguin." *Bulletin de la Société de l'histoire de l'art français*, 1970, 181–87.

Guyot, René, and Albert Lafay. "Qui était Marie Henry?" In *Le chemin de Gauguin: Genèse et rayonnement*, exh. cat., edited by Marie-Amélie Anquetil. Saint-Germain-en-Laye: Musée départemental du Prieuré, 1986, 114–15, 127.

Herbert, Virginia E. *The Artist and Social Reform: France and Belgium, 1885–1898*. New Haven: Yale University Press, 1961.

Homer, William Innes. *Seurat and the Science of Painting*. Cambridge, Mass.: MIT Press, 1964.

Jacquier, Henri. "Histoire locale: Le dossier de la succession Paul Gauguin." *Bulletin de la Société des études océaniennes*, September 1957, 673–711.

Jirat-Wasiutyński, Vojtěch. *Gauguin in the Context of Symbolism*. New York: Garland, 1978.

———. "Paul Gauguin's Self-Portraits and the *Oviri*: The Image of the Artist, Eve and the Fatal Woman." *Art Quarterly* n.s. 2, no. 2 (Spring 1979), 172–90.

———. "Paul Gauguin's *Self-Portrait with Halo and Snake:* The Artist as Initiate and Magus." *Art Journal* 46, no. 1 (Spring 1987), 22–28.

Jore, Léonce. *Un belge au service de la France dans l'Océan Pacifique*. Paris: Maisonneuve, 1944.

Kane, William M. "Gauguin's *Le Cheval Blanc:* Sources and Syncretic Meanings." *Burlington Magazine*, July 1966, 352–62.

Leprohon, Jean. *Flora Tristan*. Paris: Corymbe, 1979.

Malingue, Maurice. *La vie prodigieuse de Paul Gauguin*. Paris: Buchet-Chastel, 1987.

Marks-Vandenbroucke, Ursula. "Gauguin—Ses origines et sa formation." *Gazette des Beaux-Arts*, January–April 1957, 9–62.

Maurer, Naomi Margolis. *The Pursuit of Spiritual Wisdom: The Thought and Art of Vincent van Gogh and Paul Gauguin*. Teaneck, N.J.: Fairleigh Dickinson University Press; London: Associated University Press, 1998.

Memorial de l'exposition Eugène Delacroix, Centenaire. Paris: Musée du Louvre, 1963.

Merlhès, Victor. "Le 'Cahier pour Aline,' Histoire et signification." In Paul Gauguin, *A ma fille Aline, ce cahier est dédié*, facsimile ed. of 1893 manuscript, edited by Victor Merlhès. Paris: Société des amis de la Bibliothèque d'art et d'archéologie; Bordeaux: William Blake, 1989, 14–25.

———. "Labor: Painters at Play." In *Gauguin's* Nirvana: *Painters at Le Pouldu, 1889–90*, exh. cat., edited by Eric Zafran. Hartford, Conn.: Wadsworth Atheneum Museum of Art; New Haven, Conn.: Yale University Press, 2001, 81–101.

Michaud, Stéphane. *Flora Tristan: La paria et son rêve: Correspondance*. Fontenay/Saint-Cloud: ENS, 1996.

Morice, Charles. *Paul Gauguin*. Paris: Floury, 1920.

Nicholson, Bronwen. *Gauguin and Maori Art*. Birkenhead, New Zealand: Godwit, 1996.

Nochlin, Linda. "Gustave Courbet's *Meeting:* A Portrait of the Artist as a Wandering Jew." *Art Bulletin*, September 1967, 5–22.

Rewald, John. *Gauguin*. New York: Hyperion, 1958.

———. *Gauguin Drawings*. New York: Bitner/Yoseloff, 1958.

———. "The Genius and the Dealer." *Art News*, May 1959, 30–33.

———. *The History of Impressionism*. New York: Museum of Modern Art, 1973.

———. *Post-Impressionism: From Van Gogh to Gauguin*. 3rd ed. New York: Museum of Modern Art, 1978.

Roskill, Mark. *Van Gogh, Gauguin, and the Impressionist Circle*. Greenwich, Conn.: New York Graphic Society, 1970.

Rotonchamp, Jean (Jean Brouillon) de. *Paul Gauguin, 1848–1903*. Paris: G. Cres, 1925 (1906).

Segalen, Victor. *Gauguin dans son dernier décor et autres textes de Tahiti*. Fontefroide: Bibliothèque artistique et littéraire, 1986.

Stuckey, Charles F. "L'énigme des pieds coupés." In *Gauguin: Actes du Colloque Gauguin, Musée d'Orsay, 11–13 janvier 1989*. Paris: La Documentation française, 1991, 51–58.

Svenæus, Gösta. "Gauguin og van Gogh." *Billedkunst* (Denmark: Hvidovre) 2 (1967).

Sweetman, David. *Paul Gauguin: A Complete Life*. London: Hodder and Stoughton, 1995.

Teilhet-Fisk, Jehanne. "Paradise Revised: An Interpretation of Gauguin's Polynesian Symbolism." PhD diss., University of California, Los Angeles, 1995.

Thirion, Yvonne: "L'influence de l'estampe japonaise dans l'œuvre de Gauguin." *Gazette des Beaux-Arts*, January–April 1956, 95–114.

Vance, Mary Lynn Zink. "Gauguin's *Poèmes barbares* and the Tahitian Chant of Creation. " *Art Journal* 38 (Fall 1978), 18–21.

———. "Gauguin's Polynesian Pantheon as a Visual Language." PhD diss., University of California, Santa Barbara, 1983.

Venturi, Lionello. *Cézanne*. New York: Skira/Rizzoli, 1978.

Welsh, Robert P. "Gauguin et l'auberge de Marie Henry au Pouldu." *Revue de l'Art*, no. 86 (1989), 35–43.

Welsh-Ovcharov, Bogomila. "Paul Gauguin's Third Visit to Brittany, June 1889–November 1890." In *Gauguin's Nirvana: Painters at Le Pouldu, 1889–90*, exh. cat., edited by Eric M. Zafran. Hartford, Conn.: Wadsworth Atheneum Museum of Art; New Haven: Yale University Press, 2001, 15–59.

Werner, Alfred. *Paul Gauguin*. New York: McGraw-Hill, 1967.

Werness, Hope. *The Continuum Encyclopedia of Native Art*. London and New York: Continuum, 2000.

Wichtman, Siegfried. *Welt Kulturen und moderne Kunst*. Munich: Haus der Kunst, 1972.

Zafran, Eric M. "Searching for Nirvana." In *Gauguin's Nirvana: Painters at Le Pouldu, 1889–90*, exh. cat., edited by Eric M. Zafran. Hartford, Conn.: Wadsworth Atheneum Museum of Art; New Haven: Yale University Press, 2001, 103–27.

ILLUSTRATIONS

All artworks are by Paul Gauguin unless otherwise specified. Descriptions of some images are followed by letter/number combinations. These refer to the following catalogues raisonnés:

B Bodelsen, Merete, *Gauguin's Ceramics: A Study in the Development of His Art* (London: Faber and Faber, 1964).

G Gray, Christopher, *Sculpture and Ceramics of Paul Gauguin* (Baltimore: Johns Hopkins University Press, 1963; repr. 1980).

W Wildenstein, Daniel, Sylvie Curssard, and Martine Heudron, *Gauguin, A Savage in the Making: Catalogue Raisonné of the Paintings, 1873–1888*, 2 vols. (Milan: Skira, Wildenstein Institute, 2002).

1. Flora Tristan y Moscoso, grandmother of the artist. Lithograph. Bibliothèque Marguerite Durand, Paris/Archives Charmet/Bridgeman Art Library. *4*

2. Aline Gauguin (Aline Chazal-Tristan), mother of the artist. Lithograph. Bibliothèque Marguerite Durand, Paris/Archives Charmet/Bridgeman Art Library. *8*

3. *The Little One Is Dreaming*, ca. 1881. Oil on canvas, 59.5 × 73.5 cm (23⁷⁄₁₆ × 29 in.). Ordrupgaard, Copenhagen. Photo: Pernille Klemp. W75. *23*

4. *Sleeping Child*, or *Clovis Asleep*, 1884. Oil on canvas, 46 × 55.5 cm (18 × 21⅛ in.). Samuel Josefowitz Collection, Lausanne, Switzerland. Photo: Erich Lessing/Art Resource, New York. W151. *24*

5. *Still Life in an Interior, Copenhagen*, 1885. Oil on canvas. Private collection, Switzerland. W164. *24*

6. *Jewelry Casket with Carved Reliefs of Dancers*, 1884. Pear wood, leather, string, iron, and inlaid *netsuke*, 22 × 14.8 × 51.5 cm (8⅛ × 5⅞ × 20¼ in.). Side, top, side, and interior. Present location unknown. G8. *30*

7. Edgar Degas, *Ballet Rehearsal on the Stage*, 1874. Oil on canvas. Musée d'Orsay, Paris/Giraudon/Bridgeman Art Library. *31*

26. *Leda Vase*, 1887–88. Unglazed stoneware, decorated slip, 20 cm (7⅞ in.) high. Present location unknown. B34, G63. *73*

27. *Design for a Plate—Leda and the Swan*, 1889. Lithograph (zinc), watercolor, and gouache on paper, 30.1 × 25.7 cm (11⅞ × 10⅛ in.). Private collection/Christie's Images/Bridgeman Art Library. *74*

28. *Design for a Carved Bookcase*, 1888. Graphite, crayon, watercolor, and gouache, 43.5 × 47.5 cm (17⅛ × 18¹¹⁄₁₆ in.). Private collection, Papeete. Photo courtesy of Sotheby's Picture Library. *75*

29. *Grape Harvest in Arles*, or *Human Misery*, second week of November 1888. Oil on canvas, 73 × 92 cm (28¾ × 36¼ in.). Ordrupgaard, Copenhagen/Bridgeman Art Library. W304. *78*

30. *Woman in the Hay with Pigs*, or *The Heat of the Day*, third week of November 1888. Oil on canvas, 73 × 92 cm (28¾ × 36¼ in.). Private collection/Peter Willi/Bridgeman Art Library. W301. *79*

31. Vincent van Gogh, *Sorrow*, 1882. Lithograph on tinted paper, 38.5 × 29 cm. (15⅛ × 11⁷⁄₁₆ in.). Rijksmuseum Vincent van Gogh, Amsterdam (Vincent van Gogh Foundation). *82*

32. Félicien Rops, *In the Ardenne Country—Now, That Daft Marie-Josèphe Thinks of a Child Who Has Been Buried*, 1857. From Erastène Ramiro, *Félicien Rops* (Paris, 1905). Collections Jacques Doucet, Institut national d'histoire de l'art, Paris. *82*

33. *Human Miseries*, 1889. Zincograph, 28.5 × 23 cm (11¼ × 9 in.). Collections Jacques Doucet, Institut national d'histoire de l'art, Paris. *86*

34. *Village Drama*, 1894. Oil on canvas, 73 × 92 cm (28¾ × 36¼ in.). Formerly The Art Institute of Chicago. Present location unknown. *87*

35. *Pas écouter li . . . li . . . menteur (Don't Listen to the Liar . . .)*, or *Eve*, early June 1889. Watercolor and pastel on paper, 33.5 × 31 cm (13¼ × 12¼ in.). Collection of the McNay Art Museum, San Antonio, Texas, Bequest of Marion Koogler McNay. W333. *88*

36. Peruvian mummy, pre-Columbian period. Musée du quai Branly, Dépôt du Musée de l'Homme, Paris. Photo: all rights reserved. *89*

37. *Soyez amoureuses vous serez heureuses (Be in Love and You Will Be Happy)*, 1889. Carved and painted linden wood, 95 × 72 × 6.4 cm (37⅜ × 28⅜ × 2½ in.). Museum of Fine Arts, Boston, Arthur Tracy Cabot Fund. Photo © 2007 Museum of Fine Arts, Boston. G76. *91*

38. *Life and Death*, 1889. Oil on canvas, 92 × 73 cm (36¼ × 28¾ in.). Mahmoud Khalil Museum, Cairo. Photo: Erich Lessing/Art Resource, New York. W335. *94*

39. *Aux roches noires II (At the Black Rocks)*, in or after 1895. Woodcut, image: 10.1 × 18.4 cm (4 × 7¼ in.); sheet 13.1 × 23.8 cm (5³⁄₁₆ × 9⅜ in.). Similar (reversed) image used for the Volpini exhibition catalogue frontispiece, ca. May–June 1889. Rosenwald Collection, National Gallery of Art, Washington, D.C. Image © 2007 Board of Trustees, National Gallery of Art, Washington. *95*

40. *Female Nude with Sunflowers*, or *Caribbean Woman*, late 1889. Oil on panel, 64 × 54 cm (25¼ × 21¼ in.). Private collection. W330. *96*

41. *The Tathagata Meets an Ajivaka Monk on the Benares Road* and *Merchant Maitrakanyaka Greeted by Nymphs*, eighth century C.E. Sandstone relief from the Temple of Borobudur, Java. Albumen photograph, ca. 1889, private collection, Tahiti. *98*

42. *The Assault of Mara* and *Scene from the Bhallatiya-Jataka*, eighth century C.E. Sandstone relief from the Temple of Borobudur, Java. Albumen photograph, ca. 1889, private collection, Tahiti. *98*

61. *Breton Fantasy*, 1889. Crayon on paper. Musée des Beaux-Arts, Reims. *135*

62. *Self-Portrait with "The Yellow Christ,"* late 1889 to early 1890. Oil on canvas, 38 × 46 cm (15 × 18⅛ in.). Musée d'Orsay, Paris/Lauros/Giraudon/Bridgeman Art Library. W324. *136*

63. *Black Venus*, 1889. Glazed stoneware. Sands Point Park and Preserve, Port Washington, New York. B49, G91. *138*

64. *The Loss of Virginity*, late 1890 to early 1891. Oil on canvas, 89.5 × 130.2 cm (35¼ × 51¼ in.). Chrysler Museum, Norfolk, Virginia/Bridgeman Art Library. W412. *141*

65. *Bonjour Monsieur Gauguin*, 1889. Oil on canvas, 113 × 92 cm (44½ × 36¼ in.). Christie's Images, London/Bridgeman Art Library. W321. *143*

66. Gustave Courbet, *Bonjour Monsieur Courbet*, or *La Rencontre (The Meeting)*, 1854. Oil on canvas, 129 × 149 cm (50¾ × 58¾ in.). Musée Fabre, Montpellier/Giraudon/Bridgeman Art Library. *143*

67. *Exotic Eve*, 1890. Gouache on millboard transferred to fabric, 43 × 25 cm (17 × 9⅞ in.). Private collection. W389. *147*

68. *Madame la Mort I*, early 1891. Charcoal on paper, 23.9 × 29.3 cm (9⅜ × 11½ in.). Musée du Louvre, Paris. Photo: Réunion des Musées Nationaux/Art Resource, New York. Photographed by C. Jean. *150*

69. *Madame la Mort II*, early 1891. Charcoal and highlights of gray wash on paper, 33.5 × 23 cm (13¼ × 9¹⁄₁₆ in.). Musée du Louvre, Paris. Photo: Réunion des Musées Nationaux/Art Resource, New York. Photographed by Gérard Blot. *152*

70. *Portrait of the Artist with the Idol*, before late March 1891. Oil on canvas, 43.8 × 32.7 cm (17¼ × 12⅞ in.). Collection of the McNay Art Museum, San Antonio, Texas, Bequest of Marion Koogler McNay. *153*

71. Charles Bird King, *Ma-Ka-Tai-Me-She-Kia-Kiah (Black Hawk, a Sauk Brave)*, nineteenth century. Color lithograph from *The Indian Tribes of North America*, vol. 2, by Thomas L. McKenney and James Hall. Photo: Private collection/Bridgeman Art Library. *154*

72. Maori *taiaha*, redrawn after a diagram in C. S. Curtis, "Maori Taiaha," *Journal of the Polynesian Society*, December 1965, 489. *155*

73. *Hina: Goddess of the Moon*, 1892. Carved tamanu wood, 40 cm (15¾ in.) high. Present location unknown. G97. *156*

74. *Portrait of Stéphane Mallarmé*, January 1891. Etching, 18.3 × 14.3 cm (7¼ × 5⅝ in.). Collections Jacques Doucet, Institut national d'histoire de l'art, Paris. *158*

75. *Ia orana Maria (Hail Mary)*, 1891–92. Oil on canvas, 113.7 × 87.6 cm (44¾ × 34½ in.). The Metropolitan Museum of Art, New York, Bequest of Sam A. Lewisohn, 1951 (51.112.2). Photo © 1983 The Metropolitan Museum of Art. W428. *168*

76. *Upaupa (Tahitian Dance)*, 1891. Oil on canvas, 73 × 92 cm (28¾ × 36¼ in.). Israel Museum, Jerusalem/Bridgeman Art Library. W433. *169*

77. Preparatory drawing for *Upaupa*, 1891. Graphite on paper. Private collection. *170*

78. *Mahna [Mahana] no varua ino (The Evil Spirit Speaks)*, 1893–94. Woodcut, from the endgrain of a boxwood block, in black on ivory China paper, image: 20.3 × 35.4 cm (8 × 14 in.), sheet: 26.7 × 42 cm (10½ × 16½ in.). The Art Institute of Chicago, Gift of the Print and Drawing Club. Photo © The Art Institute of Chicago. Photographed by Greg Williams. *171*

79. *Te faruru (Here We Make Love)*, 1893–94. Woodcut printed from endgrain boxwood in ochre

and black on japan paper stained prior to printing with various hand-applied and transferred watercolors and waxy media, 35.6 × 20.3 cm (14 × 8 in.). Clarence Buckingham Collection, The Art Institute of Chicago. Photo © The Art Institute of Chicago. Photographed by Greg Williams. *171*

80. *Te raau rahi (The Big Tree)*, 1891. Oil on canvas, 74 × 92.8 cm (29⅛ × 36½ in.). © The Cleveland Museum of Art, Gift of Barbara Ginn Griesinger, 1975.263. W437. *172*

81. *Te fare Maorie (The Native Hut)*, 1891. Oil on canvas, 73.34 × 91.44 cm (28⅞ × 36 in.). Present location unknown. W436. *173*

82. *Aha oe feii? (Are You Jealous?)*, 1892. Oil on canvas, 66 × 89 cm (26 × 35 in.). Pushkin Museum of Fine Arts, Moscow/Giraudon/Bridgeman Art Library. W461. *178*

83. Javanese shadow puppet. Painted animal hide. Private collection, by permission. *179*

84. *Auti te pape (Playing in the Water)*, or *Women at the River*, winter 1893–94. Woodcut on boxwood with touches of gouache. Collections Jacques Doucet, Institut national d'histoire de l'art, Paris. *180*

85. *Nafea faa ipoipo? (When Will You Marry?)*, 1892. Oil on canvas, 105 × 77.5 cm (41⅜ × 30½ in.). Basel, Switzerland, Rudolph Staechelin Family Foundation, Basel, Switzerland/Bridgeman Art Library. W454. *181*

86. *Te nave nave fenua (Delightful Land)*, 1892. Oil on canvas, 91 × 72 cm (35⅞ × 28⅜ in.). Ohara Museum of Art, Kurashiki, Japan. W455. *182*

87. Odilon Redon, *Cul-de-lampe (Endpiece)*, 1890. Lithograph, no. IX in a portfolio of prints inspired by Baudelaire's *Fleurs du Mal (Flowers of Evil)*. Rosenwald Collection, National Gallery of Art, Washington, D.C. Image © 2007 Board of Trustees, National Gallery of Art, Washington. *184*

88. "Dialogue between Tefatou and Hina," from the album *Ancien culte mahorie*, folio 7 (recto), 1892–93. Watercolor on paper. Musée du Louvre, Paris. Photo: Réunion des Musées Nationaux/Art Resource, New York. Photographed by Hervé Lewandowski. *186*

89. Top of a Marquesan oar. Carved wood, line drawing after the original in the British Museum, London. *187*

90. "Dialogue between Tefatou and Hina," from the album *Ancien culte mahorie*, folio 4 (recto), 1892–93. Watercolor and ink on paper. Musée du Louvre, Paris. Photo: Réunion des Musées Nationaux/Art Resource, New York. Photographed by Hervé Lewandowski. *189*

91. *Two Marquesan Women and Design of an Ear Ornament*, 1892. Reed pen and metal pen and brown ink and graphite on velum, 24 × 31.8 cm (9½ × 12½ in.). The David Adler Collection, The Art Institute of Chicago. Photo © The Art Institute of Chicago. *190*

92. *Hina and Tefatou Cylinder (recto and verso)*, ca. 1892. Carved tamanu wood, 32.7 × 14.2 cm (12⅞ × 5⅛ in.). Art Gallery of Ontario, Toronto, Gift from the Volunteer Committee Fund, 1980. Photo: Carlo Catenazzi. G96. *191*

93. *Pape moe (Mysterious Water)*, 1893. Oil on canvas, 99 × 75 cm (39 × 29½ in.). Private collection. Photo courtesy Pierre Gianadda Foundation, Martigny, Switzerland. W498. *192*

94. Auguste Rodin, *The Awakening*, 1889. Bronze, 52.7 × 22.5 × 30.5 cm (20¾ × 8⅞ × 12 in.). Musée Rodin, Paris. Photo: Adam Rzepka. *194*

95. *Hina Tefatou (The Moon and the Earth)*, 1893. Oil on burlap, 114.3 × 62.2 cm (45 × 24½ in.). Lillie P.

Bliss Collection, The Museum of Modern Art, New York. Digital image © The Museum of Modern Art/Licensed by SCALA/Art Resource, New York. W499. *195*

96. Cover for notebook *A ma fille Aline, ce cahier est dédié*, 1893. Watercolor on paper. Collections Jacques Doucet, Institut national d'histoire de l'art, Paris. *196*

97. Aline Gauguin, daughter of the artist. Photograph from Jean Dorsenne, *La vie sentimentale de Paul Gauguin* (Paris: l'Artisan du livre, Cahiers de la Quinzaine, 1927), following p. 112. *196*

98. Sketch for *Vaïraumati tei oa*, 1892. From a letter to Paul Sérusier in Sérusier's *ABC de la peinture: Correspondance* (Paris: Librairie Floury, 1950). *198*

99. *Vaïraumati tei oa (Her Name Is Vaïraumati)*, 1892. Oil on canvas, 91 × 68 cm (35⅞ × 26¾ in.). Pushkin Museum of Fine Arts, Moscow/Bridgeman Art Library. W450. *199*

100. "Oro Changing Himself into an Immense Column of Fire," from the album *Ancien culte mahorie*, folio 15 (recto), 1892–93. Watercolor and ink on paper. Musée du Louvre, Paris. Photo: Réunion des Musées Nationaux/Art Resource, New York. Photographed by Hervé Lewandowski. *200*

101. "Tahitian Woman Standing in Profile," from the album *Noa-Noa*, folio 82 (recto), 1893. Musée du Louvre, Paris. Photo: Réunion des Musées Nationaux/Art Resource, New York. Photographed by Gérard Blot. *201*

102. "Taaroa: L'Univers est créé" ("The Universe Has Been Created"), from the album *Ancien culte mahorie*, folio 5 (verso), 1892–93. Watercolor and ink on paper. Musée du Louvre, Paris. Photo: Réunion des Musées Nationaux/Art Resource, New York. Photographed by Michèle Bellot. *203*

103. *Idol with a Pearl*, 1892. Carved tamanu wood, pearls, and gold, 23.7 × 12.6 × 11.4 cm (9⅜ × 5 × 4½ in.). Musée d'Orsay, Paris. Photo: Réunion des Musées Nationaux/Art Resource, New York. Photographed by Hervé Lewandowski. G94. *205*

104. *Idol with a Shell*, 1892–93. Carved toa (ironwood), mother-of-pearl, and children's teeth, 34.4 × 14.8 × 18.5 cm (13½ × 5⅞ × 7¼ in.). Musée d'Orsay, Paris. Photo: Réunion des Musées Nationaux/Art Resource, New York. Photographed by Gérard Blot. G99. *206*

105. "Taaroa and Hina," from the album *Ancien culte mahorie*, folio 19 (recto), 1892–93. Pen on paper. Musée du Louvre, Paris. Photo: Réunion des Musées Nationaux/Art Resource, New York. Photographed by Hervé Lewandowski. *207*

106. *Arii matamoe (The Chief Is Asleep)*, or *The Royal End*, 1892. Oil on canvas, 45 × 75 cm (17¾ × 29½ in.). Private collection. Photograph courtesy of Fondation Pierre Gianadda, Martigny, Switzerland. W453. *208*

107. "Matatini, Patron of Fishnet Makers," from the album *Ancien culte mahorie*, folio 9 (verso), 1892–93. Watercolor and ink on paper. Musée du Louvre, Paris. Photo: Réunion des Musées Nationaux/Art Resource, New York. Photographed by Gérard Blot. *210*

108. "Tiis" ("Spirits"), from the album *Ancien culte mahorie*, folio 11 (recto), 1892–93. Watercolor and ink on paper. Musée du Louvre, Paris. Photo: Réunion des Musées Nationaux/Art Resource, New York. Photographed by Hervé Lewandowski. *211*

109. *L'Univers est créé (The Universe Has Been Created*, or *The Creation of the Universe)*, 1893–94. Woodcut on boxwood with touches of watercolor (recto), 20.6 × 35.6 cm (8⅛ × 14 in.). Clarence Buckingham Collection, The Art Institute of Chicago. Photo © The Art Institute of Chicago. *212*

110. *Manao tupapau (The Spirit of the Dead Watches)*, 1892. Oil on canvas, 73 × 92 cm (28¾ × 36¼ in.). Albright Knox Art Gallery, Buffalo, New York/Bridgeman Art Library. W457. *216*

111. D. P. G. Humbert de Superville, *Allegory of Onanism*, 1801. Etching. Print Room, University of Leyden. *218*

112. *Manao tupapau (The Spirit of the Dead Watches)*, 1894. Lithograph in black on ivory wove paper, image: 18 × 27.1 cm (7⅛ × 10⅛ in.); sheet: 42.3 × 59.4 cm (16⅝ × 23⅜ in.). The Art Institute of Chicago, Gift of Jeffrey Sheld. Photo © The Art Institute of Chicago. *219*

113. *Manao tupapau (The Spirit of the Dead Watches)*, 1893–94. Woodcut, 16.8 × 12.2 cm (6⅛ × 4¾ in.). The Art Institute of Chicago, Gift of Carl O. Schniewind. Photo © The Art Institute of Chicago. *220*

114. *Parau na te varua ino (Talking about the Evil Spirit)*, or *Words of the Devil*, 1892. Oil on canvas, 91.7 × 68.5 cm (36⅛ × 27 in.). National Gallery of Art, Washington, D.C., Gift of the W. Averell Harriman Foundation in memory of Marie N. Harriman. Image © 2007 Board of Trustees, National Gallery of Art, Washington. W458. *222*

115. Sketch for *Parau na te varua ino*, 1892. Graphite on paper. Musée du Louvre, Paris. Photo: Réunion des Musées Nationaux/Art Resource, New York. *223*

116. *Nave nave moe (Delicious Mystery)*, or *Sacred Spring*, 1894. Oil on canvas, 73 × 98 cm (28¾ × 38⅛ in.). Hermitage, St. Petersburg/Bridgeman Art Library. W512. *226*

117. *Tahitian Landscape with Figures*, preparatory drawing for *Nave nave moe*, 1893–94. Black chalk with touches of watercolor, 19.5 × 30.5 cm (7¹¹⁄₁₆ × 12 in.). Photo: © Archives Wildenstein Institute. *226*

118. *Oviri (The Savage)*, 1894. Partly glazed stoneware, 75 × 19 × 27 cm (29½ × 7½ × 10⅛ in.). Musée d'Orsay, Paris. Photo: Réunion des Musées Nationaux/Art Resource, New York. Photographed by Hervé Lewandowski. B57, GP113. *229*

119. *Ea haere ia oe (Where Are You Going?)*, or *Woman with Mango*, 1893 (?). Oil on canvas, 92 × 73 cm (36¼ × 28¾ in.). Hermitage, St. Petersburg/Bridgeman Art Library. W501. *230*

120. *E haere oe i hia (Where Are You Going?)*, 1892 (?). Oil on canvas, 96 × 69 cm (37⅞ × 27⅛ in.). Staatsgallerie, Stuttgart. W478. *231*

121. Félix Vallotton, *Le bain au soir d'été (Bathers, Summer Evening)*, 1892. Oil on canvas, 97 × 131 cm (38¼ × 51⅛ in.). © 2007 Kunsthaus Zürich. All rights reserved. *232*

122. Jean-Honoré Fragonard, *"La Gimblette" (Girl with a Dog)*, ca. 1770–75. Oil on canvas, 89 × 70 cm (35¹⁄₁₆ × 27⁹⁄₁₆ in.). Alte Pinakothek, Munich/Bridgeman Art Library. *233*

123. *Oviri (The Savage)*, 1894–95. Color woodcut, sheet: 20.4 × 12.2 cm (8¹⁄₁₆ × 4¹³⁄₁₆ in.). Rosenwald Collection, National Gallery of Art, Washington, D.C. Image © 2007 Board of Trustees, National Gallery of Art, Washington. *235*

124. *Arearea no varua ino (The Evil Spirit Is Having Fun)*, or *Amusement of the Devil*, 1894. Oil on canvas, 60 × 98 cm (23⅛ × 38⅛ in.). Ny Carlsberg Glyptotek, Copenhagen. W512. *237*

125. *Mahana no atua (The Day of the God [or Goddess])*, 1894. Oil on canvas, 68.3 × 91.5 cm (26⅞ × 36 in.). Helen Birch-Bartlett Memorial Collection, The Art Institute of Chicago. Photo © The Art Institute of Chicago. W513. *239*

126. *Te arii vahine (The Noble Woman)*, 1896. Oil on canvas, 97 × 130 cm (38¼ × 51¼ in.). Pushkin Museum of Fine Arts, Moscow/Bridgeman Art Library. W452. *244*

127. *Self-Portrait, near Golgotha*, 1896. Oil on canvas, 76 × 64 cm (30 × 25¼ in.). Museu de Arte, São Paulo. Photo: Erich Lessing/Art Resource, New York. W534. *246*

128. *Poèmes barbares (Savage Poems)*, 1896. Oil on canvas, 62.9 × 47 cm (24¾ × 18½ in.). Fogg Art Museum, Harvard University Art Museums, Cambridge, Mass./Bequest from the Collection of Maurice Wertheim, Class 1906/Bridgeman Art Library. W547. *248*

129. *Nevermore*, 1897. Oil on canvas, 60.5 × 116 cm (23⅞ × 45¾ in.). Courtauld Institute of Art Gallery, Somerset House, London/Bridgeman Art Library. W558. *250*

130. *Te rerioa (Day Dreaming;* referred to by Gauguin as *The Dream)*, 1897. Oil on canvas, 95.1 × 130.2 cm (37½ × 51¼ in.). Courtauld Institute of Art Gallery, Somerset House, London/Bridgeman Art Library. W557. *251*

131. *D'où venons nous, que sommes nous, où allons nous (Where Do We Come From? What Are We? Where Are We Going?)*, 1897. Oil on canvas, 139.1 × 374.6 cm (54¾ × 147⅛ in.). Museum of Fine Arts, Boston/Tompkins Collection/Bridgeman Art Library. W561. *254–55*

132. *Faa iheihe (To Embellish Oneself)*, or *Tahitian Pastoral*, 1898. Oil on canvas, 54.3 × 169.5 cm (21⅜ × 66¾ in.). Tate Gallery, London. Photo: Tate Gallery, London/Art Resource, New York. W569. *258–59*

133. *Te atua (The Gods)*, 1899. Woodcut printed in black with touches of ochre in two printings from one block on ivory Japanese tissue laid down on white wove paper, 22.4 × 22.7 cm (8⅞ × 9 in.). The Art Institute of Chicago, Gift of the Print and Drawing Club. Photo © The Art Institute of Chicago. *260*

134. *La guerre et la paix (War and Peace)*, 1901. Painted tamanu wood, 44.45 × 99.53 cm (17½ × 39⁹⁄₁₆ in.). Museum of Fine Arts, Boston, Gift of Laurence K. and Lorna J. Marshall. Photo © 2007 Museum of Fine Arts, Boston. G127. *261*

135. *Cavaliers (Riders)*, or *The Ford (The Flight)*, ca. 1901. Oil on canvas, 73 × 92 cm (28¾ × 36¼ in.). Pushkin Museum of Fine Arts, Moscow. Photo: Erich Lessing/Art Resource, New York. W597. *266*

136. *Riders on the Beach (Hiva Hoa)*, 1902. Oil on canvas. Museum Folkwang, Essen, Germany. Photo: Interfoto/Bridgeman Art Library. W619. *266*

137. Sketch of figures and a tree, from the album *Ancien culte mahorie*, folio 37 (verso), 1892–93. Musée du Louvre, Paris. Photo: Réunion des Musées Nationaux/Art Resource, New York. Photographed by Hervé Lewandowski. *269*

138. *Nativity*, 1902. Traced monotype in brown and black (recto), 24.3 × 22 cm (9½ × 8⅝ in.). The Art Institute of Chicago, Gift of Robert Allerton. Photo © The Art Institute of Chicago. *269*

139. *Still Life with Maori Kumete, Sunflowers, and Fruit*, 1901. Oil on canvas, 93 × 73 cm (36 ⅛ × 28 ¾ in.). Private collection, Lausanne. W606. *271*

140. *Te tiai na oe ite rata? (Are You Waiting for a Letter?)*, 1899. Oil on canvas, 73 × 94 cm (28¾ × 37 in.). Private collection. Photo courtesy of Fondation Pierre Gianadda, Martigny, Switzerland. W587. *272*

INDEX

Boch, Eugène, 141

Bodelsen, Merete, 290n23, 291n44, 293n6, 295n37

Bolívar, Simón, 4

Bonjour Monsieur Gauguin, 133, 142–45, *143,* 291n47, 306n16; death themes/symbolism, 142, 144, 218, 307n21, 307n22

Bonnard, Pierre, 174

The Book of Beginnings (Massey), 320n26

Borja family, 4

Borobudur temple decorations (Java), *98,* 156–57, 166, 291n44, 298n94; Breton works, 53, 97, 148, 284n82; Tahitian works, 156, 183, 204, 258, 260, 268

Boucher, François, 59

"Le bouddhisme en Occident" (Burnouf), 18, 19, 117, 284n77

Boulanger, Georges, 15, 50

Boussod et Valadon exhibition, 159

Bracquemond, Félix, 42

Breton, Jules, 277

Breton Calvary: The Green Christ, 131–33, *132*

Breton Eves, 64–65, 72, 76, 184, 209, 297n79. *See also* falling Eves

Breton faces and costumes, sketch of, *58*

Breton Fantasy, 135, *135*

Breton Girls Dancing, 77

Breton Girl Spinning (Joan of Arc), 103, *104,* 291n47

Breton mores, 62, 65, 164

Breton peasants: portrayals/descriptions of, 57–60, *58*

Breton Shepherdess, 293n6

Breton works: Eve themes in, 62–65, 172; style/influences, 42–43, 57–60, 166. *See also specific works*

Brettell, Richard R., on Dorra and his work, ix–xiii

Brittany: 1886–91 stay, 13, 41–42; 1894 stay, 225, 236, 240; Gauguin's feelings about, 131. *See also* Breton works; *specific towns*

Brouillon, Jean, 50–51

brushwork, 288n35; Breton works, 42, 43, 45; early works, 11, 36–37, 38; *Grape Harvest in Arles,* 77–78

Bruyas, Alfred, 143–44

Buddhism, 117, 283n73, 284n77; Gauguin's interest in, 17, 18–19, 283n73; metempsychosis and nirvana, 17, 19, 34, 140–41, 213; Theosophy and, 18–19, 48, 283n73

Buddhist allusions/influences, 18, 19, 291n44; *La Belle Angèle,* 53; *Black Venus,* 139; *Breton Girl Spinning,* 103; *Martiniquaises,* 71; *Self-Portrait Jug,* 121; *Self-Portrait with Halo,* 19, 124, 126, 303n41; Tahitian works, 204–6, 249, 258; van Gogh's *Self-Portrait,* 19, 116–17. *See also* Borobudur temple decorations; Indian art/influences; Javanese art/influences

Buddhist iconography: hand gestures, 97, 103, 249, 298n94; lotus, 71, 106; water, 193

Buffalo Bill, 137

Bunyan, John, 307n24

Burnouf, Emile, 18, 19, 117, 284n77

Buvette de la Plage decoration, 54, 103, 240, 291n47, 307n32. See also *Bonjour Monsieur Gauguin; Breton Girl Spinning; Female Nude with Sunflowers; Portrait of Jacob Meyer de Haan by Lamplight; Self-Portrait with Halo*

Café Voltaire, 159

Caldecott, Randolph, 73

calla lilies, 124, 126

Cambodian art/influences, 37, 97, 103, 166, 298n94

Caractères (La Bruyère), 42, 51

career, 259–60, 270; beginnings of artistic career, 10, 11, 12; criticism, xvi, 157, 159, 217, 265 (*see also* Aurier, G.-Albert); dealers, 41, 42, 240, 263 (*see also* Gogh, Theo van); early employment, 10–11, 12; Gauguin's fears/concerns about, x, 126–28, 209, 244; sales, 42, 54, 128, 159, 224–25, 240, 245; supporters, 127–28, 157–59, 224. *See also* exhibitions of Gauguin's work

Caribbean Woman. See Female Nude with Sunflowers

caricature, 43; in portraits of friends, 42, 46, 51, 54; in portrayals of peasants, 57, 121

Carlyle, Thomas, 56

Carrière, Eugene, 151, 159

Catholic Church, Catholicism: Gauguin's anticlericalism, 7, 9, 17, 19, 256–57; Gauguin's Catholic education, 9, 16, 255; influence on Baudelaire, 16, 223; and morality in Breton culture, 59, 62, 65, 72, 83; in Polynesia, 164, 166–67, 267

Caucasian women, 109; "*The Awakening* figure," 109, 194, 225, 227, 256, 313n15, 313n16

Cavaliers (Riders), 265, *266*

ceramics, in Gauguin's paintings, 23–24, 25, 121, 135–36, 285n4; *La Belle Angèle*, 53, 291n43, 291n44, 291n45; *Madcap/Gauguin Vase*, 43–44, 157

ceramic works, 42. *See also specific works*

Cézanne, Paul, 42, 45, 53, 289n8

Charlier (prosecutor), 262

Chaudet (dealer), 240, 252

Chazal, André, 3, 6

Chazal-Tristan, Aline. *See* Gauguin, Aline (mother)

Chérubin (Morice), 159

Chevreul, Michel Eugène, 11, 36, 288n35

chickens, 146

The Chief Is Asleep (Arii matamoe, or The Royal End), 208–9, *208*, 257, 315n49

childhood and education, Gauguin's, 2, 8–10, 16, 146

The Child of God (Te tamari no atua), 252

children: in Breton works, 103; in *Jewelry Casket*, 31, 33; in Tahitian culture, 165, 167, 177, 201–2; unwanted, concern for, 83, 296n64

children, Gauguin's: deaths of, 252; with Mette, 10, 252; Polynesian, 165, 252, 262, 263, 270; portraits of Aline and Clovis, 22–25, *23, 24*, 26. *See also children by name*

Childs, Elizabeth C., 313n12

chimera/lizard figure, 183

Chodzko, Olympe, 7

Christ: artist-Christ identifications, 20, 120–21, 128–29, 137, 245–47; Gauguin on, 246–47; spiritist/Theosophical views of, 18, 256–57. *See also* Christian subjects

Christianity: in Tahiti, 164, 166–67; Theosophy and, 18–19, 257, 284n77

Christian subjects, 137; *Breton Calvary: The Green Christ*, 131–33, *132*; *Christ in the Garden of Olives*, 126–30, *127*; *Ia orana Maria (Hail Mary)*, 156, 167, *168*, 173–75; *The Vision after the Sermon*, 21, 38, 74–76, 84, *110*, 111–15, 296n69; *The Yellow Christ*, 92, 121–23, *122*, 129, 135, 137, 303n35

Christian themes/symbolism, 118; the Fall, 75, 76, 93; nativity themes, 252, 268, 270; original sin, 16, 254–55, 257; in *L'univers est créé*, 213. *See also* apples, apple symbolism; Christian subjects; Eve themes; serpents, serpent symbolism; wise and foolish virgins

Christ in the Garden of Olives, 126–30, *127*

Les cigales et les fourmis (The Grasshoppers and the Ants), 69–71, *70*

Clark, Kenneth, xii

class allegiance, 16, 285n3

class characterizations, 42, 46, 51, 53, 144

Clemenceau, Georges, 158, 159

Clovis Asleep. See *Sleeping Child*

color, color symbolism, 11, 28, 36, 38; *Breton Calvary: The Green Christ*, 133; Charles Henry's ideas, 29, 119; *Christ in the Garden of Olives*, 126, 128; complementary contrast theory, 11, 36, 281n39, 288n35; death symbolism, 80, 84, 315n52; *Female Nude with Sunflowers*, 93, 95; *Grape Harvest in Arles*, 77–78, 79, 80; *Portrait of Jacob Meyer de Haan by Lamplight*, 54; *Self-Portrait (Les misérables)*, 118–19; *Self-Portrait with Halo*, 124; synthesis with form, 79–80; in Tahiti, 165–66; in Tahitian works, 166, 177, 178, 179, 222, 256; *The Vision after the Sermon*, 111

compassion. *See* humanitarianism

complementary color contrasts, 11, 36, 281n39, 288n35

Concarneau, fight at, 236, 240

confidante/duenna figures, 66, 69, 106–7, 245, 251

Constant, Alphonse-Louis (Eliphas Lévi), 231–32, 280n13

constructive style, 42, 45, 289n8

Cook, James, 168, 176, 177, 201, 268

Corot, Camille, 11

Correspondances (Baudelaire), 114, 302n15

Courbet, Gustave, 267, 277; *Bonjour Monsieur Courbet, or La Rencontre (The Meeting)*, 142, *143*, 144

cows, 112, 265

crayfish, 193

creation: Polynesian creation mythology, 203–4, 205, 206–7, 210, 215, 247–49. *See also* evolution, evolutionary themes; Genesis

The Creation of the Universe. See L'Univers est créé

creativity, creative struggle, 120, 121, 236, 318n18, 318n31; Aurier on, 114–15; Gauguin on, 115, 118, 120; immortality of artists/artistic creation, 140, 189–90, 202, 315n49. *See also* artist's role/plight

Creole Women, 294n27

critics and criticism, xvi, 157, 217, 265; "Symbolism in Painting: Paul Gauguin" (Aurier), 114–15, 159, 302n14, 302n15

Dupuis, Charles, 188, 312n6

Durand-Ruel, Paul, 13, 54, 145, 282n47

Durand-Ruel exhibition (1893), 236, 240, 244

Dürer, Albrecht: *The Knight, Death, and the Devil*, 265

Dürer (Panofsky), xii

Ea haere ia oe (Where Are You Going?, or *Woman with Mango)*, 229–30, *230*, 318n20

The Earthly Paradise. See *Exotic Eve*

Ecole Nationale des Beaux-Arts, 117, 118, 303n27

eel, 193

Egyptian art/influences, 37, 119, 166, 202, 210, 303n41

E haere oe i hia (Where Are You Going?), 229, 230, *231*, 318n19, 318n20

Eisenman, Stephen, xi

elephant, 193

emblem books, 99, 148–49, 151, 299n99

emotional control, 180, 183. *See also* instinct/ impulsiveness

emotions, artistic expressions of, 28, 118, 287n21; symbols for, 118–19, 121

Encausse, Gérard (Magus Papus), 48–49, 66

Enfantin, Prosper, 7, 280n12

eroticism: in pastoral scenes, 59–60, 64–65; *Woman in the Hay with Pigs*, 84–85. *See also* sexual themes/symbolism

escape dreams/allusions, 45, 65, 99–100, 145–46, 263, 293n14

Escobar y Mendoza, Antonio, 281n23

esprit d'Escobar, 9, 281n23

L'esprit moderne et le catholicisme, 19, 204, 256–57, 314n33

Esquiros, Alphonse, 7, 180, 280n13, 293n12, 317n15

ethics: Gauguin's views, 15–16, 35; subordinated to aesthetics, 20, 113, 115, 118, 302n17, 304n27. *See also* morality

Eve (statuette), 107–9, *107*

Eve (watercolor and pastel). See *Don't Listen to the Liar . . .*

Eve and the Serpent, 66, *67*, 93

Eve themes, 56, 293n10, 293n12; author's early papers on, ix, xi, 276; Breton Eves, 64–65, 72, 76, 184, 209, 297n79; Breton works, 62–65, 172; Eves as foolish/wise virgins, 172, *173*; parallels with Flora

Tristan's work, 6; Tahitian works, 167, 183, 184; three aspects of, 62–64, 102, 293n12. *See also* fallen Eves; falling Eves; mummy Eves; self-righting Eves

evil, 16, 223; struggle against, 112, 126, 301n9

evil spirit evocations, 170

The Evil Spirit Is Having Fun (Arearea no varua ino), 236–38, *237*, 318n32

The Evil Spirit Speaks (Mahna [Mahana] no varua ino), 170, *171*

evolution, evolutionary themes, 20, 248–49, 283n73, 287n30; Gauguin's musings on, 34, 184, 204, 213; *Jewelry Casket*, 29, 34; Tahitian works, 204, 210, 212, 213, 239; Theosophical evolutionary spiritism, 20, 34, 213, 248, 283n73, 287n30

exhibitions of Gauguin's work: Boussod et Valadon, 158; Denmark, xvi, 217, 224–25; Durand-Ruel, 236, 240, 244; impressionist exhibitions, 12, 26, 145; Les Vingt exhibition, 141; Salon of 1876, 11; Volpini exhibition, 85, 93, 126–27, 128

existentialism, 284n86

Exotic Eve, 146–49, *147*, 307n32

Exposition Universelle (1889), 90, 93, 137, 298n94, 303n41

eyes: Marquesan-influenced, 186, 207, 230, 231; slanted, 47, 53, 101, 104, 124, 154–55, 290n20

Faa iheihe (To Embellish Oneself, or *Tahitian Pastoral)*, 257, *258–59*, 262, 265

Faille, J.-B. de la, 302n13

The Fall, 75, 76, 93. *See also* Eve themes; original sin

fallen Eves, 63–64, 102; *Aux roches noires II (At the Black Rocks)*, 93, 101; *Design for a Carved Bookcase*, 76; *Don't Listen to the Liar . . .*, 86–90; *Grape Harvest in Arles*, 85; *Human Miseries*, 85; *Jar with Figure of a Bathing Girl*, 72; *Life and Death*, 93; *Loss of Virginity*, 141–42; *Nirvana: Portrait of Jacob Meyer de Haan*, xv, 101, 102, 172; Tahitian works, 167, 209; *Two Women Bathing*, 63. *See also* mummy Eves

falling Eves, 62, 102, 172; *Aux roches noires II (At the Black Rocks)*, 93, 101; *Be in Love and You Will Be Happy*, 90, 92; *Be Mysterious*, 104, 172; *Design for a Carved Bookcase*, 76; *Eve* statuette, 108; *Jug with Half-Clad Breton Eve*, 64–65; *Nirvana: Portrait of Jacob Meyer de Haan*, xv, 101, 102, 172; *Les*

primitive, 4, 34, 52, 66, 68, 102, 114, 120, 130, 134, 106, 290n45

Pritchard, George, 175, 176

Promenades dans Londres (Tristan), 6, 280n7, 287n27

Proudhon, Pierre-Joseph, 6–7, 83, 280n11, 280n12

psychological health/states, 149, 224; depression, 128, 144, 163–64; fears of isolation/motherlessness, 145–46; during second Tahiti sojourn, 244–45, 250, 252–53, 257, 262; suicide attempt, 252–53

Punaauia, Gauguin's residences in, 243, 250–51, 252, 262, 263. *See also* Tahiti, second sojourn

puppets, 22, 23, 187; Javanese shadow theater, 179, *179,* 251–52

Puvis de Chavannes, Pierre, 37, 253

rabbits, 66, 252

Rachilde, 149, 159; drawings commissioned by, 149–52, *150, 152*

ram, 66

Rapetti, Rodolphe, xii

rationalization, 9, 281n23

rats, 92, 121, 258

Ravanas, 5, 294n23

Rave te hiti aamu (The Monster Takes Hold of the Fable), 313n15, 313n16

realism, 114, 277, 302n14. *See also* naturalism; Romantic naturalism

Reclining Tropical Eve with a Fan, 66, *68,* 69, 245, 249; Eve figure in, 69, 93, 95; observer figures in, 69, 71, 90, 106

Redon, Odilon, xii, 159, 265; *Cul-de-Lampe,* 99, 183, *184; Death: My Irony Surpasses All Others,* 140, 149, 308n37; *Flower-Cyclops,* 99; letters to, 140, 149

regeneration symbolism, 197; Breton works, 71, 106, 109, 140, 146, 148, 151; Tahitian works, 170, 193, 202, 209, 252. *See also* resurrection/regeneration

religion: Enlightenment views of, 188; evolutionist views of, 204; Theosophical views of, 17–19, 34, 53, 174, 284n77. *See also* evolution, evolutionary themes; Polynesian religion and deities; Tahitian religion and deities; *specific religions*

religious movements: Mapah, 7, 280n12, 280n13; Swedenborgianism, 16, 17, 109, 118. *See also* Theosophy, Theosophical Society

religious skepticism, 7, 9, 17, 204

religious subjects/works: Gauguin on, 130; primacy of aesthetics in, 113, 115, 118, 302n17; van Gogh's feelings about, 128, 129, 304n58. *See also* Christian subjects; Tahitian religion and deities

religious syncretism, 17–19, 53, 174, 175, 206

Rembrandt, 267

Renan, Ary, 157–58

Renan, Ernest, 157, 247, 285n88

republicanism, 7, 14, 280n16. *See also* liberal politics

restorations: *Self-Portrait, near Golgotha,* 245

resurrection/regeneration: "Dialogue between Tefatou and Hina," 187–88, 189–90; Gauguin on, 268, 270; Hina associated with, 219. *See also* immortality; regeneration symbolism

La Revue Blanche (periodical), 313n11

Rewald, John, ix

Riders (Cavaliers), 265, *266*

Riders on the Beach (Hiva Hoa), 265, *266*

rider symbolism, 257, 265, 321n2

Rimbaud, Arthur, 280n14

rodents, 92, 121, 258

Rodin, Auguste, 145; *The Awakening,* 194, *194,* 225, 227. *See also* "*The Awakening* figure" in Gauguin's work

Romanticism, 5, 8, 129–30, 188, 302n17

Romantic naturalism, 10, 11, 129–30; Barbizon school, 10, 11, 57, 59, 129, 130

Rops, Félicien, 299n99; *In the Ardenne Country—Now, That Daft Marie-Josèphe Thinks of a Child Who Has Been Buried,* 81–83, *82,* 85

Roskill, Mark, 288n34, 296n67

Rossetti, Christina: "Uphill," 144–45

Rotonchamp, Jean de, 50

Roy, Louis, 313n11

The Royal End (Arii matamoe, or *The Chief Is Asleep),* 208–9, *208,* 257, 315n49

Rubens, Peter Paul, 225

Rupe rupe, 257, 262, 265

Ruskin, John, 20, 115, 118, 302n17

Ryan, Michael, 5–6

Sacred Spring (Nave nave moe, or *Delicious Mystery),* 173, 225–28, *226,* 313n15, 317n12

Sagesse (Verlaine), 227–28

Final editing of Henri Dorra's manuscript was completed
by Mary Dorra, Helen Dorra, and Hope Werness.

SPONSORING EDITORS: Stephanie Fay, Deborah Kirshman
ASSISTANT EDITOR: Sigi Nacson
PROJECT EDITOR: Sue Heinemann
EDITORIAL ASSISTANT: Lynn Meinhardt
COPYEDITOR: Charles Dibble
INDEXER: Thérèse Shere
DESIGNER: Sandy Drooker
PRODUCTION COORDINATOR: John Cronin
TEXT: 10.5/15.5 Fournier
DISPLAY: Cochin and Akzidenz Grotesk
COMPOSITOR: Integrated Composition Systems
PRINTER AND BINDER: Friesens